STARTING YOUR CAREER AS A PHOTO STYLIST

STARTING YOUR CAREER AS A PHOTO STYLIST

A Comprehensive Guide to Photo Shoots,
Marketing, Business, Fashion, Wardrobe,
Off-Figure, Product, Prop, Room Sets,
and Food Styling

SUSAN LINNET COX

ALLWORTH PRESS
NEW YORK

Allworth Press
New York, New York
© 2012 by Susan Linnet Cox

Allworth Press books may be purchased in bulk at special discounts for sales promotion, corporate gifts, fund-raising, or educational purposes. Special editions can also be created to specifications. For details, contact the Special Sales Department, Allworth Press, 307 West 36th Street, 11th Floor, New York, NY 10018 or info@skyhorsepublishing.com.

15 14 13 12 11 5 4 3 2 1

Published by Allworth Press
An imprint of Skyhorse Publishing
307 West 36th Street, 11th Floor, New York, NY 10018.

Allworth Press® is a registered trademark of Skyhorse Publishing, Inc.®, a Delaware corporation.
www.allworth.com

Cover design by Mary Belibasakis
Cover photograph by Siobhan Ridgway

ISBN: 978-1-58115-910-3

Library of Congress Cataloging-in-Publication Data

Cox, Susan Linnet.
 Starting your career as a photo stylist a comprehensive guide to photo shoots, marketing, business, fashion, wardrobe, off-figure, product, prop, room sets, and food styling / Susan Linnet Cox.
 p. cm.
 Includes index.
 ISBN 978-1-58115-910-3 (pbk. : alk. paper)
 1. Photography—Vocational guidance. 2. Image consultants—Vocational guidance. 3. Marketing. I. Title.
 TR154.C694 2012
 770.23—dc23
 2011048726
Printed in the United States of America

Dedication

For Gary, Elizabeth, Adrian, and Levi, my growing family, and Ann, my dearest friend. I also dedicate this book to my students, to the stylists who have shared their stories, and to all those who have encouraged me to share the fascinating career of photo styling.

Contents

Introduction

Photo styling is an "invisible" career.

The goal of the stylist is to create the illusion of naturalness in a photograph. We make a stack of sweaters look as if they were casually placed. We make a dining room look like the residents just walked out of the scene. We make a model look like she is confidently walking down the street in an attractive outfit. In reality, all these scenarios take a great deal of preparation, planning, adjustments, and precision. That is the job of the photo stylist.

Secondly, the career is "invisible" because not much is known about it outside of the photo industry. Little has been written about the career. Most of us come upon the field accidentally through graphic design, as I did, or as my fortunate interns have done, through college fashion programs. However, no formal education is required.

This career manual explores the numerous directions photo styling can take. The book provides new and working stylists with information on all these specialties. The stylist can take on various roles; production, casting, and location scouting are a few. In this book, the photo crew, etiquette, creating a portfolio, and marketing are explored in depth. The aspiring stylist must learn how to develop and maintain a freelance career. Business forms such as proposals, invoices, and vouchers will give stylists a head start on building their own freelance businesses.

Dirty little secrets of the trade are revealed. Challenging and hidden aspects of styling, such as merchandise returns and re-tagging garments, are discussed. Interviews with professionals introduce stylists to real career stories.

Photo styling touches nearly every image we see, except for the raw portrayals of journalism. From the self-conscious primping for snapshots to the most exacting attention to details in commercial photography, styling makes a visible difference in the world around us. Though some might say "It's not rocket science," the skills of a photo stylist have an effect on all the images around us.

Styling is a tremendous opportunity for creative and organized individuals to express themselves. What adds to the excitement is that one can continuously draw on life experiences and accumulated practical skills to energize this intriguing career.

Since this book was originally published in 2006 as *Photo Styling: How to Build Your Career and Succeed*, the photography industry has changed. Digital technology has evolved even further, adding the role of digital technician to the crew. We are all more connected than ever, with social media enhancing our personal communication and marketing techniques. And we are facing even more challenges as an industry as the global marketplace changes.

Despite the accessibility of images (cell phones, small digital cameras, YouTube), there is still a place and a need for the quality images created by an experienced photographer/stylist team.

I am happy to bring you this new edition, complete with more first-hand stylists' stories, styling tips, and portfolio challenges to help you build your book and promotional materials.

PART I
INTRODUCTION TO PHOTO STYLING

CHAPTER 1

What Is a Photo Stylist?

PHOTO STYLING IS THE little-known art of manipulating and controlling all the physical elements in a photograph to create an effective image. It takes a creative and organized person to be a good photo stylist. Many artistic people find styling to be a more practical outlet for their creativity than a career in the fine arts.

And now the word is out about this behind-the-scenes career. Many young adults have heard of styling, having read about celebrity stylists in magazines, and it has become their dream job. This glamorous image of styling, though, is not wholly accurate. Knowledge and understanding of the interdependent fields of photography, graphic design, and marketing are important factors for success as a photo stylist. Long hours, physically demanding work, thorough organization, and business management skills are as crucial as creativity.

Boston stylist Ann Fitzgerald says, "Becoming a good stylist takes time; to build resources, train your eye, and learn to beg, borrow, and steal in the nicest way possible."

DESCRIBING WHAT YOU DO

The goal of styling is to make a photograph look as though there wasn't a stylist involved. So it's no wonder most people don't know about photo styling. They see photographs in catalogs, magazines, and advertisements and have no idea of the amount of work involved in creating them. As a stylist, you can explain that you make everything in a photograph look just right. But there are people who hear the word "photograph" and stop right there. Even after the explanation, they may say, "Oh, so you're a photographer?" Then you bring out a catalog and describe the process—how you stacked the T-shirts so that one might see every color, making them thicker with batting, like the kind used for quilting, tucking in the sides, lifting the top one with cardboard held up by a brick; how you adjusted and readjusted the stack so it would look perfect. The response will be, "Oh, I had no idea every photograph took so much work!"

The preparation—and expense—involved in a fashion shoot on location will amaze them even more; the weeks of planning, scheduling, booking models, prop shopping, the travel to locations, hotel rooms, meals, and steaming the merchandise. The response then may be, "All that, just for a background that you can hardly see?" "It's the light," you'll say, "and the local landmarks we include in some shots for atmosphere." They won't believe you, but who's complaining?

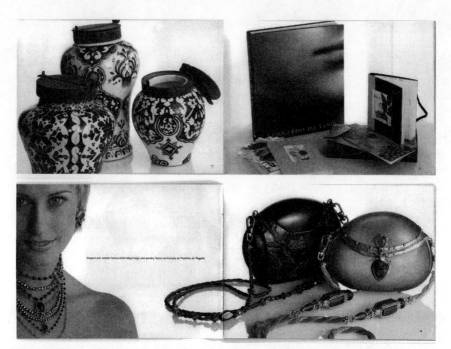

Four pages from a holiday catalog showing different types of styling. Photographer: Tim Mantoani; art director: Cindy Cochran; stylist: Susan Linnet Cox; hair and makeup: Claire Young. © Tim Mantoani

DISCOVERING STYLING

What leads one to discover this fascinating hidden career? Most stylists just "fall into it" as a career. One of the interns I trained, Veronica Guzman, admitted she wished she had known there was such a thing as a stylist during all those youthful years when she was cutting photos out of magazines.

Conversely, New York fashion student Tiffany Olson said, "I am one of the few who have been interested in it from the start, since my mother is a catalog art director. Growing up, I used to sit for hours at my mother's photo shoots just watching and knew it was for me. Now I'm looking for an opportunity to learn more about styling."

Generally, photo stylists emerge from creative fields like fine art, graphic design, theater, or fashion. Many have a college degree in these fields, but what is really required is a visual aesthetic, an independent spirit, with an organized and practical nature. Most stylists have a desire to create something visually pleasing, while earning a good income.

THE REAL LIFE RÉSUMÉ

When you create a résumé, you don't tell the whole truth. You only tell the good parts, the skills and accomplishments that qualified you for your present goal. You're not hiding the truth when you leave out the various forks in

the road and side trips that you've taken in your life; you're just getting to the point. And as you grow, you will take more side trips—that is, if you're adventurous. And if you are reading this book, you probably have a penchant for adventure. It is not an easy business—it's never easy to work for yourself, to wonder what job you will work on next, to work long and hard, and to have responsibility for your part of the project. But it is still the best career in the world.

All those trips you've taken won't be wasted. The dead ends can teach you skills that will surprise you later. After the long hills…the potholes…even the crashes, you learn that you have experienced the worst that can happen, and you survived.

You meet people that turn up again later in your life. You find out you weren't wasting your time fishing when you know the strengths of various monofilaments and where to find them. Your brief interest in embroidery, your study of perennial plants, your experience driving a motorcycle, your time in nursing school—they all come back to you in your styling career with some useful knowledge or skill. Because in this field you don't only deal with fashion or gourmet food. You work for clients in such diverse enterprises as pet stores, window blind companies, software designers, nursing homes, fork lift manufacturers, or ice cream shops. The more you know, the better you will understand why they need a photograph taken and how it can help them sell their products.

So your "real life résumé" is mysterious at times and confusing at others. The older you get, the more you will accept your path and realize it was all really worth the trip.

MY BACKGROUND

I wish I had discovered styling earlier. I think I would have had a delightful adult life as a photo stylist. Instead, after finishing a fine arts degree, I put in thirteen years of waitressing, off and on. It was a job I could always find, with ready cash. At the same time I owned a house-plant store in Kent, Ohio, in the 1970s, the decade when young people were rediscovering their grandmothers' house plants and placing them in macramé plant hangers. I was able to live for five years on an initial investment of $50 from my waitressing money, supporting quite a few employees as well.

I was a substitute art teacher in the Akron Public Schools. I sewed samples for a small designer in Venice, California. I constructed one-of-a-kind shirts for a Melrose Avenue boutique. I made custom lingerie for Trashy, a famous private-membership store in Los Angeles—but it was a small room in a shoe store at the time, and I had a sewing machine set up between the shelves in the stock room. I held a job in a fabric store. I worked part-time in a darkroom for my brother who was making copy prints of old photos. I started a mail-order t-shirt company with another woman. We sold sushi T-shirts from our ad in the now-defunct Wet Magazine in New York and Los Angeles. I designed the ad and didn't even know I was doing graphic design. I drew the silkscreen design of the sushi by hand on seven sheets of tracing paper,

which all fit together to print seven different colors. I sewed and marketed soft sculpture TVs and guitars out of satin.

A FEW DEAD ENDS
If all of this sounds like I flitted from success to success, it is not true. There were lots of dead ends. That is why the waitress skills kept coming in handy. The economy in Northeastern Ohio grew steadily bleaker in the late 1970s. I gave up on the beloved plant store. California beckoned me, as it did many of my generation and I found myself in luxurious Montecito, near Santa Barbara. It was the home of a rock star friend and I was able to camp there in a guest room for three months—too long. It is not as it sounds. I literally spent my last dime while helping his wife shop for antique furniture with royalties from a major album. I found another waitress job and then the lingerie opportunity in Los Angeles. I left that job to start my own line of silk lingerie, Suzy, which I took to Beverly Hills boutiques. I didn't get a single order. It was around that time that I met a photographer from Kent who shot for "girlie" magazines. He told me there are people whose job it is to actually shop for the props and other items that are used in photo shoots. A stylist! I was amazed but never imagined it would later be my profession. First I had a different road to travel.

THE LONG ROAD
I found a waitress job in a jazz club in West Los Angeles. I spent my days roller-skating at Venice Beach and worked at Snooky's at night. It was the best job I'd ever had. There were famous musicians playing and a real nightclub atmosphere. The cash was good and my boss, Gary Cox, became my husband. We fell madly and truly in love, and I left my job to stay home and be a newlywed. Eventually I got serious and started to face the idea that I was about to have a child who was going to need my support and I didn't even have a sensible career yet!

After my daughter was born, she enthralled me. Fortunately, I didn't have to leave her and go to work full-time like many mothers do. I did want to do something, though, and worked part-time at a day-care center where we could be together. At night I parked cars for an all-women valet parking service. What a contrast!

Finally, when Elizabeth was three, I found the career I'd been looking for and that career led me to styling. I became a graphic designer. When I was in art school, "commercial art," as it was known then, was somewhat repugnant. It was "selling out." We all wanted to be artists and had no idea how that might support us. The art department didn't offer much practical help.

THE FLORIDA YEARS
We had moved to St. Petersburg, Florida. Gary worked in developing property, and I was hired by one of those chains of TV and appliance companies that place a big ad in the newspaper several times a week with lots of little boxes showing all the microwaves, refrigerators, and televisions, and their prices. I sketched out the ads and the newspapers produced them. The company

advertised "Christmas in July," and I got to be involved in a TV production. The owner was dressed as Santa and was sitting in a sleigh with a group of children, including my own darling daughter. While helping him with his costume, I searched for a pillow to fill in the jacket. I found a throw pillow in his office that was embroidered with a Jewish star and used that. It was my first real styling experience and I enjoyed the irony.

After another graphic design job, I was familiar with the tools of the trade, an X-Acto® knife, T-square, triangle, and waxing roller. We sent copy to typesetters and printed halftone photos in the darkroom. When I was hired, it was assumed I knew the basics of graphic design, having done all those complex ads, but my lack of experience with these tools was nearly my undoing. Luckily, my coworkers trained me, and I repaid them by going out on my own after a year. (I'm being facetious, of course.) Now I was getting somewhere. I had clients and loved the process of graphics, designing ads, brochures, and catalogs.

ONE STEP CLOSER TO STYLING
Next, we moved to Portland, Oregon, so my husband could continue his equally indirect career path. He had returned to the field of education and was hired as a counselor in a middle school. I found a freelance position with a major catalog company, Norm Thompson. I liked being there and they liked me. I was hired just as computers were being introduced. The computer training was hard—we were all pretty attached to our X-Acto knives.

Soon the company had cutbacks due to postal increases (we'll talk in Chapter 3 about the ups and downs of the catalog industry). To my amazement, I remained employed. Typically, when there are layoffs, the remaining employees do the extra work of those let go. We had to find someone who could art direct the fashion photo shoots. My family and I had just returned from a Christmas trip away from the rainy weather to Mazatlan, Mexico, which had reminded me how much I love travel. So I willingly agreed to direct a shoot in Miami, just to see if I liked it.

I have never done anything in which I instantly felt so competent. With no training, I knew to stand behind the photographer to get the right view of the model. I could see what background would end up in the shot. I understood that the reflector would bounce sunlight back into the model's face. I knew what I was looking for when the photographer passed me a Polaroid print, and how many shots we could get done in a day. I loved my new world behind the camera.

LIFE AS AN ART DIRECTOR
I also felt sort of guilty. I was flying out of the gloomy climate of the Northwest every six weeks or so and leaving my husband with all the responsibilities of a home, a daughter, and a dog. I was leaving my child. But I also loved my job, even with the long exhausting days and the pressure of bringing back photos that sold the merchandise. Sometimes Gary and Elizabeth visited me on location, and that helped. The tension in our family was growing, though,

and I had to find another way. So after three years of this, I decided to move on. Elizabeth had only five more years before growing up and moving away, and I didn't want to miss any more of her life.

Besides, I was ready to embark on three new ventures. I was going to model for the older model market. (I found an agent but ended up with just a few bookings.) I was designing a cookbook, but the chef authors never completed their recipes, and the project fell apart. And I was planning to art direct photo shoots on a freelance basis. However, I hadn't done my homework—there wasn't much opportunity for that. Most companies in the area used in-house staff for art direction, as with my Norm Thompson position.

It wasn't all a waste of time. I started another plant store, something I'd dreamed about, feeling even more competent at store display than the first time. I did some freelance preproduction planning for Norm Thompson's photo shoots. And I had my first styling job. I was asked by a photographer to style "laydowns" of Adidas clothing for a catalog. Most of my art direction had been on location shoots of models, not in studios, but I knew the look the client was after. I thought that batting and foam would probably fill the garments enough to give them a good shape when the photographer shot them from above. I jumped in.

After one more rainy winter we moved to San Diego—we all missed the sunshine and were ready to be Californians again. There I found enough freelance graphic design and art direction jobs to meet quite a few people and progressed nicely in my career as my daughter completed high school and Gary worked in special education services.

MORE VALUABLE EXPERIENCES

I also worked for a photographer as a studio manager. I thought that going to work in a photo studio every day might be pretty heavenly. And it was—I got to do styling and find props; I built my portfolio. I found out that what I did not like was doing estimates, answering the phone, monitoring the status of my employer's jobs and stock photography sales. I observed the art directors and clients, who spent time on the phone instead of watching the shot, and I brought them their coffee and ordered their lunches. That was hard. I held back from giving advice about their photographs: If you move over this way a little your background will be better, maybe a slightly higher camera angle. One photo assistant referred to me as "the secretary," and I decided the styling opportunities weren't worth the rest of the job.

Next, I spent the better part of a year in the in-house graphic design department of a software company. There I experienced the security and give-and-take politics of the corporate world.

I took a position as senior art director of an Orange County catalog company. I watched the stylists I hired and had to hold back from doing their jobs—I was one level up, I was the art director. I directed the fashion shoots and had more foreign travel but I felt unable to use my creative experience to refine and improve the rather stodgy catalogs.

The following year I spent as a model agent. This difficult field gave me more appreciation of the work that both models and agents do. When working on the production aspects of photo shoots, you'll be working with both of them (see Chapter 4).

MAKING THE LEAP

During these few years I maintained one wonderful client, a home-products catalog. The art directors regularly came to San Diego in the winter for their spring and summer photo shoots. I started out doing a little prop shopping for them. There would be a few things they needed and if I was employed I'd just drop them off. This was my first steady client. Soon I worked on complex prop shopping expeditions and did all the styling on these shoots.

When I stopped working as a model agent, I finally had the courage—and the portfolio—to stop procrastinating and be a serious stylist.

TYPES OF STYLING

At this point in my career I had experienced many types of styling. In the coming years I'd learn even more.

I had a call from a Minneapolis-based "production designer." He wondered if I could assist him with a month of work for a window-treatment company. I learned an immense amount from him about renting furniture, carpets, and accessories. During that project I had a chance to work on a couple of days of video, and styled a bubble bath.

I'd always wanted to work on a car shoot to see what a project of that scale was like. I had an opportunity to style a series of photos for Buick, and found out about the water trucks that wet the street and about shooting on streets at night. I didn't style the cars. My role was wardrobe styling for a family that was out of focus in the background of one shot, and decorating the front of a boutique in the night shot. I also got to drive my Jeep up and down the street, carefully shining the headlights onto the Buick's side while the photographer did a long exposure.

There is no absolute description for each type of styling; there are regional differences, different terms, and different job descriptions. When I was called to style for a Tampa, Florida catalog company, I was told I'd be doing two days of "fashion." So I brought my styling kit for models to the studio the first day, and waited for the makeup artist and models to arrive. It turned out that what they called fashion was what I call "wall styling." You'll read more about wall styling in Chapter 8. I spent the days quietly styling dresses and capri sets on a vertical board. Luckily, because I'd had lots of experience with this type of styling for other clients, this was not a problem for me. I still did not know what to officially call the technique of forming life-like clothing on a wall.

Your own life history will come into play in many ways as you develop a styling career. You'll find what type of styling appeals to you and what you're most comfortable with. Here is a summary of the seven most common areas of photo styling.

FASHION STYLING

For years I looked at magazines trying to figure out who put those fabulous clothes on the model and never could find a listing for the stylist. The photographer, the makeup artist, and, sometimes, a prop stylist would be listed on the pages, but never the stylist. The image that many of us have of what a stylist does, dressing all those fashionable models in magazines, is not called a stylist at all. This is a "fashion editor."

FASHION EDITOR

Fashion editors create the fashion stories in magazines, from start to finish. The role is universal: fashion magazines from many countries have fashion editors who analyze the new styles and trends by attending the major semi-annual runway shows, develop photographic stories relevant to their readers, produce and style them, and even write about the fashions. Newer and smaller magazines are more likely to use freelance stylists for these roles. The big-name magazines have the coveted positions in which an editor can become a well-known name.

COMMERCIAL STYLING

Styling clothing for fashion advertisements, the kind you see in the same magazines, can be well-paying work. The designer clothes are the star; the model, photographer, and stylist work to create a photo that will make the shopper desire those garments. They may be creating a mood or identity for the brand more than featuring the fashions. It's a natural step for an editor who knows the fashion world inside out.

CATALOGS

Styling for catalogs that market clothing may not be cutting-edge fashion, but it provides a great deal of work for stylists. The resources are limited to what is available for sale, rather than pulling together garments from many designers into exciting new combinations. Though catalog styling may be referred to as either fashion or wardrobe, we include it with fashion styling here.

RUNWAY SHOWS

Another role in fashion is styling fashion shows. The major designer shows in Milan, Paris, London, and New York involve concepts in styling and makeup. Exhausting and stressful to execute, they are an extraordinary opportunity for a stylist. Local, smaller-scale events can be good practice.

FASHION CONSULTING

Freelance fashion stylists often supplement their careers in several areas. One-on-one consulting may be done to help individual clients make the most of their appearances and purchase the right garments for an event or everyday.

CELEBRITY STYLIST

A consultant who advises celebrities on fashion and provides the clothing they wear in public appearances is a celebrity stylist. A major part of the stylist's role

is finding sources that will loan the garments in exchange for free publicity. (These careers will be described in Chapter 6, with a focus on magazine and catalog fashion styling.)

WARDROBE STYLING

Wardrobe styling and fashion styling can easily be confused. Wardrobe styling may seem a little less creative. Indeed it is more practical—finding clothing to be worn in advertisements and other photographs, TV commercials, and videos, which may not be made for selling clothes. For lifestyle photography, the stylist is dressing the talent in generic items so as not to distract from the featured product or concept. Or perhaps the stylist is replicating a historic period for a video or commercial. The effect should be just enough that the clothes work but do not distract.

LIFESTYLE, ADVERTISING, STOCK

A lifestyle shot depicts real-life situations and people for an ad or for stock photography. The people portrayed in advertisements usually look real and approachable. Lifestyle is often also the theme of stock photography. Stock photos are available for clients to use for a fee, as opposed to photography commissioned by a client for a specific project. Because stock photographers may be paying for the shoots themselves, they often don't use a stylist.

People in non-fashion advertisements may be interacting with a product or enhancing a lifestyle concept for a specific company or brand. In these cases, as well, the wardrobe should not distract from the lifestyle being portrayed.

VIDEO, COMMERCIALS, FILM

There is some crossover between video styling and still photography styling. The fields are not so different that a stylist cannot move back and forth between the two. And skills learned in one can be useful in the other. Here, the wardrobe may need to be generic, historic, outrageous, or anything else that's required for the commercial or video.

The world of movies, however, is more complex than the world of video. There are particular resources available for the movie industry, as well as unions and other protocols to be aware of. The wardrobe team is larger and the duties more exact. Wardrobe for film, like set design, would be a fascinating and exciting career.

(Chapter 7 will describe styling for wardrobe, and provide information on shopping, organizing, and prepping garments, working with models to provide wardrobe options, and how to manage it all.)

STYLING OFF-FIGURE

In discussing styling off-figure, we will be looking at techniques for styling clothing that is not being worn. Presentations range from showing natural-looking folded items to imitating gestures of the human body.

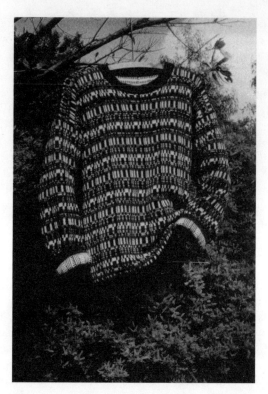

Sweater on vintage hanger shot on location. This shot resulted in opportunities in off-figure styling.
Stylist and photographer: Susan Linnet Cox. © Susan Linnet Cox

STACKS, HANGERS, MANNEQUINS, LAYDOWNS, AND WALL STYLING

There is a variety of techniques stylists use in working with clothing to show the details of garments, color selections, and the texture of the fabric. It may be folded and stacked on a tabletop in a studio, hung on hangers to show a selection of colors, dressed on a mannequin, laid down flat and shot from above, or arranged on a wall in a manner that suggests the human form. Most often this work is done in the studio environment, but garments may be styled on location.

(In Chapter 8, you will learn the basic techniques for styling clothing all five of these ways. Understanding what fabric does and how to manipulate it can enhance your skills in all other types of styling.)

PRODUCT STYLING

Rarely will a stylist work exclusively with either clothing off-figure or products. We are making distinctions here because there are different techniques that stylists use, depending on the product styled. Some stylists may excel at one or the other, having a preference for the draping qualities of fabric, or adeptness with setting up dishes.

Photographers do many product shots without the need for a stylist. For simple items in a catalog, a photographer might present a smaller budget

to a client, resulting in a greater volume of work for the photographer. You wouldn't want to style some of it anyway. Endless variations of hammers, office supplies, or electronic components might make you feel like you're working in a factory.

Other items are much more fun, especially when props are needed, or there is the challenge of making a handbag strap drape in mid-air.

TABLETOP

Products may be handbags, accessories, beauty products, dishes, or other household items. Often a background surface needs to be selected, as well as other props that will give a sense of scale and create a variety of levels. Sometimes the term "tabletop" is used to describe product styling.

SHOES

Styling shoes is fun, but there are standards for showing aspects of shoes that present their own challenges. A surprisingly large part of styling work, footwear may be shot on location or on a tabletop in studio.

JEWELRY

You may find jewelry styling, which requires working on a much smaller scale, inspiring. When shooting an item so close, clean jewelry and clean backgrounds are important. Challenges arise from positioning the items in a variety of arrangements, with the photographer carefully controlling reflections.

(In Chapter 9, I will share useful techniques for working with varied products, and hints for propping these shots.)

PROP STYLING

While props are a frequent element in styling, there are some stylists who can develop a career as "prop stylists." Most often, this opportunity occurs in markets where there is a good bit of food photography. Working alongside a food stylist, the prop stylist searches out and provides all the right props to complete the environment for the food.

Another area of prop styling is building and creating challenging props and sets for shoots. The prop stylist can face many varied challenges that require improvisation and creative problem solving. (In Chapter 10, we will explore these careers and find ways to solve prop challenges for all stylists.)

FOOD STYLING

In a world full of mysterious techniques, the food stylist has a unique kit and set of specialized skills. Except when propping the shot, the food stylist operates in a separate world, not as a jack of all trades like many other stylists. An appreciation of cooking is important even though the styled food may not always be made for consumption.

(An interview with a professional food stylist will shed light on this field, as she reveals some trade secrets in Chapter 11.)

ROOM SETS AND BEDDING

The photographers who work in this area are architectural photographers. They are skilled at lighting and shooting a large area without distortion; they see the big picture. As a stylist for room sets, you too will be thinking big. Furniture, rugs, curtains, and the props that make a room look like home are all part of the stylist's responsibility.

PRODUCTION DESIGN, ADVERTISING

Many projects the architectural photographer/stylist team works on are advertising images. Typical clients might produce kitchen cabinets, appliances, windows, window coverings, or grills. The product is the feature and the environment, like wardrobe, is there to enhance it.

HOME MAGAZINE EDITOR

Like a fashion editor, an editor for a home magazine produces visual stories for magazines. The subject is homes instead of fashion. The editor may find the home, pitch the concept, style the shots, and write the article.

LINENS

Bedding, blankets, curtains, towels, and other linens make up a large part of the catalog industry. Stylists use special techniques to make these products beautiful and inviting. The stylist is again thinking big, and decorates the whole room, or the constructed set.

(Specialists in several of these areas will provide insight into their careers in Chapter 12. You will learn from their techniques for creating the big picture.)

FINDING YOUR NICHE

While you may be familiar with the concept of styling, you may not be familiar with all the ways you can express yourself as a stylist. A fashion student may discover a fascination with styling food; a fine arts major may find that the perfect outlet is in building and styling props.

Product and wardrobe stylist Anne Ross says, "When I first started out, I tried everything. I did celebrities, editorial, advertising, assisting, commercials, and film. It was a great approach, as I quickly found out what I really enjoyed and what seemed less interesting." Ross was "drawn to print advertising for the fun, quirky ways products compete for your attention." She says, "These are usually the more creative jobs, and stylist input is usually appreciated and admired."

PRIMED TO IMPROVISE

What is so fascinating about the world of photography is how it touches every other field. What other career could bring you into contact with everything from running shoes to auto parts to edible flowers? Once I participated in a casting for an instructional video on forklift safety. What I learned from that experience has come in handy in more than one catalog warehouse.

The techniques you will learn in this book are practical and useful. You will have the tools for folding sweaters and styling a room. You'll know what to do in a photo studio and on location. You'll know who everyone on the crew is and what their responsibilities are. But no matter what I teach you in this book, you will invariably run into some unexpected challenges. Each styling project can be completely different. No two photo shoots are alike. And there are no absolute rules for photo styling. You'll solve each challenge as it comes. Your kit will grow to include new tools and materials. And you'll participate in one of the most unique and intriguing careers in the world.

RESEARCH CHALLENGE: MAGAZINE PROJECT

Choose a current magazine. It should be in the categories of men's or women's fashion, home decorating, or health and fitness. Find an example of each of the seven styling specialties in editorial features or advertising. If you feel ambitious, you can also determine whether the photographs are editorial or advertising, finding examples of each.

CHAPTER 2 The Photo Shoot

As you have already learned, there is a great deal of variety in the field of photo styling. There is almost no such thing as a typical day. But I will try to take you through a day in the life of a photo stylist.

There are three days that might be described as being typical in this career. One of them is working on a photo shoot. The second is spent catching up on all the aspects of life that get out of control while one is working long, focused, ten- to twelve-hour days. The third day is when there are no projects coming up, and the stylist gets a panicky feeling and wonders, "What if I never work again?"

You'll get a further look at a typical photo shoot in the seven chapters on styling specialties. Every adult is familiar with the practical second type of day, taking care of business, and the third will be addressed in Chapter 13 on marketing yourself.

First we'll start with some basics you need to know before you get to the photo shoot.

WHAT TO WEAR

One might think, in the exciting world of photo shoots, that the crew would be chicly dressed. The makeup artists would have flawless makeup and the stylists would be wearing some very cool fashions. While stylists tend to be creative dressers, most photo crews are dressed for work, not style. I've heard more than one makeup artist say she hadn't even bothered to put on her own makeup.

There are two reasons for this. The crew is not the focus of the shoot, and they work too hard to be anything but comfortable. Very early call times don't allow for much morning primping either. The priority at that point in the day is usually remembering everything you have to bring to the shoot.

YOUR WARDROBE

Exactly how nicely you dress depends on where you are shooting. If you're shooting in an upscale restaurant, country club, or hotel lobby, it would be disrespectful to dress too grungy. If you're on a golf course, you might avoid jeans and t-shirts. But for the most part, your wardrobe can consist of anything comfortable.

Since the days extend from early morning to high noon to dusk, it's good to have several layers with you. Even in the studio, temperatures can vary. Some areas of the studio are warm because of heat-producing lights in use there, whereas other unheated or air-conditioned parts of the studio may be chilly. Have layers handy. Sunscreen is probably the most important thing you can wear when you are outdoors all day. Keep it in your kit and share it with the crew.

COMFORTABLE FEET

Shoes that allow you to stand comfortably and move quickly are important. I even bring along an extra pair, which feels wonderful to change into in the middle of the day. Sometimes, the set-up in the studio is on "seamless" paper, which is white or colored paper on a roll, pulled down to make a smooth background. To keep the paper clean, you'll have to remove your shoes when you go onto the set. Then it's good to have shoes that are easy to slip on and off. Or you can use hospital booties for covering shoes; some photo studios keep them on hand.

Essentially your work clothes are the same as your everyday clothes. You can be creative as long as you don't scare your clients; but mainly, be practical. From New York to California, stylists can expect to climb around sets or work on the floor, and dress accordingly. Some stylists do dress fashionably; it's really a matter of personal taste. But remember, no one is really going to be looking at you.

THE CREW

The photo crew is a tightly organized group of people, working together to create the needed photographs. All members work hard to fulfill their own roles but also contribute to help the others. They have fun together while performing as an effective team.

The **photographer** is the person behind the camera who has experience with all aspects of creating photographs and is ultimately responsible for making the shot happen. A good part of the photographer's time is spent marketing to get new business and estimating potential projects. The photographer's business also includes learning about new techniques and equipment, purchasing equipment, and managing a studio.

A photographer may employ a studio manager or other staff to take care of some of these tasks. Marketing may be handled by a "rep," or representative. In any case there is more to the photographer's business than shooting images.

The **assistant photographer** is a photographer in training. He (often a male, but less and less frequently) helps the photographer with equipment and lighting. Photography assisting is one of the few classic apprenticeship situations in our world today. In the days of Michelangelo, artists were trained for many years by assisting an established artist. They learned from the artist and performed many of the more difficult tasks for which the artist was given credit. Throughout history, workers in many fields were trained this way, but nowadays most career learning occurs in schools.

Assisting is the next step after photography school, according to San Diego photographer Taylor Abeel. He says one big advantage for the assistant is the freedom from responsibility for the shoot. This period of time also gives assistants time and income to purchase equipment for their own careers, such as cameras and lights. Assistants participate in the details of the photographer's business. Like a good internship, it can be an opportunity to acquire the skills of a practicing professional. And assisting a recognized photographer can add prestige to the assistant's new career.

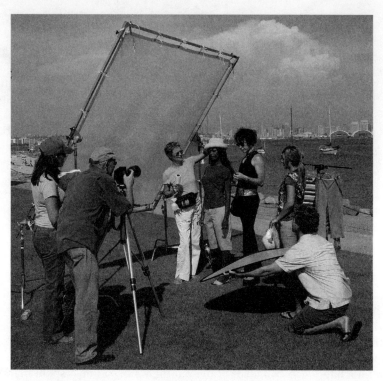

Crew members doing their jobs are, from left, art director Heather Neibert; photographer Michael Christmas; stylist Susan Linnet Cox; model Jolie Benoit; hair and makeup artist Claire Young; assistant stylist Michelle Siscon; and assistant photographer Marty Carrick. © Michael Christmas

For a complex shoot, the photographer may hire two or more assistants. There is usually one assistant who works regularly with the same photographer and is familiar with the studio. Responsibilities include setting up the lighting and trouble shooting any technical problems, as well as anticipating the photographer's needs. The assistant can also take the blame for anything that isn't working, Abeel says, helping the photographer look good in the client's eyes.

Assistants often carry equipment on location, hold reflectors and other light-modifying devices, and are a valuable part of the team. As a stylist, you will get to know many assistants and see their careers progress; most will become photographers themselves. They are great contacts for collaborating on test shoots, because they too are in the process of building their portfolios.

Digital technician is a newer role on photo shoots. Acting as more than a photo assistant, the technician is continually checking the image for focus, light balance, and other details, and cataloging the images. When a "tech" is hired, the photographer is freed from these details to be back behind the camera. The two will consult about lighting and how it is "reading" in the image. If there is a photo assistant present as well, he or she may be one step

down in the hierarchy, working to adjust lighting and backing up the tech in addition to the photographer. The collaboration between the photographer and technician results in a technically stronger image and highly organized files.

The **producer**, or **production manager** coordinates the details and logistics of a photo shoot, generally on location. This function is sometimes filled by the art director or the stylist, so this may or may not be an additional member of the crew. A producer is more likely to be hired if the project is complex and involves travel. (Production duties are explored in Chapter 4.)

The art director is ultimately responsible for approving the look of the photographs. He or she may have a graphic design background and may be the designer of the printed piece. The art director may be employed by a catalog company, an in-house design department, an ad agency, or be a freelancer. Sometimes it seems the photographer and art director are the "mom and dad" of the crew. They share the responsibility for the best photos being created and have more control over the budget and expenses.

Client is a representative of the company financing the photo shoot. As an employee of the company, the client may be an executive or merchandise buyer. If the client is not very experienced with photo shoots, he may frequently consult with the art director to achieve the best results. A client, while financially responsible for the entire shoot, can sometimes slow down the process. During the early steps of setting up a shot, the stylist may not have adjusted the model's dress and the lighting is not yet refined. The client wants to feel a part of the project and draws these problems to the crew's attention. Be patient—this is your boss for now.

The art director, whether staff or freelance, also could be considered "the client," because she represents the company that commissioned the photograph. There is no client shown in our crew photo, but the art director would be considered the client.

Stylist is you, the one who makes all elements within the photograph have the look your client needs.

An **assistant stylist** may be hired in a more complex shoot—one involving models and wardrobe or lots of props—to help the stylist by performing multiple tasks, such as steaming clothing and dressing models. While not as established a tradition as the photography assistant, being an assistant is excellent training for styling. In fact, assisting is the ideal way to learn about the field. As an assistant, you may spend most of the shoot steaming garments or keeping track of merchandise, but you are there. You have an opportunity to watch, listen, and learn. It is considered improper to solicit work by handing out your card or promotional materials—you are there only to support the stylist.

The **makeup artist** and/or **hair stylist** may be a single person who styles hair and does makeup, or there may be separate specialists. This specialization, and the budget for it, is more common in larger markets. The makeup artist/hair stylist takes up to an hour preparing the model at the beginning of the shoot and makes sure the model continues to look good on set.

Describing her duties during the shoot, makeup artist Mary Erickson says, "I am like a waiter in a fine restaurant, hovering and watching to see if there's anything I need to do. As soon as there is, I'm in there."

Talent is a generic term for the person being photographed, whether professional model, child, famous person, or lifestyle actor. In a product shoot, of course, the talent and makeup artist are not included in the crew.

Another member of the crew, if you are shooting in California, is a **set teacher**, also known by the union term, **studio teacher**. By state law, a certified set teacher must be present any time people under the age of eighteen are working, with a few exceptions. Responsibilities include checking children's work permits and providing educational guidance.

There may also be an **RV driver** if a production vehicle has been rented. The driver knows where the vehicle can be parked and will run the generator on request throughout the day so there's power for prepping clothes, drying hair, or air-conditioning. The driver will keep an eye on merchandise in the RV, and will occasionally be an extra hand for carrying things. Often, the driver will provide catering services such as coffee and snacks.

MORE ABOUT THE ART DIRECTOR

On most photo shoots, an art director is involved, but this is not always the case. Sometimes the responsibility for getting satisfactory shots is handed off to the photographer. This may be the case with simple, repetitive products or with a regular photographer familiar with the client's goals and standards.

THE OFF-SITE ART DIRECTOR

A tenuous economy and digital technology have created a changing role for art directors. An art director at the shoot has become a luxury for some companies. They can't "afford" to have the art director out of the office for days at a time. An art director back at headquarters can view files from the shoot while working in the office or attending meetings. However, the result is often a less efficient shoot.

Digital files of each shot can be emailed to the client or art director off-site and presented for approval. The consequence is a tremendously slowed-down process for the photo crew, in spite of new technology. Those in the studio are waiting for an art director to finish a meeting, return to the computer, read an email, open an attachment, and respond. Meanwhile, the crew is unable to proceed to the next shot, sometimes even to make a minor change that would take seconds with an art director's input.

PRODUCT MANAGERS AS ART DIRECTORS

As marketing departments become more efficient, the role of art director is more likely to be filled with a marketing major than a graphic designer. A "product manager" may be responsible for marketing and promoting one or more products in a company's line.

Often, on a photo shoot, the goal is to build a library of lifestyle or product images that can be used in future marketing materials. If you are fortunate, your

art director will have a visual idea of the desired shot and be able to communicate it to the crew.

TAKING CRITICISM
Critiquing photographs is subjective. Everyone sees something different in each photo. Art directors who have the job of analyzing photos often feel the need to find something to criticize. They are not criticizing you—they are looking at elements of your styling. And after working on shoots with an absent art director, you will value the feedback more than ever.

A TYPICAL DAY IN THE STUDIO
Here's a very basic day styling in the studio for a catalog. Having packed your kit and all your supplies the evening before, you'll arrive on time, or preferably, earlier. Enjoy a cup of coffee and a muffin now, because you won't stop moving until lunchtime. You will go over the shot list with the photographer and the art director. Make sure you are clear about the look and styling of the shots, how the merchandise is organized, how much time can be spent on each shot, and in what part of the studio you'll be working. Become familiar with the studio, and if you need any materials, a work table, or an electrical outlet, the photo assistant will know where to find them. Plug in the steamer if you're using one, so it gets hot. Pull together and organize your products, along with any props you're using.

NOW YOU'RE WORKING
Exactly what you do next varies according to the styling project; you may be shooting models or stacks of sweaters. Keep your work flowing and be aware of what's coming next so you can be prepared. Maybe you can begin to stage the next shot while this one's being refined. Always be available to make any changes and adjustments to the products or clothing. Be cautious with all the photo equipment around—you may have to bend and reach into some pretty awkward positions to style your items. You'll be on your feet a lot.

Try not to make personal phone calls or to read magazines. Some cell phone usage during the day is to be expected with freelancers, but your main focus is on the job at hand. If you are really meant for this career, you'll be so interested in the shoot that you won't want to miss a moment.

The day goes like this until lunchtime, with maybe a snack or a bottle of water. After a quick lunch in the studio you wash your hands and get back to work. The afternoon progresses the same way—more styling, more shots checked off the list. You may get a sense of how the catalog is coming together by reviewing the photographs.

MUSIC AND HUMOR
Two consistent elements in photo shoots help keep the atmosphere light and fun: humor and music. The people you're working with are intelligent and creative, and so are you. Conversation and jokes are part of what makes the shoot day

interesting, and they make the models comfortable. Don't get so involved in talking, though, that you are distracted from your work or that you distract others.

In a studio, there is almost always music playing and a selection of CDs or iPod tunes to choose from. When appropriate on location, music can add to the relaxed atmosphere. Sometimes you'll see a dartboard or a basketball hoop in a photo studio, but I have never found that there's time to use them.

THE END OF THE STUDIO DAY

When the day ends, help the other crew members with any clean up that needs to be done. Make sure your job is finished and that you are free to leave. Unplug the steamer, thank the photographer and the art director for a good day, review your call time for the next day if the job is continuing, stretch, repack your kit, and go home.

LOCATION DAYS

When your location is outdoors, the call time usually is early, as the photographer typically wants the early morning light. The photographer may also want to capture the warm glow of sunset. The sun at midday is usually too bright and high to get the best shots. You're carrying your kit and merchandise to and from vehicles, and moving more quickly.

If you're shooting in a private home, you'll probably move furniture and other décor; everything needs to be put back in place and returned to the way it was when you arrived. It helps to take a digital or cell phone image of the room at the beginning of the day; remembering where things were placed is harder than you expect. You might even need to vacuum the areas where you shot or worked. Load your car, then take one more look around.

By the time the location day ends, you still have to travel back from the location, unload, and get reorganized. But you've had a great time working on the project with the crew.

THE "POLAROID PROCESS"

This is my own term, left over from the days before digital photography. The procedure involved defines the hierarchy and good manners of a shoot to this day. A special "Polaroid back" is attached to the camera so the photograph can be previewed. An image is taken through the actual camera lens and exposed on Polaroid film instead of on regular transparency or negative film. The image is the size of the film, so if 35mm is being shot the image is small—a rectangle about 1" × 1 ½". 120mm film creates a larger image, and 4 × 5 film is a bit under 4" × 5" (See page 24.) The photographer pulls the Polaroid film out of the camera and hands it to the assistant, who times development for sixty to ninety seconds. When it is developed, the assistant looks at it and hands it to the photographer.

Here they are both looking at the lighting of the shot and may get to work on making some changes. The photographer may use a "loupe," which is a

THE "POLAROID PROCESS"

This is the order in which the crew members view a photograph in progress. The image may be a traditional Polaroid preview of the shot in actual film size, if film is being shot. Or it may be a digital shot viewed on a computer monitor. In either case, the viewing sequence is a matter of etiquette and respect in a photo shoot.

1. Assistant photographer (or digital technician)
2. Photographer
3. Art director
4. Client
5. Stylist
6. Makeup artist, hair stylist
7. Talent

small magnifying glass, to check for focus and other details. Unless they see a problem that they can quickly resolve, the art director is next to see the Polaroid.

THE ART DIRECTOR VIEWS THE POLAROID

The art director also looks at aspects such as composition, overall color, depth of field (how much the background is in or out of focus), background elements, and whether this image represents what he or she wants. The art director will look for anything odd or distracting, like a horizon line going straight through a model's head. For a product shot— a sweater laid down against a white background, for example—critical elements would be the overall shape of the featured item, and whether the folds and shadows are too deep.

The art director then discusses these details with the photographer or the stylist. As they make more improvements to the image, they take more Polaroids. This film is expensive and used to be a significant part of the expense of photo shoots. It is not unusual for multiple Polaroids to be shot before the image is considered ready to be photographed.

THE NEXT STEP

If a client is present at the shoot, he views the Polaroid next. Here, the art director should remind the client (probably her boss) that this is only the first look at the photo. After the client, the stylist is next in the chain of command. You have waited on the sidelines until it's your chance for a close look at the Polaroid. This is really your first opportunity to see what the shot looks like through the camera, and it may surprise you.

The art director will point out improvements that you can make to the product or wardrobe. You may notice some improvements you'd like to make in addition to those suggested by the art director. She will appreciate that you have the experience and dedication to improve your work.

On a fashion shoot, the makeup artist would like to see the image and be sure the makeup and hair look right. It is optional to share the Polaroid with the talent at this point. It may be helpful for a model to see how the shot looks, how it's cropped, and if the positions look natural.

Polaroid images, slightly smaller than actual size. Image on the Polaroid is approximately the same size as the film being used. It may be 35mm, 120 or 220mm, 4" · 5", and so on. Photographer: Michael Christmas. © Michael Christmas

DIGITAL PHOTOGRAPHY

With the use of digital photography, the cycle of the Polaroid is a rarity. Previewing of the image takes place not on Polaroid film but on a computer monitor. I wanted you understand the way it used to be, so you can appreciate how easy it is now to see and revise your styling. But the etiquette still applies. You don't want to put your head in front of the monitor until the photographer and art director have had a chance to see what the shot looks like. In addition, there may be lighting or composition improvements that will change everything.

Once it's your turn to make styling revisions, it is fine to ask the photographer to take another view of the image since no costly Polaroid film is being wasted

while you make adjustments. The benefits of digital photography are obvious when the stylist is working on a product shot, since you don't have to worry about exhausting the talent. The product waits to be perfected.

IMAGE VIEWING TECHNOLOGY

New developments, such as the app Capture Pilot, are changing the cycle further. Crew members and clients can view the image directly on their own Apple devices in the studio or remotely, eliminating the need to crowd around the monitor. Still, awareness of the Polaroid Process protocol shows basic respect for the process of collaboration.

THE FLOW OF FILM

Having directed fashion photography during the days of silver-based film, I can see a great deal of difference when shooting fashion digitally. With film, there is a rhythm to the shoot. The model can hear the automatic winding of the camera as a roll of film is shot. Experienced models build a series of moves based on this cycle. Often, the first half roll of film is just for warming up. The photographer shoots dozens upon dozens of rolls, or sheets, of film; the art director will have five to ten really good shots to choose from.

Some photographers still prefer to shoot film on location. There is less equipment to transport; maybe the camera, tripod, film bags, reflectors, scrims, C-stands, and sandbags, but not the computer equipment. And it can be hard to view the image on the monitor in bright light.

THE MODEL STANDS ALONE

And then there is the spontaneity and the flow of the traditional film shoot, once the Polaroid is accepted. With digital photography, the flow is interrupted—the model is often left standing alone while the crew goes to look at the monitor. When they return to the model on the set, she needs to resume modeling. And hope they weren't criticizing her look or technique over at the monitor.

The photographer may use a digital camera on location and simply view the images on the LCD display on the back of the camera. But when the photographer pauses to look at the image, it still changes the pace.

Only "old school" people like me notice the difference now. Newer models may prefer digital photography because they get instant feedback on the success of the shoot. They like looking at the monitor to see how they're looking, instead of the guesswork of Polaroids.

The advantages of digital photography far outweigh the altered rhythm of a fashion shoot. There is little doubt that the ideal shot has been captured. No more editing countless strips of film over a light table. And the technical processes of graphic design and printing are integrated. The image files can be placed directly into the designed catalog, brochure, or other material. When the printer receives the files, everything is in place.

COMMUNICATION

While the talent is being shot, it's best if one person is designated to communicate instructions. Usually this will be the photographer. It can be confusing for the model to hear suggestions from several voices at the same time.

THE SPOKESPERSON

The chain of command takes effect again. A good art director is near the photographer at all times, watching the shot from behind the camera, and can make comments when necessary. The stylist and makeup artist clear it with the photographer or art director before "going in" to make adjustments. If they see something they would like to improve, they can quietly tell the art director, who will decide if it's worth asking the photographer to pause for them. It's distracting for the photographer, too, to be addressed by various crewmembers while shooting.

When the photographer uses a long lens—to put the model in focus while making the background blurry—the model may be thirty feet or more away from the crew behind the camera. That makes it especially difficult to communicate. I have been on shoots when the model was so far away, a walkie-talkie was used to communicate with her. Walkie-talkies were more commonly used in the days before cell phones, but are still used sometimes. They also help the crew communicate when the equipment and vehicles are far away, as is often the case on location. A walkie-talkie-enabled phone could take care of these situations.

WORKING WITH CHILDREN

When children are being photographed, the shoot becomes more complicated. It's harder to determine who is the designated communicator. The parents, stylist, and photographer may all be trying to get the attention of a small child who doesn't understand what all the fuss is about. All this takes special skill on the part of the crew.

No matter how much experience children have had with photo shoots, they are still unpredictable. Weariness, hunger, boredom, and tense parents all play a role. Photographers who work with children may have some squeaky toys or music to capture the child's, or even infant's, attention. Bubbles might come in handy. As a stylist, you'll spend more time on the floor styling the little ones.

THE CHILD'S "ENTOURAGE"

When children are modeling, the shoot tends to become crowded with family members. In addition to one or two parents, there are likely to be siblings, aunts, uncles, grandparents, or nannies. Some are there to bring the children, others for the excitement. In addition, several children may be scheduled for the same time period, and often a backup model is hired in case the first one is less than cooperative. Try to have a comfortable and separate area where the other children not in the shoot can wait, with all the extra family members. If there is a set teacher in attendance, that person can greet families and help herd the extra talent.

Be patient. The excitement will end soon, and you can look back at how adorable the children were and how hard they tried to be young models. The older ones will have learned to thank you and shake your hand.

THE STUDIO TEACHER

If the shoot is in California, the client needs to be aware of the law requiring a studio teacher, also called "set teacher." The purpose is to protect the health, safety, and morals of minors on film sets or still photo shoots. The studio teacher checks to make sure children and teens under eighteen have a current work permit and that working conditions are safe. With a few rare exceptions, a certified studio teacher must be present any time people under the age of eighteen are working, whether it is during school days, evenings, or weekends. Some clients may elect to ignore the requirement to save that expense on their shoots. The producer's role is to make out-of-town clients aware of the regulations, not to enforce them.

The term "teacher" may be somewhat misleading. While most studio teachers do provide learning activities, assist school children with home-work, and must be certified teachers, their presence at a shoot is the primary requirement, not that they come equipped with lesson plans. For film and commercial shoots when children are on set all day, three hours a day of in-struction must be provided.

Other states in the U.S. do not require a studio teacher but do have regula-tions about work permits. To find information on other states' child labor laws, check with your local film commission. Eventually more states may increase restrictions for child performers. Anyone working in photo shoot production should keep up to date with these regulations.

WORKING WITH ANIMALS

With the popularity of pets, some models are of the canine or feline variety. Several competing national chains of pet-supply stores create a good deal of advertising. It's not hard to find pet owners who are happy to have their darlings model, but some jobs call for more professional pet models. In the film industry, there are professional animal lovers working to provide all sorts of trained animals. These trainers are available to the photo industry, too, and are known as "pet wranglers." If you can find someone in your area to provide this service, you'll have experienced animals for your shoots; otherwise you can do your own talent search.

Pets, particularly dogs, make good props for photos, as nearly everyone responds favorably to them. My golden retriever Jake accompanied me to many shoots and was very good about looking at the camera and smiling. He would happily work in exchange for a grooming.

Lighter-colored animals photograph better than dark ones, whose eyes and noses blend into their fur. Often on location or in a home, a good model dog will appear and his owners are always happy to have him included in a shot. In some cases, a property release is needed to use a pet's image. It's a good idea to have one signed, just to be sure.

My dog Jake modeling at the feet of a shoe model in a catalog shot. Photographer: Michael Christmas; stylist: Susan Linnet Cox. © Michael Christmas

On occasion, the stylist may be asked to provide live animals as props for shoots. Stylist Leslie Holland tells this story.

> *I've had a couple of challenging projects over the years. Working with a full-grown leopard was probably the most interesting. It was slightly medicated, which helped with calming my fear of being attacked. Good thing I like cats. I had to find live butterflies and keep them on a branch during a cosmetics video. Thank goodness they were young and loved sugar water. I found and styled baby chicks for a book cover shot (which was kind of a joke, because they really do what they want). I've also had to work with squirrels, rabbits, and an iguana. Definitely, animals are the most challenging to style but the most fun.*

MORE ADVENTURES
Product stylist Trisha Hassler, who we'll meet in Chapter 9, relates this story about her adventures with animal props.

> *We did a project for a door company that was a big challenge. They had the idea to show how beautifully crafted and wood-like their metal doors were. The idea involved showing the doors fooling some wildlife. There was a woodpecker with a smashed beak, which was a retouched photo, but the idea for the shot involving a beaver was not so simple. The client wanted an actual beaver with cracked front teeth.*
>
> *I had to do lots of research, and found there were no beavers available to rent or borrow and they all had yellowed teeth anyway. So I contacted a trapper. There was a beaver*

removal project in the works so we purchased a beaver. I then worked with the taxidermist and had him position our beaver in just the exact position the art director had drawn. The teeth were bleached and broken to look like the drawing and implanted in the final phase.

The client was pleased; they put the beaver on display in their offices and ran the ads for quite a while nationally. I learned a lot, went through some difficult times—being a vegetarian made it personally challenging for me—and have not had an occasion to use taxidermy again!

PHOTO SHOOT ETIQUETTE

A stylist who is a pleasure to work with, in addition to doing great styling, will be remembered. You've eagerly done your share of the workload, helped with tidying up the studio or location, and been considerate of others on the crew. You've been energetic and happy to be working with them. You remembered to say thanks for lunch, and at the end of the day, said goodbye to the crew and especially the art director. You might also mention how much you enjoyed working with the art director, that you hope the photos turn out great, and that you hope to get a chance to work together again.

NETWORKING

Be sure to hand everyone on the crew your business card or promotional card, so they can find you again. And get theirs too, so you can follow up later. You will especially want to contact the art director when the photographs are printed to request some "tear sheets," or samples.

One exception to this networking is when you are the assistant stylist. In this case, you are working for the stylist, and you don't want to bypass your employer by trying to take away a client. As a matter of ethics, don't promote yourself when assisting: it's just a time to learn. (The photo assistant should follow the same protocol.)

A FOLLOW-UP NOTE

It's also thoughtful to follow up with a written note, or at least an email, to the art director and the photographer. I designed and printed a note card on my desktop computer with a sample of my own styling on the front and my contact information on the back (along with a credit to the photographer who shot the front image). Pre-folded note cards can be purchased at office supply stores for your desktop printer; they even come with envelopes.

THE PHOTOGRAPHIC EQUIPMENT

One item that is important to mention is your respect for the expensive camera and lighting equipment used on the photo shoot. The photographer has a great deal invested in these treasures. The assistant knows the equipment well and has complete access to it. You, however, do not: always ask before even looking through the lens and try not to touch the camera. It may not be placed at a convenient height for you, so ask for help seeing through the lens. Don't "help" the assistant with the lights, power packs, or meter readings unless requested.

It might seem fun to take some snapshots of the shoot with your own camera. Always ask the photographer before doing this. Your flash can trigger

the photographic lights to flash, and possibly cause damage. Although you're likely to get cooperation, you must respect your co-workers who may not want to deal with your photographic hobby in the middle of a shoot.

SOCIALIZING AFTER THE SHOOT

On a longer project, and especially when you are on location, there is often a crew dinner, hosted by the client or photographer. This generous meal is a chance for the crew to review the shoot and the bond that has been created.

Another social activity may be cocktails at the end of the day. It's fun to relax together and discuss the day and plans for the following day. An evening of dining and conversation may follow. For me, quiet evenings alone to recharge and relax are a necessity, especially when handling the responsibility of art direction and production, so I try to alternate the social and solitary times. There's nothing like room service and television to accomplish that.

You will need to make some decisions based on your personal style about how much socializing to do—it helps to keep a balance. On one location shoot in Seattle, I had a beautiful hotel room that had a claw-foot tub in the middle of the room, with the option of closing it off with Japanese-style sliding doors. I had to spend one evening enjoying it. I had cashews and a split of champagne from the service bar for my dinner, in a bubble bath—one of the most pleasurable times I've ever spent with myself. The next day, though, I heard about the big crew dinner that was held and wondered if I appeared too aloof. When I didn't get called back to do more work for the client, I was worried, until I heard the art director had left his job and the catalog was being shot by a team in another part of the country.

Usually, a shoot will conclude with a crew portrait and lots of sincere hugs before you all go your separate ways.

INVOICING AND OTHER PAPERWORK

Although you may want to kick back and celebrate the successful end of a photo shoot, work calls. Your first priority as a freelance stylist is to invoice this job—the sooner you do, the sooner you will be paid, which is especially important if there are outstanding expenses. Make your prop and wardrobe returns, document your expenses and mileage, and send your invoice to the client before you even think about moving on to the next project. We'll discuss these business procedures in detail in Chapter 14.

AFTER THE SHOOT

Since the crew works so closely together during the shoot, it seems strange that it is disbanded afterwards. One week you are spending all your time together working toward a common goal. The next you've all gone your separate ways. Art directors are back at the office; photographers are starting other projects. And you, after the postproduction returns and invoicing the job, are putting on a different hat. It's time to get ready for the next project, market yourself, or take some time off. You will work again!

3

CHAPTER **3** Styling Basics

IF YOU HAVE GOTTEN this far, you are indeed serious about your styling career. Let's say you have already done a couple of projects that could be considered styling. You're not sure if they qualify you as a stylist yet. Aside from the childhood project of setting up Barbie dolls and photographing them, the first time I actually styled a photograph was for my sushi t-shirt business, and I was also modeling in the photograph. I brought a pair of chopsticks as a prop and the male model was plucking at one of the sushi on my shirt. I didn't realize till later I had styled a shot.

Looking back, you will realize the creative things you've already done that have prepared you for the exciting career of photo styling. Somewhere along the way, you heard the term photo stylist and a description of the career. It piqued your interest. You're ready to get started.

GETTING STARTED

You are not going to be a stylist overnight. Remember the bumpy road and all the experiences I described in Chapter 1 that led me to styling? The most important advice is to observe and learn. The more you understand about styling and photography, the more skilled you will be.

EDUCATION

There is no official degree or certificate program for photo styling. Some fashion schools now offer classes in styling. Most styling courses at the Fashion Institute for Design and Merchandising (FIDM) in California focus on wardrobe for film, television, and video.

Some universities and art schools may teach about styling in the photography department.

Generally, the styling classes are part of larger programs such as fashion design or merchandising. They are intended to give fashion designers background on promoting their own designs, or to teach merchandisers about marketing fashion. By and large, what you learn about styling is going to happen on the job, and by keeping your eyes and ears open.

Since there is no degree in photo styling, you may find courses in adult education programs. Joan Volpe, director of styling education at Fashion Institute of Technology (FIT) in New York, says their program "is one of twelve professional development certificate programs offered by The Center for Professional Studies at FIT. Our students are adults, not undergrads. We are part of the School of Continuing and Professional Studies."

The school also offers an intensive three-day program every summer, called Fashion Styling Confidential. Joan adds, "With a New York program,

we are blessed with working professionals as instructors and loads of wonderful real world resources."

Food styling workshops are more readily available, as food stylists seem to be much more generous in sharing knowledge than other specialties. Since the career is a constant learning process, there is nothing like practicing hands-on skills in a learning environment. See the list Educational and Networking Sites in Chapter 10.

Workshops about the styling career in general are hard to find, so I began offering my own styling workshops a number of years ago. The weekend workshops included one Saturday of dialog and discussion on the business of styling, personalized to answer the needs and questions of the students. And on Sunday there was a day of hands-on participation in which students styled tabletop products and clothing on a model. Now I've developed a program of online workshops so that students from all over the world can study the career of styling in-depth at www.photostylingworkshops.com.

The response from my workshop attendees is the reason I wrote this book—there is so much to learn and absorb. I've listened to students and had emails from new stylists in multiple specialties, and hope to provide answers to their questions.

INTERNSHIPS

The chance to work as an intern with a stylist is rare. I had arrived at the mentoring part of my life with much to share about the career. After contacting San Diego Mesa College, a community college with a strong fashion program (where I now teach) to see about providing internships, I found a series of wonderful trainees. I initially thought interns would help me get some filing and marketing work done, but was surprised by their eagerness to get busy learning the field, not filing. They each inspired me too, with ideas for test shoots we could arrange together, and with all of their questions.

If you can find an opportunity for an internship with a photo stylist, you'll amass hands-on knowledge of the career. Interning with a magazine, model agency, ad agency, fashion merchandiser, photographer, or any other related business would also yield a bounty of useful knowledge. Whether or not you receive pay for your internship, the time spent will be well worth it.

EXPOSE YOURSELF TO SHOOTS

Any chance you get to be around a photo shoot is going to help you learn. You might volunteer to assist a stylist for no pay, or a nominal amount, so you can be on a shoot. If you know photographers, or photography students, you can offer to help them with any of their projects, even if you're merely carrying equipment. If you see a photo shoot going on, stop and watch. Listen to what the photographer and assistant are saying. Watch what happens when they open a reflector and bounce light back onto the model. See what the art director and the stylist are doing. And by observing, you'll know the clothing looks so good because of all the clips in the back.

The more you know about photography, the better you'll do your job. A basic photography class can introduce you to f-stops, exposure times, light meters, and tripods, along with the language and terminology of photography. You'll understand that raising or lowering the camera a few inches will completely change the composition of the shot.

You may at this point decide that you want to *be* a photographer, which is wonderful. If you find you're not the least bit competent with a camera, you'll still have learned valuable information that will come up again and again in your career as a stylist.

LOOKING AT PHOTOGRAPHS IN A NEW WAY

Now that you've been introduced to styling, you'll never look at photographs the same way. You'll see the difference it makes when the background is focused or the model is in shade or full sun. You will see good techniques and things you'd do differently. You'll analyze even more carefully the fashions and accessories used in magazine editorials, and observe how the makeup is used to enhance the theme.

Looking at catalogs, I try to identify the locations and models. After getting to know many locations, such as Miami's South Beach, Charleston (South Carolina), Mexico, Hawaii, and nearly every spot in San Diego, I can't help trying to identify locations. Sometimes I think I look at backgrounds more than foregrounds. Maybe I will recognize a model, and if not, I try to see why she is an effective model. The trends in faces, ethnicity, hair length, lips, and nose shape all distract me from looking at the merchandise. I look for misplaced shadows of scrims that should have been obscured. I see if there are any folds in the model's sleeves that I would have treated differently.

When you see print ads, you'll know the stages the photographic concept has been through. Hiring the crew, meeting with the ad agency art director, the storyboard (a preliminary sketch), props, and styling are all elements you may not have been aware of, and now you know about them. It's a good exercise to look carefully at all these details, though you'll never again have the simple pleasure of merely flipping through a catalog or magazine.

YOUR INSPIRATION FILE

You can refine your observation skills by collecting examples of your favorite images. Find photographs that you like in magazines and tear them out; these are known as "tear sheets" and also as "swipes," because you're swiping ideas from other sources. Look beyond your own comfort zone, too. You may be inspired by examples in other styling specialties, and this may come in handy when you're asked to style a challenging product.

Keep a sample/tear sheet file that works for you—with notes of where the image came from, who shot and styled it, and why you chose it. You can add Post-it notes about these details on the pages, and you can keep them in boxes or in clear sleeves in a three-ring-binder.

One way to make yourself practice and develop your skills is by trying to imitate these shots; use them to inspire your own photos. This is like painters or drawing students replicating the Old Masters.

Experienced stylists and photographers continue to do this research, using the images as a reference point when communicating about future projects or inspiring a test shoot.

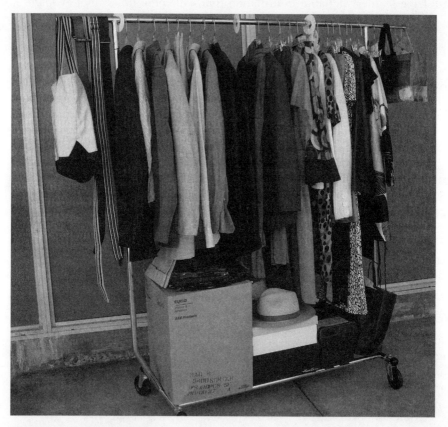

Rolling rack loaded with garments on hangers, boxes of merchandise, shoes, and miscellaneous accessories. Photographer: Cedric Chang; stylist: Susan Linnet Cox. © Cedric Chang

THE ROLLING RACK

The collapsible rolling rack is the most basic and universal piece of equipment used by stylists. You are certainly going to have more to transport than you can hold in your arms, and you want the items to remain unwrinkled, so you need to use a rolling rack. The racks hold more than just clothing; you can place boxes and your kit on the bottom rails, and hang accessories and bags on the extenders on either end of the top rod.

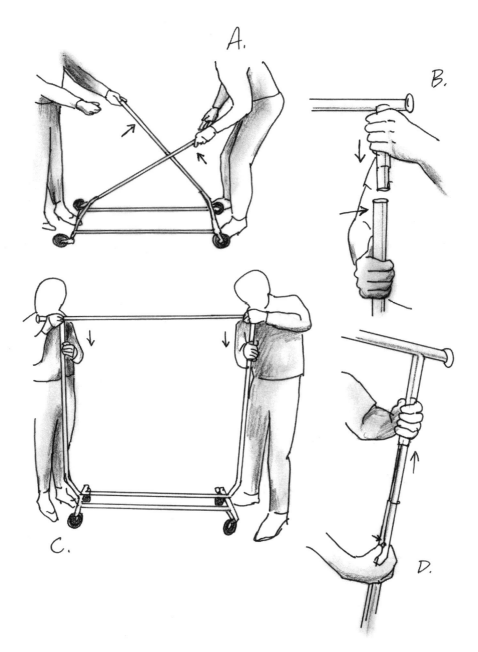

Setting up a rolling rack with two people: A. Lift the side posts at the same time. B., C. Pulling outward on the side posts, insert the top rod. D. Push button to raise rack, while holding base of top bar. © Susan Linnet Cox

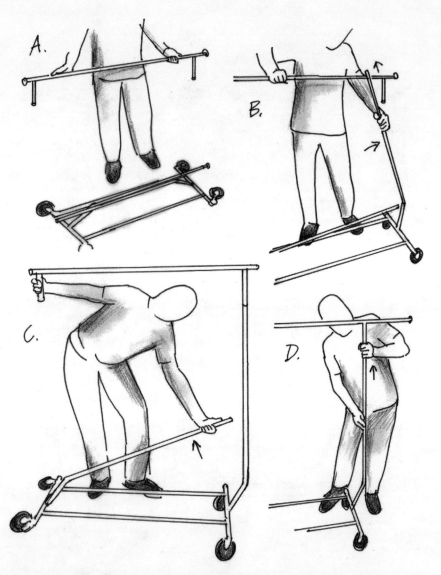

Setting up a rolling rack alone: A. Pick up top bar. B. Prepare to insert top bar by raising side bar. C. Carefully hold top bar while lifting second side bar. D. Gradually, one side at a time, push button to raise rack, while holding base of top bar. © Susan Linnet Cox

SETTING UP THE RACK

If you want to look like you know what you're doing, you need to practice setting up the rack. Since the rack is collapsible, there are points in its assembly when it wants to collapse; you're briefly fighting gravity. It's much easier if two people work together, but sometimes you may be on your own. I demonstrate this tricky process in my educational video, "Photo Styling Basics/Styling Off-Figure."

In my workshops and classes, everyone has a turn at this humiliating exercise. Attendee Rebecca Fabares said it was the only part she did not like. But she soon found herself working as a wardrobe assistant on a three-day shoot and successfully putting up the rack by herself—on a hill.

The rolling rack may be your own, or may belong to the client or studio. Most racks are the same style, and are affordably priced at retail-store suppliers. My own has extenders that slide out too easily and are always getting in the way. Some racks are more manageable than others, but watch out for unpredictable extenders.

The illustrations on the previous pages show the components of the rolling rack, assembly with two people, and the challenging process of setting it up alone. At the end of the day, remember to lower the top bar to the lowest button before reversing the procedure and collapsing the rack. This is a little easier to do on your own, thanks to gravity lowering the sides for you. Just make sure they fold down side by side, like they started.

THE STEAMER

The steamer is another piece of equipment familiar to all stylists. If you have your own steamer, you can bring it to shoots, after confirming whether there is one available. Having your own is a mark of a true professional—along with knowing how to use it and doing great styling, that is. To be effective, the steamer has to be a professional-quality model with at least a one-gallon water capacity and a removable bottle (see illustrations below).

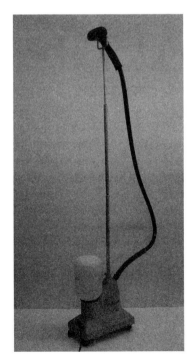

Steamer for prepping garments. This is a Jiffy brand industrial steamer with a gallon water bottle. Most other brands do not have adequate steam for professional styling. Photographer: Cedric Chang. © Cedric Chang

I have tried portable hand-held steamers and they just do not work. If you've never used a professional steamer, they might seem to work, but certainly not well enough to use for photo shoots. I'll share some hints later, though, for steaming with a spray bottle on location. You can find a selection of steamers at the same store fixture suppliers where you shopped for your rolling rack.

USING THE STEAMER

Among the first tasks upon arriving at the shoot are 1) finding a place to plug in and use the steamer, 2) filling it with water, and 3) turning it on. Once it's warmed up, you can turn the steamer off again until you use it, but the process will be quicker if the water in the chamber is already hot. Ask the photography assistant about available outlets in the studio. If you're on location, make sure you don't overload circuits that have other equipment, such as the computer or lights, plugged in.

The steamer bottle can be filled with regular tap water; no special water is needed. Find a sink with enough space to fill the bottle. Sometimes it won't fit under a bathroom sink faucet.

At the end of the day, unplug the steamer, and let it cool. Unless you're coming back to the same place tomorrow, empty the bottle, pull the steamer to the sink or take it outdoors, and empty it out completely.

FABRICS FOR STEAMING

The steamer can be used on most materials, including some vinyls and plastics. Test these materials first to make sure the steam won't warp them. I had this happen to a shower curtain that had some serious creases; fortunately, I was able to obscure the irregular parts, but I felt bad about it. I have used steam without any problems on vinyl raincoats and patio umbrellas.

On most fabrics, the steamer works as well as an iron and, in my opinion, is easier to use. Some stylists prefer to iron, but I use the steamer whenever possible, unless the item is a shirt that needs to be very crisp. Test the steamer in a less visible place like the bottom back hem to see how it works on each item. If you are steaming a sweater, it may stretch a bit temporarily; give the garment some time to dry out afterward.

STEAMING A BLOUSE

First, a safety reminder; don't touch the head or put your hand directly into the steam.

Let's look at a woman's blouse as our first example (see the illustration on page 40). It's on its plastic swivel hanger, hanging from the steamer's top loop. We'll start with the bigger areas, the front and back, before getting to the sleeves and collar. Assume that the whole garment will be prepped—it is better if it's all smoothed out, unless you are sure the shot is a detail of one specific area.

Unbutton the blouse. With the steamer head inside the blouse facing out, work it down from the shoulders while gently pulling downward with your other hand. Work in downward strokes along both front panels and along the

back, then do the same down the side seams from the armholes to the bottom, to eliminate the creases down the sides.

Steam along both sleeves, front and back, while holding each cuff. Then eliminate the sleeve crease by pulling the steamer head sideways down the outside of the sleeve (A). It's standard in styling to get rid of the distracting crease on the outside of the sleeve. Check the underarm for any creases and smooth those.

Touch up the collar from inside the neck area (without getting your other hand in the way), lifting the collar to smooth out that fold (B). With the steamer head held sideways, go inside the cuffs and smooth out the edges (C). Do the same with the bottom hem.

Go back to the shoulder area last, to smooth out any new wrinkles that may have occurred there. Use the steamer head on the inside of the blouse again, going over the shoulder and down, front and back. Inspect the blouse for any new problems that may need another touch-up, and you're done.

STEAMING A T-SHIRT

Now that you've steamed the blouse, a t-shirt is going to be a snap (see the illustration on page 41). This is a perfect candidate for the steamer, although if you're doing a laydown of a t-shirt you may really want it flat, as only an iron can do. Be sure to place tissue paper over any screen imprints when ironing, so they won't melt and smear.

When you are steaming a t-shirt, work the steamer head in the same downward motion on the inside of the front and back (A), being sure to steam out the side creases (B). Check under the arm and go down the sides, front, and back again. Steam the sleeves from the inside, softening the side edge. Go along the hem of the sleeves and shirt with a sideways motion to make the hem flat (C). Finally, touch up the shoulders and neckline, being sure to soften the creases along the shoulders.

PANTS AND SLACKS

Steaming pants is essentially the same process, except that you'll be steaming them from the outside only. Fasten the button and zipper and hang them straight across a plastic pant hanger with clips. Since the pants hang down longer from the steamer's loop, you'll end up squatting on the floor. Steam downwards, holding the pant leg gently at a lower point, and working your way down the leg. Go around the hem from the inside with the steamer head held sideways.

You can soften the top of the crease in the pant leg but, for the most part, leave it in. Steam down the top part of the pants, working into any pleats there. Steam the seat too and into the crotch where the legs meet. Watch for any folds that have developed on the sides near the pockets. Unfasten the hanger clips, one side at a time, and smooth the waistband.

A skirt will be a similar process, but you can work from the inside. If there are gathering or pleats, work into them by holding the steamer head sideways.

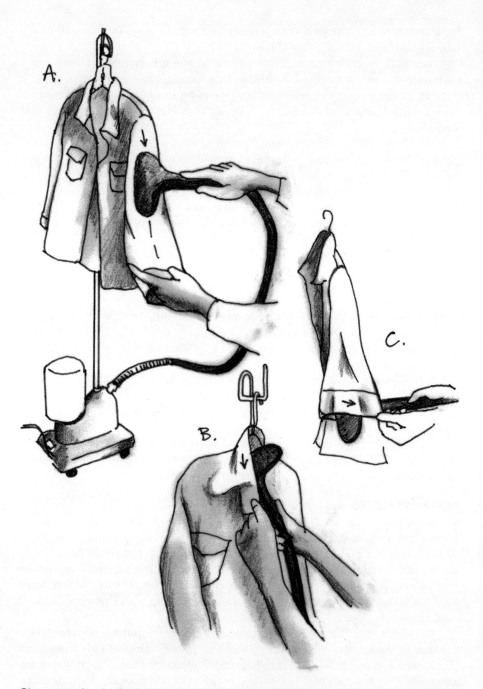

Blouse steaming details: A. Hold steamer head sideways to smooth sleeve crease while holding bottom of sleeve. B. Lift collar to soften fold. C. Steam inside of sleeve cuff. © Susan Linnet Cox

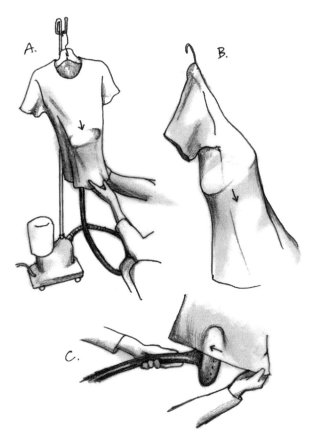

Steps in steaming a t-shirt: A. Move steamer head down inside of front and back of shirt. B. Smooth side creases by moving down from underarm. C. Hold steamer head sideways to smooth hem of shirt. © Susan Linnet Cox

HOUSEHOLD ITEMS

If you are styling bedding for a catalog or advertisement, you'll be working with an iron on a large scale. (See Chapter 12.) But, for a quick prep of sheets and bedding, you can use the steamer with the sheets right on the bed. It's a quick and convenient way to get out folds created by the packaging. Simply place the fitted sheet on the bed and run the steamer along the surfaces, and do the same for the top sheet and blankets. However, if the shot is a close detail and you need the top sheet to be very crisp, you will have more success with an iron.

Towels, tablecloths, throws, and other large household items can be attached to clip hangers and stretched out on the rolling rack. First steam one side, then the other. Or they can be touched up right on location in a similar fashion to sheets.

WATER SPOTS

It's bound to happen sometimes that your steamer will drip or spit some water droplets on the garments. I've never seen this cause a problem, and they usually dry by the time you need the item on the set. Try to work ahead to allow time for the drops to dry.

STEAMING WITH WATER AND SUNSHINE

The first time I saw this done I was really impressed with the stylist's ingenuity. I was art directing a fashion shoot that I arranged on a "no frills" Russian cruise line. But that's another story. The important story here is that we got off the ship near the shore of Belize in Central America, got onto a smaller boat, went ashore, got off, and had six hours to photograph the garments that the stylist and his assistant had carried ashore in big zippered bags.

I knew they'd be pretty wrinkled, but I was not the stylist, so it wasn't totally my concern; I had the shot list to worry about. Before I knew it, the assistant stylist had the merchandise spread out on rocks all over the beach and was spraying the items with water from a spray bottle. They were then placed on hangers and hung from palm trees to dry in the tropical breeze. By the time we needed them to shoot, they were perfectly prepped.

I have used this technique myself as a stylist, and it works very well even when the model is wearing the apparel and wrinkles occur. Temperature is the key element; it works best on a hot day. It can be awkward if the model is standing in a water-soaked outfit and it's time to shoot.

THE STUDIO ENVIRONMENT

The scene for a shoe catalog shown opposite can give you an idea what the studio environment is like. When customers look at a catalog and see these men's boots, they will envision the room they appear to be photographed in. It's a medium-sized room, possibly in a cabin or a farmhouse. The rough flooring and paneled walls indicate that it may be a back entryway or mudroom, where the owner stores his fishing tackle and removes his boots. That was our intention in creating this full-page photograph.

Note the bare-looking area in the upper left quarter of the image set-up. It was purposely left empty for overprinting copy describing the boots.

THE REAL SCENARIO

In the shot of the studio in the color insert, you see the real scenario. This "room" is in fact a fairly small tabletop set placed on sawhorses and held with clamps. The set is surrounded by five lights, including a "model light" and a "soft box," a large light that stands above the set at head level to illuminate it.

Six "C-stands"—adjustable, three-legged stands for attaching equipment—surround the set. One, just to the left of the set, is a holding a small cardboard oval to create a shadow in one area. The lights are attached to C-stands, and the poles that hold the lights extend out on opposite ends. Cords snake across the floor to power packs, which provide power to the lights to make them flash when triggered by the camera. At the rear of the set are several power packs on the floor.

Finished photograph of boots used in catalog. See color insert for the studio environment where image was shot. Photographer: Michael Christmas. © Michael Christmas

The camera isn't shown. It's attached to a massive stand with three wheeled legs and a vertical rod for moving it up and down. There may be a stepladder if the camera is raised. There is also a very important cable running from the camera to the computer. The computer is on a moveable desk not far away.

To look through the camera, clear it with the photographer first, of course. Then climb the ladder if one is being used, and look through the lens without touching the camera; it's tricky if you and the photographer are different heights.

STUDIO HAZARDS

You can see that no matter how large the studio is, the area around the set can become very crowded. You, as a stylist, spend much of your time moving in and out of the area, and can easily collide with some of these obstacles. You must be aware of what is behind you or over your shoulder. In addition to avoiding bumps and bruises, you wouldn't want to knock any equipment over. Waitress work was good training for me. I was already accustomed to looking over my shoulder before I made a move, from years of carrying loaded trays.

Now that we are in the digital age, you won't be likely to run into dark-room chemicals. If you handle a developing Polaroid, however, there are processing chemicals to be aware of and avoid. Wash your hands if you come into contact with this gel-like material.

We have already discussed the risks of using the steamer and the rolling rack. Remember to keep them in mind. Also, you need to be aware of very hot lights, which could burn you if touched accidentally.

SAFETY ON LOCATION

On location there are hazards too. There are C-stands weighted down with sandbags over the legs, as wind can easily blow them over. The stands may be holding a large "scrim," which is a piece of thin, translucent fabric for softening the sunlight, stretched onto a lightweight framework. In some cases, there may be lighting, power packs, and a generator used outdoors to supplement the natural light.

Be sure to use sunscreen on location; you'll be outdoors for many hours and may be too busy to remember to apply it. You can share it with the other crew members too—the rest of the crew may forget and will appreciate your looking out for them. A hat is a good idea, as well as plenty of water.

I almost always finish an outdoor styling project with a few bruises from carrying and moving products and my equipment, loading the car, or hurrying too much. You do need to be prepared to lift some weight and keep moving for extended periods of time.

SHADOWS AND REFLECTIONS

It may seem obvious, but always be aware of where the camera is so you don't find yourself standing in front of it. Not so obvious is the possibility of casting a shadow into the shot—watch where you're standing on location. Your position can interfere if you are near the reflector and get in the way of the sunlight bouncing onto it. I've even found that wearing white or black clothing near the set can affect the shot. These colors can reflect or absorb light, which can actually lighten or darken the shot.

Your reflection could also show up in a window or mirror in a room shoot or on a piece of jewelry. The best plan is to always be aware of your surroundings when you're on a shoot.

PREPPING FOR YOUR STYLING BUSINESS

Now that you have learned the roles of the crew, techniques for putting up a rolling rack, and prepping wardrobe with a steamer, it's time to think about building your business as a stylist. It's not enough to know what to do on a photo shoot. You need to know how to manage self-employment, find the styling projects, get paid for them, and earn enough income to live and enjoy being a stylist.

Unless you find a job as a staff stylist or a magazine editor, you are working for yourself. You have a lot to manage: record-keeping, finding clients, your portfolio and promotional materials, test shoots, health insurance, budgeting your money, and your actual styling work. No one will remind you what needs to be done. It's a common misconception that working for yourself gives you a lot of free time.

SELF-EMPLOYMENT

I grew up in a somewhat unusual situation in the 1950s. My father didn't go off to a mysterious job every day, like the classic dad; he had a home-based business. He was a court reporter who went to depositions and hearings in downtown Pittsburgh, and came home to transcribe his stenographic notes into a legal record. He usually was in his home office, but when he wasn't, I answered the phone for him and learned the importance of taking thorough messages. My mother, who wasn't the classic 1950s parent either, seemed annoyed when she found grocery lists he set out for her during the day.

THE HOME OFFICE

It was fun for me to have cabinets full of office supplies on hand. I could always find a stapler, cardboard, carbon paper, and paper clips, and use the big hand-pull adding machine. Friends and I would spin on office chairs. To this day, one of my favorite activities is shopping for office supplies.

I've been self-employed for most of my adult life. Even when I held a job, I always had some sort of home-based business. It's like an addiction, setting up my office, keeping receipts for business expenses, marketing myself, and filing a Schedule C (self-employment tax form) with the Internal Revenue Service.

Of course, nowadays the home office is centered around a computer, not a supply cabinet. Your office can be a desk in your bedroom, a corner of the dining room, or a spare room. You'll need a place to check email, research on the web, invoice clients, work on promotional materials, and keep records of expenses. When you're in the middle of a project—organizing merchandise, wardrobe, or props—you'll want to stage those somewhere so you can view your work.

The IRS has strict guidelines about exemptions for home offices. Seeking the advice of a tax accountant can help you claim a valid deduction. To establish a tax deduction, your home office must be a room or portion of your home or apartment that is not used for any other purpose. Based on square

footage, a percentage of your rent or mortgage may be a legitimate business expense. Measure the space of the home and your work area so your accountant can help you calculate the portion exclusively used for business.

You will also need to store your steamer, rolling rack, toolkit, and props you've accumulated. Perhaps you'll need to rent a storage space, especially as your supply of props begins to grow.

VARIETY

What's nice about being a stylist is that every day is different. Just as no two styling days are alike, there is a great deal of variety in your daily life as a self-employed person. I love coming off a week of focus on a studio styling project, when there isn't even time to pay bills, and then having a day or two to get my life back in order. In addition to financial duties and laundry, I might also include an afternoon coffee or a pedicure. Then I should fit in a test project to be creative and improve my portfolio as well as my relationships with others in the business.

ECONOMIC CHANGES

As the years go by, you're bound to observe the effect the economy has on your workflow. National and worldwide economic changes ultimately end up cutting advertising budgets. When companies have less to spend on advertising, there is less work for graphic designers, photographers, stylists, and other creative professionals. Ad agencies seem to be one of the least-secure work environments—their revenues change drastically based on their clientele.

Catalogs feel budget pinches when customers have less to spend or are worried about politics. Some other factors affecting the catalog industry are paper prices, postal fees, and other shipping costs.

Technical developments like computer graphics and digital photography have also touched everyone in the industry, especially photo labs. More people with fewer skills are able to do their own creative work cheaply, resulting in less work for professionals. There will be more changes in the future you will need to be aware of.

These fluctuations are natural. Pay attention, develop a backup plan for your income, and save money when you can.

THE THREE CLIENT RULE

Sometime in your career you might find yourself in this enviable circumstance. You have a new client, and you're glad because there hasn't been much work lately. Maybe the new client is a retailer that advertises every week in newspaper inserts, and the art director loves your styling portfolio. You are hired to do a shoot and it goes well. There is so much work that they would like to book you for two weeks of every month for the next year. You are set: you'll never have to market yourself and worry about work again.

In fact, it is not a perfect situation, though it seems so. The problem is that you've taken yourself off the market and are relying on one client. This great work situation could disappear, but it probably won't, will it? Yes, it probably will.

Here are some things that could take away your bread and butter client. The company could go bankrupt, leaving you unpaid for recent work. The art director can be fired, or accept a new job, and be replaced by someone who has her own favorite stylist. The company might decide to revise its entire advertising plan without informing you that a change is about to take place. A retail chain that has its own photo department in another city might purchase the company.

Those situations are always possible in our industry and may even be considered normal. It would be all right if you had three regular clients, and one went away. You'd still have work with the other two while you find a replacement for the third. You'll have some extra time to work on your marketing, but you'll also have some projects coming up with the other two.

If you've turned down new work because of your full-time client and maybe let go of another client that called occasionally, you are in the same situation as someone who was fired—but without the benefit of unemployment compensation. The work may have been worth it if you have prepared for it to end.

Let's hope you had the foresight to save some of the money you've been earning, enough for at least a month or two. And that you've stayed in contact with several of your former clients. And that you got some good samples of your work for your portfolio when you had a chance—you're going to need them.

Even though clients come and go, try to keep three regular companies, catalogs, or agencies that regularly book you, and fill in with the others that hire you for a one-time job now and then, and you won't find yourself an unemployed self-employed stylist.

STYLISTS ON STAFF

Most photo stylists work as freelancers. There are some exceptions, however. Fashion editors for magazines are generally on staff, developing and styling their own feature "stories," those gorgeous and inspiring pages of models in the latest fashions.

Some catalog photo studios are large enough to employ a full-time stylist. The studios may be a part of a large retailer that is constantly producing advertising fliers and other promotions. They may be connected with a large printing company that seeks to produce all its digital files in-house.

The main requirement for companies to hire stylists is steady workflow. If they find they need freelance stylists consistently throughout the year, it's probably more economical to have someone on staff who will be there for all the shoot days and help organize the schedule.

UPDATE ON THE LIFE OF A STAFF STYLIST

In the first edition of this book, we met stylist Pam Tocco. She was a stylist on staff for nine years at a Florida company that produced catalogs in their in-house studio. The job, with less variety and creativity—and income!—was balanced by being stable and providing benefits. Now the catalogs have been sold to another owner and relocated out of state, and she is a freelance stylist again.

I asked Pam how she prepared for this transition and survived.

I was aware that both catalogs were up for sale (seeking new investors), and I did see the writing on the wall. This facilitated my website being constructed prior to my departure date. I also began mining new clients, contacting photographers I knew to let them know I was going to be freelancing and available.

KEEPING CONTACTS

I did maintain relationships with freelance photographers who had shot our catalogs. They have introduced me to an editorial client and an independent bedding company. Catalog art directors that now have moved to other positions have hired me, knowing my skill set and work ethic. So, yes, the networking, and contacts made while being full-time were critical to my freelance success.

In the creative industry, you never know who will be art directing, producing, and coordinating, and when they will call on you for your experience. I maintain professional friendships with many former colleagues, and consider many of them personal friends as well.

ADJUSTING

Being freelance has been a large challenge for me. As a freelancer, it is a constant search for new clients and continued self-promotion, whereas in a full-time position you are guaranteed work, but it normally is not as creative. The security of a steady paycheck is great, but I know I was no longer challenged to be more creative. As I embraced the concept of freelance work and lifestyle, there were a few apprehensions, but I am one who believes in abundance; I believe in manifesting what you want and the transition has been smooth (so far!).

CHOICES AND CHANGE

While still employed, Pam Tocco had the foresight to say, "A job is not something you can count on forever, any more than you can count on keeping clients forever." In the catalog industry, there is always change and turnover. Catalog companies, ad agencies, and retail chains are purchased by other companies or go out of business. Pam sums up her experience positively: "All jobs lead to another job, another contact, another creative experience if you are open to it."

The catalog industry trade magazine MultiChannel Merchant is part of my regular reading. I keep up on what catalog is being sold to what other company—it goes on all the time. A job as a staff stylist is not a forever thing but rather a pause in the travel of your career.

As a freelancer, it can affect you when art directors that you have a good relationship with move on to new jobs. Suddenly your favorite client is gone, and the new art director has a favorite photographer and stylist who find they suddenly have more work. Remember the "Three Client Rule."

CHAPTER 4 Other Roles a Stylist Plays

IN CHAPTER 1, I told you all about myself, my trials and tribulations, and my winding career path. You can see you don't need to be a perky twenty-one year-old with a clear definition of who you are and what your goals are, funded by Mom and Dad (though it wouldn't hurt!), until you get your styling business established. Now I can tell you what attributes you *do* need.

- Enthusiasm
- Responsibility
- Hard work
- Common sense
- Courtesy
- Creativity
- Ingenuity
- Versatility

THE IMPORTANCE OF BEING VERSATILE

Since photo shoots are complex and clients are budget-conscious, it is to your advantage to be able to fill more than one role. The definition of "stylist" can be very broad and vary from client to client. Though the primary goal is to control the appearance of the items in a photograph, a stylist can be expected to perform diverse functions. Many of these merge into "production" of the photo shoot. You may scout locations, get permits, cast talent, book models, arrange travel, rent an RV, buy snacks, and build props.

PRODUCTION

The producer, or production manager, is the person in charge of the logistics of a location shoot. My background as an art director of fashion photography prepared me for this role and taught me about the many details that need to be in order on a photo shoot.

You may not be comfortable doing production and prefer to stick to styling. You may pick up these skills gradually, by being observant. Or you may never need to assume this role—sometimes there will be a production manager; sometimes the art director will handle the production. More often, you'll share a few of these duties.

And sometimes you will be asked to be entirely responsible. If so, you will be hired for more days of work before the shoot, known as "preproduction."

The production manager may also serve as a local resource for an out-of-town crew. Equipment rentals, photo labs, delivery services, Internet cafes, and good coffee are among the crew's local needs. I developed a welcome sheet for out-of-town clients that was much appreciated, and brought it to

each person the first day of production. It lists local radio stations, restaurants, free-time activities, and of course, my contact information and website.

> **TIP** The ability to offer production services in addition to styling can greatly expand your work possibilities.

THE KEY IS ORGANIZATION

Any of the responsibilities in the following list may fall under the definition of production. Organization is the key—there are countless details to keep track of, and none of them can be overlooked. I keep a job envelope for all but the simplest of projects. Inside are a notepad, all papers and forms related to the job, and an envelope for receipts. I never am without it during the time the project is going on. (In Chapter 14, I'll give you more details about the job envelope.)

LOCATION SCOUTING AND PERMITS

Location scouting is not my favorite aspect of production. It's not so bad finding a park, a charming sidewalk, or other public space. I'm not personally fond of knocking on doors and asking homeowners if they'd be interested in having their homes used for a photo shoot. But there was one period of a few months when nearly all my projects were location scouting. I was glad I could do it, or I'd have had little work. Other times I've had a cluster of wardrobe shopping or prop building. Versatility pays off.

PRODUCTION DUTIES

Responsibilities for producing a shoot may include:
- Budget
- Schedule
- Art Direction
- Hiring Crew
- Locations
- Travel Arrangements
- Transportation
- Casting and Booking Talent
- Props
- Catering
- International Customs
- Equipment

FINDING RESIDENTIAL LOCATIONS

Scouting locations requires conversation. You explain what's involved in having a photo shoot, and what it pays, how courteous and unobtrusive a photo crew is compared to a film crew; you flatter the homeowner and build a relationship of trust. You take some digital shots of the house. And after all that, your client may decide not to use the location. If you like to talk to people, spend time with them, and see their homes, you might be a very good location scout.

View the interior and exterior areas of the house and photograph them from various angles. Large rooms, high ceilings, and neutral wall colors are

important factors for photography. Note parking and areas that would be good for the crew to set up equipment. Find a place for steaming and for models to dress.

The photographs and other details of locations you visit can be kept in a notebook or three-ring binder for future clients to browse. Alternatively, you could have a website showing your locations. To respect the homeowners' privacy it would be a good idea to issue a password to clients, and not publish homeowners' names or addresses.

When the shoot is in a private home, the client may pay the homeowner a location fee directly. The fees vary widely in different areas, generally ranging from $500 to $3,000. The homeowner, if experienced, may ask you to provide liability insurance—see the General Liability Insurance box on the following page for more about this insurance. There may be valuable items or delicate floors to be aware of. Some homeowners want the crew to remove shoes, or you can buy a batch of large white "crew" socks to put on over shoes. A roll of protective paper can be purchased at a home-supply store and taped down to protect carpets from wear and dirt.

DONATIONS FOR LOCATIONS
A school, athletic program, or a non-profit agency might be interested in a donation to their program in lieu of a location fee. This can be a good option for all, as your client may claim a tax deduction, and the location owners will appreciate the donation. Keep this kind of negotiation in mind for individuals as well.

FILM COMMISSIONS AND PERMITS
Most areas where you will shoot will have a film commission. Film commissions are economic development programs and, consequently, they market their region (city, county, state) to the film and television industries. Very rarely do they acknowledge the commercial still photography industry specifically.

The film commission can provide you with a great deal of information about what permits are required and what government agency controls permits for various locations. For example, some beaches may require a permit through the state or the county. A park may be part of the city or may require permission from a state or federal park ranger. A good relationship with the local film commission makes navigating this process much easier.

It's important that you get to know your local film commission before a production project comes along. They may print a production guide that lists local crewmembers at no charge. Many clients request these guides in the early stages of their research. You will most likely find some work because of your listing, and you can learn who your peers are.

The permit application will include information about the client, the number in the crew, the number of vehicles, and a description of the project. It's best—though it rarely fits into the schedule—to allow plenty of time before the shoot for this process.

Occasionally film commissions will contact you following a production to ascertain the economic impact of the shoot. They will want to know number of days worked, number of local crew members hired, and an estimate of the amount of money spent in the area. This information is later used by the commission to obtain funding.

STUDIO RENTALS

Fewer photographers are maintaining their own studios. High rents and less steady work have caused many private studios to be converted into rental studios, so that the space can be shared by several photographers for short-term jobs. As a producer, you may need to know rental studios in your area, their daily rates, what is included, and other requirements such as insurance liability.

SHOOTING ON STREETS AND HIGHWAYS

One location scouting project I particularly enjoyed was for a British stock photography company. For a project involving cars and people, the company wanted to shoot at beaches and in the desert. Looking for these locations was fun for me. However, permits for the locations also involved police and highway patrol. The photos would be taken on streets and highways; and even when traffic wouldn't be stopped or, as in the case of the desert, there was very little traffic, an officer had to be present. I had to arrange for payment for the officers' time and provide them with detailed information about where the crew was meeting and the exact shoot locations—down to the mile markers.

GENERAL LIABILITY INSURANCE

What: An insurance policy naming the property owner or city as "additionally insured."

When: Almost always required when shooting in public places and buildings. May be requested by private homeowners.

Why: This insurance provides coverage in case anyone is injured during the photo shoot, if there is damage to the location, or if an accident occurs when a motorist is paying more attention to the filming than to driving.

How: Can be written pretty quickly and faxed or emailed to the requestor, followed up by mailing original policy. Production manager should also have a copy on hand.

How much: Up to a $4 million policy; sometimes other specifics are required such as automobile coverage and workman's compensation. (Confirm the required amount with each location.) Liability insurance generally costs the same for an entire year as it does for a short term. Clients such as catalog companies will usually provide the certificate through their insurance carriers. For smaller clients the photographer may provide it. Alternatively, hiring a production company and having them do the permitting is usually the most cost-effective way to fulfill the requirement.

I also booked the models (having emailed the models' cards to England), rented vehicles (different cars for different days and a van for the photographer), hired a local photo assistant, found an economical hotel, drove the art director and photographer to preview the locations, and made maps—but I didn't do any styling! As I say, each project is unique.

LOCATION PREVIEW DAYS

When a crew travels to a location for a shoot, a day or two should be scheduled to look at locations. A local location scout may have already been hired. The photographer, especially, needs to look at potential backgrounds. The art director, and sometimes the stylist, will accompany the photographer. (These roles were described in Chapter 2; the art director either is the client or represents the client and is responsible for the look of the photographs.) Often the stylist will stay behind to steam merchandise or shop for props.

During the location preview, the shoot schedule is refined based on backgrounds, the light at different times of day, distance, convenience, and availability. For instance, a restaurant may only be available for use as a location when it is not busy, before 11 in the morning or between two and four in the afternoon.

PRODUCTION RVs

A motor home that has been adapted for use by a photo crew is a production RV. The only change may be that the bed has been removed for extra space in the back room. Unlike in the movie industry, it isn't necessary to have full dressing rooms on set. We need transportation to and from locations for the crew and models, a bathroom, a table for makeup, an area for prepping wardrobe, and a place for models to change clothes.

An RV works perfectly for these purposes, and comes with a driver who functions as another member of the crew—drivers are usually helpful. In addition to making morning coffee, the driver can absorb the stress of driving after a long day on location.

Ask your clients if they need a production RV to make location projects easier. You can find a production company that will have one by looking in film commission production guides. If there aren't any production services available, you may need to rent an RV and find a crew member to drive it.

CASTING TALENT

Casting is the process of selecting the people in photographs. It can be as simple as viewing the cards of models to select the best look and size, or it may involve meeting talent in person (known as a "go-see"). The talent might be professional models, actors, or "real people." This last type of casting is also called street casting, finding the talent among nonprofessional people.

CASTING SHEET

> **Place Polaroid or digital image here**

Today's date: _____

Name: _____ Age: _____

Phone: Cell: () _____ Other: () _____

Email address: _____

Agent (if applicable): _____ Phone: () _____

Measurements:

Height: _____ Weight: _____ Chest: _____ Waist: _____

Hips (Women): _____

Dress size: _____ Suit size: _____ Shoe: _____

Are you available (date or range of dates)? _____

Any dates unavailable? _____

Acting experience: _____

Hobbies, interests: _____

Sports: _____

Casting Sheet courtesy of Cox Productions

Seattle Public Library
Broadview Branch
(206) 684-7519

04/03/21 01:17PM

Borrower # 1469761

This is big : how the founder of Weight
0010100876365 Date Due: 04/24/21
acbk

Hell and other destinations : a 21st-cen
0010100049997 Date Due: 04/24/21
acbk

Figure it out : essays /
0010101736709 Date Due: 04/24/21
acbk

Starting your career as a photo stylist
0010080577066 Date Due: 04/24/21
acbk

TOTAL ITEMS: 4

Visit us on the Web at www.spl.org

STREET CASTING

I was once hired by Nike to cast real runners for a catalog. Nike's feeling was that models who say they run may not be as serious about running as genuine athletes. I posted fliers at running-shoe stores and at a park where race information is often displayed. The fliers briefly described the project, rate, shooting dates, as well as the casting date, time, and what to wear. I called running clubs and asked for website postings and word-of-mouth communication. A well-known client is easy—people are eager to participate.

The casting took place in a two-hour period in a familiar park where local people frequently run. I provided extra shoes, socks, and shorts in case some runners didn't arrive as requested—in their own running shoes and shorts—or showed up spontaneously. Casting sheets were provided on clipboards with pens. (See the sample casting sheet on the previous page. You can use this to make copies or create your own form.) I took Polaroid photos of each person, both close-up and full-length, and stapled them to the completed sheets. This helped match the sheet with the video clip later. The runners then proceeded to a video camera where my assistant asked them to "slate" and to describe their running regimen. "Slating" simply means saying your name and model agency, if applicable, at the beginning of a video casting. The slate helped to identify the runners and match them with their casting sheets. It also gave the talent a chance to show some personality. As runners are often enthusiastic about their sport, some of the runners had to be interrupted and gently reminded that they were here for pictures, not sound bites. They were then asked to run about twenty feet away from the camera, make a small turn, and sprint at full speed toward the camera.

After collecting their casting sheets, I thanked the runners for coming. I let them know the client makes the decision about who is best for the catalog and that they would be contacted only if they were "selected" (a more diplomatic word than "chosen").

WATCH YOUR WORDING

At another casting, for a teenage clothing and accessories catalog, I mistakenly told the first several teens that we would "let them know." As soon as the phrase was out of my mouth I knew I would not be able to identify who I'd said that to—and that they might tell their friends we'd call them either way. Over the course of two days of casting, eighty enthusiastic kids arrived.

My client had requested "real people" because, she said, they were more open and genuine than models, but I suspect it had something to do with cost. I contacted a few high school drama teachers and acting coaches with a description of the catalog and the casting, reassuring them that I was a legitimate production manager and providing information about my website. I suggested that parents were welcome to accompany the kids. The teachers explained to them that the selection had nothing to do with them or their appearance, but with what the client was looking for. The instructors, the people

who helped me with the casting, and I were all very sensitive about how the casting process could affect the youths' self-esteem.

Back to my promise to let them know: I notified the kids who were selected and started to call the ones who weren't. Upon hearing that I was calling, their voices were so hopeful that after the first few I couldn't bear it, gave up, and took it as a lesson learned.

CASTING MODELS AND ACTORS

Most castings are held for professional talent, which is easier than walking less-experienced people through the process. If your project is expected to portray "lifestyle," a realistic family, or an unusual character, your best bet may be an agency that represents actors. They will have plenty of people on the roster representing all types and ages. Model agencies have a narrower range of standards for the people they represent. Height, weight, age, and appearance are among the factors limiting their talent, though model agencies may also represent older adults, children, petites, plus sizes, and pregnant women.

Casting does not necessarily mean previewing the talent in person. You may be requested to simply contact model agencies and ask them to provide "comp cards" to you for selection. These are models' promo cards with photos, sizes, and agency information. They may be mailed to you or viewed online.

Or you may need to see the models in person, especially if there are clothes or shoes to fit. One client of mine was a high-quality shoe company that distributed shoes through retail stores and catalogs. The shoe samples were size six for women and nine for men. Most professional models have much larger feet, so the agencies really had to explore their rosters to find models small enough to fit these shoes, and then the talent had to represent typical customers, in case their faces weren't cropped out.

A CINDERELLA STORY

I previewed the talent for the shoe catalog through model-agency websites or by email. Most agencies protect the privacy of their models by requiring that clients register and have a password to see models' information, such as last names and sizes. I forwarded the best choices to my clients, who narrowed the list down to their favorites. Since the photo shoot was planned for another city, I worked with agencies there. We couldn't have the talent "go-see" to try on the shoe samples until arriving—and that was the day before the shoot!

It was like a Cinderella story as the models squeezed their slightly-larger-than-stated feet into the shoes. Since I didn't know the sizes of the eventual talent, it was particularly challenging to shop for the wardrobe, especially men's pants, which are so visible in photos cropped from the knee down. I picked clothing for the most part that was larger and fitted it to the models with large safety pins.

When casting talent from agencies, you will call the agent with the time and location for the casting. The agent informs the talent. You should also

provide any special details such as what to wear and a cell phone number, probably yours, in case of emergencies or lost talent.

ALTERNATIVE RESOURCES

More recently, there has been a trend to post for castings on Craigslist and other media. For one production client, a beer company, I was tasked with finding "real guys, not too overweight but, you know, believable." Craigslist was the perfect solution. Not all people who respond to a Craigslist ad are amateurs; they may be professional or wannabe talent who are searching there for opportunities. In this case, the perfect talent turned out. There is a fee for this type of listing, but it is quite nominal.

(Incidentally, you should know when casting that talent portrayed in alcohol and cigarette advertising must be 25 years of age or older.)

Teri Cundall, of San Francisco's production resource Propville (www.propville.com), finds that talent who respond and are already represented by agents are usually good. Nonprofessionals also are interested and show up with varying results. In fact, they may be quite unprofessional and not aware of photo shoot etiquette. The "flakeability factor" is what Teri calls it.

She recommends "real people" castings conducted through agencies that handle talent that is more character-driven and who have other jobs. These individuals may be actors or just real people who are interested in having an occasional freelance job. Sometimes these agencies may do a "street casting" for you for a fee. It's a pre-screening that will put a layer of professionalism between the talent and you. The agency may have a file of subcategories or characters on hand.

Others report successful results casting from these media:

- **Craigslist:** opens casting up to public, pros and amateurs alike.
- **Facebook:** only exposes the casting to people on your network, but may spread to friends which could work for a local project.
- **Model Mayhem:** can work for students and test shoots but the racy element is a little high.
- **Twitter:** one casting director reported finding results for an unusual character in one hour.

BRING TO YOUR CASTING

- Casting sheets
- Polaroid camera and plenty of film or…
- Digital camera and preprinted numbers or casting sheets
- Stapler and extra staples for attaching talent's comp cards or head shots
- Clipboards
- Pens
- Numbers or markers for placing numbers on casting sheets
- Camera or video camera— easier if it's on a tripod
- Signs directing talent to casting
- Envelope or folder for casting sheets and materials
- At least one assistant to help with the flow, paperwork, or camera

ORGANIZING THE CASTING

One challenge after the casting is matching the talent images with the casting sheets. Traditionally, Polaroid photos of each person were used, stapled to their casting sheets. We don't have digital images available so instantly and may need to print them out later.

An alternative to Polaroids could be a number the talent holds for a digital photo. You'd need to be sure to record the correct number on the casting sheet so you can match the photos to the right sheet later, after you've printed the photos. As a precaution you could place a visible number on the casting sheet and have the applicants display their own casting sheets in the photo.

BOOKING TALENT

Booking is the process of notifying the agency (or the talent directly) who has been selected for the shoot and arranging the specifics. Booking is far easier with professionals, as the agent serves as a layer between you and the talent, making it more efficient (and less painful). At this time, you may find out that someone is not available after all. This generally happens right after you have created and perfected a shot schedule, which must then be rearranged.

CALL SHEETS

Assuming that all your talent and crew are available, and the agents let you know they have spoken to and confirmed it with them, your next step is to provide the job information or the "call sheet." Review the hourly rate and number of hours that you discussed earlier with the agent. Then you can email (with the call sheet as an attachment) the photo shoot information to each agent you are working with. When the talent arrives at the shoot, greet them and introduce yourself and the crew, so that they feel at ease.

When booking non-professionals, you will contact them yourself by phone and follow up with an email containing all the relevant details and attach the call sheet.

I strongly suggest finding directions to the location by reading a map, or better, by previewing the trip. Though many people use online directions and GPS systems, these are often confusing and misleading. Most of the times that talent or crew arrive late at a shoot, they say, "But I got the directions from MapQuest!" Help them arrive on time by providing good directions or a printed map.

INFORMATION FOR THE CALL SHEET
- Client and project name
- List of models from that agency
- Shoot date
- Call time (time the talent is expected to arrive)
- Location
- Directions (and a map if necessary)
- Crew contact names and cell phone numbers
- What to bring (see wardrobe list in Chapter 7)
- Arrive "makeup-ready" or "clean face/no makeup" (tells talent whether there will be a makeup artist on the shoot)

MAKEUP

While the makeup artist is usually a key member of the crew, there are occasions when the stylist may be asked to do the makeup. In smaller markets (everywhere but New York and Los Angeles), there is more expectation that the stylist can perform both functions. Tighter budgets are one reason. In addition, the projects may be less "editorial" and more commercial.

Even as an art director, I was not skilled at recognizing whether a model's foundation was a good tone or if lipstick was too dark. Makeup artists have experience with how makeup appears in photographs. Says San Diego–based makeup artist Claire Young, "Skin tone needs to be evened out, blemishes covered, shiny places matted down. It's a lot harder than it sounds, because you need the model to look flawless, but you don't want it to look obvious that she has makeup on."

For lifestyle shots, as opposed to fashion or beauty (when a makeup artist is nearly always present), the model is often asked to arrive "makeup-ready." I am quite willing to maintain a model's makeup, applying powder when the face starts to shine. That's basic knowledge, and sufficient for booking a simple lifestyle job. If you are trained as a makeup artist, you may be able to fulfill both functions on fashion shoots, but you'll be awfully busy and should consider adjusting your rate accordingly.

PROFESSIONAL RESPONSIBILITY

The unfortunate thing is that you may bump someone out of a job because you are doing the makeup in addition to styling. Conversely, makeup artists are sometimes asked to provide and style wardrobe; this may eliminate the need to hire you. We must encourage our clients to respect our professionalism; don't be too willing to do everything. We can be reasonable and say no. Taking on too many responsibilities usually means not doing any of them well. It may be a slow process—educating our clients while still getting their jobs—but the quality of our work will be worth it.

In some markets, though, you may find you have to be skilled in several areas in order to get jobs. In a tight economy, this happens more and more often.

A makeup artist has an extensive kit with countless tones of foundation, eye makeup, lip color, and brushes. As a photo stylist, your kit might contain a few makeup items. (I'll list some of them in Chapter 6, Fashion Styling.) You'll decide how much you want to invest in this facet of your styling career.

MEALS AND SNACKS

Another production role that a stylist may fill is making sure everyone at the shoot is fed and hydrated. Providing snacks may be part of your daily role on location. Use a cooler and make a morning stop for ice, refilling anything that is getting low. Many clients will not think about this necessary aspect of a shoot and will appreciate your suggesting it.

Another popular part of the day is a "Starbucks run." There is usually a nearby coffee spot and if a crew member can be spared, the response is always favorable, especially in the slump after lunch. The expense for snacks

should be established as part of the client's or photographer's budget. Snacks should be easy to eat (think about models who have on makeup), and not leave grease or residue on the crew's hands. Most makeup artists bring straws for models to use; you can add some to your kit too.

POPULAR SNACKS FOR CREWS AND MODELS:

- Water, water, water
- Soda and diet soda
- Gatorade if in a hot climate
- Breath mints (Altoids are a photo shoot basic, especially after coffee)
- For morning: Cereal bars, muffins, bananas, grapes, juice, and if possible, coffee (with cups, cream, and sugar)
- For afternoon: Candy, especially red licorice (sure to create excitement!), small crackers, string cheese, and fruit. For a real treat try chips and salsa, or unbuttered popcorn. Be sure to bring hand sanitizer or moist towelettes to clean messy hands.
- Avoid: Oreo cookies, spinach, and poppy seeds (imagine why!); colored juice and caffeinated soda for children

SNACKS AND LUNCH IN THE STUDIO

Generally when you are working in a studio, you won't have to worry about feeding the crew. The studio manager, assistant, or photographer will make sure everyone is fed. It's a matter of hospitality. Most studios are equipped with a kitchen, which is often used for food styling. Coffee and pastries are usually arrayed on the counter in the morning, and the refrigerator is stocked with water and soda.

One of the finest traditions of photo shoots, in my opinion, is lunch. The meal is nearly always provided. Exceptions are in-house photo studios run by corporations or catalogs. While working in an environment where there are full-time employees, you are often expected to take a lunch break, as they do. If you aren't sure what to expect, bring lunch or lunch money on the first day.

In a photographer's studio, the photo assistant may order take-out food from a nearby restaurant and pick it up or have it delivered. The cost is written into the photographer's estimate for the project. The pleasure of this meal is balanced by the fact that you will most likely take a very short lunch break. Don't plan on doing any lunchtime errands when you're on a shoot. Just wash your hands and get back to work.

Lunch on location is anything from a catered meal to a group lunch in a restaurant. The production manager usually makes this decision. This expense is part of the budget; still, be sure to thank the person who pays for the meal. A catered lunch is a pleasant experience. There are some caterers that

specialize in photography productions. When they cater for films or video it's known as "craft services." I almost learned the hard way that on location for video or film, nobody goes to the craft services table at lunchtime before the director. I wanted to eat while I had a chance before steaming sheets for the next scenario, but a co-worker pulled me aside as I was on my way. Morning snacks are fair game at any time, however.

No matter how brief, crew lunches are relaxing and a good time to get to know each other and build rapport.

SHOPPING FOR PROPS AND ACCESSORIES

"A person who shops for props" is the description of a stylist that I'd heard many years before becoming one. Most people who are attracted to this field are people who love to shop. It's pretty exciting to think you can get paid for it!

SHOPPING ADDICTION

I am not a "shopaholic," someone who has an addiction to buying things. This compulsion, while temporarily satisfying, has been known to cause some serious problems in people's lives, as much as we make light of it. If you do have a problem with shopping addiction, it's a good idea to keep separate receipts, or better, avoid shopping for yourself while you're "working."

I tend to consider carefully before spending my own money on clothes or household items. But spending someone else's money and getting paid for doing it is a delightful way to make a living. Though I don't look first at the price tag when prop shopping, I am very careful with my clients' money. They want me to be. They're already spending a good bit on the crew, models, travel, and other expenses.

GENERIC PROPS

You are using props to enhance the photograph, not to draw attention to them. Catalog companies, in particular, want the props used in the shots to help sell their products. Sometimes they get phone calls from customers who want to order the props. They would prefer the customers don't even notice them. It's good to try to use props from the cataloger's merchandise whenever possible. If a fashion catalog sells bags, belts, or jewelry, these items should be used as accessories throughout the catalog.

Even if you're not working as a food stylist, edible props may come into play. A bowl of fruit, a lime slice on the edge of a glass, or a bucket filled with ice and chilled beer bottles may all enhance your shot. It's fun to shop for the perfect pear, a bottle of the finest champagne, or some other gourmet item that you might not typically allow yourself to buy. You're actually looking at the food as a perfect object, rather than being practical. (The specialty kit list in Chapter 12, Room Sets and Bedding, lists a few tools for styling these food props.)

Pay attention to details that make the photo "real." For example, construction and factory workers appear more realistic with hard hats or safety goggles. On that note, it's important to be aware of appropriate safety devices. A model posing with a skateboard or bicycle should have a helmet and other protective gear, which are required in some states, even if the model is only holding them.

SEASONAL ITEMS

The print-production industry works two to six months ahead of the seasons. A couple of months usually elapse from the time a catalog is designed and the photographs taken until it's printed and distributed. Magazines stories are photographed several months before the issue is available. Publications are presenting the styles of the upcoming season, so overall, you are going to be styling the opposite season throughout the year. This can make finding seasonal props a challenge. Searching for sandals or a beach ball during January in Minneapolis is nearly impossible. In warmer climates it's a little easier, but still a challenge. Keep your eyes open for sources so you'll know where to begin. And don't forget, there's always the Internet.

PROP RENTALS

Not all props are purchased. While most items on your list can be found at retail stores, you may need a special item like a Victorian sofa or a large area rug. When you find the sofa at an antiques store, the storeowner might be interested in renting it to you. A carpet store may be willing to rent the rug to you. This is actually fairly common, with a standardized rate of about ten percent of the retail price per day, and your credit card number on file in case the item isn't returned or is damaged. Generally, the arrangement can be negotiated for longer, and merchants are pretty flexible.

It's not a bad situation for store owners—they make some income from the merchandise and still get to sell it later, and your credit card deposit is on file. One glitch might be if the owner wants to keep the store stocked for a busy shopping day. You'll need to arrange transportation and take very good care of the item while it's in your possession.

PROP HOUSES

In some larger cities, there are thorough prop rental companies, known as "prop houses." San Diego does not have these resources, forcing us to strike out on our own. But New York, Chicago, Los Angeles, and Miami are among cities where the search is easier with prop houses that gather everything you might need under one roof. Serving film, television, and video, in addition to still photo, they have an eclectic collection of everything from dishes to antique radios to midcentury furniture. We'll learn more about prop houses in Chapter 10, Prop Styling.

A TREASURE HUNT

Searching for props can be like a treasure hunt. Sometimes what seems like the simplest thing to find becomes impossible. One spring I needed to find a basic red cooler chest. We've all seen a million of them. That year, though, all the coolers were blue. I went to store after store and found nothing but blue coolers. I told my client I'd be glad to spray paint the chest red, but we agreed that blue would work.

My first project as a studio manager was to find a "kiddie car" for an ad agency promotion. A man in a suit and tie would be flying down a set of stairs in front of an office building in a 1950s, child-size toy car. I started out with the yellow pages, calling antiques dealers. None of them had one but each suggested someone else to call. It seemed like the chain of phone calls would never end, but at last I found the ultimate collector of children's pedal cars, and he was very generous about renting a pink kiddie Cadillac for our shoot. Never give up—the prop you are searching for is just around the corner. If not, there's always another solution—making props.

MAKING PROPS

Your creative skills can come into play when a prop is impossible to find. This is when it gets exciting. The finished prop just needs to last long enough to get through the shoot, and most important, look like the real thing. For one outdoor products catalog, I constructed a willow branch that was used countless times. I found a sturdy, curved branch about six feet long at a florist supply store, and silk willow leaves, which I attached using a glue gun. The branch was used for an evening shot of some colored party lights; it was suspended over a lighted swimming pool so that a pleasing background could enhance the lights. The branch has since been used as an out-of-focus foreground element and also to decorate the area outside a large window.

PROFESSIONAL PROP STYLISTS

You can see that props are an important part of styling for photography. While we all need to use props frequently, there are some stylists who specialize in providing or building props. In Chapter 10 we'll look more closely at this career.

"UNSHOPPING," THE ART OF RETURNS

One important thing to remember when shopping for props is to always get at least twice as many of an item as you need. Having options makes you a better stylist and often the alternative ends up being the favorite choice. However, buying twice as much as you need will inevitably lead to one of your most difficult duties as a stylist: returning props and wardrobe to the store where you purchased them. You'll get used to it, but it is never easy.

Your clients' budgets should allow for a certain amount of props, but they generally will not expect to own all the props after the shoot, especially items

they are not likely to use again. That's where returns fit in. I call it "unshopping" when you undo the prop shopping you did at the beginning of the project.

It is an accepted practice within the photo industry that props, and even wardrobe, are purchased for use on a shoot and then returned to the store. Some stylists have a policy of only returning items that aren't worn; if it's been worn, it's not a return. This is fair and should be clarified with the client at the beginning of the project. It could be difficult when the shoot is a test shoot or the budget is very small. The garments could be given to the models, kept by the client or stylist, or donated.

DONATIONS

When I did a styling job for Buick, I found out that GM's policy was to donate all props used on their photo shoots. This is a good and honorable way to handle the moral question of returns. I'm surprised more clients don't follow it.

Most stores, particularly the national chains, do have a generous returns policy—returns within thirty days with a receipt, if items are not worn or damaged, price tags attached, credit on a credit or debit card. Before you do prop shopping be sure to check out the store's policy about returns. You will want to avoid stores that give only store credit.

I used to love shopping at small local stores to support local commerce until I realized how convenient and predictable national chain stores are. They are everywhere you go and you know what you'll find.

SALES COMMISSIONS

Some upscale department stores also gladly accept returns as a customer service. This seems like a great source for expensive dresses and men's suits. But when I realized that the salespeople are paid commissions on items sold and then have those commissions taken out of their paychecks following returns, I didn't feel as good about it. How hard it must be to be thrilled with your extra income and then receive less in the next pay period.

Department store outlets offer a comparable selection but at a discount, generally don't use the commission system, and have good returns policies.

> **TIP** Check on a retailer's returns policy before shopping for returnable props and wardrobe. If they only offer merchandise exchanges you may be wasting valuable prep time.

TAGGING

Not graffiti, but simple devices for attaching store tags on clothing, "taggers" are available at store fixture suppliers. These are the same suppliers where

you buy steamers, rolling racks, mannequins, and tissue paper. A tagger is a gun-like tool for re-inserting price tags that were removed from the garment. The trick is keeping the tags in order, so the right one is attached to the right garment. I have had moment or two of panic when I was returning a cotton tank top to which I'd attached a $40 price tag, whereas the silk blouse was marked $12.

It's best, of course, to keep the tags attached as long as possible; if the item isn't used at all you don't have the difficult decision about returning it. You can use sticky notes, zip-lock bags, or envelopes to keep track of the tags. Be sure to bring these supplies to the shoot, along with a pen for noting which tags go with which garment.

If you purchase designer sheets or other packaged linens and use them on a bed, you might want to return them, as long as they are clean. It looks like you'll never be able to fit them back in the original packaging. Save the package and the cardboard, having noted the original presentation. If you have an extra package on hand—from the multiple options you've provided—you have something for comparison. Believe it or not, the sheets will fit back in and look just like they did when you bought them.

YOUR MENTAL STORY

You will notice that other people are returning purchases. It goes on all the time. Rarely does the cashier ask you the dreaded question, "What is your reason for returning this item?" But I find that it makes me feel more authentic if I have a story in my head when doing returns. "These didn't look so good when I tried them on at home; the color wasn't right; my daughter is picky; my brother bought all his own housewares at the same time I was buying these for him!" Poor me, now I have to return them!

I read one suggestion by a stylist on a blog suggesting that you consider yourself a "personal shopper." And it's valid—you are purchasing items and taking them to someone who will decide whether they're appropriate. That can be a good mental cover story.

SOURCING FASHIONS

"Studio services" are offered by many upscale department stores. These are legitimate department store liaisons for fashion rentals. Fashion stylists also work with public relations, or "PR people" representing fashion lines to use their fashion in editorial stories. Small boutiques or independent designers may be willing to work with you in exchange for some free promotion and photos they can use.

You can learn more about these services in Chapter 6, Fashion Styling.

TWENTY PERCENT LOSS FORMULA

You can figure on about a 20 percent rate of items that will be damaged, kept by the client, given to the models, or kept by you. This figure can effectively be part of your budget estimate. Also, if for one of these reasons you reserve

one or two items from each large purchase it will ease the discomfort of returns. When you calculate it into the budget you may enjoy the occasional scarf, sunglasses, slightly worn shoes, or even a giant pile of lemons, as long as they were props requested or needed for the shoot and are not returnable. (The clients always have the first option for keeping items, so ask them first.)

The pile of lemons brings us to shopping at grocery stores and garden centers for props. You can usually expect these to be nonreturnable purchases. You and the crew often get to bring home garden plants and extra food props. Evenings of celebrating the wealth of props bought for their beauty will follow.

RESEARCH CHALLENGE: FILM COMMISSION

Contact your local film commission and introduce yourself. Find out about the services they provide. Is there one person who works with still photography shoots? How important is still photography in their services? Are there directories (both print and online) where you could be listed? Is the listing free? Find out what the permit process is like for shooting in public places in your city/area. And what the fees are for commercial photography.

CHAPTER 5 Your Styling Kit

COMPARED TO WHAT IS required for many professions, your investment in your styling business is small. First, without expensive schooling you won't have large student loans to pay off, like an attorney or doctor does. You don't need to rent an office since you can usually manage your styling business from home. You needn't acquire the camera and computer equipment a photographer does. What you *do* need is a well-planned styling kit so that you have everything you might need on a shoot. The recommended equipment listed later in this chapter is fairly inexpensive and can be accumulated gradually.

Your kit, combined with your styling skills and creativity, are your most important assets as a photo stylist. This chapter provides suggestions for useful tools for all stylists and sources for finding some unusual ones. While you are assisting and building your business you can gradually build your kit.

VARIATIONS FOR STYLING SPECIALTIES

Depending on your styling specialty you'll need additional items for your kit. In each chapter are some suggestions to add to your basic kit for styling specialties. If you do all types of styling, I'd recommend having a basic kit plus several kits that you can customize for each type of project. I keep plastic bins of extra supplies on hand and customize my kits when needed. The only exception to the basic kit is for food stylists; your kit is extensive, but it's all you need. (The specialized kit described in Chapter 11, Food Styling, duplicates many of the supplies in the basic kit.)

KIT INSPIRATIONS

Keep your eyes open for kit contents. Some useful—and affordable—items can be found in dollar sale bins at grocery and drug stores. I found a miniature whisk broom and dustpan set, a spray bottle, containers for pins, and children's barrettes this way. I love the notions at the checkouts of the Container Store. This is where I find silver cleaning cloths, clear museum gel, and the tiniest bottles of Goo-Gone.

One thrilling find for me was pet-conditioner spray. I had a bottle on hand one day because my dog was modeling, and I tried spraying it on the outside of a glass lemonade pitcher for moisture. It stayed in place longer than water and looked exactly like cold condensation. Now it's part of my kit.

When a professional carpet cleaner left small white Styrofoam blocks under the furniture in my house, I gathered them and added them to my styling kit. They work well for positioning items, especially on a white set. A photographer may have a box of children's wooden blocks. In assorted

shapes and sizes, they're invaluable for styling. When covered with cloth tape, they do not slip or move.

Your kit is as individual as you are. It will take time and experience to complete. Some items you think you're carrying for no reason; then one day, you'll be glad they were there. I have a roll of magnet tape that I've never used, but someday, I'm sure it will be needed.

TIP Keep a small notepad inside your kit where you can quickly note any items you need to replace before the next job or those must-have inspirations you come across in a photo studio.

THE CONTAINER

The kit that holds your styling supplies is as important as its contents. The toolbox or tool bag should be something that you like—it will become your companion. It should be easy to access and comfortable to carry. Choose one with a shoulder strap if you think you'll carry it on location frequently.

You can shop at hardware or building-supply stores for a durable container. It should be just big enough to fit all your supplies, with a little space to spare. One stylist found a combination step-stool and toolbox that also comes in handy for use as a seat while she works on wall styling.

Since your kit is so personalized, you must decide how large or small you want it to be. Some kits on the market have wheels, drawers, and levels of trays that can be removed or added back in for specific jobs. (See color insert.) Keter Plastic (www.keter.com) makes several of these sturdy customizable containers as well as smaller toolboxes. Most of Keter's products are made from recyclable polypropylene and contain some recycled materials. They're sold in retail stores.

My own basic kit is a toolbox with small compartments on the top for things like pins, a removable tray inside with compartments where I keep my tools, and a large bottom area that holds bigger things like safety goggles, tape, lint roller, and my small bottle of degreaser. I keep everything in its place and always know where each item is—typical organized stylist behavior.

For fashion or wardrobe styling, you'll need a portable mini-kit to carry on your body, like a fanny pack, apron, or shoulder bag. When you're moving around between the wardrobe and the model, you need to have your tools handy. This may be a secondary wardrobe kit in addition to your larger complete kit. Some stylists keep their scissors on a string around their necks, and clips and safety pins attached to their clothing.

Food stylists frequently wear aprons to protect their clothing when working with food and for keeping kit items handy.

MULTIPLE KITS

More than one kit may be needed for different types of styling. No need to carry all your wardrobe supplies like lint rollers, hairspray, and clothing clips if

you're going to be styling shoes on a beach. Or the window cleaner, furniture pads, and lemon polish that you'll need for room styling when you're working with a model. You can store extra supplies you don't always use in see-through bins so you can pull them for special projects. These could even be brought to locations, as a backup.

There are some basic items that all stylists will use, and some very specialized kits, as you will see in the styling specialty chapters. Essentially, as a stylist, you need to have on hand *everything* that you might possibly need to get your job done.

BASIC STYLING KIT

Following is a list of basic items for photo stylists. You may not use them all and you will want to add your own items. Keep an ongoing list of items you think of. Often, you'll be working on a shoot and discover something you wish you had, or a great gadget the photographer has, and want to add it to your kit.

You can usually count on photographers having "gaffer's tape," a strong black fabric tape, along with lots of other tape. Ask the assistant for it. They will generally also have on hand: trash bags, tools, putty, blocks or bricks for lifting items in the shot, foam board, clamps, and C-stands for suspending items from above. In Chapter 9, Product Styling, we'll look at more useful materials that may be found in the photo studio.

One photographer I worked with even supplied the exact tools I needed for applying dewy moisture to the outside of a moisturizer bottle. He had a long, oversized hypodermic needle and a bottle of glycerin, which I used to carefully place the droplets.

Item	Description, Use
☐ Scissors, small and sharp	Clipping threads and removing labels; use only on fabric
☐ Craft scissors	Everything but fabric; clean with degreaser after using for tape
☐ Fabric scissors	Use only for cutting fabric or batting; cutting paper will dull the blade
☐ Degreaser	Cleans off labels or anything sticky; find a small bottle
☐ Rag(s)	Wiping products and sets, use with window cleaner or water
☐ Window cleaner	Shining products and surfaces, cleaning dishes without water
☐ Paint brush	Dusting small items on set
☐ Quilt pins	For pinning fabric; yellow heads, one- to two-inches long

☐	Corsage or T-pins	Also used for adjusting, lifting; like quilt pins but longer
☐	Pliers, needle nose	To bend wire, grab things
☐	Screwdriver *or* combination tool	Find a screwdriver with changeable heads or use a combination tool with many tools in one
☐	Wire cutter	For cutting heads off pins, cutting wire
☐	Safety glasses	Always worn when cutting heads off pins
☐	Wire, thin	Forms edges of off-figure clothing, lots of other uses
☐	Monofilament	For suspending objects; also known as fishing line
☐	Aluminum plumbing tape	Many uses; sturdy, shapeable tape
☐	Tweezers	To hold or adjust small items; long ones are useful
☐	X-Acto knife *or* box cutter	Cutting and trimming; be sure to cover and have extra blades, box cutter may be more convenient; retractable but less precise
☐	Weights	Balancing or weighting objects; divers weights or flat stones
☐	Styrofoam or wood blocks	Raising and lifting objects; may be from carpet cleaners
☐	Permanent markers	For touch-ups; black, brown, and other neutral colors
☐	Spray bottle of water *or* wrinkle release product	Spray wrinkles out of clothing, moistening products or sets; water works as well, but product bottle's nozzle may be better
☐	Lint roller and refills	Removing lint from fabric
☐	Putty	Holding objects in place; removable with more putty
☐	Hand sanitizer	Keeping hands grease-free
☐	Sewing kit	For mending; small kits you find at hotels are good
☐	Basic first aid kit	Antiseptic, bandages, aspirin, etc.

STYLING SUPPLY SITES
Browse these websites to find unique and specific items for various styling specialties.

STYLING KIT CONTAINERS
- **Keter Plastic,** www.keter.com: selection of rolling and traditional toolboxes

FASHION AND WARDROBE STYLING
- **Camera Ready Cosmetics**, www.camerareadycosmetics.com: professional makeup palettes
- **Manhattan Wardrobe Supplies**, www.wardrobesupplies.com: full selection of wardrobe supplies
- **Ricky's**, www.rickycare.com: makeup and beauty supplies throughout New York City and online

PRODUCT STYLING
- **Find Tape**, www.findtape.com: the ultimate resource for tape
- **Got Putty**, www.gotputty.com: source for earthquake putty, same as photographers' putty
- **Improvements Catalog**, www.improvementscatalog.com: one of many sources for clear museum gel

FOOD STYLING
- **Photo Styling Workshops**, www.photostylingworkshops.com: resource booklets available on sourcing supplies
- **Trengove**, www.trengovestudios.com: food styling special effect supplies, acrylic spills, ice cubes

GREEN STYLING PRACTICES
Styling is not a job that creates a lot of debris. Most of what we use is in small quantities or reusable supplies. But there are still ways we can take responsibility for styling green. Recycle paper by keeping a bag near your work area; if the studio doesn't have recycling, you can take it home with you. Food styling seems to generate a lot of packaging waste that can be recycled.

Location shoots usually create a great deal of trash. You're working quickly, and it's easier to just throw everything in a plastic trash bag. (At least there are no hazardous Polaroid papers anymore.) If recyclables (paper and beverage containers) are placed in a separate container and then carted home or back to the hotel, there can be much less waste.

One thing that strikes me about photo shoots is the number of half-finished plastic water bottles around. I keep a marker pen handy and am always writing

people's initials on their bottles. At the very least, I try to pour the remaining contents onto some plants and pour out the water from my steamer at the end of the day in a planted area outdoors.

When styling off-figure, you can smooth out and reuse tissue paper. And of course, the fewer toxic products you use, the better. I have been searching for an Earth-friendly alternative to the degreaser Goo-Gone. It's tough because Goo-Gone is so effective for removing sticky residue on scissors and sticky price labels. I've been experimenting with alternatives like alcohol, window cleaner, and non-acetone nail polish remover—but these options have some toxic qualities of their own and don't work as effectively. My latest experiment is a Mr. Clean Magic Eraser, which seems to do the job when moistened with water. It could be carried easily and safely in your kit and re-used.

TIP Research store fixture suppliers in your area or in the nearest large city. You'll need to shop there for items such as a rolling rack, steamer, mannequin forms, and a tagger.

RECOMMENDED EQUIPMENT

The items listed here are a financial investment in your professional career. When you're starting out, you might invest in this equipment one piece at a time, just as a photo assistant purchases cameras and lights gradually while working with a professional photographer. The initial cost of starting your photo styling business is really rather small. Your first needs are a kit, a portfolio, a home office, and some hands-on experience.

Many photo studios will already have rolling racks, steamers, and irons, but always make sure before the shoot day. If you have your own iron, you'll be familiar with its settings and know the surface is clean, so you may want to take it with you, rather than rely on a hotel or studio iron.

Having your own rolling rack does elevate you to a more professional level and you will really need it. When I've done preproduction work, I have even been able to rent mine to crews, whether I'm styling for them or not. The same applies to the steamer. I charge a reasonable weekly figure. This way you might eventually get your investment back.

I purchased a mannequin, a male torso, for a shirt-styling job and rented the mannequin to that client. I thought I'd get more use out of it but haven't used it again. Still, I like having it, and may have a need for it again someday.

Rolling Rack is essential for hanging, organizing, and transporting wardrobe. An adjustable and collapsible metal rack available at retail supply stores, this is your most valuable piece of equipment. You can organize wardrobe on it at home, transport garments to and from vehicles, and take the rack on location. Bottom bars can carry boxes and your kit. The extensions on either end carry purses, belts, and other items. A rolling rack is known as a "rail" in Britain.

Steamer is a styling basic for preparing most clothing, fabric, even vinyl (with caution). Be sure to purchase a professional-style steamer at a retail supplier, with a removable gallon bottle and valve top to avoid drips and spills. Hand-held and travel steamers are not adequate for use on photo shoots. I suggest saving the box your steamer comes in to pack it for traveling.

Iron and Ironing Board are used for crisp pressing. Shirts and fabrics needing more than steam may be ironed. Purchase a sturdy, high-quality steam iron, which you keep in clean condition. Test fabric first, iron on the wrong side of fabric, and use a cloth or tissue paper over delicate fabrics and screen prints. Some silks cannot withstand the moisture from a steamer or steam iron. Most hotels and studios will have an iron and board on hand, but check first. A **ham**, which is a rounded cushion for ironing curved areas, helps with pressing fine garments.

Plastic Hangers with swivel tops keep garments in good condition. These can be purchased at store fixture suppliers. Hangers can be hooked together for grouping outfits. Have shirt hangers as well as clip style skirt/pant hangers on hand. After using these, you'll come to detest wire hangers, like the Joan Crawford character in *Mommie Dearest*.

Rack Dividers are helpful for dividing wardrobe, by model, shot, or day. Like size markers in stores, they can be marked to help with organization. These can be placed on the rolling rack or on individual hangers.

Tagging Gun is used to replace hang tags that have been removed. It's available at store suppliers for a nominal amount, with a lifetime supply of plastic strips. Be sure to keep track of the store price tag, as well as extra buttons and other tags. Label them with a sticky note and place in envelopes so you can attach them to the right items.

Clothing Rod allows you to hang and transport wardrobe in your car. Adjustable shower rods work well and can be suspended from back seat hooks or handles. You can use permanent plastic tie-downs or small bungee cords to attach a loop.

First Aid Kit is always a good idea. A basic first aid kit is something you may some time need to have on location. Keep it stocked with a supply of bandages, antiseptic, alcohol wipes, and aspirin.

Computer is a requirement for managing your business. It is essential to have word-processing and accounting software, and an Internet connection. Use the computer for managing projects, writing client agreements, billing, record keeping, and producing promotional materials. Naturally, there is a world of information out there on the web; you should have your own site, and maybe even maintain it yourself. (We will discuss marketing yourself through the web in Chapter 13.)

KIT FEES

Some makeup artists charge a kit fee in addition to their day rate, because of the high cost of the makeup used. Generally stylists don't charge this fee; the materials used in an average workday don't amount to much expense. Materials needed for specific projects can usually be purchased for that particular job and deducted as expenses. Examples may be boxes, ribbons, and double-sided tape used for wrapping gifts.

Food stylists for still photography do not generally charge kit fees either. Requested items for specific shoots can be purchased when food shopping and added to the expenses. However, it is standard practice in video and television to charge a kit fee of up to $75.

TRAVELING WITH YOUR KIT

Your styling kit is filled with dangerous objects, which could arouse suspicion at an airport; you certainly wouldn't want to take it through a security checkpoint. When you're traveling by air, plan on shipping it ahead or checking it in. Packing it in another suitcase with the wardrobe or other supplies will give your kit some extra cushion and keep the contents from spilling out.

It is important to keep your passport up to date. You don't want to miss an opportunity to work in the Caribbean or France because you have to wait several weeks for a passport. Even with the expedited, "emergency" service, it can take days to get one.

Passports are valid for ten years, so the investment of money and time acquiring yours is dispersed over a long period of time. Don't wait until you need one. Keep it in a safe place, like a safe deposit box at a bank, so you'll know where it is when you need it. Or a fireproof safe at home can provide instant access on weekends and holidays. And check the expiration date. Nothing is as upsetting as learning the night before a trip that your passport is expired!

Everyone should have a valid passport. Even our neighbors Canada and Mexico now require passports for U.S. citizens. When you accept a job that requires travel to another country, it's a good idea to verify the visa policy, since acquiring a visa may take weeks or even months. If you're a citizen of a country other than the United States, know your country's travel and visa rules and restrictions, so you can confidently accept a job requiring international travel.

While you try to be prepared for any event on the go, sometimes you have to solve problems as they come along. A large stone might keep your rack from rolling downhill. Rope might be tied between two trees if no rolling rack is available. The trunk of your car might be where snacks are served and the interior may be the models' changing room.

YOUR OWN KIT LIST

The kit lists in this book are guidelines to get you started, not absolute rules. Your own kit will grow and evolve over time as you individualize it. No two

stylists have the same items in their kits, just as no two styling jobs are ever the same.

I hope you enjoy the process of building a kit. There is a unique thrill in finding an item like my miniature whisk broom and dustpan set at a dollar sale or discovering clear museum gel. When adding to your kit is that much fun, you know you're meant to be a photo stylist.

PART II
PHOTO STYLING
SPECIFICS

6

Fashion Styling

I MIGHT AS WELL tell you one thing about me right now. I am not a "fashionista." I'm not possessed by the wardrobe fantasies of a fashion student, or the desire to design outrageous garments. I don't shop for designer labels, though I do know who most of the designers are. One of my favorite colors to wear is heather grey; I also wear a lot of blue denim, white, and black. (But I understand some fashion designers wear only black.) I *do* read fashion magazines voraciously.

What I love most is the construction of clothing, and I appreciate the characteristics of fabric. I learned to sew when I was quite young. In those days, girls took home economics in junior high and every year thereafter. Half the year we learned cooking and the other half sewing. Girls did not have the option of woodworking, drafting, metal shop, and automotive repair. If I had, my life might have been different—I think I would have really liked those classes. But I spent my happiest school days in home economics, sewing on a Singer machine, and learning about casings, darts, facings, collars, and set-in sleeves. (I now teach sewing to college students in addition to styling.)

So, I love clothes, but I am not passionate about fashion. That love is the number one requirement to be a fashion stylist.

EDITORIAL FASHION STYLING

Fashion styling is a very wide area. Drawing on a fascination with fashion and accessories, many stylists are attracted to fashion photography. Whether they are working with merchandise available for sale or pulling together new combinations, these stylists must have a love for fashion and creating new looks. In an ideal situation you can live and work in that world—and many do. Others find that there is not enough styling work available exclusively in fashion so they also do other types of styling.

The roles involved in fashion styling were described in Chapter 1. To review briefly, a magazine fashion editor researches the coming styles and trends to create fashion stories. Fashion stylists may work with advertisers, either featuring the garments or creating a mood. The bulk of freelance fashion styling is less glamorous work for catalogs, creating a look the customer will want to buy.

The biggest difference between catalogs and magazines is that catalogs are directly selling specific merchandise and magazines are promoting a style. To do this they interest the readers with fashions that are available for purchase in the marketplace. The fashion editor draws the reader in. Readers must be engaged enough to buy magazines, which are largely financed by advertising;

Fashion styling for a designer's lookbook. Photographer: Tim Mantoani; art director: Cindy Cochran; stylist: Susan Linnet Cox; hair and makeup: Claire Young. © Tim Mantoani

subscriptions and cover prices provide only a small part of a magazine's income. Catalog income results from the items sold in the catalog. The stylist should be aware of these subtle differences.

In the magazine world, a fashion editor is the stylist—and much more. Staff fashion editors and their assistants do most of the styling themselves, along with following the fashion industry.

Styling fashion stories in magazines seems to be freer and more creative than most areas of styling. There is not usually an art director looking over your shoulder—the editor independently creates and directs the project. The editor/stylist works exhaustively on the project, researching fashion trends, creating story concepts, finding resources, hiring photographers, producing the shoots, and styling the fashion. These are the steps the editor takes in developing a fashion story.

STEPS TO FASHION EDITORIALS

1. Attend semiannual fashion shows. Look for upcoming shapes, colors, and texture. Sort out the fads from trends.

2. Follow up with visits to showrooms to see collections in person. There, editors can have a close look at garments, see how they feel, find out how they are made, and get prices and availability of samples for their shoots.

3. Keep notebooks and sketchbooks to keep track of items for more than one shoot at a time. This recording may be done on a laptop computer.

4. Request sample garments for a shoot, working with public-relations representatives to procure them.

5. Design and produce photo shoots on location or in studio. Really the most intensive part of the process, the shoot is only one part of the editor's job.

6. Take notes during the shoot of every garment and accessory worn in each shot, for writing captions, the description of items, prices, and sources that appear on the fashion pages (or at the back of the magazine). Notes help later when matching items with copy; it may be hard to remember every detail. Makeup and hair products may also be included in captions. Check name spelling of photographers, stylists, and makeup artists for listings.

7. Return garments right after the shoot to the representatives. Careful labeling and organizing helps, and the reps appreciate having samples back in good order.

VIEWING THE RUNWAY SHOWS

Editorial fashion stylists get ideas by constant exposure to the fashion world. The ultimate part of keeping on top of the latest trends is viewing the major fashion shows. Semi-annual shows in Milan, Paris, London, and New York, when new lines are presented, are the biggest source of inspiration.

The major shows occur in approximately February and March for autumn/winter collections, and September and October for the spring/summer collections. In addition, there are haute-couture shows in January and July. Menswear collections are presented in January and August to September of each year.

EDITING THE FASHIONS

Editing the collections to suit one's own ideas is the next step of a creative mind. The personal touch of combining elements from collections or mixing

them together makes the editor/stylist's approach unique. After the shows, the editor has the opportunity to visit showrooms and see the fashions up close. This step refines the impressions from the runway shows. Since the editor may be planning up to six months of stories at this phase, the garments are sorted into themes or stories.

SOURCING FASHION

Publicity for fashion lines is assigned to either a staff or an independent public-relations representative. These representatives are the main contact for obtaining samples for fashion stories. Early in the season, there may be only one sample of a garment and the bigger fashion magazines with good relationships seem to have first choice.

Extra options are usually pulled for stories; some items may not fit the model or work well once they are on set. If the sample has to be borrowed for more than a few days for travel to a location, the sample should be included in the story. Returning samples quickly after the shoot and in good order is important. Keeping a good record is essential. The necessary business forms for fashion stylists are available for purchase from Photo Styling Workshops.

PULLING SAMPLES

Here are some suggestions for pulling fashion samples, offered by Atlanta-based fashion stylist Kim Maxwell:

- Give your wardrobe vendors a one- or two-day notice before you come in to pull wardrobe, unless you are working on a last-minute project.

- Set up an appointment with the showroom manager, boutique manager, department store, or PR department at a time when traffic is slow in the showroom or store.

- Introduce yourself when you come in so they know who you are.

- Have your credit card, petty cash, and business paperwork ready and organized.

- Make sure you get a receipt or list of the wardrobe you pulled for the project.

- Before you leave, be sure you have the correct information for your credits (captions).

- Inspect all apparel and accessories before the wardrobe vendor releases the wardrobe; you don't want to bring any damaged wardrobe to set or be responsible for it afterwards.

- Set up an appointment to return wardrobe and make sure it is returned at that time. If it is going to be late, make sure you notify your wardrobe vendor.

- Discuss if they want the items dry-cleaned before you return them.

The search may not take the fashion editor far from the office. Samples are continually sent to magazines by PR reps. I accompanied my daughter, Elizabeth, to *Teen* magazine for one of her first model bookings. She was to appear in a monthly one-page feature of a girl explaining what clothes she likes and why. We went into the magazine's stuffed sample room where Elizabeth chose several pieces to wear later at the shoot (she didn't get to keep them). The editor asked her some questions about her background and the garment choices. We anxiously awaited the issue and were crushed to see, above the interview, a shot of her jumping up; her head was cropped off the top of the page. But that was the editor's call for an effective presentation.

STUDIO SERVICES

If you need to pull fashions without the benefit of a magazine's rack of options or showroom pull, you may want to work with a department store through their studio services. You can contact individual stores, asking for "studio services" to find out about their individual policies.

While each store has its own requirements, they generally include pre-registration for pre-approval and a credit card with a credit limit equal to the amount to be used. Some stores charge a restocking fee up to 20 percent or require that a certain portion must be purchased. Of course, any garments that are returned in less than perfect condition must be purchased.

> **TIP** Research studio services of department stores in your area. Register with them *before* you need them. The approval process may take more time than you have for prepping a job.

PROP AND LOCATION CONCEPTS

The fashion editor works with advertising and other editorial departments in developing fashion stories. Accessories or home editors may collaborate on feature stories.

A prop stylist may be hired to work in conjunction with the fashion editor. A fashion story may be enhanced by creative styling of outside props. Inspirations result from pulling in elements for props, such as feathers, furniture, or any "out there" ideas. The prop stylist may be functioning as a "set stylist" if a background or environment needs to be created or enhanced.

Locations can provide a big part of the fashion story, too. Unusual architecture, hotel rooms, gardens, cities, Airstream trailers, and beaches all can provide a major part of the theme.

You see these fashion stories in *Vogue, Elle,* or *Vanity Fair.* Here's an obscure European hotel room, somewhat dated looking, with the model sprawling on the bed in a gown. On the floor next to the bed is a French telephone. The funky wires extend to an outlet. The flaws in the room add intrigue to the story.

My own family's Victorian home in Pittsburgh, which was in ill repair, had possibilities. It would have been an inspiring, bizarre location for a fashion story had I been able to bring myself to produce it. But it was a little too "close to home" for me. An objective stylist/editor could have created a fashion story including a model in front of peeling wallpaper. A shot looking up at a model might have included this background: a vine that had climbed through a cracked window and created an oval on the bay window ceiling. A fashion editor is alert to these possibilities.

MAGAZINE JOB DESCRIPTIONS

Titles for magazine fashion positions are different from the commercial styling world. Though many duties are the same, the language of the editorial realm is quite distinct.

The magazine's **senior editor**, or **editor-in-chief**, is responsible for all aspects of producing the magazine, including editorial features and advertising. Editors for each department such as current events, arts, health, beauty, and fashion make presentations of their concepts to the magazine's editor. During the issue's production, layouts and images are presented to the editor for approval.

A **fashion editor** *edits* the fashions for next season into fashion stories. In essence, the role is that of a full-time stylist with inside knowledge of fashion and extra production duties. The stories are created with the readership, or "market," of the magazine in mind. There may be six to fifty pages of fashion, depending on the magazine's focus. At larger magazines, a **fashion director** may supervise the fashion editor.

The fashion editor position is often filled by the young and fresh, aspiring for a life in fashion. While many fashion editors are well-known figures who have spent a lifetime in the career, the average length of time on the job is about ten years. Long hours, travel, and the demands of a family can result in career shifts to related fields such as public relations, fashion consulting, or commercial styling.

The stylist, whether fashion editor or freelance, is usually given credit in a story. "**Contributing editor**" indicates a freelance stylist. Minor projects and those at smaller magazines are more likely to be given to freelance stylists. Sometimes an entire story will be subbed out to an independent stylist, including the production work.

On occasion a magazine may accept a fashion story created "on spec," also known as a "submission." A stylist and photographer would collaborate on a concept, hire models, pull the fashion, have a layout designed, and produce a finished story that is presented as a complete package to a magazine for purchase. An ambitious but exciting project.

Unlike art directors for photography, the **art director** at a magazine develops the look and style of the magazine, rather than supervising photo shoots. A fashion editor works with the art director of the magazine to lay out a fashion story, considering the number of pages, color themes, and other visual elements. Then it is presented to the magazine's senior editor for approval, before and after photography.

Hair and makeup artists are nearly always freelance roles. They may work with a salon or a cosmetics line or be represented by an agency. A **manicurist** may be listed if hands and feet are featured. A credit generally appears in the article, sometimes along the gutter side of the page.

NEW MAGAZINES

Smaller, newer, and local magazines may be a better place to start than at the top of the fashion world. Most cities have a local lifestyle magazine and maybe a local fashion magazine. These may be published by a regional, centralized publisher, and modified with a local viewpoint, local advertising sales, and local contributors

Alternative fashion/lifestyle magazines like *Nylon* may be published more similarly to the traditional ones. And, perhaps surprisingly, it would be a tough challenge to walk in the door as an unknown contributor.

Still other magazines are online publications. This may be a start-up magazine producing an online edition before seeking the funding necessary for a print edition. Such is the case with *The Stylist Handbook*, started by fashion stylist Devon Poer in 2010 as a resource for stylists to learn from and as an outlet for her own and other artists' layouts.

Los Angeles-based Devon has some advice for stylists hoping to break into the editorial world: "When it comes to hiring, magazines are looking for fashion editors, not just stylists, as lots of spreads (or fashion 'stories') are done in-house. My advice if you want to be in the magazine world is to have a passion for journalism, writing, and a knowledge of fashion and style. Develop your skills and intern at magazines during college, test shoot as much as possible, and get very familiar with the online world and blogging.

"It never hurts to reach out to fashion and lifestyle magazines by email and phone. Be as professional as possible, ask questions and listen. Always follow up with a phone call and don't be afraid to ask for advice too. If anything, it's great to make the initial phone call to get on their radar and learn more."

SUBMITTING A STORY

When you are creating a test shoot, you may feel your idea is good enough to submit to a magazine. In fact this may be a possibility, when done right, and submitted to the right magazine at the right time.

Devon tells us, "When it comes to submissions, it's best to send a link to a gallery of images and include credits in the body of the email of the designers and photo team. Have the images in order of your story. Your pitch email is very important; you don't want to make it too long. However, it needs to tell key information to get the editor's attention and enough about your team and concept. Collaborate with your photographer to really package your spread as a cohesive, well-thought-out story."

STARTING LOCAL

Pacific San Diego magazine is a local lifestyle monthly targeting young urban professionals. The preferred presentation to a magazine like this would be

submitting your work samples or a portfolio. Then the magazine may schedule a meeting with a stylist or photographer and decide whether they would be suitable for an assignment. If you team up with a graphic designer to make a knockout presentation, it's best not to get too locked into the design at this stage. A well-executed layout would be a plus but not necessary, and the publication will likely have some specifications to follow if your fashion story does get accepted.

Executive Editor Pat Sherman presents an encouraging viewpoint. He states, "*Pacific San Diego* is known for its amazing fashion layouts, photography, and design. We have a very specific look and feeling that we strive to capture. It's part of what sets us aside from our competition. In general, if the work submitted is good enough for publication, it will warrant pay or other compensation. The rate of pay varies, depending on the designer or photographer's experience and the quality of their work."

FASHION ADVERTISING

Stylists for fashion advertising are nearly always those already involved in the editorial fashion world. How they create looks is the most significant attribute. Laura Beckwith, senior agent at The Garden Party in New York, says stylists are hired based on a strong book, reputation, and organization, but more than anything, on their own distinctive style.

They may also work as contributing stylists to magazines and are often former fashion editors. One recognized stylist in the field of fashion advertising was formerly an editor for a major fashion magazine; she also works as a creative director for a fashion line. With extensive knowledge of the fashion industry, the stylist may be hired to work with the company to develop the brand and its style. In this case the styling job description partially overlaps with art direction.

Stylists of this caliber in the New York fashion world are almost always "repped," or represented, by an agency. With a busy schedule, lots of travel (often international), and multiple projects to organize they need the help of an agency to help with coordination, negotiation, and promotion.

There is also the more mundane world of advertising for less glamorous fashion brands. These jobs are more accessible to the stylist who is not based in New York and repped by an agency. For example, I did preproduction for the clothing company Hang Ten; another stylist was booked to style on the shoot day. The ads were placed in *Seventeen* and other teen magazines. Shot in one day at two different locations (scouting them was my role, along with hiring the RV), the ads showed a group of girls and boys in a field playing football in Hang Ten clothing and running through a sand dune at the beach in the swimwear line. That way the company was able to produce their summer and fall ads efficiently in one day with the same models and crew.

CATALOG FASHION STYLING

This is the bulk of fashion styling work for those not in the magazine world. In spite of economic fluctuations, the catalog industry remains enormous and

growing, with both print and web sales. And apparel is the largest segment. Producing catalogs—including photography, design, paper, printing, and mailing—is expensive. Catalog items have been carefully selected to appeal to the target market, and the financial aspects are highly controlled. The catalog company is looking for photographic teams to create great-selling images.

CATALOG TERMINOLOGY

It helps for a stylist to understand the language used on catalog shoots. Some of it pertains to merchandising and some to graphic design and printing. The terms provide information on how a product or a photograph is presented in the catalog. This is a sampling of the language; you will hear other terms at shoots or meetings and grow to understand, especially if you ask questions.

Star and **Inset.** The star, feature, or "hero" is the largest presentation in a two-page catalog spread. Most likely the largest sales dollars are expected for that product. You'll spend more time and effort on a great photograph of that product. Conversely, an inset is a small image of a garment placed near a larger photo, a back view, or an alternate color. It may be a close-up view showing just one detail of the garment.

Colorways. This merchandising term is usually used in the plural, since it refers to the assortment of colors in which a product is available. One color is featured on the model or the top of a stack of folded items, but the others need to be shown clearly. Sometimes the color shown on-figure is more attractive in photography but is expected to sell less than another color. In that case the second color is likely to be featured prominently in the stack.

Reshoot. The dreaded term reshoot means a photograph needs to be taken again at a later time for one reason or another. It may be a technical flaw in the photography, in which case the photographer might pick up the expense of a new shoot. This is rare, however, with digital photography (no more fears about not having film in the camera).

The garment may be an incorrect sample or may have been changed after the shoot. Or the shot may not be quite powerful enough. Buyers generally review the shots with the art director to make the final selections; they may not be thrilled with some shots and are more likely to classify them as reshoots if there is already another shoot scheduled for late samples or other reasons. It's not the end of the world and may result in another day's booking for the stylist.

Color Corrections and **Post.** You may hear someone say, "That's OK, I can fix it in post," meaning post-production. With digital images, the photographer, art director, or a retoucher can do a lot to improve a shot in the computer. Light switches and telephone wires can be erased much more easily than in the days of film. Color shifts can be corrected this way also. Previously, photographs were scanned by a professional service prior to printing (known as Scitex). But it was time-consuming and expensive to make color adjustments and revisions. Now such changes can be accomplished in Photoshop before a digital file is presented to the client.

WORKING WITH MERCHANDISERS

As you've seen, merchandisers are important to the catalog companies. In addition to buying, they are involved in everything from determining portions of pages for their products to editing the images. Most likely there will be a preproduction meeting where buyers present the products to the photo crew and discuss presentations. As the stylist, this is your opportunity to find out as much as you can and thus avoid misinterpretations. Ask questions—it's often hard to understand someone's visual concept.

A sample manager will probably be on staff at the catalog company making sure the needed photo samples are ready for the shoot. There is often only one sample for each garment, and it may have a hole cut in the back or the word "sample" written across the back, due to import regulations. Often sample sizes are much larger than the models' sizes, and that's where you come in on location. Dresses are often a medium or size eight and women's shoes are size nine. Fortunately, most models seem to have size nine feet while their dress sizes are no more than four or six—too-large clothing is easier to adjust than shoes.

THE FASHION SHOOT

Each photo shoot is a unique experience, making your styling career ever new. There are, however, some typical aspects of a fashion shoot. Your day on location will start before daylight, as there's a lot of preparation to do before the first photograph is taken. Meeting the crew and traveling to the location, unloading the garments, prepping and putting them in order are your early tasks. The model spends a good deal of time with the makeup and hair stylist. Since they may have started the hair and makeup early at the hotel, the model can travel to the location in rollers, where final touch-ups are done. Meanwhile, you get the garments ready and discuss the first shots with the art director and photographer. There is often a slow start the first morning, before the crew develops a rhythm of working together.

DRESSING THE MODEL

When the model is made up and in wardrobe, she will proceed to the set or location in front of the camera. At this point she doesn't have to be perfect. There is time to refine clothing fit and accessories after she's in place, while the photographer and assistant are perfecting the lighting and looking at the shot as a whole. Wait till after the first preview to go in and start "tweaking." When you step back and look at the shot, you'll see what's important.

One person should be designated to communicate with the model. There should not be multiple voices calling commands at the same time to a model far from the camera. Suggestions should be quietly funneled to the art director or fashion editor, who determines the priority and then, if it's determined a change should be made, communicates with the photographer. Sometimes things work themselves out; a model will shift into a new pose and the sleeve that looks wrong will suddenly fix itself.

PREVIEW SHOTS

At the beginning of each photograph, there is a process of building. Lighting the shot, positioning the model, creating the background of the set, perfecting the clothing, accessorizing, and other refinements gradually build the perfect image. During this process, the photographer, art director, and stylist are looking at, analyzing, and improving details. In Chapter 2, I described the Polaroid process in detail, the etiquette, and the order of the crew members making their contributions. It works the same whether the shot is traditional film or digital: there is a preview before the real shooting actually begins.

When you, the photographer, and art director are looking at a Polaroid preview shot or an image on the monitor, elements that you may have overlooked will become obvious. As you concentrate less on the model and clothing, other aspects of the image, such as the background, will emerge.

In a preview, be alert for any distracting juxtapositions in the background. Horizontal lines shouldn't cross behind the model's head, neck, hips, or any point that catches the viewer's eye or makes the body look heavy. Watch for vertical items too, such as a palm tree coming out of the model's head.

Often the background will be out of focus, or "blown out." Fashion photographers may use a telephoto lens so that the model and clothing are sharp and other elements are blurry. This helps the eye sort out what is important. Backgrounds may be just blurred areas of color. See how well they enhance the product.

Other fashion photography techniques incorporate sharp detail throughout. Look carefully to be sure every background item is perfect. Sometimes you'll find yourself picking up cigarette butts from a sidewalk. You don't want to see a flaw when the photograph is printed.

LOOKING AT THE MODEL

Beyond the clothing, look at the model's position while the shoot is going on. He or she should be standing in the most flattering position for both the body and the clothing. There may be some direction based on the layout and position on the page. Generally the model won't face off the edge of the page. Check that your clips aren't showing if the model turns to the side.

Watch out for missing limbs. An arm that is tucked behind the model can have a disturbingly truncated look. Usually women's fashions look more flattering when there is a space between the waist and the arm. Look for an angle that will help the body seem narrower. A hand in a pocket should not be placed too deeply; about the length of the fingers is enough, more a suggestion of a hand in a pocket.

See how the model's legs and feet look. Minor shifts can drastically affect—or improve—the shot. When a model is sitting, there are particular challenges. There may be an extra lump of fabric at the front. Creases that pants and skirts make at the groin and pulling at the hips require increased attention on the stylist's part. Models know how to tuck and release fabric

under their legs. It's always a good idea to warn the model about what you're about to do in this part of the body.

Watch the model's hands for signs of tension. When tension shows in the model's hands, ask her (or have the photographer ask her) to stretch and relax them into a less self-conscious position.

The photographer, particularly an experienced fashion photographer, is going to be seeing the same things as you. You may notice something at the same moment the photographer asks the model to change her position. If so, you are on the same wavelength and on your way to creating a great fashion photograph.

> **TIP** A bit of open space between the model's arm and torso helps make the fashions more flattering and slimmer looking.

SAFE SHOTS

When you're shooting for a catalog and get a bold inspiration, go for it. But also be sure to cover yourself with a "safe" option, something more traditional. That way, if your new approach doesn't show the garments well enough or fit the catalog's style, you've provided an option that will work.

Even alternate poses should be provided. I once presented a model seated on a Victorian sofa that I thought was gorgeous and flattering to the dress. But since we did not also shoot the model standing up, the merchandiser was disappointed in the results. Shoot options.

A LONG DAY

A fashion shoot might consist of anywhere from five to twenty shots per day, with one or several models working. Obviously you will be busy, even if you have an assistant. There are many garments and accessories to keep track of while you move back and forth between the dressing area and the shot. Your presence is often needed in both places at the same time. Lunch is a welcome break, and the sun is usually too high and bright for shooting then.

In the afternoon, it all starts again with the makeup artist refreshing the models' faces and hair; there is pressure to finish the shot list. You can expect to work hard physically and be mentally organized, without any down time. But you will be creating something beautiful.

THE HAPPINESS EFFECT

Elsewhere in this book, I describe how the mood of the photo shoot invariably ends up in the model's face. I call this the "Happiness Effect."

Any tension among the crew members or stress caused by outside factors, like locations and weather, no matter how hard you try to minimize them, show in the model's expression. The effect may be subtle and most people wouldn't know, but to the art director it is there. On the other hand, the comfort level created by a crew working well together, when everything is going

smoothly, results in a happy, relaxed model. Conversations and humor can play a big part in creating a pleasant appearance.

Years ago when I was a catalog art director, I regularly worked with a beautiful model named Lonnie Partridge. Lonnie, along with the assistant photographer and the male model, got seasick while we were doing a shoot on a small ship. Being a professional, she heroically continued to work. It was fascinating to see her nauseated state vanish when the camera was on. She appeared to be enjoying the cruise of her life, but the usual sparkle in her eyes was missing. Looking back at those images I can see the tension; but maybe it's only because I know the real story.

TECHNIQUES AND HOW-TOs

As with all types of styling, there are no absolute rules. Creative problem solving applies to almost every styling situation. The following tips and suggestions will help your days run more smoothly.

PRODUCTION CYCLES

Catalog photography is usually produced in the opposite season; winter and holiday catalogs are shot in summer; summer catalogs are shot in the middle of winter. Magazines are shot about three months ahead of the issue. On location, these cycles can make for a pretty uncomfortable model.

Experienced models will often bring a warm jacket to a shoot so they can stay warm between shots. If you're comfortably dressed, it helps sometimes to take off your own coat and put it around the model's shoulders. When I've done this I can see how much they appreciate my pre-heated, toasty jacket. It also reminds me how cold the models feel.

You have probably heard stories about models freezing in swimwear on California beaches in the winter. Even worse is when they're asked to splash in the water. Sometimes a homeowner will turn on a heated pool when shots require talent being in the water. It's expensive and they may reasonably expect compensation for the cost.

While the Pacific Northwest is often cool and rainy, July is usually a hot, sunny month. That is when we would shoot locally for Norm Thompson's winter catalogs. The fashions were cashmere sport coats, wool sweaters, and heavy jackets. Clearly, the models were roasting and the makeup artist was busy applying powder. Be aware of how the models feel, carefully holding warm clothes—or ice water—for when the camera isn't rolling.

IRONING AND STEAMING

Many delicate designer fabrics respond better to ironing than to steaming. The imported silks shown earlier in this chapter could not handle the moisture of steam and had to be ironed by an assistant. As with all fabrics, test a small hidden area before steaming. Ironing delicate fabrics should be done on the wrong side of the fabric, at least until you know how it will respond. You can also protect fabrics by using a pressing cloth or a thin cotton dishtowel. Using a ham helps with tricky curved areas.

(Instructions for steaming garments were provided in Chapter 3, along with a guide for putting up a rolling rack.)

"GOING IN!"

This is the cry of warning by stylists who want to enter the area in front of the camera. Ideally you will quietly let the photographer or art director know first, but sometimes something catches your eye that you want to change before another frame is shot. Some may call it "stepping in."

Going in inevitably results in the occasional stylist butt shot. Try to keep a sense of humor and hope a fashion photographer doesn't get inspired to publish a book of them.

An experienced model shouldn't lean down and look at what you are doing; this changes the drape of fabric that you are trying to adjust. I find I frequently need to ask newer models to stay as they are and not move.

FITTING CLOTHING

In catalog styling, where most sample garments are medium-sized and the models are size four, there is a lot of adjusting to do. What goes on behind the model to make them fit is shown in a photo in the insert. Some stylists use safety pins or straight pins, whereas others use various clips and clothespins.

You want the clothes to look comfortable, not too tight, and flattering to the typical body. In addition to checking the width of the clothing at the waist, chest, and hips, take a good look at the waist length, shoulders, neckline, and sleeves. Fabric in these areas should never look pulled; leave a little slack.

Earlier in my styling career, I had a batch of wood spring-style clothespins in my kit. I learned the hard way that they are not good for styling. In this case, I was working on an advertising shoot for which the models brought some of their own garments. When I adjusted the back of a model's silk dress, my clothespin made a tiny pull in the fabric.

I was able to smooth the fibers and I thought it was satisfactorily repaired, but after a month the photographer had not yet paid my invoice. At this point he let me know that the model had come to him with a complaint about her dress. After awkward negotiations, I deducted the value of her expensive dress from my invoice. Now I use only smooth plastic clothespins for adjusting garments.

> **TIP** Shop for plastic clothespins, office clips, and other options; explore office supply stores, hardwares, and home stores. Test them before the shoot to be sure they don't pinch fabric.

RETURN

An uneven hemline, longer at the back than the front, is known as "return." Frequently at shoots, a stylist exclaims, "I see return!" Skirts, like shorts

and slacks, are constructed with more length in the back, to accommodate the human rear end. How much length is visible depends on the fit of the garment and the height of the camera. Return can usually be resolved by bringing up the back of the skirt with safety pins, like those shown in the clipping photograph in the color insert. The two safety pins near the top of the skirt lift it just enough to avoid return.

CLOSED SET

When underwear, lingerie, or any revealing clothing is being modeled, there must be a "closed set." This means that to respect the model's privacy, no one other than the crew can come and go. For these shoots, the model should know this in advance and agree to them.

INTERNATIONAL TRAVEL

Travel to international locations requires more preparation than domestic travel. The team for an editorial shoot may be drawn from the local talent in a major fashion center, such as Milan or Paris. But when travel is to a more obscure location, the team is usually assembled at home. This is almost always the case for a catalog shoot, for which there are preplanning meetings and product previews.

Customs regulations vary for different countries, and it's crucial to have the right documents in place beforehand. A local production manager in a foreign country can be a great help with these procedures. When merchandise is being shipped, regulations can be quite complicated, because importing— and the possibility of your selling the items—is a big concern for customs officials everywhere. A list including every item is required; the same items have to be identified upon return.

A "carnet" is a document that ensures the officials that merchandise samples and photographic equipment won't be sold in their country without taxes being paid. Issued through the United States Council for International Business, the carnet requires up to a week for processing and a deposit of partial value of the items.

When I directed the photo shoot on a cruise ship in the Caribbean, I had some interesting experiences. It might sound glamorous but the cruise line that hosted us was a very basic Russian cruise line. Our ship, the Gruziya, had been a Soviet military vessel made over into a cruise ship after the fall of Communism. Our photo crew traveled for free and was able to shoot travel wear on the ship and in three ports. The cruise included a good bit of culture shock when we would find ourselves in the ship's Russian culture after a day in a tropical port.

Along with other cultural adventures, I had the responsibility of meeting with the local port officials of Honduras, Belize, and Mexico when we arrived in ports there. The Central American officials boarded in shirt sleeves, carrying brief cases and looking very much what you would expect the government officials to look like—somewhat intimidating. I, along with Yuri, the purser of the ship, met with them. They reviewed our paperwork, which

included lists of all the items we would take on shore, from garments and accessories to camera equipment and lists of crew members, their passports, and our schedule for the day. Once cleared, we met with a local guide who took us to nearby sites, which naturally had not been pre-scouted. In Honduras, we traveled in an old VW van that was started with a screwdriver held to the battery. But the chance to see back roads of Central America, women washing clothes in a river, and people carrying goats and chickens down the road was worth all of it.

ALTERNATIVE TRAVEL PLANS

For a travel magazine shoot in Mexico, I was hired to do wardrobe shopping for a couple, two models who were to be shown in an article about a charming and historic city there. They would also be shot for the cover. My role was not to go on the shoot, unfortunately, because a makeup artist had already been booked and would maintain the wardrobe too. My assignment was to purchase the couple's wardrobe items and accessories (purse, hats, scarves, jewelry, and shoes), remove all the tags, pack them in a suitcase and deliver them to the photographer's studio the afternoon before the trip. They wanted to avoid customs declarations on the items since it was a nominal assortment of garments and a casual touristy photo shoot. And of course, the items were not being shot for commercial purposes. Looking at my packed suitcase, I thought it did look exactly like a suitcase that would be packed for such a holiday trip and would therefore be unnecessary to declare. People who travel frequently to different countries eventually get a good sense about when and where they will be comfortable with this kind of thing. Don't attempt this if it makes you uneasy and you think it will add an unnecessary stress to your trip.

Different systems of electricity and adaptors have to be taken into consideration for steaming, ironing, and hair dryers. You may need to purchase adaptors for such equipment.

GETTING STARTED IN THE WORLD OF FASHION

Any exposure to the world of fashion contributes to your understanding of this career. College fashion study is an excellent start. This coursework provides a background in fashion design, marketing, clothing construction, fabric, and textiles. More and more, college programs are offering courses in styling as we'll see in Chapter 13.

Workshops such as those I offer provide a background on the business of styling and an opportunity for hands-on practice with a model and with off-figure clothing. Visit www.photostylingworkshops.com to learn about them.

Take basic photography classes if you can and expose yourself to photo shoots at any opportunity. Observe and learn the language of photography. Even looking at magazine stories is a way of educating yourself. Look at all the elements of the photo in addition to the fashion. As you have more exposure to photography and observe everything that goes on, you'll see aspects of photos that you didn't notice before.

INTERNING AND LEARNING

Interning with magazines, model agencies, ad agencies, fashion public relations, or any business related to fashion will provide valuable knowledge about this career. Fashion interns are sometimes included in the editorial listings of magazines. In this position you might do much of the less interesting detail work, but the occasional opportunity to attend a shoot would be invaluable.

Students in fashion or graphic design programs may be required to complete an internship. Instructors and guidance departments can be a great help with arranging them. If you're not a student, you'll have to make your own arrangements. You may be paid for your time or you can contribute your time for free, providing a benefit to the company taking you on.

An internship with a catalog can teach about the inside workings of photo shoot preparations. A student at FIDM in San Diego interned with Road Runner Sports catalog. There she coordinated the samples used for shoots, made copies of merchandise lists, and sometimes went to the shoots. She was gradually given more responsibilities and ended up with a position as a buyer there.

Another fashion student who had set her sights on London's culture had the courage to walk into Burberry's offices on her own. Through the course of conversation with an executive there she was offered an internship that lasted three months. Then she was offered a position heading the visual department.

It's not always so easy. Remember, all your life experience contributes to your ability as a stylist. Jobs help too. Working in a retail fashion store provides insight into the customer and how people shop for clothing, as well as knowledge of the workings of retail sales. Assisting catalog or store merchandisers, while not always glamorous, gives you an understanding of the numbers and other critical factors involved in buying decisions.

WORKING ON RUNWAY SHOWS

A great deal of behind-the-scenes experience can be gained by volunteering to assist with fashion shows. The shows could be a student production, a benefit, or a commercial production. Organization of shows is overwhelmingly complex, and any chance you can get to see what goes on can help with runway and styling projects alike.

Fashion students at San Diego Mesa College, where I teach Fashion Photo Styling, present an annual fashion show, "The Golden Scissors Awards." They do everything themselves, from designing the fashions, developing a theme, writing the script, promoting the event, casting, and styling the models.

Fashion shows are often presented as a fundraising event by nonprofit organizations. They may feature historical or designer fashions, or hand-sewn clothing. Sponsors of these events are always glad to have you volunteer as a "dresser," and you'll get to be involved first-hand. Separating and steaming the clothes for each model, dressing the models, getting them quickly in and out of their outfits, helping them with buttons, buckles, and bows are some show day tasks. You might find out about these opportunities in advance

through a fashion school career office, and any assistance behind the scenes should be welcomed.

Work with photography students or contacts in the industry to create fashion concepts and make them come to life together. You will learn from these projects and develop your personal portfolio. This creative habit should continue throughout your styling career. The next section will provide you with inspirations and information about testing.

CREATIVE IDEAS FOR TESTING

You are already a creative person if you're interested in fashion. You can stay current by being observant and keeping an eye on trends. By arranging test photo shoots throughout your career—with photographers, makeup artists, and models—you will continue to challenge yourself and enjoy these creative collaborations.

Test shoots are an opportunity to develop your own creativity, build a team, and create beautiful work for your portfolio. The results make a more attractive presentation than most catalog pages. If you include test shots in your portfolio, along with the editorial work and the catalog covers you've worked on, you can give clients a better picture of the full range of your styling abilities.

Allow for failures. Not all tests produce great portfolio pieces. But tests that don't work as planned teach you about shoots and styling—and at least the less-than-perfect project wasn't done for a client.

These shoots don't need to involve sourcing designer fashions. The reps wouldn't be very interested in lending you items for a project that won't be printed in media. Improvise from your own collection, borrow from friends, or find a start-up designer who will trade use of fashions for photos. Models' own clothing mixed with a few new pieces can provide an inspiration.

A color theme, geographical influence, or historical context can pull the shoot together as much as the fashions themselves. I participated in a group project inspired by a classic car. The photographer, Nick Nacca, had set up his studio for automotive photography and had access to a pale yellow 1969 Buick Electra. He, makeup artist Claire Young, and I developed an authentically historical fashion shoot based on the era of the car. Claire purchased the Afro wigs and I found most of the fashions at thrift stores. While our two models hadn't been around in 1969, they enjoyed recreating the era.

TREND WATCHING

Looking at trends and directions is an ongoing process, as fashion is ever changing. In addition to your own observations, be awake and aware when viewing all media from magazines to music videos. Notice what's current and get ideas for new combinations.

Research into trends is a significant industry. One example is Pantone's color research. Pantone is a company that provides color standards and tech-

nology for consistent communication of color for many industries, including fabric standards for fashion. The company is well known for its annual color predictions, developed by studying social trends and other influences. The website www.pantone.com provides more background.

As the world becomes more unified in style terms, inspirations are everywhere. Keep sketchbooks and take notes when you travel. Visiting museums can be inspiring too. Contemporary art, classical paintings, photography exhibits, and even anthropology will offer ideas to the creative person.

An understanding of styles, fashion history, and geographical influences is critical to your performance as a fashion editor or stylist. "Traveling and seeing the world allows you to become grounded with reality, all the while experiencing fashion from those who have not the slightest idea that they inspire us all," says fashion stylist Albert Mendonça.

FASHION BLOGS

In recent years, the Internet has become one of the strongest media outlets for fashion. Bloggers range from trend-watchers to magazines and retailers to fashion-loving individuals. Style blogs have become a huge source of inspiration for the masses. In fact, 160 million items come up in a Google search for "fashion blog" and 1.5 billion for "style blog."

Fashion stylist Haley Byrd says, "When I built my website, I was not blogging, but I soon figured out that if I didn't constantly update my site with fresh images or fresh content, it would become a web graveyard. Fashion is about change and renewal, so I found that blogging was a way to stay relevant, express my fashion opinion, and connect with viewers."

As a stylist, you may be interested in having a blog for your own promotional purposes. It can help you establish yourself as a fashion-aware stylist, building yourself a name and a brand. We'll discuss blogging more in Chapter 13 on marketing yourself and find out more about how Haley ties it all together. There is a list of fashion resource sites at the end of this chapter.

RELATED CAREERS IN FASHION

Along with editing and styling, there are many other careers in fashion. Working with designers, researching fabrics, marketing the fashions, and representing lines are some of the countless less visible aspects of fashion. Styling designers' runway shows and dressing celebrities are among the more high-profile careers. Private clients can be a rewarding source of work for fashion stylists.

These outlets may supplement photo styling work in many markets and most stylists find it inspiring—as well as necessary—to combine them. New York fashion stylist Alexandra Suzanne Greenawalt, author of *Secrets of a Fashion Stylist*, says, "For me, it always has come in waves. Personal styling work is way more challenging, and it's more rewarding to work one-on-one with individuals when you really have a chance to change their lives for the better. But the public values editorial and celebrity work the most since we

live in a celebrity-driven world. I do think it is necessary to get published to get the respect and my editorial work has always been a really nice creative outlet."

PERSONAL CONSULTING

Many freelance fashion stylists focus on personal clients to supplement their photography work, working with individuals to help them select fashions and improve their images. A balance of personal styling, fashion photography, and celebrity styling seems to be the ideal. Fashion stylist Kim Maxwell states that in order to market yourself effectively and build a brand, you must cross-promote yourself and offer more than one service or combine roles: for example, a personal shopper and a wardrobe stylist.

STYLING CELEBRITIES

Work with celebrities can range from sourcing fashions for events to styling photo shoots to advising on everyday dressing. This is the area of styling that has brought the career into the public eye. Famous celebrity stylists like Rachel Zoe, Kate Young, and others inspire and enthrall new stylists, many of whom eventually realize that the bulk of styling work is not so glamorous—but is just as satisfying.

As in much of styling, celebrity styling is a job that many just fall into. Being at the right place at the right time, with the right kind of style, can open a door. Wardrobe stylist Veronica Guzman tells this story: "One celebrity stylist I met in Los Angeles told me she was friends with a man that happened to manage a singer. He was in a bind and needed a stylist for his client's shoot at the last minute. He always liked her personal style so he asked her if she would be able to help him out. From that one job she ended up styling everything for them, including photo shoots, movies, and tours."

RUNWAY SHOWS

Runway fashion shows are presented by department stores, designer lines, and also as community benefits. With the complexity of runway shows and their importance to the world of fashion, there is a variety of work to do. Organization is probably the most important task in producing a runway show.

Before the show there are time-consuming tasks such as writing the script, choosing music, designing the stage, booking models and makeup artists, and planning the outfits. During the show, the stylist is literally behind the scenes. You can only imagine what it's like out front. But you don't have time to think, what with supervising the details of each ensemble and sending the models out on time.

My former intern Paula Tabalipa found a job with Saks Fifth Avenue as a visual coordinator. Her responsibilities were both presenting runway shows and creating store displays. Later, she worked freelance to manage Saks' fashion shows. For a single show, she handled everything, from pulling

thousands of dollars worth of merchandise to determining the choreography (how and where the models walk), choosing the runway lighting, hiring a DJ, and selecting the music. This in addition to dressing thirty-two teenaged models in three changes each. She found volunteers from fashion schools to assist her on show day.

Now on her own, Paula works as a fashion stylist and display designer for commercials, advertising print campaigns, and films. (Her full bio can be seen at www.paulapaula.com.) In a typical blend of fashion skills, she is simultaneously launching a clothing line, J'ampe.

VISUAL MERCHANDISING

Even without responsibility for runway shows, visual merchandising in retail stores is a significant fashion-related career. Many chain stores have uniform standards for presentations, merchandise, and props, but there is always creativity involved. Window and in-store presentations incorporate a combination of dressing mannequins; folding, stacking, and hanging apparel; and decorating with props—very much like photo styling. Upscale stores hire creative designers like Paula to create eye-catching and inventive window designs, especially for the competitive holiday season. Their concepts are inspired by merchandise, props, and themes.

SPECIALTY KIT LIST

This list includes are some specific items you will need for styling apparel in addition to the basic kit list in Chapter 5.

Item	Description, Use
For Fashion/Wardrobe Styling	
☐ Clothespins, plastic	For adjusting clothing; be sure not to use wood
☐ Safety pins, assorted sizes	For more precise adjustments
☐ Clamps	Heavy-duty adjustments, like belts
☐ Double-sided tape	Emergency hems; find a sturdy brand
☐ Contact paper	Protect the bottom of shoes, use clear and black
☐ Stitch Witchery	Iron-on hem-repair tape
☐ Simple jewelry	A selection of stud or tiny hoop earrings, simple bracelets, watches (don't need to be working)
☐ Alcohol wipes or spray	To sterilize earrings between uses
☐ Scarf	Over model's head, protects makeup during wardrobe changes
☐ Nail polish remover	Disposable packets, in case models come with colored polish
☐ Nude seamless bra, underwear	In case model doesn't bring her own (wash between shoots)
☐ Push up enhancers	Lifts inserted into bra for creating cleavage in models

□ Topstick	Double-sided tape for keeping strapless garments in place
□ Pantyhose	Several neutral colors
□ Shoehorn	For putting on tight shoes
□ Men's t-shirt	Layer under shirts; white
□ Anti-static spray	In case of clinging clothes
□ Sunscreen	For crew, doubles as moisturizer for models' elbows or knees
□ Umbrella	To keep models and photographer cool and out of sun

For Prepping Garments

□ Iron, ironing board	Use your own clean steam iron
□ Ham	Rounded cushion for ironing curved areas
□ Steamer	Use on fabrics that can withstand moisture
□ Rolling rack	For organizing prepped garments
□ Plastic swivel hangers	Hanging garments carefully; also skirt/pant hangers
□ Garment bags	Transporting garments to and from location
□ Tagging gun	Reattaching hangtags
□ Envelopes or zip-lock bags	Organizing hangtags
□ Carbon receipt book	Logging items in and out

For Makeup or Touch-ups

□ Foundation powder	MAC Studio Fix used wet or dry; several common skin tones
□ Lipstick and liner	Three or four basic colors
□ Lip gloss	Burt's Bees or Kiehl's are good, use with a swab
□ Makeup sponges	Absorbing shine or applying foundation
□ Cotton swabs	Touching up makeup mistakes
□ Makeup remover	For goofs or for models to clean up after the shoot
□ Nail file	Touch up unmanicured nails, cuticles
□ Tissues	Small pocket pack
□ Hairbrush	Changing hairstyles (clean between shoots)
□ Hairspray	For smoothing and taming hair
□ Hair gel	Styling men's hair, or short styles
□ Ponytail holders	Assorted neutral colors
□ Bobby pins	Brown and decorative styles
□ Dental floss	For models' teeth
□ Straws, bendable	Protect models' lipstick when drinking
□ Mirror	Small compact style; for models to use
□ Children's barrettes	Plus other decorations for children's hair

And, be *sure* you have the following items from the Basic Kit:

Item	Description, Use
☐ Scissors, small and sharp	Clipping threads and removing labels; use only on fabric
☐ Craft scissors	Cutting everything but fabric
☐ Spray bottle of water	Spray wrinkles out of clothing on location
☐ Wrinkle release product	Water works as well, but this product may be preferable
☐ Lint roller and refills	Removing lint from fabric
☐ Sewing kit	For mending, small kits you find at hotels

STYLING SUPPLY SITES

Browse these websites to find unique and specific items for fashion styling. Here are a few:

- **Camera Ready Cosmetics**, www.camerareadycosmetics.com: professional makeup palettes

- **Manhattan Wardrobe Supplies**, www.wardrobesupplies.com: Topstick and many other wardrobe supplies

- **Ricky's,** www.rickycare.com: makeup and beauty supplies throughout New York City and online

FASHION RESOURCE SITES

There are countless sites where you can network and learn about fashions. Many encourage you to create your own online looks. You can use these as an inspiration and for trend-watching.

- **Chictopia**, www.chictopia.com: a fashion blogging community

- **Fashionising**, www.fashionising.com: fashion social network and community

- **Le Book**, www.lebook.com: an industry sourcebook listing companies and creative professionals

- **Lookbook**, www.lookbook.nu: A lookbook is also a collection of photographs compiled to show off a model, a photographer, a style, or a clothing line. Lookbooks in their online form can be described as "fashion diaries" because bloggers are constantly updating them on a daily or weekly basis, according to Wikipedia.

- **Lots of Style**, www.lotsofstyle.com: network for fashion stylists with free or paid listings

- **My Fashion Database**, www.myfdb.com: a source for fashion industry professionals and information on publications and advertising

- **Pantone**, www.pantone.com: color trend research and predictions

- **Polyvore**, www.polyvore.com: a site where everyone can create a fashion layout from available images and styles. Merchandise is cross-sold and used as inspiration.

- **The Fashion Group International**, www.fgi.org: non-profit professional organization for the fashion apparel, accessories, beauty, and home furnishing industries

Fashion is the exciting world that many people imagine when they think about styling. While this area provides a great deal of the styling projects available, it is only one part of what styling is. Stylists frequently combine fashion with other specialties, depending on the projects available in their geographic areas. A knowledge of on-figure fashion styling, combined with off-figure and product/accessory styling, can greatly expand your opportunities.

PORTFOLIO CHALLENGE: MOCK-UP EDITORIAL
Arrange a test with a graphic designer and photographer to create a mock-up editorial story. You'll need to develop a doable but creative concept (look through fashion magazines for inspiration and pull out tears), coordinate the players, gather the wardrobe, accessories and props, and create the layout. This may be a strong portfolio piece for each of you.

CHAPTER 7 Wardrobe Styling

THE DIFFERENCE BETWEEN WARDROBE styling and fashion styling is subtle and confusing. As we saw in the previous chapter, fashion styling is done for magazine features about the latest fashion trends, for advertising brands, or for selling apparel in a catalog. Wardrobe styling is not "about the clothes." The photo is focused on something else; the clothes are essentially props.

LIFESTYLE PHOTOGRAPHY

A lifestyle shot depicts real-life situations and people for an advertisement or for stock photography. A scenario that tells a story is being created. Or the talent may be there to enhance a lifestyle concept for a specific company or brand. For lifestyle photography, the stylist is dressing the talent in generic items so as not to distract from the implied activity. In addition to acquiring the right clothing items and dressing the talent, the stylist may be asked to style product items, provide related props, and decorate the entire set. In advertising photography, the talent may be interacting with a product such as a cleaning product, car, or food. The generic wardrobe does not draw attention away from the featured product.

The same principles apply to both television and print wardrobe choices. Look at what people in TV commercials are wearing. It's fairly predictable and timeless. You often see the usual crew neck sweater over a collared shirt in a small plaid on men. For a detergent ad, you see a housewife wearing a denim shirt with rolled sleeves over a tank top and khaki capri pants. In ads featuring a group of people, you see each person dressed in different colors, or all of the people dressed in shades of the same color. You begin to notice all the details you are meant not to notice. You'll also see the same type of wardrobe styling in print ads.

A company like Hallmark shoots a huge amount of lifestyle photography—and not just for use on their cards. Images are created to have on file for holidays, themes, and advertising campaigns, often including people and other appealing elements. This is an example of the volume of lifestyle photography that goes on for an outlet that you might not expect.

STOCK PHOTOGRAPHY

You may be familiar with stock photography and not even know it. Stock is defined as images that have not been shot for a specific client, but rather are sold to clients for a licensing fee. Photographers may create specific shoots on spec for a stock agency, or may select outtakes or extras from their commercial or editorial projects. These photographs are available to be licensed again

and again because the copyright almost always belongs to the photographer. Sometimes an agreement is made with a client to own the rights to the image. The photographer negotiates this at the beginning of a job.

An assortment of lifestyle brochures, magazine pages, advertisements, and mailers using generic wardrobe styling. © Susan Linnet Cox

Stock photos are used in cases when it's not practical to assign a photographer and set up a shoot. For either a flat fee (royalty free) or a fee based upon usage and exclusiveness (rights managed), the client uses an existing image. Popular stock photos depict families, couples, business people, and other everyday scenarios, as well as photos that do not include people. The images must be model-released if people are recognizable (especially when faces are shown), whether they are professional talent or the photographer's friends and family.

You might have the occasional opportunity to style the people in a stock shoot. The principles of generic wardrobe styling are similar to those used in commercial projects depicting lifestyle.

EDITORIAL WARDROBE STYLING
In the last chapter we looked at fashion features in magazines, where fashion editors pull clothes from designers' collections and then assemble inspiring photo spreads showing models in the upcoming fashions. However, fashion

magazines also use images of models for editorial features, like health and fitness. Many other types of magazines on the market do this as well. These images of people usually provide lifestyle accompaniments to editorial stories.

One editorial shoot for which I did wardrobe styling was for a specialty women's magazine, *All Woman*. The feature was a food story—a couple entertaining friends at a backyard barbecue. The magazine hired a food stylist and a prop stylist to handle the food presentations, and I was responsible for wardrobe. The homeowners had invited their daughter's family and several neighbors to participate. They were given a list of suggested clothing to bring with them.

The magazine had also sourced wardrobe from Lands' End and L.L.Bean catalogs. Huge boxes arrived at the location filled with khaki pants, chambray shirts, and casual knits. My intern and I quickly sorted them by size and category, so that when the guests came I could make decisions about their own garments and fill in with pieces from the collections. Each person's wardrobe had to be approved by the art director before the guests could get dressed. The director was being pulled in many directions at the same time, so this was a hectic and frantic time. The makeup artist had to borrow the guests for makeup before they got dressed; this gave us just enough time to steam the clothing.

At last they were all dressed in complementary hues and generic styles. That was when the homeowner became self-conscious about her wardrobe, and we started over with her. The shoot became pleasurable once the guests were dressed and needed only occasional adjustments to look good. After the shoot we sorted clothes, repacked the boxes, and looked forward to seeing the images in print a few months later.

SPORTS CELEBRITIES
For another editorial project, I was contacted by *Self* magazine to style soccer players for a feature about the (now defunct) WUSA women's professional soccer league. I had been following the creation of the league, so I was happy to have a chance to style the key players. Athletic companies were sponsoring most of the players, and it was critical to dress them in only those labels. Again, the magazine editors had put in requests for the garments. This time they were shipped to my home, and I brought them to the field where we were shooting.

Although the final images were small and the clothing could barely be seen, I enjoyed the project. It's a shame for women's sports that the league has been disbanded.

FILM AND VIDEO
The world of wardrobe styling for television and film is another large area of opportunity, and what many think of when they hear the term "wardrobe." The focus of my own career has been on print photography—there's plenty of work there—so when my intern, Veronica Guzman, had the opportunity to work on a Los Angeles film production, I pumped her for information.

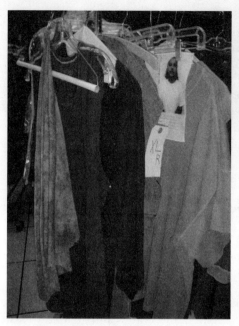

Left, garments on this rack show organizational tactics employed when pulling for different characters in a video or TV production. © Haley Byrd. Right, inside a wardrobe trailer at a video production. © Veronica Guzman.

She described her duties as a wardrobe assistant, working mostly in the production trailer prepping the clothing in the familiar way, and documenting the actors' wardrobe for continuity. She photographed them in costume with a Polaroid camera, labeled the images, and posted them in the trailer.

This is just a small hint of the complexities of styling for film. It is a separate field, with its own workshops and classes. Here is a bit more information Veronica shared about her early wardrobe projects:

> In television or film, when you're shopping for wardrobe, you have to keep in mind that you will be needing "doubles" or in some cases "triples". For example, say the principal actor was in a fight scene. You would need one outfit for the actor, another outfit for the lighting stand-in, and a third outfit for the stunt double. If you were in a situation where you only had doubles, you would put your stand-in in an outfit that resembled the one of your principal actor. Even if the movie didn't have a stunt double, you would still need at least a double in case something happened to your principal actor's clothing.

Wardrobe specialist Pippi Robben agrees that multiple wardrobe items are necessary for work in film and video. She even thinks in terms of four of each item, which can necessitate shopping for pretty generic items. Some may have to go the laundry at the end of the shoot day, some actors may take garments home, and still others mysteriously disappear. Even jewelry items

should have duplicates. If the wardrobe stylist spends time away from the production searching for a matching necklace, that's not productive use of time, and it costs more in the long run.

Fashion and wardrobe stylist Kim Maxwell says, "With music videos or film, it has a lot to do with continuity and making sure things are looking the same as the last shot. For example, if you stopped shooting yesterday and the woman had a pin on her blouse on the left hand side, then when you start shooting today, you must put that pin on the exact same spot on the left hand side for the shot to continue looking the same. Also, you are making sure the wardrobe goes with the storyboard or script and is reflecting the character within the story that is being told."

Haley Byrd, a wardrobe stylist and former student of mine, works in both Los Angeles and Hawaii on productions such as the television series *Hawaii Five-O*. She says, "You'd be surprised by the prep and research work that goes into devising clothing style for background characters, which involves scouting the location prior and checking out predominant colors and themes. We use that information to incorporate into the outfits of workers that would be in a hotel scene, for instance."

Fitting is more crucial in film than in print photography. If a garment does not fit a model you can place clips where they won't be seen. Veronica says, "In film, you can't hide clips because the actors are moving around. The clothing has to fit them correctly so that they can concentrate on their lines and not be distracted by thoughts of losing a skirt in a gust of wind."

When an actor will be performing in front of a "green screen" for a background to be added later, it is important to avoid wardrobe with the color green. Yellow can sometimes also be a problem.

HIGH DEFINITION TV

Now that nearly all television, film, and video is shown in high definition, the rules of styling for these media have changed.

While high-def doesn't have the same impact on wardrobe as it does on makeup, says TV stylist Diana Suyat, a good stylist "coordinates with the makeup team to ensure everything is complementary. Knowing that everything is magnified, I go beyond the extra mile during prep work. Jewelry must be polished with no missing stones. I also stay away from dizzying patterns, like stripes that are too close together, zigzags, and bright plaids."

Lori Bumgarner is a Nashville-based stylist for recording artists. She tells us, "I think it is important to pay close attention to the type of fabric and the finish of the fabric, how it looks under lighting *and* on the person's body. For example, a fabric with a high sheen to it can make even the smallest bulge on a person look bigger, especially in high-def. It can accentuate areas you don't want to have accentuated. Also, with high-def video production, it's more about the details, such as making sure there are absolutely no lint, stray threads, wrinkles, or creases on the clothing."

ACQUIRING WARDROBE AND ACCESSORIES

As a wardrobe stylist for still photography, a major part of your responsibility is to bring plenty of clothing options to the shoot. Early in the project, you should create a list of items needed for the talent. You may have some items on hand but need to purchase others.

The wardrobe choices will have to be approved by the art director and the photographer. They often defer to your expert opinion, but they have the last word. The photographer will know what items work best on camera and may already have a vision of the shot. If possible, spend a few early moments at the shoot reviewing wardrobe options and suggest combinations that you think are the best. Especially tricky is combining the garments that different people will wear in the same image. Tops and bottoms that contrast and complement each other, color variety, and related styles must be selected from what is available. Sometimes it's hard to nab the art director at the crucial moment since there are other things going on at the same time.

WARDROBE SHOPPING

This is really one of the most gratifying aspects of photo styling. Sometimes it hits you: you can't believe this is your job! But it's hard work when the easiest item on your list can't be found. You have to be focused, fast, and tireless. (Chapter 4 includes useful information on shopping for clothing items.)

To save time and ease the visual stimulation of walking into a store, I carry a list of the exact items I'm searching for. I look for color and category. "Sweater, ivory. Men's denim shirt. Dress slacks, charcoal," I chant to myself. In the outlet and discount stores—I seem to spend a lot of time there—I'm more likely to walk along the racks scanning for color, category, and fabric. In these stores, merchandise is sometimes hung on the wrong rack, or marked with the wrong size.

This shopping trip is going to be on your own credit card unless you negotiate money up front for wardrobe shopping. It's a good idea to arrange an estimated amount for expenses in advance, especially with new clients. You can make a deposit in your business account and know that you will be able to pay the credit card bill when it comes. You'll deduct the credit balance from your invoice when you have completed returns. Since there will be multiple choices for each person, much of the clothing will not be worn and can be returned after the shoot. Though many items will probably be returned, you are covered in case they are all kept or some unforeseen circumstance occurs. It's tricky to estimate how much the shopping will cost, but with experience and prior projects to refer to, it will become more automatic.

(In Chapter 14, The Business of Styling we'll discuss these practices more thoroughly.)

Outlet malls can be a good alternative for wardrobe shopping. Many designer stores are clustered together, prices are greatly reduced, and the returns policy is usually generous (but be sure to check in each store before you shop).

While you'll be bringing selections to the shoot, you can also present model agents with requests for clothing the models could bring. I have found that models respond well to these requests and bring lots of good items from their own closets. These wardrobe items will definitely need to be prepped, because they're going to arrive stuffed in a suitcase or piled on wire hangers. Color guidelines should be presented for the talent. Generally the best choices are in bright, neutral, or pastel solids. White and black clothing does not photograph well, especially when the colors are worn together. These colors also contrast too much with other elements in the scene. Large prints are usually not good, but on occasion they might work as an accent. While small stripes or prints can be effective, it's safer to go with solid colors.

SHOPPING BY COLOR

At the time of the September 11, 2001 tragedy, I was involved in an intense wardrobe project, styling the participants in "Chair Dancing," a series of exercise videos for people who have limited ability to exercise. The creator of the program was fond of bright colors like purple and pink, and the style was unintentionally developing a retro, 1980s exercise look. I found myself looking for slouch socks, headbands, and colorful shoelaces. I had developed a color theme for each of the three videos—jewel tones for one, bright warm colors for another, and softer colors for the yoga video. It became a mathematical problem, charting out the wardrobe items and then converting the chart into a shopping list with items, colors, and many sizes.

Especially challenging was the need to view the three groups of people from various camera angles, to make sure that there weren't participants wearing matching colors from each diagonal view. This caused endless revisions to my list.

My shopping skills became extremely focused at this time and the list was specific. I was looking for a bright blue plus-size t-shirt, orange extra-large men's tank shirt, magenta stretch capri pants, yellow ponytail holder. I walked into stores and saw, like radar, only those colors.

What surprised me most about this project during the sad, dark days of September 2001, was that I started to really enjoy this search for colors. I hung them on the rolling rack at my house and looked at the bright color combinations. I think that wardrobe styling project really helped me get through that time.

RENTING COSTUMES

Styling an ad shoot for WD-40, I had to do the following: cast an actor to play a "regular guy," find a mechanic's jumpsuit, and acquire an array of auto parts on loan from three garages. These had to be labeled and returned after the shoot. I found a source, Western Costume in Los Angeles, to rent the jumpsuit. Catering primarily to the world of movies, it also rents to professional wardrobe stylists.

What a wonderland of costumes! There were three levels of racks stretching up to the ceiling of a warehouse. There were endless rows of choir robes, medieval dresses, military uniforms. Striped prison uniforms

were hung outside on a fence after being spattered with mud. I saw a huge room of hats, and another of shoes. Needless to say, I had several choices of mechanic's jumpsuits.

Naturally, there are costume warehouses in Los Angeles, but what about in other cities? Movies are filmed everywhere now, and professional costume shops are likely to follow. Local theaters may rent their costumes to you. In addition, rental costume shops or uniform companies are available in most areas. You can search online for resources you can use.

> **TIP** Search for local suppliers of uniforms. You may need a police, firefighter, nurse, chef, or maintenance worker costume. Prop items such as hard hats, safety goggles, lab coats, and stethoscopes can help make your lifestyle shot realistic.

MAKING AND SEWING THE WARDROBE

If you have experience with clothing construction, you may have an opportunity to use it in wardrobe styling. Unique garments might be requested—I once sewed a *Cirque de Soleil*-type clown outfit for a pharmaceutical executive who made a dramatic appearance at a conference on a scooter. Another time I constructed some Santa Claus pants out of a red velvet thrift-store dress for a pair of legs coming out of a chimney. I constructed the legs with just enough room at the top to fit into a real fireplace, and sewed Santa's bag of gifts. I also had to find a freshly cut Christmas tree in August and decorate the set!

Other sewing projects may include altering a found garment to make it work, changing buttons, or shortening a hem. If you don't sew, you may need to hire a seamstress on occasion.

GENERIC WARDROBE LIST

The suggestions below will help you plan the most basic wardrobe selections, whether shopping for them yourself or requesting that the models bring them.

ITEMS FOR WOMEN, MEN, AND CHILDREN:
- ☐ Jeans
- ☐ Khaki slacks, shorts, capris, skirts
- ☐ Polo shirts, short- and long-sleeved
- ☐ Pullover and cardigan sweaters
- ☐ Collared shirts and blouses in solids, light stripes, or small plaids
- ☐ Generic white sneakers

WOMEN:
- ☐ Dressy sundresses
- ☐ Strappy sandals
- ☐ Slip-on loafers
- ☐ Natural stockings

MEN:

- ☐ Dark suits
- ☐ Dark dress shoes and socks
- ☐ White t-shirts

ACCESSORIES AND PROPS:

- ☐ Generic jewelry items (small earrings, studs, and little loops; simple necklaces; wedding bands)
- ☐ Watches (don't need to be working)
- ☐ Purses
- ☐ Sunglasses
- ☐ Hats (straw hats, baseball caps)
- ☐ Scarves
- ☐ Props for people to carry (shopping bags, cut flowers, French baguette)

DRESSING THE TALENT

There will be some intense and dramatic moments when models are made up and needed on set. You may need to keep track of labels, hangers, and hang tags in the pandemonium. Then suddenly they are dressed and walk in front of the camera and you can take a breath before you go in to make adjustments.

When you style wardrobe for any of the scenarios described above, you are striving for neatness. Let the photographer have a look at the dressed talent before you step in. You'll have a chance to clip and pin garments while the shot is being set up and the lighting is improved.

WORKING WITH REAL PEOPLE

There will be times when the talent you are working with are not professional models. Perhaps "real people" are cast for the shoot because the client prefers a variety of looks that model agencies may not have. When an older, overweight, or unique-looking person is needed, the results will be better from agencies representing actors rather than models. Actors have experience with dressing and being in front of the camera, though they're less accustomed to having their clothes pinched and adjusted.

Novice talent will be quite unfamiliar with the whole process. They will all need a briefing about the basics of dressing, like carefully putting the clothes over their heads, and not tucking in shirts or putting on their own shoes. They're likely to immediately fold their arms, wrinkling the front of shirts and the sleeves. They'll want to sit down, causing folds in skirts or pants. Lots of gentle reminders will help them stay camera-ready.

HOW TO LOOK LIKE YOU'VE BEEN MODELING FOR YEARS

Certain tendencies reveal an amateur or a new model at the shoot. These tips for new models can help the talent look seasoned and experienced. Your wardrobe styling job will go more smoothly if you diplomatically share them. (Take this book with you to the shoot!)

Know how to dress in wardrobe. Put on clothes carefully so they don't wrinkle; the stylist will take care of the details. Place a scarf over your head when dressing to protect makeup and the garment. Don't tuck in shirts. The stylist will put on your shoes (and tie them!), belt, hat, scarf, and other accessories.

Stay camera-ready. Once you're in wardrobe, don't fold your arms across your waist, sit down, bend over, tie your shoe, or anything else that will cause wrinkles. The stylist has worked hard to steam or iron the apparel.

Come prepared. Wear your own slip-on shoes rather than walking in prop shoes; put them on when you get in front of the camera. Bring a warm jacket if the weather is chilly. Wear nude-colored, well-fitting undergarments.

No need to freeze. The 1800s are over and cameras are faster. Nothing makes you look less experienced than staying still after each frame is shot. Move around unless instructed to stay put; sometimes just changing foot position improves the drape of clothing.

Don't help the stylist adjust your clothing. Avoid the tendency look down when the stylist comes in to give your clothes a tug; it changes your position from what the stylist is trying to fix. The stylist can do it without your help.

Experiment with poses. Practice in front of a mirror at home. Look at your test shots, whether film, proof sheets, or digital images. Watch other models who are working with you and study photographs in catalogs and magazines.

Work the merchandise. Remember, it's not about you; it's about what you're selling. If it's apparel, learn some moves. Work with the features of what you're wearing.

Stay on your mark. This is a focus point the photographer has established, possibly marked with tape. If you are walking in the shoot, the moment when you are over the mark is when the photographer will snap the shot.

WORKING WITH PROFESSIONALS

Most models are very nice, intelligent people with full and interesting lives. During the time you spend together, you'll get to know them well. When they arrive at the shoot, greet each of them and introduce yourself: you are the main contact for the talent.

Models who are helpful and considerate are natural favorites. When they bring the clothing back to you on hangers and right-side-out, your job is easier. In turn, they will appreciate your kindness and compassion. Modeling is actually hard work: holding awkward poses or standing up for a long time without moving are harder than you'd imagine. On set, as you make adjustments, you'll be working very closely with the models; try to give them a word of warning before touching them, especially when reaching up under a skirt, or clipping a thread on a man's fly.

TIP Experiment with double-stick tape, fusible hem tape, and hand-stitching so you can hem a pair of pants quickly and invisibly on set.

VOUCHERS

A voucher is a triplicate form, provided by the agency, which the model completes and presents to the art director for signing at the end of the workday. She fills in hours worked and the agreed rate and signs it; then the art director fills in the job name and billing information and signs it. As the stylist, you may be authorized to complete the voucher instead. The voucher is used by the agency to bill the model's rate to the client.

ROLE OF AN ASSISTANT

With complex projects involving dressing a large number of people, having an assistant can be easily justified. The assistant can help organize wardrobe items, steam them, and get the talent into clothes at the right time. Assisting is an excellent way to learn about styling and provides an opportunity to be at a photo shoot soaking up information. However, it is hard work and your focus at the shoot is to support the stylist you're assisting.

Arrive at the shoot early and help the stylist carry wardrobe and props. After greeting the photographer, plug in the steamer so it's warmed up and ready. Always ask the photographer's assistant which electrical outlet is best to use. There will most likely be a lot of prep work to do. Later you may be asked to go out for coffee or last-minute props, which you'll do happily. Your primary duty is to make the stylist look good, whatever it takes. Be attentive and ready to step in to do what the stylist requests. You're probably going to be busy behind the scenes while the stylist watches the shot. Don't expect to sit down all day.

Other ways to show your professionalism are by not handing out your card or becoming overly friendly with any of the crew. You must not express your thoughts about the shots or make suggestions to the model on set. (I have to keep my opinions to myself sometimes, even at this point in my career.)

Samples from the projects you assist on will be primarily for your own reference, looking back on the shoot. If you ever do include them in your portfolio, you must be very clear that you were the assistant on the shoot and not the stylist, and do so only with the stylist's permission.

If you perform well as an assistant stylist and have the opportunity to work with that stylist again, you can build a beneficial relationship, receive the stylist's guidance, and gradually build your own kit and career.

Having stumbled into her role as a wardrobe assistant in film and video happily but unexpectedly, Veronica Guzman has the following advice for assistants in this area:

> *In my experience, it pays to be inquisitive. If you're really interested in something, show it by asking the right questions. Don't think that just because you get in the door and you keep saying you're enjoying the experience, you will be called on for another job in the future. If you show that you want to learn and are willing to put in the hard work, then they will want to help you in the industry. When I worked on my first television show as a production assistant, I asked a lot of questions, and it was obvious that the line of work intrigued me. On the last day of shooting, the costume supervisor told me she could see that I 'wanted it' and that she would help me if I was serious about pursuing this career. She said she would keep me in mind for future jobs. About a month later, she called me to work as her assistant.*

THE PERFECT ASSISTANT

When you have a styling job big enough to hire an assistant, first be sure there is enough money in the budget to cover a daily rate of roughly $150 to $350 a day. If not, try to negotiate for the help so you can do your best work. Optionally, you may invite a friend or relative who is interested in what you do. But be sure they understand professionalism.

In exchange for a lower day rate, the assistant is there to learn. You can expect to teach and mentor assistants so that they can share in your knowledge and walk away with an understanding of a day working on set. If you find an assistant who is capable and responsible, understand that the perfect person may not be around forever.

Some assistants, however, are happy just being assistants. This is the perfect job for someone who likes a flexible schedule and does not want to *be* the stylist. They don't have to attend client meetings, manage budgets, complete invoices, and carry the responsibility of a styling career. There still is the fun of shopping; an assistant who regularly works with the same stylist may have a company credit card and earn several hundred dollars a day. The advantages are obvious for the stylist who has a reliable assistant with plans to stick around.

INTERVIEWING ASSISTANTS

When you are setting up a relationship with a new assistant, stylist Kim Maxwell suggests following this outline:

- If you haven't had any inquiries from people interested in assisting, you can post a listing on social networking sites or fashion networking sites stating that you are in need of an assistant. After you have found some prospects, you can set up interviews.

- Introduce yourself and your company. Give the interviewees time to introduce themselves and discuss what they are hoping to get out of being your assistant.

- Also let the person you're interviewing for the assistant position know a little bit about your work ethics and personality.

- Discuss with them your expectations for the assistant you will be booking. Next discuss the position, the direction you want them to take, what they will learn, and what you can offer regarding tear sheets, referrals, and day rates.

- Have the person you are interviewing fill out an Assistant Sheet that will have the name, contact information, address, and birthday (just for fun!). If they are hired, then have them fill out a W-9 and a Nondisclosure of Information Agreement. Also make notes. Do they have transportation? Do they have internet access, education, and work experience?

- I would suggest spending two days with the person you hire as your assistant prior to the shoot date. You can spend one day in the office so you can familiarize them with your to-do list, your goals for the project, and terms and forms they should be familiar with. The second day should be spent familiarizing your assistant with the project you will be working on and introducing your assistant to your wardrobe vendors. Determine whether these will be paid days or not.

STYLING KITS FOR WARDROBE

Kits for wardrobe shoots are pretty much the same whether you are styling fashions or generic wardrobe. Have envelopes or zip-lock bags handy for saving hangtags cut from garments. Be sure to have a scarf to cover the models' heads when they dress, as they may not be experienced with protecting their makeup. (See the previous chapter, Fashion Styling, for special kit items.)

If you are styling wardrobe instead of fashion, you are even more likely to be asked to do minimal makeup. Often, without the focus on beauty, a makeup artist won't be budgeted into the project. The talent will be asked to come to the shoot "hair and makeup ready." Providing they do it well, your job will be doing touch-ups and controlling shiny faces and stray hair.

You can see that wardrobe styling can take various forms—from neutral, almost unnoticeable clothes to historical or unique characterizations. All of it is challenging, especially when combined with other types of styling, as it usually is. You will never be bored.

THE MODEL'S BAG OF TRICKS

An experienced model knows just what to bring to a photo shoot. She needs the right undergarments to make the clothes work and other items for her own comfort at the shoot. A sweatshirt and slip-on shoes will keep her warm

and comfortable between shots. Models should wear or bring a button-down shirt so they don't have to pull clothes off over their heads after makeup.

MODEL BAG FOR WOMEN:
- ☐ Vouchers
- ☐ Zip-up sweatshirt, or warm jacket
- ☐ Slip-on shoes
- ☐ Button-down shirt (for makeup)
- ☐ Bathrobe (if shooting lingerie)
- ☐ Nude-colored seamless bra
- ☐ Nude thong or full underwear to waist
- ☐ Nude body suit
- ☐ Panty hose
- ☐ Bra lifts, also known as push-up enhancers (if needed)
- ☐ Small stud earrings
- ☐ Basic jewelry
- ☐ White t-shirt
- ☐ Jeans
- ☐ Generic white sneakers

MAKEUP KIT FOR WOMEN:
- ☐ Brush
- ☐ Hair spray
- ☐ Ponytail elastics
- ☐ Foundation
- ☐ Powder (or use combination product like MAC Studio Fix)
- ☐ Neutral lip color
- ☐ Neutral eye shadow
- ☐ Mascara
- ☐ Makeup remover for later
- ☐ Moisturizer for elbows and knees

MODEL BAG FOR MEN:
- ☐ Vouchers
- ☐ Zip-up sweatshirt, or warm jacket
- ☐ Slip-on shoes
- ☐ Button-down shirt (for makeup)
- ☐ White t-shirt
- ☐ Jeans
- ☐ Generic white sneakers
- ☐ White and dark socks
- ☐ Watch

GROOMING KIT FOR MEN:

☐ Hair gel
☐ Brush
☐ Powder (or use combination product like MAC Studio Fix)
☐ Rechargeable shaver (for touch-ups)
☐ Vaseline for lips
☐ Makeup remover for later
☐ Moisturizer for elbows and knees

As the stylist, you may need to back the model up by providing some of these needs. I suggest adding most of them to your styling kit.

On a fashion shoot, of course, there will be a makeup artist present. But models should be able to effectively do their own makeup for certain lifestyle shoots. The basic makeup items listed here will get them through. And it doesn't hurt to carry an assortment of makeup and hair items to a fashion shoot, just in case.

RESEARCH CHALLENGE: WATCHING TV COMMERCIALS

Spend an evening or a morning watching TV programming. Watch news broadcasts, sitcoms, movies, anything that happens to be on. Also watch all the commercials! Note what the talent are wearing and imagine who was responsible behind-the-scenes for dressing them.

Wardrobe for television commercials is likely to be bright-colored solids or neutral tones. Now that high-definition television is the norm, you will see some printed fabrics and the color purple is included frequently. Notice that the talent may be wearing colors to coordinate with the package being shown. Or the colors of the company that's advertising—watch for the logo at the end of the commercial. They will *not* be wearing corporate colors of the company's competition.

PORTFOLIO CHALLENGE: EVERYDAY PEOPLE

Select one of the following stock-type scenarios and dress the participants in the appropriate wardrobe.

1. A senior couple is shopping at an antiques store, arm in arm.

2. Two children are walking on a sidewalk next to a neighborhood grocery.

3. A mother and her toddler are seated on a living room chair reading a book together.

After selecting your scene, find some people (perhaps photogenic friends or relatives) to play the characters. Gather the wardrobe and helpful props. Shoot the photograph yourself or work with a photographer to do natural, snapshot-style images. You will need to apply minimal makeup to the "talent" and dress them in complementary but generic wardrobe items. Don't over-prop. Edit the photos to find one where the people are interacting naturally and their clothing is flattering. You may want to crop into the image to eliminate some of the background.

CHAPTER **8** Styling Off-Figure

CLOTHING, WHILE MADE TO be worn by people, is not always shown on the human figure. To create variety in catalog and magazine pages, photos of clothing on models are interspersed with laydowns, stacks, or other off-figure presentations.

In this chapter, we will focus on garments and leave the occasional throw, tablecloth, or carefully rippled napkin for other styling chapters, like product styling and room sets.

WHY USE OFF-FIGURE STYLING?

While we tend to associate fashion with models, much of it is photographed off the figure. Off-figure photos show color choices, fabric, and features, while the model shots create lifestyle and mood, and show how the clothes fit. Some features of garments may be shown better when off-figure. Button plackets, cuffs, pockets, and side slits can be positioned, brought to the front, or lifted. This is done in a precise and exacting way that wouldn't work on a model. Features can be specially lighted for emphasis in studio shots; a light or reflector can be directed inside the smallest fold.

Array of pages showing off-figure styling in magazine editorials and catalogs. © Susan Linnet Cox

Catalogs that sell apparel usually mix the presentations. Combined presentations make the catalogs effective and more interesting. Eye flow is important to catalog design, because the reader is visually encouraged to keep looking at the page, stop at interesting features, and then turn the page for more.

Looking at fashion magazines, you may have noticed off-figure features. These styled items are used for comparing designer fashions with more affordable options, mix-and-match travel wardrobes, lingerie, swimsuits, accessorizing, or a sampling of new products. The clothes and accessories aren't always shown in scale; a bracelet may be as large as a blouse. But they are all styled using off-figure techniques.

By the time the shoot is booked and the stylist hired, a catalog has already been roughly designed. There are probably sketches in place for the off-figure clothing. The art director may or may not know exactly how these outlined garments will be set up in the studio.

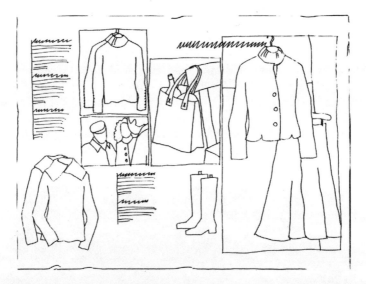

This layout is typical of those created by catalog designers prior to photography. Image placement indicates which shots will be on- and off-figure, square-finish or knock-outs, overprinted with text, and features of the spread. © Trisha Hassler

FABRIC TEXTURES

When we shop in a store, we touch the fabric of clothes to make buying decisions. Notice, the next time you browse in a department store, how often you reach out and touch the clothing on racks. Something that feels particularly soft or textured can make you stop for a closer look. Fabric stores are a particularly sensual experience; many times I have walked along the rows feeling every bolt of fabric on display.

This is a disadvantage for catalogs. Their only opportunity to give customers the fabric experience is through photographs. The more touchable the clothing looks, the better. The customer wants to know how it feels to

wear this item, how it hangs on the body, and what it will be like when washed.

Studio photographers are experienced with the challenges of lighting garments to enhance the texture. At the same time, they are working for continuity in lighting various items. The light source should be similar throughout the catalog, with a strong light coming from one side and a softer light coming from the other side to fill in some of the deeper folds while still preserving a three-dimensional effect. As you're styling the garment, the photographer and assistant are refining the lighting. Your styling will show them some areas that need emphasis, and thus the shot evolves.

SHOWING COLORS

In addition to creating a tactile experience for the customer, catalogs need to show all the color choices, known as "colorways" by merchandisers. While the model looks lovely in the blue sweater, the customer may prefer the black or red sweater for herself. Merchandisers have studied the color preferences of customers and have ordered quantities of the fashions based on those preferences. The color expected to sell the best is generally the "star" or feature. This may be the one shown on figure or at the top of the stack. The on-figure color is rarely featured again at the top of the stack. Other colors may appear in relative importance, or this may be an aesthetic decision for the stylist. Be sure to clarify these priorities before styling a stack.

When merchandisers elect to feature a black garment, photographers are often frustrated. The difficulty of showing detail in dark fabric is further complicated by printing. Usually dark colors run together a bit even in the best quality printing. And each type of fabric absorbs light differently. A black satin blouse, with its reflective shine, will need completely different lighting than a black knit top which seems to soak up light. Another unpopular choice is placing black and white next to each other. Since their lighting requirements are so different, it is almost impossible for a photographer to capture detail when they're side by side. A better plan is to place a transitional color between them.

Sometimes the photographer will shoot different exposures of the same grouping and then blend the images in the computer.

CLOTHING CONSTRUCTION

Although a sewing background is not a requirement for styling, it can be helpful to understand how clothing is constructed. You would know that stitched seams can pucker slightly or hemming can stretch a knit. Most fashion students have studied the basic features of clothing construction and will know how they affect the garment. This can help in styling.

A set-in sleeve is shaped like the human shoulder and upper arm, and has a limited range of motion. A raglan sleeve has a seam going diagonally from the underarm to the neckline and a less defined shoulder. A third style, the dolman sleeve, has ample fabric under the arm, like a wing, which could make it challenging to show the fabric and could be unattractive. Shoulder seams generally are placed a bit in front of the shoulder ridge.

Pattern for slacks shows the difference in back and front pieces. Back pattern, at right, is both wider in the seat and deeper at the center back seam than the front pattern. This fabric allows the human body to sit and move but causes challenges when styling pants off-figure. Pattern courtesy of Cochenille software for creating patterns. © Susan Lazear

Pants are constructed with more room in the rear than in the front. The pattern is designed to be wider and longer in the back; the place where the crotch and inner leg seams meet is actually more toward the front of the body, resulting in more back fabric. When you're styling pants, you need to tuck away and conceal this extra fabric to see two separate legs. And the back of the waistband is higher than the front. This must be evened out so you don't see a large expanse inside the pants.

Just as with styling on figure, the clothing needs to be prepped and organized. Concentrate on steaming or ironing the portion that will be shown, and get rid of side creases so the item can be shown full and rounded. Stage the merchandise for the shots that follow so you can stay ahead.

SETTING UP THE PHOTOGRAPH

Techniques used for off-figure styling vary depending on how they are set up in the studio or location.

For stacks or single folded items, a tabletop is easiest for the whole crew to work on. The camera is generally directed downward at the scene from about three-quarters of a right angle starting from eye level.

When a full outfit is being shown, the photographer may need distance to fit it into the camera's field of view. A head-to-toe presentation might work as a floor setup if the camera can be looking straight down from many feet above

it. This can be achieved in a studio with a ladder or an upper loft-style level. Products may be styled on a low table or a background surface. Awkward to work on, such a surface does provide a flat area that will fit in the camera's view. This laydown setup may be used to shoot down on an array of garments and accessories, or a life-like human figure.

AVOID THE FLATTENING EFFECT

Gravity is the deciding factor in many off-figure presentations and something you will constantly be aware of. When garments are placed flat and shot from above, they need to be filled and shaped to avoid gravity's flattening effect. As you hang garments on a wall, gravity is an advantage, but you'll need to use techniques to counteract it when bending an arm or lifting a skirt hem.

Gently touching and lifting the fabric with the tip of a pin is sometimes all that's needed. For the most part, with all types of off-figure styling, you can let the garment and fabric direct you. Before you try to control it, see where it wants to go and what it wants to do. Let the clothing take the lead and work with it. Sometimes the gentlest lift or tug can create the most natural effect. And there are times when you realize you're overworking it. Start over instead of struggling.

SHOOTING GARMENTS ON LOCATION

Off-figure clothing may be shot out of doors for a more interesting background. As with shooting models on location, challenges consist of wind and changing light.

Be sure to have all your supplies with you. If a stack is placed on a bench or on steps, you need to be able to clean them first. For a wall-type presentation there are questions: what to hang the clothing from (perhaps a tree branch or C-stand), and how to attach the monofilament, which helps keep the item in place, to the ground. To make visual sense, the clothes should probably be on a hanger—it helps explain why they are there in a natural setting. And the background naturally is a critical element in positioning the shot.

STACKS

The designers of the J.Crew catalog are masters at utilizing stacks. When I think of the catalog, a stack of men's dress shirts or women's wool sweaters comes to mind. They are so big they fill the page. There's little white space around the presentation and almost no copy describing the merchandise. Why use words when the button placket or neckline is so large you can see every thread?

The natural look of such a stack fools the public. It looks like someone came and plopped them there for the photographer, implying how nice they'll look in your closet. In fact, the stylist was very exacting in creating the stack, placing thicker stuffing in the bottom items so they maintain the same thickness when the top ones weigh them down. The sides are neat; there is no sleeve hanging out unless it's the top one with a sleeve casually brought up to show the cuff. There's a gentle ripple on some items, and the shadows help show the fabric.

But even when a stack is not a star with its own page, it may be needed to show color options. Perhaps it's partly concealed on one side by the fashion

photo. It may be placed in an environment to create a story about the merchandise, on a chair or table. Some favorite shots of mine were styled for a sports catalog, using a locker-room setup in a studio. We had a wall of lockers and shot some stacks in the front of open lockers and on a bench that was built from a wood shelf.

TECHNIQUES FOR STACKS

When styling a stack of shirts or sweaters, begin by laying each one face down with a sheet of quilt batting cut to the width of a folded shirt. Fold the sides inward and then make another fold in half (see illustration on opposite page). Each shirt in the stack should have the same dimensions. If the shirts are heavy, add more thickness in the lower ones to compensate for the weight of the stack. The top shirt may have a sleeve coming out, as shown in the illustration.

Your stack may be neat and straight or casually staggered, but the top item will most likely need to be filled and lifted a little at the back so the neckline doesn't settle backward. You might use cardboard or another handy material to lift it. Some studios have bricks covered with white tape for this purpose. Look at the stack from the camera view, checking for rough edges, and clean those up. It will take more precision than you might expect to get the outlines perfect.

The basics of styling a stack of shirts can be used for styling other items. A stack of shorts or jeans might include some items turned so the waistband shows. Demonstrate as many details as possible while still presenting an attractive stack.

HANGERS

A row of clothing items on hangers can make a nice catalog presentation to break up the routine of fashion and stacks. It's appropriate for tailored clothing and blazers. Propping with the right hangers is critical; they can be traditional wood, something modern, or even everyday wire hangers for a funky look. I've used some of the antique wooden hangers I collect for these presentations.

On page 12 in Chapter 1 is a shot I styled for my portfolio to acquire more off-figure work. I took an antique hanger and a textured, reversible sweater outside to photograph near my home. Tissue was rolled around my own arm to shape the sleeves, and placed inside the body of the sweater. The photo took under an hour to style and shoot.

Another attractive presentation consists of a clothesline and clothespins, usually incorporating a sunny day, bright blue sky, and the illusion of a nice breeze. Monofilament can be attached to the bottom corners of garments with a bit of tape or by feeding it through a tiny hole, and then taped to a weight out of frame to create the breeze—if you're lucky enough to be styling on a still day or in the studio.

All the styled shots appear simpler than they are to create. Every detail is crucial, from propping to the drape of the fabric to backgrounds.

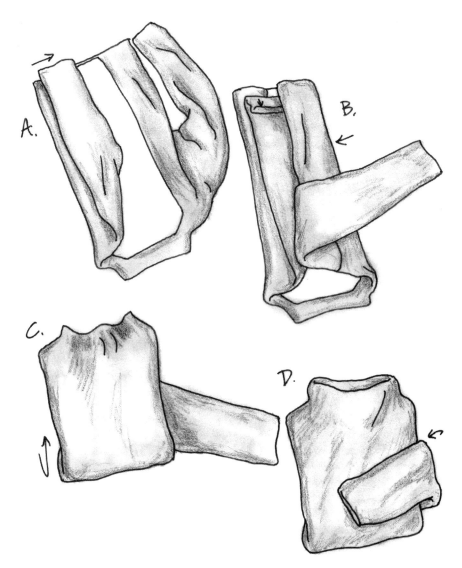

Folding a sweater (same technique is used for items in stacks without sleeves showing): A. Lay garment face down, place batting the width of the stack, and fold sides in. B. Fold under extra sleeve length. If a sleeve will show on top, leave it out. C. Fold top half of garment back. D. Raise back of neckline and fill opening with some batting. Position sleeve over garment, tuck in wide edges, and soften with some batting. © Susan Linnet Cox

> **TIP** Collect vintage coat hangers, brackets, hooks, chains, and knobs that can be utilized in off-figure photography. They can be painted or covered with paper or fabric.

LAYDOWNS

My first actual styling job was a wholesale catalog for Adidas. It was a week's worth of laydowns portraying the full line of athletic clothing for that season, including running jackets, pants, sweats, shorts, running bras, and t-shirts. The second week, there were insets of athletic models wearing some of the clothes. At that point I'd directed countless fashion shoots but hadn't often visited the photo studios for the off-figure shoots.

Wholesale catalogs, or "lookbooks," which present a manufacturer's line to buyers for stores, are often nicer printed pieces than consumer catalogs, with heavier paper, better printing, and less copy.

Since I was figuring it out as I went along, I was fortunate that my instincts were right about the techniques and materials. I brought lots of tissue paper, fiberfill, and batting to the shoot. The clothes were laid on a flat board two feet off the floor, with the photographer on a ladder. Uncomfortably squeezing between lights and reflectors, I managed to fill the garments and create realistic, athletic, but imaginary bodies inside them. This shoot was done on traditional film, years before digital was common; and any speck on the merchandise would have involved costly retouching, so a good part of the styling included keeping the set dust-free. Tiny rolls of masking tape and bits of putty helped me with that chore.

TECHNIQUES FOR LAYDOWNS

A laydown without dimensionality is going to look especially flat on film. And the shape of the clothes usually looks very large and unattractive if they are lying flat. Adjustments include tucking extra fabric from the back of pants, evening out the waistband, narrowing the torso for both men and women, and placing sleeves in a natural way. The stylist creates the impression, to some degree, of a human form inside the clothing.

A problem created by gravity is flattening, as when lightweight fabrics like t-shirts seem to be sucked down onto the surface and really need to be built up. Also, the fabric may be translucent. A piece of white felt or fabric cut to the shape of the item can alleviate the show-through and allow you to place some batting or tissue inside for shape.

A wad of batting to soften the edge of the shoulders is a good start. Filling in sleeves with tissue paper or batting can create a soft shape and make the sleeves less wide. For women, create the illusion of breasts and a waistline. A gentle fold or ripple on the diagonal can make the garment much more appealing and give the photographer some dimension to light, just as you do with stacks or wall styling.

Laydown styling of baby outfit, shot outdoors on blue foam board. Photographer and stylist: Susan Linnet Cox. © Susan Linnet Cox

LIFELIKE STYLING DECISIONS

I wanted to add some infant clothing to my portfolio, and shopped for a cute outfit to style as a laydown. Since I wanted only an online portfolio piece, I decided to shoot it myself outdoors on a piece of blue poster board. When I started stuffing this shot I realized there was a fine line between creating a lifelike pose and a lifeless one. I think one key element in this illusion is making sure it does not look *too* real. For example, filling the booties could cause confusion. I held back from having the legs up and kicking and left the chest area and arms a little flat so the outfit would look more like merchandise.

BACKLIT LAYDOWNS

Backlighting can provide an appealing presentation for the right item and is often effective for white and sheer fabrics. A translucent sheet of white acrylic is placed on a framework or shooting table, which many studios have; lights are positioned above and below for the right balance of light.

Be careful when working on these surfaces not to scratch them or apply tape that will leave a residue, thus interfering with future shots.

A background color could be added later. White on white is not very captivating. One of my favorite presentations was of white lingerie and sleepwear with a background of blue sky and clouds.

MANNEQUINS

Occasionally a mannequin is used for off-figure clothing. At first, dressing full-length mannequins is like a puzzle. For a stylist with retail display experience, this will be a snap. For the rest of us, decisions have to be made about how to get clothes on a stiff body. The arms twist off and need to be rotated back into place after a blouse is put on. The rod that is inserted to hold the mannequin up can get in the way of putting pants on. But at least it patiently stands still.

I styled a shoot for Univibe, a skater-style men's shirt manufacturer that revived the odd styles of the 1950s. The shirts were shown on male torso mannequins, much easier to dress than the full-length ones. Without arms or a head, the torso stands on an adjustable base. The shirts had to be pinned, clamped, pulled, and adjusted, just as with on-figure styling, to create a good look. Filling the body and sleeves with rolled tissue paper helped with what I was trying to achieve, which was a human aspect.

Some photographers shortcut styling by using a mannequin to shape the garment, then simply remove the mannequin from the shot. The giveaway is that the inside back of the garment is missing. Others are challenged to see into the inside of the garment and appreciate the skills of an off-figure stylist.

WALL STYLING

"Wall styling" is the creation of a life-like presentation of clothing, often an entire outfit, styled against a vertical surface. With or without a hanger included, the fashions suggest living human figures. (Unable to find any universal description for this style, I came up with this term.)

Looking through catalogs, you'll notice evolving trends in styling. In the late 1990s, a few catalogs started shooting all their fashions off-figure. There were no models. The idea was that models were distracting and the customers might not relate to them. Soon other catalogs mixed off-figure fashions with models or lifestyle shots, and gradually imitated the leaders by doing away with on-figure fashions altogether. Some used scenic shots as backgrounds and others set up the off-figure shots on location. No matter how it's shown, the off-figure clothing suggests a human body in a way that lets the customer imagine herself or himself in the clothing.

Though the trend has swung back toward models, off-figure shots styled vertically are still used frequently in catalogs, but it's not a specialty that all stylists feel comfortable with.

This type of styling gives you an opportunity to display more features than on a model. Side slits, pockets, linings, layers, and tricky button plackets can get lost when the garment is being worn. Here I'll show you the techniques to emphasize them. Remember how much your art director will appreciate your

pointing out special details, since your goal is to make the art director look good *and* sell products.

CONFIDENTIAL TECHNIQUES

One stylist who worked for a catalog featuring what I call wall styling was asked to sign a non-disclosure form promising not to reveal the techniques used. I feel that if more stylists learn techniques and efficient, organized ways of doing things, there will be more good stylists for a company to choose from. But be aware that the techniques used by a particular client can be closely guarded secrets and actually are a form of intellectual property.

SCULPTING THE FIGURE

For most wall-styling jobs, your task is to create life-like poses. Your client may sell sports clothing, travel wear, or business suits. The client wants you to imply the active person who will wear the clothes. How much activity is shown is the art director's call; the look the company portrays in its photos will set the standard.

I find this part of the process to be like sculpture. You are building a three-dimensional structure with a human form and realistic body language. In this case the illusion is not that the clothing has been tossed on a bed or stacked on a closet shelf, but that there is actually an invisible "someone" wearing it.

Using tissue paper, batting, foam, wire, and monofilament—and sometimes, a preconstructed form—you will be bringing the garments to life.

Keep in mind that customers—women and men alike—want to visualize their best physical attributes in the styled fashions. The desirable female form will have defined yet feminine shoulders, rounded breasts at a realistic but youthful level, a waist that is narrow but believable, hips that are curved but not wide, and healthy long legs and arms. This is the body that most women want to have, and the one they imagine they will present if they buy these fashions. It's credible but not extreme. The desirable male figure is defined by strong squared shoulders, a full chest and neck, a flat stomach, and a slightly tapered waist. Long legs with no hip bulge complete the full-length presentation. Each catalog will have its own standards for the figure based on the customers; they want to attract but not alienate them.

HUMAN PROPORTIONS

It wouldn't hurt to pick up one of those how-to-draw books, the ones about drawing the human figure. You don't have to draw if you don't want to. Just looking at the diagrams will be a good start. If you have taken a life drawing class, you may know exactly where the elbow bends. Notice it is not a curve but an angle—there are bones in there. You will also learn by looking at other people or in the mirror.

Generally the human body is divided into eighths. The top eighth is the head. The hips are about four heads, or halfway down. The elbows bend at a point just above the waist. If the arms are straight down, the fingertips brush the hips just below crotch level. Bend the arm slightly and the hand is raised high enough to slide into the pants pocket. The bent elbow will extend out away from the body or toward the back.

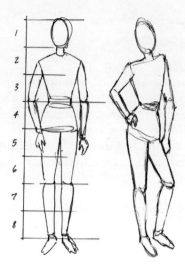

The ideal human figure is eight "heads" tall, important to visualize when doing wall styling. In a contrapposto pose, the left knee bends as right hip is raised, forming a gentle S-shape to the body. © Susan Linnet Cox

The distance from waist to crotch is about one head, or one eighth of the entire body. The knee is about halfway down the leg. If the knee bends, the hip joint bends too. This lifts the leg. These two joints mostly move front to back, not off to the side. The leg can assume a casual sideways movement but don't let it be too exaggerated, like a marionette. When this leg is bending, the opposite hip is going to rise up a bit. The torso curves in the other direction to compensate, toward the bent leg. An S-shape is formed, a position called *contrapposto*. Now the shoulders are affected. They balance by lowering in the direction of the raised hip and straight leg. Study the illustrations.

See how all the parts of the body are connected and balanced? The body seems to be in movement. It could be walking, or at least standing and listening to a friend talk. It is friendlier already.

TECHNIQUES FOR WALL STYLING

Depending on the client's preference, the process of styling garments begins with a hanger, a form, or just building the figure on the wall surface. Let's start with women's items on a foam board wall. See the illustrations.

Position the outfit on the foam board, outlined with pins holding the neckline and shoulders in place, step back and look. Let it drape and see if the shoulders are even and the proportions look right. If so, start styling. You'll take some foam and cut two shoulders to place inside the garment, pinning them through to the board. Shaping has begun. The breasts can be mounds made of tissue paper covered with batting and tape. These are shown in the wall-styling illustration on page 132. A pin goes straight through the top and into the back board at the right position. Form the collar in a rounded shape to indicate the neck.

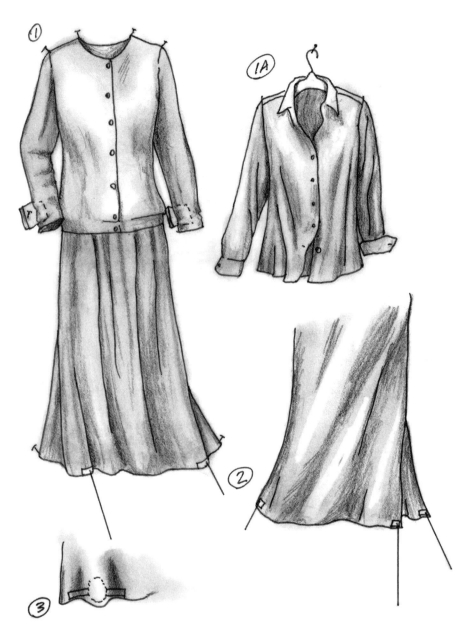

Wall styling: 1. A sweater and skirt styled without a form or hanger, showing blocks of foam positioned behind sleeves. Note T-pins at shoulders. 1A. A blouse styled on a hanger. 2. Skirts styled with monofilament taped to inside of hem and to floor or stand. 3. Rippled tape attached to two folds of skirt with batting under raised portion. © Susan Linnet Cox

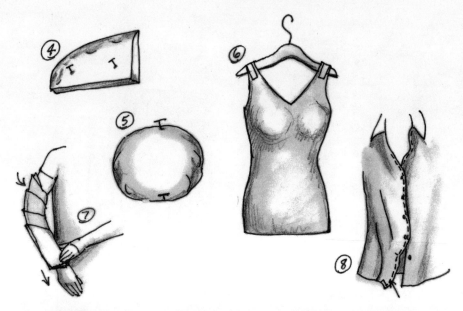

Wall styling details: 4. Foam cut to shoulder shape. 5. Breast made of wadded tissue paper wrapped with batting. 6. A form made of foam board, covered with batting, and taped to a hanger. 7. Wrapping tissue around your own arm for sleeves. 8. Wire (dotted line) inside button placket, held with tape at inside bottom. © Susan Linnet Cox

Sleeves can be filled with tissue paper rolled around your own arm and placed into the garment sleeve from the top. We'll look at some more complicated options for arms later in this chapter.

Early in the process, before refining too many details, call your art director over for a consultation. How is this looking? Is this the look you had in mind? Look at the monitor if the shoot is digital; if it's digital you can check it out yourself *before* calling in the art director. Invariably the outfit will not be satisfactory. You will need to make changes. This is the part where you do not get discouraged or take criticism to heart. Do your best to quickly make requested adjustments, and you will find the clothing looking better and better.

Small blocks of two- to four-inch-thick foam rubber can be used behind the figure to move it away from the wall. Shown in back of the sleeves in the illustration, they may also be placed inside the waist to build roundness.

MORE TRICKS FOR WALL STYLING

There are some special techniques you can use to counteract the effect of gravity and make the clothes do what you want. The button placket of a shirt or blouse looks good with a gentle ripple in it, especially near the collar where it otherwise tends to sink in. Cut a minuscule hole in the fabric near the edge and insert a length of thin wire, feeding it through to the top. It can be manipulated to create the curves you want, perhaps lifting the placket out at the bottom. The same procedure can be done along the bottom edge of a hem, to lift and ripple the bottom of a shirt or skirt.

An architectural image of a living room. Symmetrical arrangement of furniture is balanced by just enough styled elements to make the image inviting. Exterior and interior lighting are carefully controlled. Photographer: Karen Melvin; stylist: Jay Bruns. © Karen Melvin Photography

Studio environment showing tabletop setup, lights, C-stands, and other obstacles the stylist must be aware of. Photographer: Michael Christmas. © Michael Christmas

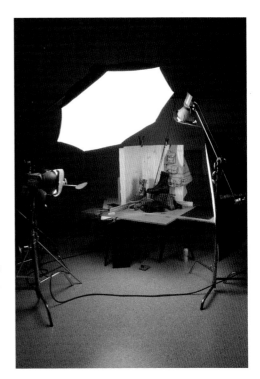

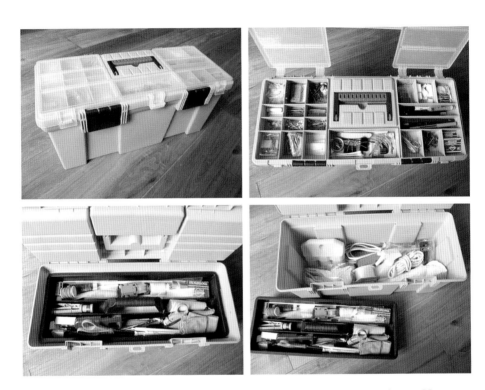

Styling kit. There are three levels including the small compartments on the top. Next level contains frequently used items and deeper bottom allows for bulkier supplies. This is an older model of a Keter toolbox. © Trisha Hassler

Prop warehouse. This is an aisle full of props in Prop Coop, one of San Francisco's resources for prop rental. © Josh Koral

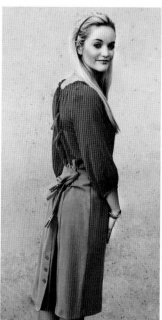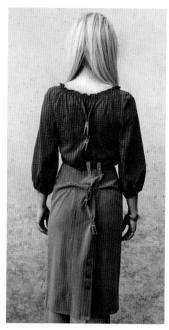

Clipping an oversized outfit, front, side, and back views. Notice horizontal safety pins are used for raising skirt to avoid return. Plastic clothespins and small clips are used for narrowing blouse and skirt. Garments were not prepped for back view. Photographer: Kornelia Vitek; stylist: Eunice Vielmas. © Kornelia Vitek

A fashion shot styled by Devon Poer, editor of *The Stylist Handbook*. Photographer: Daryl Henderson of www.daryl-henderson.com; stylist: Devon Poer of www.devonpoer.com. © Daryl Henderson

Back to 1969 in a test shoot inspired by this vintage car. Photographer: Nick Nacca; stylist: Susan Linnet Cox; hair and makeup: Claire Young. © Nick Nacca

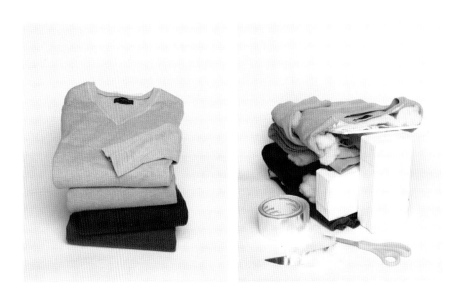

Front and back views of a stack of folded men's sweaters reveal the amount of styling—and filler—that builds the stack. Notice two bricks covered with gaffer's tape, small piece of foam board, fiber fill, and aluminum tape used to position and lift sweaters. Photographer: Siobhan Ridgway; stylist: Susan Linnet Cox. © Siobhan Ridgway

Acrylic studio table allows diffused light to shine from behind the sheer blouse and necklace. Seams and folds provide thicker fabric for tonality. This shooting technique is effective for certain garments and products that are enhanced by the backlighting. Photographer: Siobhan Ridgway; stylists: Susan Linnet Cox and Cedric Chang. © Siobhan Ridgway

A stack of belts is harder to control than it looks. Strong white carpet tape or aluminum tape at the back can help keep them in place. These were shot on an art paper background. Photographer: Tim Mantoani; stylist: Susan Linnet Cox. © Tim Mantoani

Purple suede platform shoes arranged in an atypical position to catch the viewer's eye. Rarely is the inner side of a shoe featured but all requisite details are well displayed. Photographer: Nicole Ollerton; stylist: Eunice Vielmas. © Nicole Ollerton

An assortment of antique props are arrayed in preparation for a magazine shoot. Photographer and stylist: Beth Reiners. © Beth Reiners Images

Soccer is all about teamwork, sportsmanship and having a good time. It's also about trying to keep your kids and your house clean. And as every soccer parent knows, this can be a real challenge.

Fortunately, Publix can help. As the official supermarket of the GYSA, we know what you're up against. And we thought you could use some valuable coupons to help get you through the soccer season.

So when the game is over and it's time to clean up, make sure you team up with your neighborhood Publix. We have everything you need to keep your house and your little soccer stars looking their best.

Styling a constructed environment with mud and soccer shoes. Photographer: Dave Spataro; stylist: Susan Linnet Cox; client: Publix. © Dave Spataro Photography, Inc.

Several images from *My Favorite Glass*, a self-promotion booklet created by Dan Whipps, demonstrate an array of prop styling. The hand-bound book is sent to potential clients with a pair of the glasses. Photographer: Dan Whipps; stylists: Dan Whipps and Debbie Wahl.
© Dan Whipps Photography

Generic props. At left are obvious brand-name food props: wine, hot sauce, bottled water, and balsamic vinegar. Items at right are generic and less distracting. Photographer: Siobhan Ridgway; stylist: Susan Linnet Cox. © Siobhan Ridgway

These two photos are from a project conducted by the IACP (International Association of Culinary Professionals) and stylist Delores Custer. Photo on left is a three-bean salad in the fashion of the 1950s with harsh lighting, lots of props and garnishes, and positioning in the middle of the pale yellow tablecloth. The same recipe on right is styled with a tight view of the food, fresh ingredients, and natural-looking lighting. Photographer: Colin Cooke; stylist: Delores Custer. © Colin Cooke

Three images from a promotional brochure for Lisa Golden Schroeder, food stylist. It features four photographs created for GNP Company, a natural chicken producer in Minnesota. The brand is Just Bare® Chicken, a line of fresh chicken that has no added antibiotics or hormones. Photographer: Dennis Becker; stylist: Lisa Golden Schroeder. © Dennis Becker Photography

Berry cobbler and ice cream styled with a homey touch using appropriate props. The surface is an antique Formica tabletop. Photographer: Dan Whipps; stylist: Debbie Wahl. © Dan Whipps Photography

Dining room image features a simple chandelier, a vase of fresh tulips, and custom wall paint. Stylist: Colleen Heather Rogan. © Milwaukee Magazine

Architectural photography of a kitchen for Omega Cabinetry. Styling incorporates just enough dishware, glasses, cookware, and small appliances to create a lived-in feeling. Warmth is created by the use of bread, San Pellegrino water, and apples. Photographer: Karen Melvin; stylist: Jay Bruns; client: Omega Cabinetry. © Karen Melvin Photography

Almond-tatsoi-crusted sea bass, one of the recipes in the award-winning cookbook *Flying Pans: Two Chefs, One World*. Photographer: Gregory Bertolini; stylist: Cindy Epstein. © Gregory Bertolini

A complex production shot like this requires working with one or more stylists. In addition to food styling in the foreground, there were many models to dress in complementary sports-related wardrobe, props to create atmosphere, and a room set to arrange—too many aspects for a photographer to handle alone. Photographer: Bill Schilling; stylist: Debbie Wahl; client: Snyder's of Hanover. © Bill Schilling

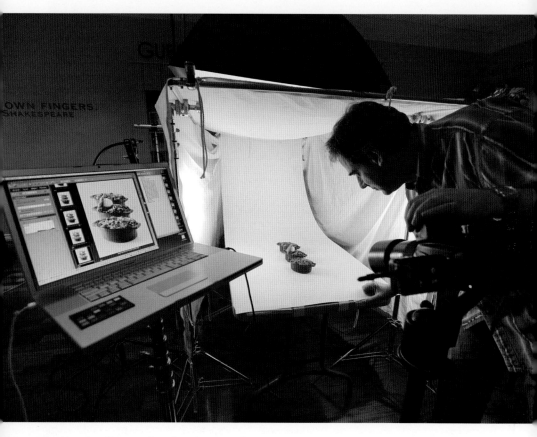

Photographer Gregory Bertolini shown perfecting a food shot for a cookbook. A food stylist prepared stand-ins for the food while the lighting was perfected, then the "hero" food was placed on the set for the final shot. The long white sweep provides distance in the background of the shot while translucent white fabric diffuses light onto the set. © Gregory Bertolini

Another technique for lifting a hem is attaching monofilament and taping it to the floor or a C-stand. The line can be attached to the garment with a small piece of tape inside the hem or poked through the fabric and knotted. A simple trick for shaping a hem, one I usually use on shirts and blouses, is placing a long piece of tape along the bottom edge, leaving some segments free from the tape. The untaped parts can be kept away from the tape by inserting a bit of fiberfill, as the illustration on page 131 shows.

A final trick is shaping lengths of tape into a roll, which can be placed behind the edges of the garment to hold it to the board. Useful for positioning shoulders or other edges, this is a convenient shortcut that can be easily adjusted. When you are working with a background that can't hold a pin, the rolled tape can be a good way to control the garment's outer shape.

MOVABLE WALLS

One studio I worked in had four movable walls. With a wood framework on wheels and 4′ x 8′ sheets of foam board attached to both sides, the walls were very practical for styling catalog shoots. The foam board was used for working with pins to arrange the garments. With movable walls, the stylist could style the clothing, even starting another shot on the reverse side, and then wheel the wall to the camera.

If large panels of foam board are attached to studio walls, you can be staging the next item on another piece of foam board on a tabletop. Using T-pins, the board can be pinned onto another board attached to the studio wall and styling can be completed vertically. Photographers' assistants generally are responsible for these studio setups.

A background other than white foam board is sometimes preferred. Colored seamless paper, which comes on wide rolls, can be positioned over the foam board. Often a photographer will choose to use grey seamless paper as a more neutral background for knock outs. (We will also see this used in Chapter 9, Product Styling.) If another background surface, like a wood panel, is specified, the challenges of arranging the clothes in front of it are greater, since pins can't be used.

WALL STYLING OF SINGLE ITEMS

The processes above for styling an entire outfit can be used for simpler shots of single items. A blouse or shirt, skirt, slacks, shorts, or even underwear may all be presented on a vertical surface. This allows the garment to drape and bring itself to life. You can combine that drape with wall styling techniques to create an appealing off-figure shot. Roundness, a couple of gentle folds toward one side, and a gently rippling hem will give life and provide some surfaces for the photographer to light.

SETTLING QUICKLY

Pre-styling garments on boards may sound like an efficient plan and I know some studios that do it, stacking the boards while they wait. But if you do this, don't take much time perfecting them. If they wait overnight, the weight of the garment and all its stuffing and pins will cause it to settle and slump.

USING A FORM

A form can be constructed out of foam board, which has breasts attached and then is covered with batting. If your presentation uses hangers, the form can be taped to the hanger at the shoulder.

The shiny plastic half-forms that can be purchased for store displays are too slick to use for the wall techniques; you can't put a pin through them. The procedure for making them usable is described below. Something similar can be fashioned out of foam board, padded and covered with batting.

MAKING A FORM

For a recent high-volume wall styling project, I went into production with my intern making our own forms out of these clear half-forms. We wanted to have several each of men's and women's torsos for uniformity in the catalog. After purchasing the torsos from a store display supplier, we measured the narrowest tank tops that we'd be styling and marked the outline on the forms. We cut them with heavy-duty scissors, sanded the edges smooth, and, wanting a shapelier figure, experimented with bra cups from a fabric store. Layering a couple of cup sizes together, we taped the edges down and curved the waist into a narrower shape by taping a strip of foam board across the back. Gaffer's tape works fine for all these purposes, is strong and flexible, and tears easily.

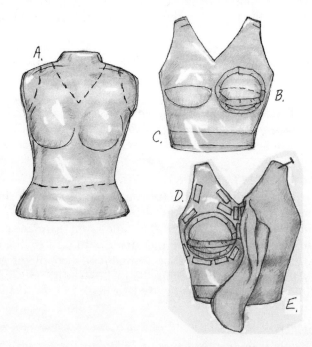

If you have your own form for wall styling you can experiment on your own to be more comfortable with the process. A. Cut a half-mannequin form to shape. B. Enhance the shape with bra cups. C. Narrow the form at waist with tape; this also provides an area for pinning to the back board. D. Cover the entire form with soft knit fabric.

To smooth the surface and hide the layers of padding and tape, we covered the form with a thick, soft fabric, placing double-stick tape around the breasts and edges for a defined shape. See illustration.

The same procedure created the men's forms, with batting taped in place for pectoral muscles. With T-pins through the form at the shoulders, they held the basic body shape but still required shoulders and arms. Purchased shoulder pads created a good shoulder shape in the men's clothing; we had to be a little more inventive for the women's, using miscellaneous materials. Smaller shoulders are formed with the carved foam and concealed by a piece cut from a thin foam sheet.

Similar forms can be crafted out of foam board and covered with quilt batting. The challenge is determining the ideal size and outline for your client's garments.

MAKING ARMS

This client wanted structured arms as well as curvy bodies. More experimentation occurred, since every project is a new adventure and requires new solutions. Stuffed arms purchased from a mannequin company were flexible and a perfect shape, but they were too heavy to keep in place. I made comparable arms using rubber tubing meant to insulate pipes. To create the elbow bend, I cut a wedge out, then wrapped the whole arm with batting, thicker at the top. An extra flap of batting at the shoulder could be taped to the form, and it allowed for putting the arm through a garment sleeve. For short sleeves, tissue paper worked well.

TIP Practice making your own form using a clear half-form, bra inserts, tape, and soft fabric. It will take a good bit of experimenting.

OPPORTUNITY

There is a tremendous opportunity for a mannequin company to market forms for wall styling. All available forms seem to be geared toward retail display. The ideal form will be three-dimensional, have a cut-out to see into the back of the garment, and be pinnable and lightweight.

Until that hits the market, we will have to continue to make our own forms using countless experiments.

SPECIALTY KIT LIST

As an addition to the basic kit list in Chapter 5, this list includes some specific items that will help with off-figure styling.

Item

For Off-Figure Styling
- ☐ Foam board
- ☐ Hangers
- ☐ Form, provided by you or the client

- [] Blocks of foam rubber
- [] White felt or fabric
- [] Quilting pins, about two inches long and with a large head
- [] Long pins, T-pins, or corsage pins
- [] Tissue paper, preferably unfolded flat sheets
- [] Fiber fill
- [] Quilt batting
- [] Monofilament
- [] Double-sided carpet tape (read about this tape in Chapter 9)
- [] Heavy white tape
- [] Wire (florist wire comes in pre-cut lengths)
- [] Wire cutter
- [] Safety glasses
- [] Scissors, sharp and pointed for threads, and others for tape
- [] Degreaser, for cleaning scissors

A NOTE ABOUT SAFETY GLASSES

Sometimes yellow-headed quilting pins are used for positioning the product into the foam board. They are placed around the edges of the garment and at crucial points on the front. The photographer may request that the heads be cut off for the final shot, to avoid retouching them out later.

The first day I was doing wall styling at The Territory Ahead, a catalog that uses appealing off-figure presentations, the yellow heads cut off of pins were flying everywhere. The studio was filled with the heavy clipping sound of wire cutters followed by the "pling" of the plastic pinheads hitting the floor, the walls, or some remote corner of the studio.

That's the way the other stylists were doing it, so that's the way I did it. Then, one of my pinheads didn't make the pling sound and I realized it was nestled in the inner corner of my eye. I plucked it out with its tiny nub attached and decided I needed safety glasses. I told the art director about the near miss, and she sent the studio assistant straight to Home Depot to get safety glasses for everyone. I was, however, the only one who wore them. I don't know how the others managed not to have their eyes poked out.

LEARNING OPPORTUNITIES

Styling assistants are not hired as frequently for off-figure styling as they are for wardrobe. Sometimes catalog shoots will incorporate on- and off-figure styling in the same workday, which provides an opportunity to observe both. But you may have to learn these techniques on your own. You might try practicing independently. Look at catalogs and magazines, trying to visualize the techniques that you've just read about.

PORTFOLIO CHALLENGE: MAKE YOUR OWN HANGER

One unique idea is to create your own hanger to accentuate a styled hanger shot. Use a curved branch or carve your own shape. You might use an everyday object with a hanger-like shape or paint and decorate a wooden hanger. Mix it with an appropriate garment and find a place to position it, outdoors or in. Go on to style the garment using tissue and other materials to give it some life. (Remember how effective my hanging sweater shot was for gaining clients!)

CHAPTER 9 Product Styling

IN THIS CHAPTER, WE will see what product styling is all about and explore standards and techniques for working with products. This type of styling may be used in magazines, presenting a still life to enhance an article or displaying the latest consumer products. But the bulk of product styling work is done for selling products in catalogs and online.

Whatever you usually style, there will sometimes be the spontaneous product-detail shot, inspired by the time and place. A careful look at a room the model is in brings your attention to other details you can improve with styling. The purse the model is holding in a restaurant setting may be photographed on the table for an inset. You will need to know how to fill it with just enough stuffing, position the strap, and pay attention to the tablecloth. As you know by this point, all types of photo styling overlap.

A PRODUCT STYLIST'S STORY

I met product stylist Trisha Hassler when I was sending out photo layouts to her husband, photographer Tom Hassler. They worked as a team, the first of many I have met through the years. They came to our catalog design offices and we discussed the layout of the images we wanted but did not supervise their shoots. The results were always just we wanted.

Trisha defines this specialty area of styling this way: "Product styling can be anything *not* on a human body. It can include furniture, jewelry, food, accessories, machinery, clothing, animals, large scale or small. Usually done to present an item for a specific purpose rather than editorial, which sets a certain emotion into the photograph, product styling is about *stuff*." Let's take a look at how she learned this trade.

According to my mom, I have been arranging the world around me my whole life. I have always been aware of the space I live in, work in, and the arrangement of things—either furniture in a room or a few items on a desk—placement is something I notice and want to be able to play with. One of my first jobs involved doing store display for several areas in a large department store. Display cases, floor displays, and mannequins were all part of that experience, and I learned quickly how to work with different materials and display supports.

As an art director a few years later, I was fortunate to work with a few gifted stylists. I watched over their shoulders and asked a lot of questions. When my photographer husband found himself in need of a stylist quickly, we decided I could fill in—we ended up working together for 20 years. Having worked in NYC with top stylists, he knew lots of tricks, so I continued to learn as we worked together.

CATALOG PRODUCT STYLING

Product stylists for catalogs may work in a studio or in various environments on location. Since details of products are being shown, the shot will usually be tightly cropped, rather than showing an expansive environment. As a product stylist, you will often use props to illustrate the use or "scale" (size) of the product you're featuring. Here product styling and prop styling tend to merge, but we'll look at prop styling as a specialty on its own in the next chapter.

PROPPING FOR PRODUCT SHOTS

All stylists need to use props occasionally for their shots, most often in product styling. Props that are used in catalog styling should enhance the scenario, never distract. To sell a set of bookends, you might select a group of hardcover books in one product-flattering color, with the dust jackets removed and without obvious titles on the spines.

Trisha says, "Times have changed. Years ago, the storytelling of studio photos was a big element. Every shot had props, certain surfaces, and even themes. Current advertising photography has evolved into a much simpler photographic style, and now many shots require no propping at all, or if something is called for, it is minimal. When there is such a style, the right prop becomes very important because the wrong prop hurts more than it helps."

When props look too inviting, customers sometimes want to purchase them, not understanding why they can't have them if they were in the catalog. This is a distraction from sales of the featured products and a negative experience for the customer.

If you're styling a cutting board for serving cheese, you might prop it with some Swiss cheese and a few crackers, a plaid napkin, and a small knife. The crackers could be a recognizable brand, like a Pepperidge Farm assortment or Ritz, or something more generic-looking—they're obviously props. But the cheese knife needs to be neutral and not make the customer want to order it. It should be undecorated and possibly set toward the back of the grouping. If there is a cheese knife offered in the same catalog, of course, that would be a good prop for you to use. The designer could even "line list" it, adding in small type, "Cheese knife sold on page 7."

For the cheese, I suggested Swiss—its holes make it easily identifiable as cheese. But choose on the set from several types of cheese in different colors to see what works best.

CATALOG PRODUCTS

The cheese board in the previous example is typical of many catalog products you will style. The home and food are important to people and products used around the home or with food represent a large portion of catalog sales. Products including furniture, decorating accessories, gifts, and kitchen items can provide a great deal of work for the product stylist. (Food styling is discussed in Chapter 11 and room sets in Chapter 12.)

Fashion accessories claim a large portion of catalogs' product mix. In addition to footwear, catalogs often include handbags, belts, hats, scarves, and other accessories alongside apparel. These accessories can easily be sold to catalog shoppers when presented with coordinating clothing items. They may be shown on the model and also in a separate product shot.

Styling jewelry is a matter of working small and clean, as fingerprints and dust will show in such a close-up shot. The photographer will have particular lighting challenges with trying to control reflections in the shiny jewelry items. You will make small, precise adjustments to positions and allow the photographer to adjust lights accordingly. Chains, earring backs, and other components are precisely positioned to fit into the shot and create an effective composition. Often, the products must be tightly controlled to stay in gravity-defying arrangements.

> **TIP** Make a variety of tabletop surfaces for still life shots. Purchase a 4 × 8 foot piece of birch veneer, have it cut in half, and apply acrylic stains in various wood tones to each side.

STYLING PACKAGES

One product category you may often overlook is packaging. In a store flier, you may see countless small images of a bag of dog food, package of diapers, or other products sold this way.

This is one area of styling that you may not even notice and will be surprised by the process involved. Again, a package is not just plopped into place by the photographer then set aside. The package has to be prepped before it's in front of the camera, so the photographer won't have to deal with a thousand tiny reflections in shiny packaging when it's lighted.

Minneapolis-based stylist Herb Schnabel is an expert in these high-volume projects.

He works as a freelance illustrator in addition to styling. Working in Minneapolis, a good bit of his work comes from Target stores, which produce a great deal of advertising, catalogs, store display, packages, and fliers. Now that Target is selling groceries, there is more work for food and prop stylists, too.

One of Herb's niches is styling packages for photography. This type of styling is not Herb's only work—he barely spends four or five days each year on it—but when he does it, he does it well. When you're faced with a packaging shot, now you'll know what to do too.

PACKAGE STYLING RULES

Herb's advice is: "Start over with the package as much as you can; you are building it over. Do it right once rather than spending time redoing it later—when only one sample package is provided, you must do it right." The most challenging shots are when the package is see-through plastic. Then the product itself must be styled inside the outer wrapping. Here are few examples.

STEPS/PACKAGE WITH ONE PAIR OF MEN'S UNDERWEAR:

1. Cut the package open from the back with a large X-shape (use an X-Acto knife).

2. Remove the cardboard sheet and product.

3. Cut a piece of foam board slightly smaller than the package (this will be larger than the original cardboard).

4. Wrap the foam board in felt; use white gaffer's tape to attach it.

5. Cut the butt portion out of the underwear, keeping waistband, as this is all that will show in the package, discard front.

6. Iron this piece.

7. Wrap it around the felt shape, neatly.

8. Wrap the plastic package around all.

9. Tape the X closed as snugly as possible.

STEPS/PACKAGE WITH SEVERAL PAIRS OF WOMEN'S UNDERWEAR:

Follow steps 1 and 2.

3. Cut away all but the butt and elastic of the underwear, iron them.

4. Instead of wrapping the underwear around the felt-covered piece of foam board, create tubes of felt, sized to fit the package (Note that they must be of uniform length and thickness).

5. Stack inside the package and close up as above.

STEPS/PACKAGE OF DIAPERS:

Follow steps 1 and 2, removing all the diapers.

3. Build a filler for the package using sheets of foam (2" or 3" thickness, available in fabric and craft stores). Use as many layers as needed to create the right thickness. This should be almost as large as the package.

4. Tape layers of foam together using gaffer's tape.

5. Wrap batting around foam filler and pin at back.

6. Tape the X closed as snugly as possible.

EDITORIAL STYLING

Home-related magazines such as *Martha Stewart Living* and *Real Simple* that present many product and propped shots maintain their own photo studios. Therefore, these magazines are more likely than fashion magazines to have full time staff stylists to produce beautifully styled images. The shots are there to enhance an article or to showcase new products.

An editorial shot may be considered prop styling, setting the mood for a feature story. But more often, magazine presentations show new household products, accessories, and apparel (experience with off-figure clothing is an asset for a product stylist).

Styling notes are usually printed in the gutter, the page's inner margin, listing the stylist or prop stylist.

MAKEUP SMEARS

While much of product styling seems to be "hard goods," there is another, softer category of products that fits in here. How often have you looked at fashion magazines and stopped at those shots of makeup brightly smeared, dripped, or sprinkled across the page? How do they do that?

The backlit tabletop described later in this chapter is sometimes a key player, as well as a great deal of practice. There are experts at these techniques (largely in New York and other fashion capitals) who closely guard their secrets, and sometimes even food stylists are hired for these jobs. Their experience with manipulating food can be transferred to the malleable materials of makeup and nail polish.

But we may all be presented with these challenges during the course of product styling. Cincinnati stylist Lauren Emmerling was given the job of writing out the word "Smile" in toothpaste for a grocery chain. She says, "I just had to practice a lot to get it right! I bought several brands and types to get the exact color they wanted and ended up cutting a hole in a zip lock bag to get the right flow."

If this type of styling appeals to you, I suggest you practice, practice, practice. Get some good knives and small brushes together and a clean surface, maybe a sheet of white acrylic. Copy the styling in magazine features and see what you can do. Each makeup product will respond differently.

EDITORIAL RATES

As with fashion styling, magazines generally pay a lower rate for freelance product styling than commercial clients do. The motivation for working for less is that you will be likely to get some wonderful samples of your work. Photographers usually receive less for their editorial shoots also. Being able to state that you have styled for a national (or even regional) magazine is a plus, and a cover or full-page tear sheet can be an admirable addition to your portfolio.

SETTING UP THE PHOTOGRAPH

Camera positions for product shots are similar to those used for off-figure shots. The most common view of a tabletop set is a roughly sixty-five-degree angle down from about eye level (like the view you would see if you are standing three or four feet away from a dining table). The tabletop may be a large board placed on concrete blocks or sawhorses, which allows for variations in height. A larger set may be positioned on the floor and shot from the same "three-quarter angle" or directly from above.

TABLETOP

The accessory photograph on the book cover is a good example of a tabletop set. Items that will fit on an area around four by six feet are suitable for tabletop shots. The camera is generally looking at the waist-level set from an angle above eye level. And the tabletop will most likely be a comfortable height for styling the shot. Around the set are lights and reflectors for controlling the light and shadows within the shot, so you have limited room to move.

As the shot progresses and the lighting is adjusted, there may be even more small lights, reflectors, and "flags," cards used to create small shadows. There will be C-stands in place for suspending products. Always look over your shoulder before you make a move, preventing accidents to both yourself and the equipment.

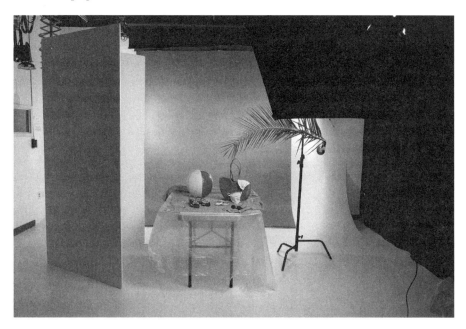

The studio environment where the cover of this book was shot. Folding table is covered with an oversized board and plastic tarp for easier cleanup of sand. Foam boards at left bounce light back into the set. Clamps on C-stand at right hold the palm leaf in position. Roll of blue seamless paper in background provides the sky while the ocean is created by a soft blue towel draped at back of tabletop. Photographer: Siobhan Ridgway; stylist: Susan Linnet Cox. © Siobhan Ridgway

INFINITY BACKGROUNDS

Often products are shot on a white or grey background, which becomes, in essence, *no* background. The graphic designer may want the item to float on the page. This may be referred to as a "knock out," "KO," "silo" (for silhouette), or other terms. When the shot is placed on the page, a new shadow usually is added by computer, so you don't need to be too concerned about the area outside the item, only that it is a defined shape.

The photographer's tabletop set may consist of a "shooting table," a curved white Plexiglas sheet extending above the surface so that the whole shot will have a white background with no visible seam. This is known as a "cove." Many studios have a large built-in cove, with the floor curving into the wall (both usually painted white), for shooting people. The tabletop cove is a similar idea. A cove can be created by unrolling a section of seamless paper, creating a curve to hide the point where the horizontal table meets the vertical back of the set.

TIP Keep a pair of thick, clean socks in your supplies for those occasions when you are working on a white cove. Walking on concrete barefoot or in thin socks all day can be very tiring.

BACKLIGHTING

Translucent Plexiglas, or a shooting table, may be used as a tabletop surface to allow light to be projected from behind and beneath the product. This technique is dramatic and can be used for products that have translucent qualities themselves. The photographer will also light the object from the front, aesthetically balancing the two light sources. The shot of a sheer white blouse in the color insert was photographed this way, but backlighting can be an effective presentation for other products as well, such as food or jewelry.

SURFACE OPTIONS

Decorative art paper, fabric, colored seamless paper, and other background materials can be positioned on the tabletop to create a more interesting shot. These would be used for a "square-finish" or rectangular shot, when a knock-out isn't needed. Pay attention to the layout to see the shape of the image. The catalog or advertiser doesn't want any wasted space around the image so the product can be shown as large as possible and, at the same time, create a pleasing composition. The photographer may create a rectangular frame in front of the monitor (sometimes by using "croppers," which are two L-shaped pieces of cardboard to see what the final cropped shot will look like). A clear acetate print of the layout may be used to view the image shape, or the photographer may simply create the image proportions in software.

Note that the finished photograph presented to the client should have more space around it than the cropped layout dimensions, allowing the designer to position it in a variety of ways.

Other surfaces like wood, tile, or bricks might be used to create an environment that looks like a room or an exterior setting. I particularly enjoy duplicating an outdoor environment in the studio, working with leaves, soil, sand, and other natural materials: maybe it reminds me of sandbox days. Remember the cover shot of this book, shown earlier, and the boot shot shown in the color insert? A small environment may be built on a tabletop.

SET BUILDING

A client may present a layout that includes a specific type of room or some other location for a shoot. While it's always an adventure to go on location, studio shoots are much easier, even when a set must be built. Not only is the studio environment controlled—there are bathrooms, coffeemakers, convenient electricity, and control over lighting and equipment—but it is often difficult to find a location to match the client's layout.

Photographers seem to enjoy these set-building projects immensely, being creative people too. The project may require subbing out construction, hiring set builders, or having a prop fabricated by craftspeople such as welders or carpenters.

For a series of holiday shots, a San Diego photographer I worked with built a fifteen-foot-long wall in his studio. He painted the wall red and then added a fireplace, chair molding, baseboard, and hardwood flooring. We used it for close-ups of products under a Christmas tree, on the brick fireplace hearth, and for a wide layout of socks.

I booked my husband, who has great runner's calves, to sit out-of-frame with a female model resting their sock-covered feet on a leather ottoman I had rented. The scenario to the left of them was a lighted Christmas tree, gifts, stockings on the mantel, and a lively fire in the fireplace. While the models sat very still, the photographer lit Sterno and newspaper behind the fireplace to create the perfect roaring blaze, which was captured during a long exposure. I hoped we wouldn't be affected by fumes in the studio. We weren't, and ended with a great shot—all to sell running socks in a holiday catalog.

On another full-page shoe shoot, the same photographer built a large box so we could create a stream environment. We filled the box with soil and rocks, then added vinyl to form the stream bed. Final touches were smaller rocks, water, ferns, and moss (use of my old plant-store experience). Three styles of water-resistant hiking shoes were presented in this natural-looking world. I made ripples in the stream with a stick out of frame.

ON LOCATION

If a location shot is specified, you need to be sure to have all your props, supplies, kit needs, and especially the products with you. A whisk broom and window cleaner are especially useful to have on hand to make an outdoor scene presentable in a photograph. Unexpected litter or dust can be quickly cleaned up.

On the plus side, the products can look much more interesting in a realistic location, and the outdoor spots can provide a story line or theme for the studio shots. Finding the perfect set of tiled stairs or tree branch to display a pair of shoes can be lots of fun.

TECHNIQUES FOR MAKING OBJECTS OBEY

Much of product styling is problem-solving and logic. There are plenty of materials and techniques that you will use, but as with other types of styling, there are no absolute rules. Useful materials that a photographer might have

in his or her studio include putty, monofilament, clear plastic stands, wooden blocks, bricks, concrete blocks, pieces of foam board, mat board, metal weights, permanent markers, and all types of tape.

PUTTY

Photographers' putty has been a mainstay of studios forever. The source of this useful, sticky material, however, is always a bit of a mystery even within the photo industry. The information is rarely shared. Several years ago, a photographer from India who had lived in South Africa gave me a flat package of light gray putty he bought there. I mentioned this to a stylist I worked with who was a native of South Africa. She seemed disturbed that another stylist knew about the elusive putty. She'll be sorry to see I'm letting the secret out here.

The package lasted until recently, since only a pinch is used at a time. (Plus, it can be re-used!) I had to find a new batch of putty and didn't know anyone who was traveling to South Africa, so I took a chance on some putty I found in an online search. This putty is sold to consumers for holding objects in place during earthquakes. When it came I was happy to discover it was imported from—you guessed it!—South Africa.

The uses of putty range from holding something in place to lifting an object the tiniest amount. Mostly it's used for controlling where an object is positioned. A little dab can be molded as needed. You can even use a bit for picking up dust and lint from products. If the putty leaves a residue on the product or set, it can be cleaned up by touching it with more putty, as it sticks to itself. It's similar to the material used for putting up posters, but more durable.

There is a similar product called clear museum gel. I was excited to find a jar of this transparent gel at the Container Store checkout stand and had the opportunity to try it for a jewelry shoot that included see-through watchbands. It did work well for positioning the products with minimal touch-up for the photographer—we were shooting on art paper backgrounds and needed the color and light to show throughout the shots. My only disappointment was that it left a tiny oily mark on the art paper. When online, visit www.gotputty.com for earthquake putty (same as photographers' putty) and www.improvementscatalog.com, one of many sources for clear museum gel.

MONOFILAMENT

Translucent and nearly invisible, monofilament is the second most useful tool for product styling. A strand can be taped to the back of the product at one end and taped to a C-stand at the other. Taping lets it be more adjustable than tying would. Monofilament, also known as fishing line, is for sale in sports and fishing departments and online.

This is how you would style a handbag and add the perfect curve to its strap. Start with the bag at a slightly turned view rather than straight on, unless it's required by the art direction. See which portion of the bag has the

most important features. Stuff the bag with tissue paper or batting. A towel might work for a large bag or suitcase.

Tape a strand of monofilament to the back of the handle or strap where you need it to be lifted, using a bit of aluminum tape, white carpet tape, or gaffer's tape—or tie it. Lift the other end of the monofilament above the set till you create a good "drape" for the handle. Tape the monofilament strand to a C-stand, which has been moved into place by the photo assistant. The stand can be moved and adjusted as needed. Perhaps you will want to do this to a couple of areas of the strap. A longer strap looks good draped behind the bag and gracefully looped around to the lower front. This arrangement helps the layout stay compact. Keep an eye on the layout and on features of the bag. Floppiness at either end of the strap attachments can be corrected with small pieces of aluminum tape or putty.

TAPE

As you've seen in the kit list, tape is one of the most crucial materials for styling. Most photo studios keep gaffer's tape on hand, often in multiple colors, but definitely black. Gaffer's tape is a matte finish cloth tape, perfect for countless uses, from marking the model's mark on the floor to attaching monofilament to a product. It's easy to tear by hand and easy to remove.

One of my long-time favorite tools is white, double-sided cloth carpet tape. With a paper liner, it can be used as either double- or single-sided. The adhesive is incredibly strong, but with the paper attached, it is sturdy enough to provide shape to a soft material. Its only drawbacks are that it must be cut with scissors and the residue it leaves behind on the scissor blades, which can be removed with degreaser.

Unfortunately, when I looked recently, it seemed to be off the market. A search through builders' supply stores was fruitless; however, a long online search finally resulted in the thrill of discovery. I found this double-coated carpet tape with paper liner at the ultimate tape supplier, www.findtape.com. Gaffer's tape in many colors is also sold there.

While we're on the topic of tape, it's important to mention aluminum plumber's tape, sold in builders' supply stores. I first discovered this valuable tool when styling shoes, but it is a must to have on hand for many uses. Shapeable yet lightweight, it can be used to stiffen a corner of a garment or purse and can be sculpted into a shape. We'll explore aluminum tape more in Chapter 12 on room sets and bedding.

PLASTIC STANDS

If you visit a plastics shop, you're likely to find a scrap bin with odd sizes of clear Lucite, Plexiglas, and other scraps. There will be plenty of other shapes and sizes available in the showroom. These can be used to create a variety of levels for positioning items within a shot.

The advantage of using these clear materials is that light can shine through them on to other parts of the set and the blocks are nearly invisible. Having several different stand heights will help you to stagger products in

the shot and choose the height you need. Some photo studios will have these clear stands on hand. If it seems like a crucial need, be sure to check first.

WOODEN BLOCKS

Having used a photographer's set of children's wooden blocks in one studio, I have searched in toy departments only to find them no longer available at many stores (how sad for children!). However, they are for sale at specialty toy retailers. You don't need the fancy colors and shapes, just squares, rectangles and triangles of wood. Trisha Hassler loves these styling aids, too, and suggests making your own.

"I find it's great to have tiny wood chunks and an assortment of medium blocks in my toolkit. I like to have matching groups of four blocks in case something like a chair or table being used as a prop needs to be lifted evenly. These blocks are best made by you or someone you know with a saw. I have collected end cuts or begged lumber from friends who are working on a wood project over the years, and this way you help them by taking their scraps."

They're just right for lifting or supporting items in a shot. If you wrap the blocks in white and black fabric gaffer's tape, they can blend in with the set and, even better, won't slip.

BRICKS

On a larger scale, a couple of bricks can come in handy. I've used these for supporting the back of a stack of products, anything heavy. Again, wrapping a brick with fabric tape prevents it from sliding on the set and also keeps it clean and smooth.

Photographers can clean up the shot in postproduction—they will let you know how much they are willing to do—but your objective should be to make your shot look as close to perfect as possible.

STYLING SHOES

Some clothing catalogs have so many shoes in their merchandise selection that art directors assign certain photographers just to shoot footwear. They may become bored with endless parades of shoes, but they do have steady work. Other catalogs sell nothing *but* shoes. Along with fashion footwear, the athletic-shoe market is huge. I love styling shoes, finding variety in combinations of three or four single shoes and showing the essential features.

Shoe styling involves certain traditional standards. While a series of shoes may be portrayed in profile, most arrangements show all the features important to a customer. These especially include heel height, toe shape, and colors. The arch side of the shoe is not usually shown; the outer side is considered more attractive. Shoe samples are generally size six for women and size nine for men, considered to be the most attractive for viewing off the foot.

A grouping may include one or two shoes of each color, a side view to show the heel, and a fairly straight-on view of the toe box. If there are distinctive sole treatments, a bottom view is included. Extra colors are generally shown from a variety of flattering angles. Some shoes may be placed in gravity-defying positions by using

Lucite blocks, monofilament, putty, and other tools of the product styling trade.

When I've styled shoes for sports catalogs, different standards applied. Technical features are of prime importance: sole structure, arches, and laces. In this case the arch side is the featured view. The laces may be tied, tucked, or shown casually untied. Although untied is rarely the presentation of choice, I enjoy creating a beautiful drape to the untied laces.

If shoes are soft and floppy, aluminum plumbing tape can be placed inside the shoe. Since it's flexible but stiff you can sculpt the shape you want. We'll explore more uses for this fun styling material in Chapter 12, Room Sets and Bedding.

CREATIVE PROBLEM SOLVING

Your job as a product stylist is finding the right solution for styling each shot, whether it's a stack of belts, an array of shoes, or a vase of flowers. Problem-solving and creativity teamed with the materials above will help with each styling challenge. After many years of styling, I still have moments at the beginning of a shoot when I wonder if I know what I'm doing! But I proceed one step at a time until the familiar processes of styling take over.

And, I try to include the tips I collect from others in my "fix-it kit." I learned this valuable hint from a Seattle stylist when I was directing a holiday shot of a model in sleepwear, and I've used it ever since. When I blew out the candle we were using as a prop on the homeowner's antique dresser, the wax splattered all over the top. After I cautiously scraped it off with my thumbnail, the stylist said, "What you do is hold your forefinger anywhere between your mouth and the candle. When the wind goes around it to blow out the flame, it won't spatter." Try it: it never fails.

A NOTE ABOUT CLOCKS

Clocks have their own standards for styling. Have you noticed that on analog clocks it is always ten to two, or ten after ten? Most of those who are even aware of it assume that is the most aesthetically pleasing position for the hands of a clock to be in. A British photographer explained the background of

the trend this way: most traditional clocks had a brand name in the upper center of the clock face. When photographing them, photographers—or perhaps illustrators, if the tradition goes back to before the camera was invented—positioned the hands on either side of the logo or brand name.

When digital and LCD clocks entered the market, the rules changed. A challenge to stylists and photographers involves shooting three digital watches together. If they are actual working watches and not prototypes, they must be set to the same time, but typically (and frustratingly) the minutes on each don't change at the same moment. Almost always, after controlling the lighting to show the display and enhance the rest of the product, and watching the time progress, the photographer layers many exposures together in Photoshop to create a final image. This means much work for one shot of three watches. This is the behind-the-scenes reality of photography.

KIT SUGGESTIONS

Item

For Product Styling
This list includes some specific items you will need for product styling in addition to the basic kit list in Chapter 5. Be sure to have them with you on shoots.

- ☐ Monofilament (fishing line)
- ☐ Putty
- ☐ Clear museum gel
- ☐ Lucite blocks in varying heights (buy from plastic companies' scrap bins)
- ☐ Weights (divers' weights or other pieces of metal)
- ☐ Wooden blocks
- ☐ Double-sided carpet tape
- ☐ Plumbing tape (aluminum waterproof repair tape, available at builders-supply stores)
- ☐ Jewelry cleaning cloths
- ☐ Paintbrushes for cleaning sets

ADVICE FOR PRODUCT STYLING

When I accepted one of my first product styling jobs, I consulted with a friend who was an experienced stylist. Her advice to me was, "Don't get too precious." I believe she meant that I shouldn't get too involved with endlessly reworking the styling. While we want to do the best we can, sometimes it helps to stop styling, step back, and take a look at the shot. It may be just right, which is hard to see when you're working up close. Those words often come back to me when it seems something is not working. I may just be too involved, too precious, to see what is there.

PORTFOLIO CHALLENGE: STYLE A COSMETIC OR BATH PRODUCT

Choose a cosmetic or bath product you would like to work with. Face cream, bath salts, or something with some color and/or textural interest will work best here. The photo will be showing some of the actual product in the container with the lid open as well as the packaging, so think about what your product will look like with the top open. Look for a product that comes in a jar and has a screw top or pop-top so the contents can be viewed from over the top of the container.

You may find some practice will be necessary to get the right look, so do not purchase anything expensive! An extra jar to use as backup can make this less nerve-wracking. And you might use some of its contents to supplement your product.

Begin by working at a counter, not on your clean white surface. Take your product and open the top. Next, swirl the cream or crystals while they are still inside the container into a pleasing circular swoosh. Think small movements. Be sure to keep the edges of the container clean and free of product. (Swabs could be useful here) And when you have a swirl you are happy with, move the container to the set and place in the center of the white background. Next, place the lid off to the side and compose your photo. Be sure to have the entire product in the shot with white edges of background all around producing your KO or silo photograph.

Remember, this is to sell a product, so the product needs to look appealing and the lid of the container will reinforce the packaging, perhaps even the name of the maker. Does it read well? Can you tell what the product is? Does the photo make you want it?

Option: add a small prop to help clarify the product by relating to its use or fragrance. Be mindful of taste level and target customer. Keep the propping in small scale to the product so it doesn't overwhelm or get lost. Product is always the hero.

CHAPTER **10** Prop Styling

SOME STYLISTS MAY SPECIALIZE in pulling together props for a magazine or a food shoot; they are known as prop stylists. They usually don't dress models or other talent. Instead, they excel at tracking down the right props and presenting them in an appealing way. In a food shoot, for instance, the food stylist would prepare and present the food, but the prop stylist might gather options for dishes, silverware, napkins, and a tablecloth or background surface. Or sometimes there might be a wardrobe stylist and a separate prop stylist. This was the case in the shoot I described in Chapter 7, which portrayed a real family hosting a barbecue meal for their friends. Crew members included the art director, photographer, food stylist, her assistant, me as wardrobe stylist, my assistant, a makeup artist, and a local prop stylist with an editorial background. The prop stylist's responsibilities included providing tablecloths, flowers, and a vast assortment of serving dishes and tableware.

But this is relatively rare. Generally photo stylists work in several areas, moving back and forth between clothing, hard goods, and styling with props. In many markets, you need to accept the projects that are available, and shoots may involve a combination of styling areas. On many of my projects, I am the only stylist and I focus on wardrobe, products, and all the props. While you may be asked to use skills ranging from clothing to hard goods, it is helpful to know specific techniques for finding and styling props.

A PROFESSIONAL PROP STYLIST
Beth Reiners does what she loves best: propping and styling beautiful food sets. Her creative job is to find, rent, purchase, and execute the props that surround the products featured in print advertisements. With a background in fine arts and photography, she worked for an ad agency whose main client was Kraft Foods; that led her down a path of styling props for food photography. Beth works in Chicago as a freelance prop stylist, having perfected her talents for nearly two decades.

Beth's education, experiences, and love of shopping have led to a fabulous career and a strong passion for prop styling. It doesn't hurt that she lives near an area (Chicago) that has lots of food industry clients and agencies that work with them to do advertising.

WORKING ON FOOD PHOTOGRAPHY
Many magazines are published about food, full of articles, recipes, and gorgeous photography. Nearly every lifestyle magazine seems to include at least one food story, with menus and recipes. The articles are surrounded by food advertising. Cookbooks, as you know, present gorgeous images of plated food.

There is a photograph on the packaging of nearly every product in the grocery store portraying what is inside.

Props are an essential element in these images. Food stylists must select just the right item to enhance and flatter the food they're styling. On the perfect shoot, they are paired with a skilled prop stylist to accomplish this and are free to concentrate on the food. The next chapter is about food styling and the styling specialists who learn how to work with and present food in photography. First, we will look at how the food is served.

PROPS FOR ADVERTISING

In advertising, layouts tend to be specific. The advertising agency will have planned the space carefully, and the prop stylist's job is to provide options that will work with it. Tear sheets may be provided to demonstrate the look the agency is after. The background of the shot may be as critical for the prop stylist as the dishes used in the foreground.

TIP Gather autumn leaves when they are on the ground and save them for those fall shoots next year. You can mix in some artificial leaves for brighter color. If you keep them in a clear plastic bag you will remember they are there when you need them.

STORE DISPLAY

Images you may not even be aware of until you're in the business include store display, also called "point of purchase," or POP display. Placed throughout retail stores, these are placed on merchandise racks and boxes, in window displays, and above shoppers' heads. They may be large, backlighted images or simple cardboard signs.

Beth describes a shot she was assigned for a wide "header card" for a brand of bread. The header card tops a freestanding display in a grocery store and can be interchangeable for different seasons. The layout provided showed only the shape and the logo position, leaving the photographer, food stylist, and Beth to come up with the image. She did some research and found a stock photograph of eight pieces of bruschetta on a square white plate on a rich wood surface with some basil and other ingredients in the background for an inspiration. It was challenging for her to find an arrangement that would work for the wide, horizontal layout; a single slice of bruschetta would have looked gigantic. The client would not be present at the shoot but requested three different versions of the header card image, leaving the creative team the whole day to spend coming up with solutions.

PROPS FOR FOOD PACKAGING

Food packaging is an exacting art. Federal laws and corporate standards are quite specific about what can and cannot be portrayed. In essence, the food shown on packaging must be the real product the consumer will be purchas-

ing. While the food stylist is weighing the exact proportions of ingredients to be shown, the prop stylist is preparing the dishes, utensils, and setting. Companies are extremely consistent in the styling of their product lines, whether a new line of products is being introduced or new items are added to an existing group.

EDITORIAL PROPPING

When it comes to styling for magazines and cookbooks, your creativity is given freer rein. Look through food magazines to see the range of possibilities the prop stylist can work with, from dishes to background materials to seemingly random bits of storytelling.

In a cookbook, there may be many images needing a variety of views, tones, and props, so the book holds the reader's attention while representing the recipe honestly and enticing the appetite. Props may be antiques, colorful, or barely noticeable. Vessels for the food may range from baking dishes to cutting boards to bowls and mugs. Food stylists and prop stylists should work together to plan what is needed for each shot, paying attention to the portions and quantities in the recipes. A food stylist told me about a prop stylist's delight at finding an antique dish that was attractive—but too large for the recipe and, furthermore, wasn't ovenproof. And there weren't any options! This is the Rule of Propping that we will discuss shortly.

SMALL SCALE

A small plate makes the food look bigger. "In food photography," says Beth, "this trick is one of my favorites. In fact, almost all of my prop dishes, flatware, and glasses are small. For plates, I use dessert plates or even saucers. For glasses, I use juice glasses and sometimes even tall shot glasses. My flatware, then, must be accordingly small or the plates will look oddly sized. Dessert forks and spoons (and the occasional baby silverware!) work beautifully.

"A small plate allows the food to take the stage, not the plate. Heaping the food becomes simple. Piles stay in place. You can get close, showing the texture of the food, without having to crop out too much of the overall setting. Getting close also changes the perspective on the photo and makes the food look new and interesting."

WHITE DISHES

White plates are the go-to solution in food photography these days, especially for advertising, when a neutral white plate really allows the food to be the feature. As you'll see in the next chapter on food styling, many companies have their own style of plate reserved for all the products in a line, for consistency. The dishes and silverware used in packaging, in fact, are packed away and reserved in a photographer's studio for that client only. As new products are added to the line, the layout and all the elements often are identical. Learn more about how this is done in Chapter 11.

SET DESIGN AND PROP STYLING

While many consider set design to be part of prop styling, and as you know, there are no firm lines between any of the specialties, I have included styled room sets with bedding, considering that part of styling to be more of the big architectural picture. But some environments created for photo shoots require the skills of a prop stylist specializing in set design.

Summer Moore graduated from Parsons, The New School for Design with a BFA in photography and has since built a career in New York City assisting set designers and other stylists on a variety of projects. Her eventual goal is to incorporate skills learned while working on sets into her own photographic projects, and she is learning the ropes as an assistant while she builds her portfolio.

She says, "Set designers most often work on fashion shoots or portraits where a wider view is seen, dealing more with the entire set (floor, backdrop, props, furniture, etc.) being put together in a studio or location.

"The terms prop styling and set designing do go hand in hand, and many stylists can do both and end up using the terms interchangeably. I know of some set designers who do prop styling for still life as well. There doesn't seem to be an absolute line between the two, although people may focus more on one than the other. The term production designer is sometimes used, which is more of a film term, but I have seen it used on still shoots as well."

SETS FOR FASHION SHOOTS

Summer describes one dramatic set design project she assisted on for a fashion shoot, which "involved shooting a picture within a picture, which essentially meant creating two sets for one image. We built the first set using antique tapestries, rugs, and furniture in blush and gold tones. We also shipped in real (though dead) butterflies from around the world. We shot the models with this first set, both a male and female version. Then had a professional sign company make a 20×30 foot decal of the images, much like a billboard, to be installed onto the marble walls of an old mansion staircase. The models were then shot again in front of their image within this new set/mansion. It was an intense shoot, but the images turned out incredible."

Look at fashion editorials and advertising in magazines to see the possibilities for set creations. Whether it's a series of Jackson Pollock-inspired wall panels or a vintage gas station in the desert, when there is lavish background, there was likely a set designer involved in addition to the fashion stylist. But even on very simple shoots with just seamless paper and a chair, there may be a set designer/prop stylist as well. It is not always the photographer who is responsible for sets.

According to Summer, "Advertisements and catalogs tend to have a very specific look they are going for, whereas editorials are more open to creative input, and at times you must get creative based on the smaller budgets magazines have.

"The photographer has a lot to do with this process, and interesting things happen when you have someone who shoots more fine art photography, come

in and shoot products or fashion. Those are the projects that work your brain in a different way, and unique ideas come out of the collaboration." I expect that Summer will have an interesting career as a photographer.

PROP BUILDERS

When complex props are called for, they may be created by a prop builder. This could be someone who works on photo shoots (and film) regularly or an industrial fabricator. Think metal shops, awning companies, and carpenters. A painted canvas backdrop may be created by specialty companies or even available as a rental.

But you as the stylist may be challenged to build props. A decision must be made as to whether custom fabrication should be contracted out. In that case, says Summer, "It's our job to arrange everything to be delivered and built at the studio in time for the shoot and be sure that everything is returned and sent back to the appropriate place. Once the shoot wraps, the final step is compiling and itemizing receipts for billing the client."

TIP When you meet craftspeople, such as glassblowers, sailmakers, welders, or carpenters, collect business cards in case you need their services for prop building later.

PROPS FOR FASHION SHOOTS

If you've looked at an Anthropologie catalog, you've seen the crucial role of props and settings in their presentations. The praiseworthy thing about Anthropologie's environments is that they never distract—the environment tells a "story" that makes the products and fashions even more attractive.

One of my favorite editions of the catalog is based on a circus theme. Classic circus tents and props are displayed in fashion shots, with the fashions on models shown relatively small. In other shots, close-up details are shown, always accompanied with a big-top prop. The accessories are also photographed with themed props and backgrounds. What fun it would be to search for these classic circus props!

I haven't been able to find out whether Anthropologie hires prop stylists (though it appears they must) or incorporates the challenge with the fashion stylists' duties. Each issue of the catalog presents a different propping theme and does so tastefully and skillfully.

Other fashion lookbooks and catalogs use a theme to differentiate sections. A background color or setting can divide the book in the way that different areas of a department store feature their own style. Props and colors can help to create a cohesive style even when models are shot on location and accessories in the studio.

Throughout fashion magazines and catalogs you will see themes that either inspired the shoot or were inspired by the fashions. Whether it's a location

or a set built in studio, the colors, shapes, and associations of the set add to the appeal of the fashion story. We will discuss these scenarios more in Chapter 12.

MOOD SHOTS AND BRANDING

A styled photograph may be used to create a mood or tell a story rather than sell a product. An advertising agency is more likely to initiate the concept for this type of image. An example of this is a brochure I worked on for the Florida-based Publix grocery chain. The photo was used inside a brochure sent to soccer-league parents; it included coupons for cleaning products and a reminder of the grocery's sponsorship of the league. The purpose of the photo is to pull the viewer into a story: You have a small child who plays soccer, has dirty uniforms, and tracks mud into your home. You don't mind because you love your child and you can simply buy some products to clean everything up.

My role as the stylist included finding children's soccer shoes, which had to be dirty and well worn. I purchased them at used-sporting-goods stores. I also needed shin guards and socks, preferably in green, the chain's color.

The key styling material was mud. It was unique and enjoyable mixing dirt found outdoors with water to get the best consistency, and then dipping the sole of the soccer shoe in the mud to make tracks in the set. I also rubbed mud into the socks and shin guards. Other props included the lamp, book, vase, and flowers on the table. The "hallway" was built by the photographer in his studio, with hardwood flooring and baseboard. The background space was left empty for the overprinted text.

BRANDING CONCEPTS

Mood shots are used for selling a brand, a company philosophy, or a service: they may not even include a product. There is a concept being portrayed and your role is to understand and express that concept with your props and styling. Often there is an advertising agency producing and art directing these shoots.

There will be a written overview and a well-drawn "storyboard," an illustration of the layout idea, based on resources the art director has viewed for inspiration, or simply on imagination. Some of these layout ideas are realistic, but others are physically challenging for the photographer to reproduce. The layout will usually be sent to you before the shoot so you can develop prop ideas.

ANNUAL REPORTS

Public corporations are required to provide an annual report to their share-holders. These are a classic example of corporate branding: the company philosophy is presented along with a financial report of the year's business. These printed pieces are an opportunity for graphic designers to be creative and for photographers to shoot a variety of material, from executives' portraits to mood shots. Annual reports are not a regular source of styling work, but you may be called in by a photographer to develop some of the concepts. The project would be similar to a non-product advertising image.

THE RULE OF PROPS

Probably the most important thing to remember about props is that you should bring two or three times as many as you think you need. If a client requests a set of desk accessories, a wastebasket, and a throw for the back of the chair for an office scenario, bring three choices of each. So often, what appears in your head when you hear "desk accessories" is not what the art director is visualizing. When you're shopping, you may find an additional style that neither of you imagined. Maybe bring a set from your own collection too.

Always apply this rule when supplying props (as in wardrobe styling), and you'll never mind having to carry so many props to the shoot and back. The glow in the art director's eye when you bring out your unexpected "backup option" is worth every effort.

PROP FUNCTIONS

The second rule of propping is that props are used to enhance products when the products are the focus of the shot. The prop is not the star, only the "straight man" making the star look good.

However, when a photograph is used to capture the reader's attention or to illustrate a concept, the prop itself may be the primary element. Note that the props can be both hard and soft materials.

SHOWING SCALE

An important function of props, particularly in catalogs, is to show the size of another item. A photographer friend of mine has a tiny beer mug that he likes to shoot by itself and then with a handful of Goldfish crackers next to it to illustrate our perception of size.

As you've seen, small dishes are a good choice to make food appear larger. This can be effective in catalogs as well. Just follow the fine line between reality and showing a perception that may cause a resentful customer later.

GENERIC PROPS

You want to avoid any easily recognizable brands—props should be "generic," suggesting a plain wine bottle, for instance, rather than distracting the customer with an identifiable label. You can create more timeless photos this way, too. Props that are fashionable or trendy soon make the photo appear dated. If electronic equipment is shown, make sure it's the latest technology available, since these products change quickly. Magazines can be rolled so that only a portion of the cover shows. Calendars can have the year marked out. Careful use of props can make the photo real and, at the same time, simple.

PROPPING SUGGESTIONS

This is a brief list of ideas for propping shots, meant as an inspiration. Many of these props will also be useful for room sets.

- **Fake ice cubes, ice gel:** Photographers may have these, or see resources at the end of Chapter 11.

- **Food props:** Popcorn, potato chips, pretzels in large bowls; lemons, apples, or tropical fruit piled in a bowl; slices of lemon or lime in drinks.

- **Generic food props:** It's best to *suggest* products. (See the photo of generic products in the color insert.) Turn labels partially away from camera, if using brand name products, like a bottle of Perrier water or Corona beer.

- **Dish towels:** Soften the scene with folds of fabric. These can also fill in as a napkin in a food set.

- **Water droplets:** Glycerin and hypodermic; alternatives are pet conditioning spray or leave-in conditioner.

- **Books:** Remove dust jackets of hardcover books, look for color and size, or wrap books in art paper. Collect small and old books to have on hand.

- **Vases:** Flowers, enhanced with vines and branches or fill with tropical leaves or tree branches.

- **Pictures in frames:** Use your own snapshots, color copy to size; but use nothing copyrighted or with visible people (need model releases).

- **Driver's license or diploma:** Obscure name and address, partially cover, or show far enough away to be illegible.

- **Keys, money, cell phone:** Needed often for wallets or purses, pull your own from your bag.

PROP COLLECTIONS

Magazines such as *Martha Stewart Living* and *Real Simple* keep a bountiful supply of props on hand, as do many in-house catalog studios. Target is known to have a huge prop collection. Every item is catalogued and tracked with a bar code. For creating images to accompany feature articles and propping new-product stories in magazines or selling products, these prop collections include everything from furniture to vases.

I was delighted to find my way around the prop collection of one catalog studio I worked in. Nearly every item you might need was there: bars of soap, silverware, candles, vases, beach balls, picture frames, and endless stacks of books in all colors, with dust covers removed. How nice it was to wander the aisles seeking the perfect props to complete a shot, and finding them right there in the studio!

Many photographers, especially those who shoot a lot of food or other product shots, keep well-stocked prop closets in their studios. Props used for previous shots seem to stay and become part of the studio's resources.

BUILDING YOUR OWN PROP COLLECTION

As a stylist, whether or not you specialize in props and whether you plan to or not, you will soon have your own prop collection. We all appreciate the beauty

of things, sometimes more than their function, and some items are just too beautiful to let go. Many of the items you acquire will come in handy when selecting options for future shoots. Some you will never use again, and some will become part of your daily life.

For a while, I kept a storage space. It was nice to keep my rolling rack and steamer in there, and in time the space was filled with props I stored for a once-a-year garden client (they helped pay for the rental, which was helpful). I also kept props on hand that I hoped to rent to other clients, but it seemed that not one item was ever called for again, except some seashells. If you have a storage area at home or a garage, you can keep your overflow props there. Otherwise, you may have to live with them, literally.

If you work with the same photographer regularly, you may be able to keep a shared storage closet there. Beth suggests using small plates in part because they take up less room in a storage area.

SOURCING PROPS

Sourcing is the process of finding props that can be provided for use in a photo shoot. It's a benefit for a company's products to be shown in a photo, especially if they are recognizable.

For a branding photo for Marriott Renaissance hotels, the concept included twenty-four chaise lounges lined up poolside in front of a podium to indicate the hotel chain's unique approach to business meetings. Each chaise had a dark red towel and a pair of sunglasses. Acquiring more than two dozen of each prop was a challenge. I contacted the public relations company for Martha Stewart for the towels, but they were unwilling to provide the quantity needed. I purchased them, visiting several stores—and returned them after the shoot. Dragon Optical managed to loan me thirty pairs of expensive matching sunglasses. (A Dragon Optical–sponsored athlete referred me to the sales manager who was kind enough to respond to my request.)

PROP RENTAL HOUSES

Several years ago, I was invited to contribute to a conference call for food stylists as one of two professional prop stylists; the other was from New York City. I had my list of resources in front of me: the chain outlet stores, Marshalls, Ross, and T.J.Maxx; Target; Salvation Army. I felt like such a hick when the other expert started to talk about her "prop houses" and how she goes and browses for what she needs.

And it seemed too easy! After all my furtive driving around from store to store, she goes to one place where they've already selected the best of everything? And rents it? But why not, if the option is there? How heavenly to browse in a warehouse-like store where the best of everything has been gathered, you can have whatever you want, and they understand the work that you do.

Beyond New York, many cities do have prop rental services. Los Angeles, naturally, has many rental options for the movie industry—you can find anything there. There are antiques, vintage items from specific eras, '50s era modern, and contemporary. There are dishes, furniture, carpets, suitcases, historic

costumes, old appliances. Prop houses are found in many major cities also, like Chicago, Seattle, San Francisco, and Miami. Research your own area.

PURCHASES AND RETURNS
In Chapter 4, we discussed the process of purchases and returns. This applies to props as well for those occasions when you don't have access to a rental house.

Rentals can sometimes be arranged with retail stores, especially antiques stores. And some department stores, like Macy's, will make arrangements with you if you let them know you are a stylist. Of course you will have blown your cover, but it's worth it if you can conveniently prop shop.

PROP STYLING FOR FILMS AND VIDEO
When I watched the Johnny Depp movie about John Dillinger, *Public Enemies*, I remembered that Beth Reiners had mentioned prop styling for the film. I asked her for more details and she told me about the project.

> *I helped the L.A. prop stylist pick out all the props for the scene shot right here in Crown Point, Indiana! It's the jail scene (it is the actual jail Dillinger escaped from) where he escapes and steals the sheriff's car. We went to all the local antiques stores and found anything that pertained to the jail and to a later scene in downstate Illinois at the prison: old buckets, old irons and ironing boards, old stools, old keys, paintings, brooms, tables, and benches, etc.*

What a fun and fascinating job! Occasionally, a set stylist for film may call on a local stylist to help with prop shopping. We know all the best places to shop, the thrift stores, and antique stores that will rent or sell us just the right obscure item. We drive them around and follow the creative trail to the props that are needed.

After Beth described the scene she helped to style, I re-watched the film. In the jail scene I could see a few of the props she helped to track down. But just a few—that's the way it works with props. You need to bring many options to provide a few select items for the shot. You can't have any attachment to the others and can't expect that everything will be chosen. Beth's props helped to make a perfect scene, in my opinion. If I didn't know the story, though, I would have seen a complete and believable room from the era—and that's the goal.

PORTFOLIO CHALLENGE: TELL A PROP STORY
Style something that you love. Select one feature item—maybe a favorite pair of shoes, Grandma's jewelry, a beautiful bowl you brought back from a trip—but whatever the subject, do your best to depict your product as if you are styling for a magazine. To prop your shot, gather items from your home or from nature and artfully arrange them on the surface of your choice. Photograph and compare several arrangement options.

CHAPTER 11 Food Styling

THIS IS ONE AREA of styling that is not invisible. Even the general public is aware that there are people who style the food portrayed in photos. What people don't know is how much experience and training is required to progress at this career, more than simply being a good cook and knowing a few so-called "tricks."

MEET A FOOD STYLIST

Lisa Golden Schroeder has been a food stylist for more than twenty-five years. Based in St. Paul, Minneapolis, she teaches both online and live classes, and blogs about food styling and photography in the *Tweezer Times* at her website, www.foodesigns.com. She describes the profession this way:

> *The food stylist is responsible for organizing the food—sourcing unusual ingredients, arranging for shopping, preproduction preparation of food, preparing food on the shoot, and the final inviting presentation of the food under camera. Taste is of little concern, but looks are everything. The goal is to create images that appear to be freshly made, coming straight out of the kitchen to your dining table. The ability to do this, despite having handled the food a great deal or having food that must stand for long periods of time on a set, is an art and a science.*
>
> *It's important to have several years of training in food handling, by earning a food or nutrition degree, going to culinary school, or working in a professional kitchen. I put emphasis on good training and experience, because it is very important that a food stylist understand how food works.*
>
> *Problem-solving is a key element of the business, and being able to control what food does is of primary importance. If something is not the right color or consistency, what can be done? Stylists develop an interesting arsenal of equipment to do their jobs—from standard cooking equipment and knives to tweezers, paint brushes, scalpels, artists' palette knives, and cosmetic spritz bottles!*
>
> *A food stylist should have a natural flair for design and presentation. Understanding graphics, color, symmetry, asymmetry, and other elements that are important to an art director and photographer when creating an arresting visual will make you a valuable member of the team. Having the ability to be creative with props (the plates, bowls, utensils, surfaces, and other items to round out the scene) and being prepared with an open mind toward presentation—and lots of ideas—make an even better stylist.*

In addition to being a busy food stylist, Lisa is a published cookbook author, culinary consultant, and educator. Like me, she is at a point in her career when sharing her knowledge is a mission. She's been an avid supporter of food styling education, starting as one of the organizers of the Food on Film®

food styling seminars in Minneapolis, Minnesota, as a past chair of the Food Photographers & Stylists special-interest section of the International Association of Culinary Professionals (IACP), and as cofounder (with John Carafoli) of the International Conference on Food Styling and Photography at Boston University. She is part of the team at Photo Styling Workshops, developing and teaching food styling courses.

Working with other experienced stylists, photographers, and food professionals from all over the world, her site Foodesigns.com is an excellent reference for up-to-date food styling information and networking.

OVERVIEW OF FOOD STYLING

Photographs of food are everywhere you look—from coupons in Sunday newspapers to almost every magazine you read. Food images are used for cookbooks, magazine features, advertising, television commercials, food packaging, and scenes in feature films.

STYLES OF FOOD PHOTOGRAPHY

For several years I have noticed a certain style in food photography. The shots are tightly cropped, with very selective focus, and they are beautiful. This presentation puts the focus (literally) on the food, makes it come alive, and appear more appetizing.

This is the current fashion for photos portraying food, but it has not always been the way. Earlier styles included more propping, with other food items shown in the same scene. Looking back at older cookbooks makes this obvious. The crowded, bright, and sharply focused shots of an entire meal are out of place now, but trends may change again in a few years.

The most challenging food styling is for packaging photography. Magazine work, compared to packaging, can be looser, more natural, and ultimately more creative. The style is always the choice of the client and is related to the purpose of the photo. The soft-focus dreamy style is not as useful for packaging as it is for magazine presentations.

TYPES OF WORK AVAILABLE

Projects for clients are surprisingly varied, from restaurant menus to billboards. Some unexpected clients include cruise lines, wine and liquor companies, and barbecue-grill manufacturers.

Editorial projects for magazines and cookbooks are plentiful. As in other styling specialties, editorial projects may not pay as well as commercial projects but will provide excellent portfolio pieces.

In all types of styling, catalogs are an abundant source of work throughout the United States. Catalogs market food products such as hot sauce, fruit, or desserts. Other catalogs selling cookware and kitchen products feature styled food shots and even present special recipes. Non-food catalogs use food styling occasionally, propping with food the other products they are marketing.

FOOD MAGAZINES

Cooking magazines are the fashion and beauty of the food world. Food can be so gorgeous; magazines present recipes and other food "stories" in such a way as to intrigue the reader who buys the magazine, tries the recipes, and views the advertising (which can also be beautiful).

Though *Gourmet* has ceased publication, facing competition from less distinguished magazines, food magazines still sell. Each has its own style and demographics, and editorial food photography and styling is the cream of the crop. As with fashion, editorial work pays a lower rate than advertising, but the beauty is what attracts stylists and enhances portfolios. Plus, the work can be creative and steady.

In addition to food magazines, most lifestyle magazines will have a regular food feature, often including recipes and sometimes lifestyle stories including people. These features are also accompanied by food advertisements.

WORKING ON COOKBOOKS

For a food stylist, a cookbook project is an opportunity to collaborate with other creative professionals on an attractive product. This may be considered an editorial project and also be paid at a lower rate. But the benefits of doing such an editorial project at the lower editorial rate are that the results may be gorgeous and the stylist will have more work days than is typical since the project will last longer.

Cookbook shoots are longer, more cohesive projects than most styling jobs. The food stylist with a photographer, and often a prop stylist, work as a team to develop a consistent style, schedule the number of shots per day, and determine a budget for the resources.

Southern California food stylist Cindy Epstein was fortunate to start her food styling career with a cookbook project. We'll read more about the path her career took in Chapter 13. She met photographer Gregory Bertolini when she attended a workshop we gave together and took him up on his offer to visit a cookbook shoot he was working on at the time. She tells us:

Greg and his wife Jane, who is a publisher, were collaborating with the two chefs from the Marine Room of La Jolla, California, Bernard Guillas and Ron Oliver. They had already started the project before I got involved, but I worked with them from March until early fall. Shoots were scheduled every three to six weeks, usually for several days in a clip.

For props, we had free range in Macy's! Shooting in Macy's Culinary Kitchen, we could take anything off the shelves that we wanted to use—every stylist's dream. Greg and I did a lot of the prop selections, and then the chefs coordinated with us based on the requirements of each dish. The focus was the food. Props played a very minor part in the images. The style was clean, sharp, and tightly focused. Meticulous.

For me, the biggest challenge was the turkey because it was my first one on a professional set. At that time there were no styling books on the market except for an older edition of John Carafoli's Food Styling & Photography. I had a copy I had picked up years ago, and I followed his directions to the letter. It was a glorious bird! Greg said it

was the best-looking turkey he ever shot. Wow! Talk about walking on air after that compliment!

Collaborating with a group of creative professionals was definitely fun for me. It was very stimulating and we had a good energy together.

PACKAGING

Precision is the rule, as each company or line of products has its own unique style. Each aspect must be consistent. We have seen in the prop styling chapter that the same props are used throughout. The weight of each ingredient is critical, and the stylist selects and weighs it. The layout is very tight, with space for the brand name, UPC codes, ingredients, and nutritional information in a rather small area. At the same time, the product must look delicious to appeal to the customer.

ADVERTISING

Generally, working for an advertising agency with specific concepts and storyboards, you will need the strongest skills when styling an advertising shot. In an advertisement, the products shown *must* be the actual products being marketed, though other elements in the shot can be substituted products.

ADVERTISING AND PACKAGING REQUIREMENTS

Government guidelines about how food can be shown are a positive step for the consumer and something you must be aware of as a food stylist.

The landmark government case occurred in 1968 when the Federal Trade Commission brought a lawsuit against Campbell Soup Company for putting clear marbles in the bottom of their bowls of soup so that the vegetables would show up on top of the soup. This case changed advertising for the better, so that consumers can be more trusting that what is advertised is what they will be purchasing.

TIP Research etiquette manuals so you will know the proper way to set a table. There are standards such as the distance from the edge of the table and glass placements that will make your shot look authentic.

STYLING FOR FILM

Food stylists may have opportunities to work with both still photography and film. On a film shoot, there are more layers of communication; the stylist may work more closely with the director or art director than the camera person. As with all shoots, there should be good team interaction—the food stylist, art director, photographer, prop stylist, and the client all must be in sync with the goals of the shoot.

Susan Spungen, food stylist for film and editorial projects, brought food styling into the limelight when she styled all the food for the movie *Julie and*

Julia, the story of a blogger who tried to replicate every recipe in Julia Child's cookbook. Since the movie's theme was the process of following a recipe and the food itself acted as the star, audiences appreciated Susan's contribution.

Food in films can be less prominent, however. Scenes with food being served, which when you look closely happens rather often in movies, usually requires the work of a food stylist. The food may be viewed from different angles and may be eaten by the actors. Film schedules are often challenging and unpredictable.

NEW OUTLETS FOR FOOD PHOTOGRAPHY

These new outlets for food photography join the ranks of other social media. Food companies now employ a collection of outlets such as Facebook pages, videos, recipe contests, and interaction with experts, all online.

INTERACTIVE MEDIA

As the edges blur between what is commercial and entertainment, a personal approach has found its way into food marketing. It is not enough to have an attractive package on a grocery store shelf and place an ad in a magazine. The brand must have a personality. Your role with a company may include more than food photography, though food photography is still a very strong medium. Now it's just one of several.

RECIPE DEVELOPMENT FOR FOOD COMPANIES

Food stylists, who are often also food writers, testers, and recipe developers, may be hired to perform a multifaceted role and serve as a spokesperson for that company. Images may accompany the recipes and be presented in a number of ways, even live demonstrations or videos of the process. Often public relations companies or marketing departments will initiate these projects.

FOOD BLOGGING

Blogging about food is a good outlet for a creative person who loves to cook. Some current stylists have developed their skills this way, through constant practice. These individuals are often blogging, cooking, styling, and shooting their own subjects at home and face the challenges of varying them.

The sites Tastespotting.com and Saveur.com honor the best images from blogs. TasteSpotting, with more than 5 million visits monthly, curates the photos, selecting only the best to be represented. Saveur holds an annual contest to find the best images in multiple categories.

A good example of a blog used for both love of food and self-promotion is that of Matt Armendariz, a Los Angeles writer/photographer whose partner is a stylist. He tells interesting tales of his food photography adventures and shares videos on the blog *Matt Bites*, www.mattbites.com.

Though blogging "doesn't pay the rent," some industrious bloggers have found a way to finance themselves with their blogs, develop careers as stylists, or become experts in their field.

A reluctant blogger at first, Lisa Golden Schroeder says blogging for professionals is

a great self-promotion vehicle that can become a showcase for your best work: wonderful shots, good recipes, compelling stories that really show the expanse of your talent or unique view of the world. A blog can make money if you devote an inordinate amount of time to it—getting advertisers, posting frequently, etc. But I see blogs as a way to give insight to your range and entice potential clients to hire you for what you can bring to their products. Be subtle, avoid blatant self-promo or divulging too much about other clients—just share your best problem-solving stories. As a stylist/cook, you may not be confident about your photo abilities—so find a photographer you can collaborate with. They might want to use your cooking skills to enhance their blog at some point—trade out services.

A TYPICAL FOOD STYLING DAY

Predictably, a typical day in the life of a food stylist is as nontypical as in any other styling field. With such a variety of projects and clients, there is no normal routine. The preparation, planning, and shopping are unique for each job. There may be food preparation the day or evening before the shoot. When you buy, bake, and prepare as much as possible ahead of time, you look more organized and professional.

On the morning of the shoot there may be special items that have been ordered from grocers and must be picked up early. If the budget allows, an assistant will do the shopping or meet the stylist at the store. And there's packing the food items, ice, props, and supplies to take to the shoot.

Then it's on to the studio. Most photo studios, particularly those used for food photography, will have a complete kitchen. While useful for entertaining clients, the kitchen is a necessity for shoots involving food. Generally there is a stove but occasionally one may be rented for the shoot.

The groceries and props are unpacked and organized. The schedule and layouts for the day's work are reviewed with the art director, photographer, and client. The stylist then gets to work, preparing a "stand-in" for the first shot. This is a rough substitute for the actual food, so that the art director can create the desired layout and the photographer has something to light. Once they are satisfied with the look of the shot, the stylist recreates the food carefully and places it on set for final photography. This is known as the "hero."

For a food-packaging shoot, with its exacting criteria, only a couple of shots are done in a day. The image is presented on a small surface, with lots of type that must, sometimes by law, fit on the package along with the photo. Clients are extremely particular about how the product must look, and these shoots can take a long time. Creativity plays a lesser role in these shoots; technical know-how is what is needed.

The crew may spend an entire day on one shot for advertising. The shot volume for catalogs is much higher, as with other styling specialties. Shooting days for cookbooks and magazines also encompass a larger number of shots.

Food projects are usually shot in studios, but occasionally you may need to improvise on location. If you're working at a private home, arrange access to the kitchen. More pre-planning and preparation than usual might be needed.

REGIONAL DIFFERENCES

Years ago, food stylists were advised to live in San Francisco, Los Angeles, Minneapolis, Chicago, or New York—and nowhere else. Now the industry has grown, along with the variety of projects there are to style.

Depending on where you are working, the types of work you do can vary tremendously. In Los Angeles, expectedly, there is more work in film and television commercials. And the editorial rate there is comparable to the commercial rate.

In the Midwest, there are fewer commercials but more advertising and other still photography. Since many food companies are based there, packaging is a significant source of work. Editorial work and cookbooks are less commonplace.

On the East Coast, where there are more publishers, there is more opportunity to work on cookbooks. There is also more competition, so the rates for this editorial work are lower. More recently, cookbook opportunities have increased on the West Coast. Dallas, Orlando, and Atlanta are good cities for finding work.

Interestingly, in most areas, a higher rate is charged for work with ice cream because of the difficulties and challenges it presents.

STAFF POSITIONS

There are opportunities for staff employment in the food styling field. They include working as an in-house stylist for a food company, publisher, printer, or agency studio. There is also work in commercial studios, art direction, and advertising or marketing agencies that focus on food accounts.

KIT FEES

Fees for materials used, called "kit fees," are rarely charged by food stylists for print projects. Stocking supplies in one's kit is considered a normal part of doing business as a stylist. When special materials are needed for a specific project, they may be incorporated into the production budget.

It is more common in television and film to charge a kit fee. Kit fees for television commercials are often billed at a daily rate up to $50 per day.

STYLING THE PROPS

Frequently, prop stylists work closely with food stylists to complete the shot, as we discussed in Chapter 10. Although food stylists are often asked to prop their own shots, collaboration with a prop stylist can provide a wider array of resources and allow the food stylist to focus attention on the food.

Provided props can includes dishes, utensils, linens, and backgrounds. Essentially, anything called for in the shot beyond the food can be the prop stylist's responsibility.

Details can be very important, especially when working with a recipe; the choice of a measuring container or baking dish can make the shot authentic

or throw it off. Remember the baking dish we mentioned in the last chapter that was too large and not ovenproof? The prop stylist had to come up with something more believable, quickly. Early and ongoing communication about all the job details is essential.

This additional member of the photography team is nice but sometimes a luxury that is not available. As a food stylist, you will often need to do your own propping. Study the previous chapter about what to select and where to acquire the right props. Many photo studios maintain a well-stocked prop closet or employ a studio coordinator who does some shopping.

FOOD PROPPING HINTS

Here are some more suggestions from Beth Reiners, who we met in the previous chapter:

- Do not over-prop. Always remember to have your food as the hero, the centerpiece, your finale.

- Place solid or simple patterned papers (available at a scrapbooking store) as a background. Think in terms of contrast and similarity. Also, make sure that you have enough paper to completely cover the entire field of view.

- Experiment with incorporating serving pieces, whole place settings, napkins, placemats, and tablecloths. Try silverware, drinks, and even candles to convey the right mood. If you're budget-conscious, you can always find these items at thrift and resale stores, flea markets, and garage sales.

- For inspiration, read food and fashion magazines, photography manuals, cookbooks, catalogs, and the Internet, even fashion and home magazines.

LIST OF PROPS

This is a list of the types of items you may be in charge of finding for your food shoots:

Kitchen/cookware	Desktop/office
Plates/bowls	Clocks
Serving platters	Vases
Butcher blocks/cutting boards	Furniture
Cutlery/utensils	Linens
Glassware	Flowers/greenery/herbs
Accessories	Outdoor/gardening
Barware	Types of backgrounds/surfaces:
Artwork	Woods, rugs, laminates, tile,
Decorative objects	terrazzo, marbles and metals

PHOTO STYLISTS STYLING FOOD

While I am not a professional food stylist, I have worked with food in the course of other styling projects. Most often it has been slicing a lemon to place on the edge of a glass of iced tea or decorating with fruit. But I have styled raw chicken in a faux marinade sauce to demonstrate a unique marinating dish, and I've grilled chicken and vegetables in a grilling basket for a catalog shot. Since the homeowner's grill was being used in the upcoming shot, I prepared the food on a small portable grill I had brought along.

I am ashamed to admit this, but it was long before I knew about current food styling trends: I once applied motor oil to the top crust of a prop cherry pie. The dessert was a prop for a line of cherry-printed plates a catalog was selling. I had heard it suggested somewhere that motor oil painted onto a pie crust would give it a rich, golden look, so I tried it. It worked and the pie looked golden. But that is a very outdated way of styling food: Nothing inedible is used now.

The professionals should be called in to do specialized projects, but every stylist, at one time or another, may be asked to work on projects involving food. It's best if you understand the basics enough to feel comfortable, and getting some training from workshops surely wouldn't hurt.

PROFESSIONAL TRAINING

In the field of food styling, there seem to be more resources available and stylists willing to share them than in any other area of photo styling. Workshops are plentiful, websites are informative, and styling supplies are available from specialty suppliers.

While there is no absolute path to getting into the studio, more training is required for food styling than for other styling specialties. The food stylist needs knowledge of how food works, good food-handling skills, understanding of the food industry, and creative vision. Meticulous organization, willingness to experiment, and problem-solving are crucial attributes.

EDUCATION

A food stylist needs solid cooking skills and knowledge of food chemistry. A bachelor of science degree in food science, nutrition, or home economics is an excellent background for food styling. Alternatively, a bachelor of arts in design or art can provide a foundation, when combined with further exploration into the food field.

Culinary training, either from culinary schools or apprenticeships in restaurants, provides useful, hands-on experience in working with food. In addition to learning what food does, there is exposure to the business side of food through this type of education.

My own site, Photo Styling Workshops, offers several online courses in food styling. These are our most popular classes with students worldwide joining together in the online gallery.

THE FOOD BUSINESS

Time spent in the food industry on the business side could include working in a test kitchen, developing recipes, or consulting with marketing and

advertising departments. Work for organizations that promote various food industries, such as the National Dairy Council, can provide a great perspective on the business side.

In addition to having knowledge of food preparation, the food stylist is creative, curious, and organized. While most enter the field through the food profession, many stylists find it another way. With backgrounds in art or advertising, coupled with a love of cooking, they possess a natural sense of design and color and an understanding of what is visually appealing.

Exposure to the visual aspects of presenting food may come from graphic design for food photography, advertising, supervising shoots as an art director, or even publishing food magazines or cookbooks.

EXPERIENCE THROUGH ASSISTING

Regardless of education, most stylists enter the business by assisting other food stylists. The opportunities for learning from an experienced stylist are more plentiful than in other areas of styling. The learning process may take years, until you are prepared to go out on your own.

Food stylists would rather work with an assistant than without. An assistant is available to run out for items the client comes up with at the last minute. An ideal assistant should have a good knowledge of food preparation, be quick and organized, without any ego in the way, and listen carefully to requests. While clients often prefer not to pay for an extra person, it saves time and money, freeing the stylist to focus on work under the camera.

Lisa Golden Schroeder states: "Having a good assistant can make or break a day, especially if the client wants to fit a lot into a single day. It can be possible to do much more if there is a competent assistant in the kitchen while the stylist is on the set. I look for assistants that have enough experience to do basic things like shop properly for good produce or baked goods, and understand the way a studio team works, and how they can make the job and day easier for the stylist. I've trained assistants, but also hire others I hear are good from other stylists. I like to work with assistants who have a positive attitude and don't mind working hard."

APPRENTICESHIPS

Many food stylists say they learned the most through an apprenticing relationship with another stylist. This unpaid mentoring process prepared them for their careers, much the way the photographer/assistant relationship does. When you mature in your career, you can keep this in mind and help other stylists learn the profession.

Contact the best food stylists and food photographers in your area and offer your services, even if you are simply observing or assisting for free.

You can develop ideas for test shoots through this exposure and find photographers willing to work with you so you can gradually build a portfolio. As stated on Foodesigns.com, "the best way to learn all the nuances of the business is by working diligently with someone who knows the ropes." Your

helpfulness and willingness to take direction will help you find more assisting opportunities, gradually moving into the profession.

NETWORKING AND WORKSHOPS

Talk to food stylists in other parts of the country. Since you won't be competing with them and they are almost always eager to share information, you can ask professional questions. Local food stylists can provide you with a network where you can share techniques, problems, and even referrals for jobs.

If you like to be involved in organizations, you can find groups that include potential clients, such as art directors, corporate home economists, and chefs. These organizations include the International Association of Culinary Professionals—who have a special-interest section for food photographers and stylists, Les Dames D'Escoffier, and other networking groups for advertising professionals.

The International Conference on Food Styling and Photography, held every two years, brings photographers, stylists, and experts in the field together for panels, discussions, hands-on workshops, and networking.

Find workshops you can attend to learn what's new and meet other stylists and food professionals. Making a commitment to take classes is very important; you can approach it as an investment in future success.

You may find plenty of websites about food styling, but here is a sample of what's currently available to help you learn about the field.

EDUCATIONAL AND NETWORKING SITES

- www.delorescuster.com/courses: Food stylist and author Delores Custer conducts a variety of live workshops at all levels.

- www.foodesigns.com: Networking site for beginners and professional food stylists offered by Lisa Golden Schroeder

- www.foodstylingandphotography.org: Biannual conference of food styling and photography professionals from around the world

- www.iacp.com: International Association of Culinary Professionals, an organization of the business-to-business food industry, with a section on food photography

- www.laraferroni.com: Lara Ferroni's informative blog for food stylists. There are countless numbers of food and styling blogs and the number is growing, opening dialog and communication between us all.

- www.ldei.org: Les Dames D'Escoffier, an organization celebrating women of achievement in the culinary field

- www.photostylingworkshops.com: My own "school" with online courses and workshops for all styling specialties, including food styling

While there are many routes to food styling, the key to success is having a firm idea of your goals, a willingness to do everything necessary to get good experience, and, perhaps, patience. Being a pleasure to work with, highly competent, eager to learn, and able to anticipate client needs will assure repeat work. Success is entirely up to the individual.

TECHNIQUES

While stylists use many special techniques, depending on the shoot and the food, the goal is always to present the food in the most appetizing, appealing way possible. Food stylists have a collection of equipment and tools, from basic cooking equipment and good knives to artist brushes and dental picks.

Rumors abound about food-styling tricks, like using glue instead of milk for a bowl of cereal, mashed potatoes instead of ice cream, and blow-torching the outside of raw chickens to make them seem cooked. Lisa Golden Schroeder dispels these outdated illusions:

> There have been so many stories circulated about how the food is faked in photos, but they are generally not true. In past years, there were more instances of using inedible items as stand-ins or added to food. But the trend has been for a more natural approach in recent decades. And most food companies have policies that dictate nothing artificial be used on a shoot—particularly in advertising, where there are laws that govern these issues. There are formulations that simulate certain foods that are very difficult to work with, like ice cream. But the recipe for fake ice cream is edible—it's basically a very thick frosting that can look like ice cream when scooped.
>
> Sometimes foods are cooked down, like maple syrup, so that they become thicker and easier to control. Or in the case of poultry (especially turkeys), the bird may only be cooked in the oven with steam until the flesh is firm but not completely cooked. This is because a fully roasted bird, once cool, will wrinkle and look very unappetizing. By cooking the poultry less, then coloring the skin, the cooled bird looks fresh, like when it first came out of the oven. But again, this method varies. There are many magazines and cookbooks now that completely cook food and shoot it immediately—and it looks natural and delicious.

CURRENT TRENDS

The drive to get more authentic and real in styling food has been with us for a number of years. Delores Custer in her book, *Food Styling*, has researched and chronicles changes in the look of food styling from 1950 onward. If you do not have her book, I would highly recommend it. Delores observes that *Real Simple*, Martha Stewart's magazines, and the Australian magazine *Delicious*, among others, have had a significant impact in the trend of more casual food photography. Also, federal legislation for truth in advertising has had an influence.

FORKS AND SPOONS ON PACKAGING

Have you noticed that there is always a spoon on soup cans and a fork on cake mixes? Food stylist Debbie Wahl explains, "Initially, a prop stylist might be used to source the spoon or fork for the packages, but usually the client or

the photography studio will keep those props so that the same fork or spoon is available to them for future shoots or line extensions. Most studios I know have boxes labeled with the client's name and product—these contain the plateware and forks or spoons that are used exclusively for that packaging line."

STYLING GREEN

"One way to help in styling green is to be authentic in following the recipe or preparing the client's product. This means keeping to a minimum any of the old-fashioned styling 'tricks,' and excluding non-edible products. Another way is to recycle! Preparing five or six recipes in a day and/or sorting through the client's products can create a lot of trash from opened packaging. It is helpful to have a recycling bin or bag set up close to the kitchen prep area," suggests Debbie Wahl.

BEVERAGES AND SPLASHES

Beverages are an important aspect of food styling and photography. Often involving ice cubes and chilly-looking glasses covered with condensation, they have their own special challenges. Whether they appear hot or cold, drinks are shot for cookbooks, packaging, and advertising.

You may also notice that liquids, swirling and splashing, are used in advertising for a variety of other products. Some photo studios in New York City and elsewhere have developed this as a specialty and have the tools and facilities to create large and small splashes. One distributor, listed at the end of this chapter, markets all types of faux ice cubes and acrylic splashes for the photography industry.

YOUR INSPIRATION FILE

As with all other styling specialties, keep a file of tear sheets from other sources. There are plenty of inspirations out there if you keep your eyes open. Use these to inform your own portfolio shoots. Practice by replicating images you like; the challenge of figuring how something was done will force you to expand your skills.

Shoot food that you really like or even are passionate about. Love beer? Do some pour shots. Love to bake? Shoot what you like to make. Your best portfolio shots will likely be foods that you care the most about. Tell some stories with your photos.

SHOPPING FOR FOOD

Know good food resources, where to get the best produce, and sources for exotic ingredients. Find ethnic markets and explore them. Get to know the growers of produce and herbs at farmers markets. Even when you're not working, scout suppliers for ingredients, equipment, and garnishing ideas.

A good relationship with the produce manager of a natural-foods store is invaluable. Items that are not in stock, like edible flowers or tropical fruit, can be specially ordered with some advance notice. Seafood- and meat-department managers will be very receptive to your requests also. Imagine how special it is to find a customer who appreciates their contributions so much, compared to the daily routine of a grocery store.

Web searches also can yield a wealth of resources, items not readily available in your area, as well as inspirations and style ideas from around the world.

By the way, since snacks and treats are such an everyday part of photo shoots, make sure the food you need for the shoot doesn't get mixed in—and eaten. Don't forget to label the food items as "Product, DO NOT EAT!"

> **TIP** Build your food styling kit gradually. Since tools are available from different sources and many of them are cooking utensils, keep a list with you and collect them as you find them.

TOOLS OF THE TRADE

The food stylist's kit is very personal and is developed through a lot of trial, error, and experimentation. You won't need the basic kit described in Chapter 5. Your kit will be unique to your trade.

SPECIALTY KIT LIST

Here, Lisa Golden Schroeder shares her well-honed list of what is necessary for a food styling toolkit. She says, "I consider myself a good cook, first and foremost. So I rely on basic cooking equipment, my knives, and my hands (and brain!) as my most important tools. You'll discover over time what works best for you, but these are what I find to be essential."

Item

For Food Styling

- ☐ Set of excellent knives
- ☐ Set of large and small art and pastry brushes
- ☐ Small dropper and squeeze bottles (needle-nose dropper bottles are good for water)
- ☐ Glass eye droppers or plastic pipettes
- ☐ Tweezers (long, either straight or bent-nose)
- ☐ Small paring knives, X-Acto blades, or disposable scalpels
- ☐ Selection of small spoons (baby spoons, demitasse, etc.)
- ☐ Selection of scissors (poultry, small craft, cuticle, or embroidery)
- ☐ Small metal or plastic spatulas (frosting spatulas or painting palette knives)
- ☐ Small lifting spatulas (metal, like for brownies or cake)
- ☐ Kitchen timer
- ☐ Citrus zester and channeler, other garnishing tools
- ☐ Microplane or other ultra-fine shredders
- ☐ Good vegetable peeler (swivel blade is nice for peeling or making garnishes)
- ☐ Bamboo skewers or metal picks
- ☐ Small spritz (spray) bottle
- ☐ Acrylic cutting board and board liner

FOOD STYLING SUPPLY SITES

There aren't any one-stop shops for food styling supplies. But in reality, most of us collect our tools gradually from various sources anyway. These will help you know you where to look:

- **Photo Styling Workshops:** www.photostylingworkshops.com: resource booklets available on sourcing supplies

- **Trengove Studios:** www.trengovestudios.com: food styling special effect supplies, acrylic spills, ice cubes

Here is some final encouragement from Lisa for would-be food stylists. "Like all new ventures, be willing to pay your dues. It might seem like a slow process to get started. But once you have the skills and savvy to do the job, you'll find yourself in a unique business that requires hard work but is also very creative and often fun! Food styling is a competitive business, but if you do good work you'll always be in demand."

RESEARCH CHALLENGE: EXPLORE OLD COOKBOOKS

Explore old cookbooks. These may be some that you already have or some that you find at used bookstores. Observe the styling of the props, backgrounds, garnishes, portion size, along with the lighting, cropping, and focus of the photographs. Compare this with current magazines and cookbooks. Find as many changes in styling as you can.

PORTFOLIO CHALLENGE: UPDATE A VINTAGE COOKBOOK SHOT

Choose a recipe from one of these old cookbooks, one that is accompanied by a photograph. Interpret the recipe in the current style of food styling. Use healthful ingredients when possible, minimal garnishes, simple plates, and focus on the food. Your challenge is to create a contemporary editorial style shot, either on your own or with a photographer.

CHAPTER **12** Room Sets and Bedding

PRESENTING ROOMS IN HOMES is a big part of styling. Projects can range from feature stories in decorating magazines to advertisements for refrigerators or windows to catalogs for linens. Titles for professionals who do these projects can vary, but essentially they are doing styling with special expertise in decorating techniques. Stylists may refer to room sets and bedding styling by other names, such as interiors, set design, soft goods, or environments.

Rooms and interiors are styled for video and film, of course, and these set designers have unique skills and techniques. Many stylists work in both still photography and commercials, as do other specialty stylists. For our study of room styling, we will focus on still photography. There is plenty to learn, and the basic skills explored here will carry over to film.

ARCHITECTURAL PHOTOGRAPHY

Architectural photographers are experts in various areas requiring unique knowledge and specific equipment. Some photograph interior design and residential spaces; these are the photographers you will usually work with as a stylist. Others may have expertise with exteriors, industrial locations, or commercial spaces.

The stylist must become accustomed to working with an architectural photographer. Lenses, lighting, and camera position are different from small-scale studio photography; here, an entire room is being recorded. You need to be able to visualize the space from a ladder or wherever the camera is positioned.

WHO ARE THE CLIENTS?

There are many home-related clients, because our society continues to appreciate the comfort and security of the home. Magazines geared toward the home contain interior and sometimes exterior shots for feature stories and smaller articles about homes and gardens.

Business-to-business clients such as manufacturers of windows, window coverings, carpets and other floor coverings, kitchen cabinets, bathroom fixtures, countertops, and furniture provide a huge volume of photography work. They produce wholesale distributor catalogs and other marketing materials. They also generate advertising for selling directly to the public.

Retail catalogs sell furniture, home products, bedding, and linens. Some notable catalogs with great styling are Crate & Barrel, Restoration Hardware, and Pottery Barn.

Most jobs are generated through the photographer; having a few photographers recommending you for their jobs can keep you sufficiently busy. Find and make contact with architectural photographers in your area, and do the

same for magazines, catalogs, and manufacturers. When calling magazines and catalogs, ask for the photo art director or the person who books stylists for photo shoots. Manufacturers' marketing departments would be the place to start your contact there. Advertising agencies that represent those clients may provide you with opportunities or at least give you an idea of the type of projects going on. (The self-promotion strategies discussed in Chapter 13 are basic to all photo stylists.) Word of mouth is the best form of advertising. Once you have established relationships with architectural photographers or clients who can give referrals, you are on your way.

CREATIVE SET DESIGN
In our study of prop styling in Chapter 10, we talked about creative set-building for photography. Whether a space already exists or is built by a prop stylist or set builder, it is being utilized as a background for a featured product and a way to imagine the product in its ultimate setting.

SETS BUILT IN STUDIO
Often it is more convenient for clients to build rooms in studios than to go to location houses. Even though architectural details would already exist, limitations include smaller spaces, location availability, transporting products and props, and more lighting challenges for the photographer.

Set builders may be full-time or freelance workers who have skills and materials to quickly build temporary walls. They will add details such as window frames, doors, painted walls, sconces, baseboards, flooring, and even bathtubs, sinks, and toilets. When a window is used, there may be large rear-lit film images to create instant exterior views.

The stylist will be responsible for styling the entire room, unless there is an art director on hand who selects furniture for the space, as sometimes happens. Smaller props and details are the stylist's job, in any case.

A HOME STYLIST'S STORY
Colleen Heather Rogan is a stylist who has been involved in many aspects of the home-styling industry. She has worked for magazines, both on staff and as a contributing editor, and styled for commercial and private clients. She moved back to her hometown of Milwaukee after many years in New York City, bringing her skills to a new market and finding a welcome home there for her journalism talents as well as styling skills. She tells us in her own words about finding her place as style and home editor of *Milwaukee Magazine*.

> *I think the best way to describe what I do is to say that I gather things together, to aesthetically create a mood, character, or context to meet a reader's or client's needs.*
> *When I'm about to style a shot or an interior, I familiarize myself with the product or the space before making a "wish list" of the general sort of props I feel I'll need. Having established the "mood" I want to create, I can quickly pick out the props based on whether they'll feel as though they belong on set.*

Given that I started out as a visual artist, composition and spatial relationships between objects remain paramount to me. I approach each room setting, tablescape, vignette detail, or product shot in the same way I would a drawing, painting, or collage.

VISUAL DECISIONS

As I begin to stage a set or interior, I go through a kind of internal editing process. Whether establishing something soft and feminine, sleek and sophisticated, cool and urban, warm and homey, or quirky and eccentric, my goal is to always create something where nothing feels out of its own particular place in space. While I might not use everything I bring to the shoot, everything I bring will have the potential of aesthetically working together.

My own styling work has been a natural outgrowth of my fine arts background, early years spent in a large department store display department, styling done for New York designer showrooms, and years spent working as a staff editor for a national women's lifestyle magazine.

After leaving my hometown as an artist with a discerning eye and some success with dressing windows and pulling together store displays, New York became my graduate school, and it was there I really polished my skills as a stylist.

EDITORIAL VERSUS COMMERCIAL STYLING

I enjoy editorial styling for its creative freedom. Commercial styling comes with a decidedly bigger paycheck, though sometimes that higher day rate comes at a cost. The styling goal of an editorial feature is to visually tell a story or support copy with images. On an editorial shoot, it's usually just me, a photographer, and an assistant or two. Things are styled, film is shot, and that's that.

On the other hand, the direct goal in styling an advertising shoot is to, well, sell. To make money. From creative directors to company executives, the primary focus is how well the product looks. And because there's a lot of money riding on the success of a convincing advertising image, there are always tons of people on set—each with a vested interest in every little detail of how the product comes across.

DIFFERENT MARKETS

There is a definite difference between styling for a national market and a local market. New York is a styling mecca; the work is intense, sophisticated, and lucrative; plus, stylists have plenty of venues to pursue given the amount of television, film, advertising, magazines, retail, and fashion options open to them. California and big cities like Chicago are strong, too. But in other areas of the country, frankly, there isn't as much interesting work. You won't find as many major clients, budgets are often smaller, and in many cases the directives and goals of the shoots aren't as creatively ambitious. Plus, if there's no one to raise the bar by example, the quality of work can suffer.

STYLING QUALITY

Another aspect of smaller markets is, unfortunately, that without the challenge of interesting work, good stylists miss the opportunity to get experience and develop their skills to their full potential. In the end, a good stylist's intent should be to make anything and everything look the best it possibly can.

I believe that if you're presenting something for public consumption—whether it's a table setting or a room shot styled for an ad, a magazine, or a catalog page—just "getting it done" isn't good enough. Stylists are in the business of inspiration, of bringing ideas to life, of showing what can be done. The importance of their role in a shoot is easily equal to that of the photographer. After all, no matter whether a shot is well photographed and badly styled, or badly photographed and well styled, you end up with a bad photo, don't you?

HOME MAGAZINES

One of the most fascinating careers I have heard about is that of a West Coast editor/stylist I met several years ago. Her work for a home magazine includes scouting interesting homes in her area, approaching the homeowner about the idea, and presenting the story concept to the magazine. If it is accepted for an issue, the editor/stylist works with a photographer to style and shoot the rooms according to the magazine's approved layout and shot list, and finally, writes the accompanying article. What a nice job to have if you love home decorating and have writing skills. At least that was my initial impression.

On further investigation I found she is a journalist by training. The editor is not on staff and works as an independent contractor, or freelancer, with no benefits provided, or advances for expenses. Most non-journalist field editors don't write articles but do gather extensive facts, sources, floor plans, and "before" photos for use by the assigned writer. Multiple projects are submitted before any are selected for publication, so there is upfront time and money involved. It often feels like a wild goose chase, and that might be frustrating for some. In addition, magazines are particular about selecting applicants and interview extensively for these positions.

While the position is more complex than I initially thought, I still feel it's a fascinating use of skills for the right person.

STAFF OR FREELANCE EDITORS

Colleen Heather Rogan, with her editorial background, describes the work this way: "An on-staff editor might style shoots as well as research the bed, bath, furniture, stationery, and gift markets and major industry launches looking for current trends. Some magazines have 'scouts' or regional people who act as a first response to stories and ideas. Their function is to funnel appropriate stories to the magazine, for editorial consideration. Some years back, I was paid a monthly fee by a national magazine to find good prospects that fit the magazine's editorial vision. I presented the 'why, what, and where' of the story to them and the magazine would assign someone on staff or freelance to style the stories they were interested in pursuing."

When stylists are hired freelance for editorial projects they may be listed as "contributing stylist" or "contributing editor" in the magazine. No matter how well decorated the home is, there are always adjustments that need to be made for photography. Items will be repositioned or omitted, and props will be added.

PRODUCTION DESIGN

Jay Bruns is a Minneapolis-based production designer with years of experience in his profession. I first met Jay when he needed an assistant on a one-month photo shoot for Hunter Douglas window coverings. Assisting him was a pleasure, as I had the opportunity to learn about the big picture of styling rooms, renting furniture, accessorizing, and propping for architectural shots.

The photographer, art director, client, and Jay had earlier traveled to San Diego to scout several homes for the series of photos, focusing on the right type of windows and other factors such as high ceilings, open space, and architectural details. The rooms had already been selected when Jay arrived to work with me on a week-long search for the furnishings.

I was the local resource, knowing my way around town, but I found stores I didn't know about before. Each project presents the stylist with such a unique challenge that the work is always new. Together Jay and I visited antiques stores, carpet stores, and other sources to find potential items from merchants that were willing to rent them to us. I photographed them—after asking permission—and Jay made presentation boards for the art director's approval. We rented a truck, hired a driver and a helper, and bought needed supplies. Daily schedules of locations, styles, and individual furniture and décor had to be refined. Part of my responsibility was coordinating the complex rental and return of furnishings to and from various sources each day.

INTERVIEW WITH A PRODUCTION DESIGNER

I was curious about Jay's use of the term "production designer" when defining his profession and asked him how it differs from "stylist." I also wondered how he estimates the amount of time preparing for his projects, and how many assistants are needed.

The title "production designer" may be different for different people. I use the term to indicate to clients that I have other skills than just photo styling. I'm able to manage an entire production from ground up, including designing sets, consulting on styles and trends, shopping and dressing the sets, and managing a production crew both on location and at home.

Designing sets is fun for me because I get to use all my interior design background: architecture, period details, scale, materials, colors, etc. Then, all of the above has to be designed to be seen through a lens, whether motion or still. Each picture has a product "point of view," and everything—windows, floors, cabinets, and furniture—has to be geared for that product. All aspects of the set are chosen to give the viewer a clear and quick read on the product. Materials and "dressings," or props, need to coordinate with the product, but not take too much attention.

Shopping and dressing sets is more the job of stylist. I have many jobs like this too, where the set is already determined, and it becomes my job to do the prop shopping and decorate the set. It can be as simple as adding fresh flowers and moving around a few things that are already there, or more complex, bringing in full rooms of furniture. A great deal of thought goes into what goes where. I can always tell shots that are "propped," meaning the stylist is more of a propper than designer and puts something on a table because it looks bare; the overall result is a propped room, as opposed to one with lifestyle.

PREP TIME AND WRAP

Every job is different and will have its own particular requirements. Typically I'll ask for two to five days to plan and shop a job before it's photographed. If there is "design time" involved, designing a set, shopping for set materials, story boards, concepts, and tear sheets, I'd usually ask for another four or five days. Smaller jobs have shorter prep times. I usually do all the shopping, which is useful at the return since I'll know where everything came from.

The wrap is usually a one-day task. The assistants do most of the returns. When I can, I like to go along to personally make sure it's all there and in good shape, and to thank the merchants for playing along and letting us use their merchandise. It's also nice to send a short thank you note to merchants, which is one more level of creating a "comfort zone" with them.

WORKING WITH ASSISTANTS

Also as a production designer, I always work with at least one assistant and sometimes three or four. I hire hard-working assistants who are geared to solving production issues, leaving me free to concentrate on design and putting rooms together. When we do large shoots involving a lot of furniture, I like to use the "two guys and a truck" method in addition to having my assistant. These workers do all the furniture pick-ups, drive the truck, prep the location, and do returns. It's a great load off my mind to have someone else handle that part of the job. My assistant will also do the out-of-town hiring when we go on location, and many times I'll look for a local stylist to work with to lead me to good resources and help with the shopping.

STAYING CURRENT

Research for production designers is ongoing and endless. It includes almost everything from visiting places when traveling, such as historical sites, museums, gardens, churches, and new shops; attending classes and seminars; and exploring libraries, books, magazines, movies, and plays.

Jay presents seminars for some of his clients, educating them about trends in home decorating, helping them plan for market positioning and future product launches. This motivates him to keep ahead of trends.

Writing articles, giving talks, and serving as a resource for clients are some ways of establishing yourself as an expert in the home styling field.

RENTING FURNISHINGS

Regardless of the quality of the homeowner's belongings, it may be necessary, for style reasons, to replace them with rented furnishings. If items already in the home can be used, it certainly helps with the budget. Often some combination will be the solution. But keep in mind how things look on film, as Jay mentioned. The camera sees details and flaws while our vision can filter them out.

Flooring (carpet or hardwood) may be placed over existing carpets or other floor surfaces as a temporary solution in room styling. If you're styling an empty room or a studio set, you will start from scratch.

Experience with retail furnishings not only provides knowledge of the industry; it also helps a stylist work with merchants. Contact with wholesale

buyers or retail stores early in your career can create a basis for later styling or production design work.

Says Jay, "It's valuable, when shopping for jobs, to speak the language of the merchants and put them at ease when asking to rent their merchandise. You should talk about what the project is, how long you'll need to have the item out of their store, and how well you'll take care of it while you have it."

TIP Find inspiration in the paint department of hardware stores. Not only are there inspiring examples of room styling in the paint brochures, you can keep up on current color trends.

STYLING SUGGESTIONS FOR ROOMS

Remember that in styling for rooms and homes you are literally looking at the big picture, unlike the precise, close-up styling you might use in, say, folded garments. Working with an architectural photographer, critical parts of your job are your awareness of the entire set, your place in the room, and coordinating all the elements you are responsible for.

Watch for reflections in mirrors and windows. Photographers will use techniques and materials to minimize these problems. Checking for camera angle and what is visible, be sure *you* don't create a reflection or shadow. Areas outside windows or doors are important. Be prepared to style these areas with bedding plants, potted trees, or patio furniture. The outdoors will generally appear bright, or "blown out," in relation to the lighted interior.

If a photographer is using a dim light indoors, such as a lamp turned on, candles, or Christmas lights, it will take multiple exposures to allow them to show.

STYLING THE ENVIRONMENT

Beth Reiners, the prop stylist we met in Chapter 10, has these suggestions for styling the home:

- **Prop styling a shoot is like staging a house to sell it**. This is the best general rule of thumb we can offer. On a funded shoot, truckloads of furniture are brought to locations, and the prop stylist re-props the entire house. They remove the owner's furniture and re-prop so that the house is clean and uncluttered and well designed. It needs to look livable and lived-in, but not messy and not personally specific. Scan the room and if you see any mess or anything ugly to the eye, anything cluttered or unnecessary to the story—get rid of it.

- **Remove all personal items.** No family pictures, souvenirs, or kids' toys. Remove all of these items, unless they have a real purpose in the shot.

- **Tell the story.** Just as with styling a model, know the scene you are setting and set it accurately. A family in a living room after dinner

doing homework requires different props and styling than a family in a living room in the morning getting ready for school. Make sure you have props to indicate the story and make sure they are the right props. **A lot of images are shot in too sparse a setting.**

- **Green lawns.** If you are outside, the lawn should be green and the plants healthy, with no grimy or dirty areas.

- **New appliances.** If any of your props involve appliances (kitchen or bathroom) or technology, make sure everything is new, clean, and modern.

- **Modern furniture.** Use up-to-date furniture, not overly used, and clean.

- **Table settings matter.** If you are shooting a table, pay attention to everything: the dishes, the silverware, the salt and pepper shakers, the candles. You don't want to see an old melted candle, but it also shouldn't be brand new.

- **Think graphically.** Design your environment in terms of color blocks and composition. For a picnic, use a graphic red and white tablecloth with white plates and white napkins and that's it. Don't go wild—think graphic, clean, simple.

- **Props on a budget?** Prop stylists are the same as wardrobe stylists—they have arrangements with stores, and when desperate, buy items and return them. If you want to buy props, stay mainstream. Think Pottery Barn and Ikea.

LIFESTYLE

Create the feeling that the resident just walked away, that there is life going on there even when you can't see people. Some props that create this feeling include shoes or slippers on the floor, an open book and glasses, a magazine, a glass of lemonade or iced tea, or a cardigan sweater draped over a chair.

WORKING WITH TALENT

Often, to complete a room set, there will actually be talent hired. This is truly creating a lifestyle image to show the space in use. As a room stylist, you may be expected to dress and style the talent in addition to the room set. Review Chapter 7 to understand how to select generic wardrobe items and make requests to the talent's agent for items they can bring to the shoot. You'll also need to steam and prep the garments.

Even if the people are just an action blur to indicate their presence, you will still need to have them dressed in the right items and colors. A hand or arms, or even feet, may be shown instead of a whole person. In that case, the model must be prepared for that and have a recent manicure with neutral nail colors.

In these situations, as in most wardrobe shoots, there may or may not be a makeup artist or hair stylist hired. Ask the talent to come "hair and makeup ready" and read up on touch-ups for makeup and hair.

PROPS FOR ROOMS AND EXTERIORS

The props used for magazines, catalogs, advertising, and business-to-business promotions are essentially similar. The focus is always on the product or lifestyle, with props used carefully to enhance rather than distract. A food stylist may be booked for food and beverage props, or when there is complex propping in a kitchen or dining room set.

The following lists of props for areas of the home are provided as inspiration and a starting point for your thinking process, not as a complete list. These props can help create an appealing environment, enhancing larger items such as furniture and area rugs. With many different styles and types of projects you may be working on, your own creative mind will complete the lists.

PROPS FOR LIVING AREAS:

- ☐ Flowering orchids in pots
- ☐ Flowers in vases
- ☐ Tropical leaves in large vases
- ☐ Large potted plants like fiddle-leaf fig, ficus Benjamina, or palms
- ☐ Stand of umbrellas
- ☐ Books on shelf or table, hardcover with dust jackets removed
- ☐ Stack of large books to serve as end table
- ☐ Framed prints, paintings, or mirrors hung or leaning against walls
- ☐ Stacks of boxes and baskets
- ☐ Flat tray, basket, or dish
- ☐ Stack of letters, other mail, car keys
- ☐ Lamps
- ☐ Candles arranged on platter
- ☐ Glass of lemonade or iced tea
- ☐ Glass(es) of wine, or martinis
- ☐ Plates of hors d'oeuvres
- ☐ Bowl of popcorn
- ☐ Throw pillows
- ☐ Shoes on floor
- ☐ Open book or magazine
- ☐ Cardigan sweater draped over chair
- ☐ Throws, to add softness and drape

PROPS FOR BEDROOMS:

- ☐ Flowers in small vases
- ☐ Books
- ☐ Clock
- ☐ Slippers

□ Prints or photos on wall
□ Small framed photos (Don't use without model releases if people are visible.)
□ Glass and/or decanter of water
□ Bedside lamps
□ Extra blankets or throws

PROPS FOR KITCHENS:
□ Cookbooks
□ Wall clock
□ Bulletin board with notes and lists
□ Bowls of vegetables or fruit
□ Container of cooking utensils
□ Coffee cups, maybe next to coffeemaker
□ Cruet of dish soap
□ Dishtowel draped on counter
□ Cutting board and knife
□ Food being prepared on counter
□ Wrapped bouquet of flowers

PROPS FOR HOME OFFICES:
□ Laptop computer
□ Desktop blotters
□ Pens and pencils, loose or in containers
□ Notebooks and file folders
□ Letters with letter opener
□ Racks for supplies
□ Collectible paperweights
□ Wastebasket
□ Office chair
□ Desk lamp
□ Telephone, either very modern or classic
□ Pair of glasses

PROPS FOR BATHROOMS:
□ Bathrobe
□ Slippers
□ Glass jars of cotton balls and swabs
□ Fancy soaps
□ Towels, folded or draped
□ Loofah sponges
□ Shells, in jars or on shelves

PROPS FOR EXTERIORS:
□ Doormat
□ Jute outdoor rug

- [] Rolled newspaper
- [] Potted plants, small trees
- [] Flowering border plants and ferns
- [] Flip flops, beach ball, or beach towel, for poolside
- [] Children's toys, bicycles
- [] Croquet set
- [] Open book or magazine
- [] Sunglasses
- [] Candles
- [] Tray
- [] Glass of lemonade or iced tea
- [] Cardigan sweater draped over chair
- [] Throws, to add softness and drape

HOW TO STYLE BEDDING

Quite a few catalogs sell bedding and other linens to consumers. Their goal is to present an attractive environment that makes readers want to decorate the room where we spend the most time, the bedroom. Seasonal changes and updated color themes result in repeat shoppers.

Over time, styles for all types of presentations change. The current fashion for styling beds is soft and sensual. Look at catalogs and you'll see partially made beds, soft ripples on blankets or bedspreads, and a casual, comforting look. Years ago the style was tight and precise. The styling had to be perfect and smooth. Not long ago beds in catalogs looked recently slept in. The style now is somewhat neater but still soft.

The days of flawless bed styling are gone; now you need to use fluffs of batting to build the gentle folds. Keep up on design magazines and catalogs as styles continually evolve.

A BEDDING STYLIST

Philadelphia-based Susan McDaniel is a specialist in styling bedding and textiles. This is what she has been doing for most of her years as a photo stylist. She tells us, "I was in visual merchandising originally and learned to make beds in the linens department of the store where I worked. No one taught me, but I picked it up quickly and it was one of my favorite things to do. I did my first styling job for an ad agency with a high-end linens store as their client. I think that was the worst day of my styling career! It took me far too long, the linens were really difficult to prep, and my photographer was grumpy." Keep this in mind as you build your styling career—you will survive.

Let's see how Susan keeps up on trends and finds inspiration.

I find that bedding style has more to do with the individual company I work for now. It used to be that everyone did it one way, until a new look came on the scene. I like it better this way, where you really look at the bedding and imagine what room it would be used in, what customer would choose this, and what would appeal to them. If I were backed into a corner, I would have to say that the days of the really rumpled, pulled onto

the floor bedding seem to be behind us for the time being. I sense the communal need for order in these hectic times.

I am a voyeur. To keep up on my career, I take every opportunity to explore people's homes; it is so fascinating to me, the way we surround ourselves with our "stuff." I also have close to twenty magazine subscriptions, both home and fashion, and keep my eyes peeled for new ideas and trends. I get every catalog I can get my hands on and have quite a large library of books on the subject of decoration.

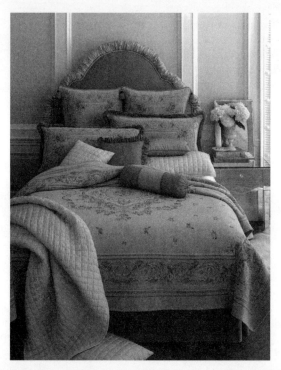

Elegant bedding styled by Susan McDaniel for a catalog. Formal styling is just soft enough to be inviting. Notice coordinating props on nightstand and room set constructed in studio. Photographer: George Ross; stylist: Susan McDaniel, client: Ross-Simons catalog. © George Ross/georgeross@mac.com

BEDDING TECHNIQUES

Ironing the linens is the first step in the process of styling a bed. While the top portion that is showing is the most important, the entire sheet should be pressed. (Some stylists do just iron the quarter that will be shown.) Work on a large table that is covered with a blanket; an ironing board is not large enough for most prepping. Steaming just isn't adequate for sheets and pillowcases, though it can be used for towels. Most blankets and quilts, however, respond well to steam, perhaps needing a bit of ironing. Keep a steamer nearby on the set, preheated and ready to use. It will be useful for touch-ups.

The bed you are styling may be a real mattress or it may be a fake, made out of lightweight foam carved to a mattress shape. These are much easier to move around a studio. It will probably be placed on "apple crates," or wooden boxes, to the optimum height (but not necessarily level), and have a headboard positioned the same way to make a good presentation.

Cover the mattress with a couple of down comforters folded or tucked to fit the mattress top. The effect will be softer and fluffier, more comforting. Cover this with another layer of felt for smoothness. The bottom fitted sheet now goes on as usual, but pull it firmly and hold it in place on the far sides with T-pins pushed into the mattress. The top sheet shouldn't be tucked in at the bottom; leaving it loose will allow you to pull it later to the most attractive position without having to take apart the bed. The next layer, the blanket or bedspread, looks better with another layer of down comforter under it. Yes, this is why those beds look so inviting. Pull the top sheet up and over the top of it, adding a soft ripple or two.

Lots of pillows are placed at the head of the bed. Pillows covered by a layer of batting or felt pinned to them are smoother and fill the pillowcases better. Use a complementary assortment of pillowcases approved by the art director to build the head of the bed. By looking at them from the camera view, layer them for the desired effect.

TIP Floppy pillowcase corners can be stiffened by placing a piece of aluminum tape (or clear packing tape for lace or sheer flanges) at the back.

The next stage is the top surface of the bed. Based on the style, look, and color of the product, you will have selected some props and accessories for the room to make the bedding look its best in the environment. Will there be a prop placed on the bed? While styling the bed and allowing the photographer to set up lighting, you will be placing other accessories in the room and assessing how well they work.

All this takes time, with a good deal of consultation with the art director and photographer. The project is physically large, the set is far from the camera, and the linens can be heavy. Your bed shots may be interspersed with stacks and other presentations, and you may be working alongside other stylist and photographer teams.

STACKS AND SWATCHES

As with clothing catalogs, the merchandise is available in several colors. These need to be shown in very neat or casually irregular stacks. And since this is the catalog shopper's only opportunity to imagine the feel of the fabric, it must be shown clearly and up-close.

Study the section on styling stacks in Chapter 8, Wardrobe Styling. The same principles apply to stacks of towels, sheets, or blankets. But the linens are more challenging: they are bigger, heavier, and harder to manage. Keeping

a very large stack in position can be quite a challenge—use hidden tape, foam board, bricks, or other materials to stabilize the stack. A stack may be used to show edge details with some items turned in a different direction. A corner may be flipped over at the top of the stack for the same purpose.

Other presentations are sometimes used. For instance, linens may be fanned out in a radius, rolled, or stacked on top of a made bed. On top of a stack of towels, one may be draped to soften the shape and to show thickness and texture.

RELATED CAREERS

Creating store displays, though it is not photo styling, requires many of the same skills and techniques. Whether store windows or dressed mannequins, a display is created for the public to view from various perspectives. It is used for store "branding" and to make the products desirable.

Another related area, yet a world apart, is set design for films and television. An imaginary world is created with every detail in place, and it needs to be consistent throughout production and from different viewpoints.

SPECIALTY KIT LISTS

This is a list of items that are helpful to have in a room or bedding stylist's kit, in addition to the basic kit described in Chapter 5, which of course includes the valuable aluminum plumbing tape.

Item	Description, Use
For Room Styling	
☐ Folding table	When you have many props on hand, keeps them in view
☐ Dustpan and brush	Cleaning sidewalks and floors
☐ Broom	Sweeping sidewalks and rooms
☐ Mini vacuum cleaner	Quick vacuum of set; battery powered and rechargeable
☐ Hairbrush	Straightening carpet fringe
☐ Collapsible mop	Quick floor clean ups, reaches to clean windows; compact
☐ Disposable cleaning sheets	Dusting and wiping up or used with mop; both wet and dry
☐ Furniture polish	Even out tones of wood floors, furniture; touch up scratches
☐ Furniture repair markers	In assorted colors, touch up marks and scratches
☐ Cotton rags	Cleanup, polishing
☐ Furniture pads	Adhesive felt disks to protect floors
☐ Paring knife	Slicing prop lemons, etc.
☐ Cutting board	For slicing; find thin type that can be rolled up
☐ Corkscrew	Opening prop wine, beer, or soda bottles

☐	Dishwashing detergent, sponge	Washing dishes prior to use and afterward
☐	Paper towels	Drying dishes, cleanup, and other uses
☐	Window cleaner	For windows and mirrors; touching up plates and glasses
☐	Torch lighter, matches	Lighting candles or fires
☐	Gardening gloves	Keeping hands clean when working with garden plants
☐	Garden shears	Trimming plants, cutting branches
☐	Rake	For clearing lawns of leaves and debris

For Bedding and Linens

☐	Iron and large covered table	For ironing bedding
☐	Down comforters	To pad mattress
☐	Rolls of batting and white felt	Wrapping pillows, building stacks
☐	Fiber fill	Fill and soften beds, building stacks
☐	Sturdy scissors	To cut batting and tape
☐	Long T-pins	Positioning sheets into mattress
☐	Aluminum plumbing tape	Stiffening pillowcase corners
☐	Clear packing tape	Stiffening sheer or lace corners
☐	Apple crates	Wooden boxes used by photographers, use for raising furniture
☐	Foam board	For supporting stacks and pillows

RESOURCE

Susan McDaniel's informative ebook *How to Style a Bed* is available at *Photo Styling Workshops*, www.photostylingworkshops.com.

The home is, more and more, a comforting environment. More money is spent on home furnishings than ever, as people go to movies and restaurants less and less, and stay at home watching DVDs. This trend shows no signs of diminishing, and there should be plentiful work on home product catalogs in the future.

PORTFOLIO CHALLENGE: BED CLOSE-UP

You can develop your bed styling skills by styling a cropped-in viewpoint. Unless you want to design an entire bedroom to use as a location (and have enough room to find a good camera angle), you can come in close on some sensual details. Or show a portion of the bed and a well-styled bedside table at the side. Try different cropping options with your photo editing software.

PART III

BUSINESS FOR PHOTO STYLISTS

CHAPTER 13 Marketing Yourself

THE REAL-LIFE STORY OF food stylist Cindy Epstein can inspire us with the hard work required to build a strong career. I met Cindy when she assisted us at a weekend styling workshop in San Diego after contacting Lisa Golden Schroeder. We offered her a reduced rate at the workshop in exchange for help with purchasing groceries for styling demos, and coffee and water for attendees. Her willingness to do anything and more to help, including giving me a ride one morning, was impressive.

A FOOD STYLIST'S SUCCESS STORY

Cindy had spent eleven years in her own catering business in Philadelphia before selling it and apprenticing with a stylist for a few months. She moved to San Diego and took a detour to launch an Internet company with her husband but became restless and missed the food industry. She wanted to become a food stylist, and she has succeeded.

The first break came because she was in the right place at the right time—our workshop. Gregory Bertolini, presenting the food photographer's viewpoint, was in the midst of shooting a major cookbook in San Diego, authored by two recognized chefs. He invited members of the workshop to visit a photo shoot for the cookbook. Cindy was the only one who took him up on his offer and was there with her styling kit in hand. After spending a day on the set, she was invited to work as part of the team.

At the workshop, she and Carl Kravats, an aspiring food photographer who had recently relocated to San Diego, were teamed up to do some practice shots. They hit it off and continued to work together on test shoots, which soon evolved into commercial projects.

It sounds easy, doesn't it? Like everything fell into Cindy's lap. But I relate her story because she is a great example of the hard work and motivation that are required to build a styling career. Her approach included networking at photographers' events, postcard mailings, calling photographers and ad agencies to introduce herself, advertising in the local film commission's directory, printing business cards, continuing her education at workshops and conferences, building a website, joining professional associations, and testing with photographers who also wanted more food images for their portfolios. Cindy tells us how she did it all.

I read anything I could get my hands on about styling and production and used the Internet as a resource to study food photographers' and stylists' websites. I subscribed to all the best food magazines and studied the images, sometimes using a photo as inspiration to learn a

new technique. But I think the two most important keys to honing my craft and breaking into the industry were testing and marketing. I know having owned two companies gave me a great business background. I'm an entrepreneur at heart and know how difficult it is to start a company. The hardest part for new stylists and photographers is actually marketing themselves, and being willing to invest that much time and energy to building their business. I spent 80 percent of my time marketing my business and 20 percent testing or actually working a job. I have also been very blessed to have several fabulous mentors who have provided me with guidance and advice. Thanks to Susan's workshops, I met three of them there!

BUILDING YOUR STYLING BUSINESS

When you're starting out, you'll learn from any role you play in a photo shoot, whether it is assisting a stylist or doing errands (or like Cindy, helping with a workshop). But you want to be a stylist. When you've built up a portfolio and you're ready to embark on your career, you need to find your first clients.

You can start by looking at the market area you're located in and doing some research. Are there catalog companies and magazines based near you? Are there any large retailers or manufacturers that create their own advertising? How many advertising agencies are there? What is the predominant industry? How far will you have to travel to the nearest large city? Do you have a friend you could stay with while you visit possible clients there? Find out who the photographers are in your area and in the nearby city.

FINDING CLIENTS THROUGH PHOTOGRAPHERS

Most often, commercial photographers are your best source of work. Wedding or portrait photographers won't be likely to use a stylist. Commercial photographers shooting for advertising or catalogs are the ones who hire stylists.

Ad agencies, graphic designers, and publications are likely to select the photographer for a project first. Often art directors will contact several photographers for estimates on proposed projects. They may have found one photographer they're anxious to work with but will contact a couple others for comparison. Then the photographer needs to line up a potential stylist and get a quote to incorporate into the estimate. After that, the photographer may not get the project. Don't count on bidding a job as anything more than a possibility. But it might happen and you may work with the same photographer again and again.

So it's good to let photographers know who you are. You can contact photographers, locally and even nationwide, by sending postcards to a mailing list. Introduce yourself to all nearby photographers who do commercial work. If you find one or two photographers whom you work very well with, they may be your best source of clients. Find lists of photographers through local film commissions, and photography organizations such as APA (American Photographic Artists, formerly known as Advertising Photographers of America) and ASMP (American Society of Media Photographers). See Suggested Resources at the end of this chapter.

FINDING CLIENTS DIRECTLY

Other clients, such as catalogs and magazines for example, may contact you directly to work with a photographer they have chosen. Catalog art directors generally hire stylists for fashion shoots themselves, since it's such an important role. Make sure that any local catalog companies or retailers know who you are by contacting the art directors and asking to show them your "book," as your portfolio is known.

Word-of-mouth recommendations are wonderful when they happen; this is where your alliance with photographers comes into play. You might send your postcard to a mailing list of ad agency photo buyers or catalog companies. But the most effective, and easiest, marketing method is to let clients find you through your website. Remember to include the name of your site in all listings and promotional materials.

I have been contacted by photo editors from magazines, or their assistants, for styling projects. The key was my website and other resources I was listed with (more about these resources follows.)

THE IRONIES OF STYLING

I've found, as an amusing irony, that when I have travel plans that can't be changed, I will inevitably get a call from a new client for a great project. When this happens you just have to laugh, get the contact information for the missed client, and hope you get another opportunity.

After you commit to a month-long project, you will surely get a call or two about some interesting one-day styling jobs during the same period. And you'll have to pass them by. When it rains, it pours, especially after a long unsettling drought. This is a good time to remember other stylists you have gotten to know—and they'll refer jobs back to you. Also, you then become a problem-solver for the caller, who might appreciate it and remember you for the next job. It helps if you have worked with the other stylist and can recommend her based on professional experience. If not, get yourself off the hook by saying so, but that you've heard good things about the stylist. Keep the client's information for a follow-up call or email.

If your search for styling work is really dead in the water, you can always look for a job. Even if you apply for a part-time or seasonal job, it's inevitable that once your application has been submitted and your references checked, some styling work will suddenly appear. If worst comes to worst, and nothing happens, at least you will have a transitional job lined up.

COLLABORATION AND TESTING

Due to the nature of the catalog business, every page is valuable "real estate." The costs of design, photography, writing copy, merchandising the products, and then printing and mailing mean that there won't be much wasted space. There are a few well-designed catalogs that feature one product on a whole page, but this is the exception, not the rule. You may do a styling project for a catalog, and do a marvelous job. Each individual shot was magnificent,

and you can barely wait till the printed catalog arrives. You will probably be disappointed. Your beautiful shot that took so much time will end up about two inches tall—and may even have words printed over it. When you scan the image so you can enlarge and add it to your portfolio, the printing on the back of the page shows through. That is the catalog industry.

But take heart. The way to get around this problem is to participate in testing. It is also known as trade-out or test for prints (TFP). Testing is a group effort in which a crew develops a photography concept, plans the project, and executes it, all to produce images for self-promotion.

THE CREATIVE VALUE OF TESTING

Your best and most rewarding work may result from testing. This is also your opportunity for creative expression. You aren't limited by what the client and art director are looking for. You aren't selling a product—you are bringing a concept to life. Inspiration may come from editorial stories in magazines. Perhaps another stylist's portfolio or website will give you ideas about what is missing in yours. Your test shoot may be an edgy concept involving fashion, props, and a unique environment. Or it can simply be a "beauty shot" using a beautiful model and classic wardrobe in the studio.

Contact modeling agencies to find new models who need to build their portfolios and are willing to work for images, hence "test for prints." Be clear with the agent that the shoot is a test for self-promotion. When you call the agency later for actual clients, you will already have rapport with a particular agent. The model will need to sign a model-release form at the shoot and will expect some digital files or printed samples for her book. Occasionally agencies will hire photographers and stylists for promising new talent's head shots.

You may have acquaintances with the look you want, but their lack of camera experience could make the shoot less successful. It might be worth trying for the learning experience or cases when the talent isn't the feature of the shoot.

Use the contacts you make during shoots for your collaborations. Photographers, assistants, models, and makeup artists all should be glad to work with you on tests. It can be an opportunity to work with a new photographer and see how well you work together, sometimes building a lasting professional relationship.

What is difficult is finding a time when everyone is available for a non-paying project. If a job comes up for any of them, they are likely to take it, rather than decline it for a test shoot. In that case a lot of planning is wasted, but the risk is worth it, and the test shoot can always be rescheduled.

Tests are usually done on a shoestring. Since everyone is volunteering in exchange for images, there isn't usually any budget. Sometimes, but not often, an experienced model will be hired to ensure high-quality modeling. Wardrobe is likely to be something from your own collection or items that will be returned, so there isn't much styling expense. And you'll certainly want to find a location that is free.

Actual expenses may be snacks and water, and the photographer's film and printing costs. If the shoot is digital, making image CDs will be a nominal amount.

Otherwise, the crew members' investment is largely time. It is important to clarify the expenses and how they'll be shared at the beginning of the collaboration.

> **TIP** Prepare for tests by recruiting compatible crew members when you work together. Later you will be able to think of the perfect photographer, model, or makeup artist for the concept, and you may inspire each other's ideas.

EACH TEST IS UNIQUE

In most cases a photographer or stylist will initiate the test, or they may come up with a concept together. My intern, Paula Tabalipa, was talking with San Diego photographer Jeffrey Brown about an underwater camera he had borrowed. Before returning it, he wanted to use it for a test, so together they developed an idea to shoot clothing in a swimming pool. The photographer had a contact at a public swimming pool and was able to arrange an early-morning shoot.

I helped Paula gather some fashion separates and accessories like a silk-flower lei and some handbags. One challenge was determining what styling supplies we would need to position the clothing underwater. After some experimentation we used monofilament tied to weights and to long bamboo sticks suspended over the pool, and also used poles for poking and arranging the items. Paula spent a good bit of time diving under the water while I stayed at the edge of the pool, on my belly, reaching out to control floating garments. The photographer, of course, was underwater, and communication was limited. Later we all selected some outstanding shots for our portfolios, because we'd each contributed to the project.

For an earlier test shoot, I was inspired by an old "woody" station wagon that a friend of a friend owned. Also, my daughter was working on her modeling portfolio. I contacted Greg Bertolini, who was then in the earlier stages of his career—I knew he was building his book too. It was one of those fortunate tests involving a number of people available on the same Saturday morning. The photographer, a makeup artist, my daughter, a young male model, the car owner, and I met in a beachfront park. The beach restrooms were convenient for changing clothes, and I had brought several surfer-style Hawaiian-print garments.

The makeup artist ended up with a couple of close-up shots of the models' faces. The photographer took photos of the models and also details of the car for his book, and my favorite shot is one of Elizabeth in the car interior. Finally, we set up a portrait of the car, which was printed as an enlargement for the car owner.

Although the benefits—building a portfolio and experience—are obvious for a beginning stylist, you should continue testing throughout your career. It's a habit you can maintain to keep yourself creatively challenged and your portfolio fresh. After the test shoot, make arrangements to view all the images and select your favorites for your portfolio.

EDITING LIKE AN ART DIRECTOR

This image selection is close to the process art directors go through when editing the photographer's shots. As an art director, I used to edit transparency film over a light table by looking at every single frame, narrowing it down to the best six to ten shots, which were placed in a plastic sleeve, and then making final selections with the merchandise buyers. When a detail was not right in frame after frame, I would be annoyed that I hadn't stopped the process to have the stylist change it.

Knowing how to edit your photographs like an art director will improve an art director's impression of your work. The final choices are ones where everything is nearly perfect. The model's expression and posture, the styling, and visible garment features are the main elements to watch for. When you review the film or digital images from your tests, you'll have a chance to see what you might have done differently and also make the best choices for your portfolio.

If you are shooting a group of two or more models, the editing process is more difficult. In addition to the above details, you need to look at the models' body language and how naturally they interact. There is also the matter of where they are looking. It doesn't work if they're looking in opposite directions, but it can work if the guy is looking at the girl, and she is looking down. If the models are caught in a moment when they're looking in the same direction or at the camera, the image is stronger.

ACQUIRING SAMPLES OF YOUR WORK

Tear sheets, also known as "tears," are actual printed samples of your work. In the ad agency world, it's routine to have extra copies of an advertisement printed on high-quality paper. These can be provided to the photographer and also to you, if you ask for one. The tear may also be a page from the actual magazine where the ad was placed. If you have to purchase the magazine yourself to get a tear sheet, cut the page out carefully using an X-Acto knife along the inside margin where the pages are glued or stapled together (known as the "gutter"). This can be placed directly into your portfolio or scanned and printed.

Remember to get the client's contact information during the shoot, so you can follow up and ask for tears. Try to find out when the ad will be in magazines and in which ones, so you can buy them. It's exciting to see your work in a national magazine!

It's not too difficult to get sample catalogs. You can ask the art director to send you some, but most likely new projects will get in the way and cause her to forget. The best tactic is to call the catalog's toll-free number and ask to be put on the mailing list, or sign up on the company's website. Do it right after the shoot so you don't forget. The catalog you worked on will probably appear in your mailbox in two or three months, or more.

Although the catalog shots may only be one inch tall, you should still add some printed catalog pages to your portfolio. For one thing, it's interesting later to look back over your career and see how styles have changed and also that you've become more experienced. If you are pursuing a client in some

specialty field, you can look through your samples and find related work, even though it may not be useful for your primary book. Save all your samples!

> **TIP** Make a note for yourself in your planner (digital or book) to follow up on your work samples. Write down the expected publishing date, job info, and contact email or you may forget three months and many jobs later. If it's a catalog, visit the site the same day to join the mailing list.

YOUR PORTFOLIO

Portfolios are not as much a part of self-promotion as they used to be. Thanks to the Internet, you can present yourself without having to meet to show your portfolio. If you have a website, potential clients can find you from anywhere in the world. They might be looking at your online portfolio while they're speaking to you on the phone.

Still, you need to have a portfolio for those occasions when it is requested. You can carry your portfolio with you to jobs, too. You might have an opportunity to present it toward the end of the shoot day to the art director or photographer, if they have not recently seen your work.

Photographers and stylists represented by agencies usually use high-quality portfolios bound in leather and embossed with their names. This investment isn't a necessity when you're starting your career, but you should select a tasteful style.

Art-supply stores are good places to look for portfolio cases when you're getting started. Usually black, they needn't be expensive. A good choice has removable sleeve-style pages that can be added and rearranged. Choose a portfolio that will accommodate standard printer paper or larger, so that all your printouts and tears will fit into the pages.

PAGINATION

Pagination is a process of designing "spreads" and deciding what goes where. A spread is a set of two facing pages. Even though different pages are printed together for collating later on, a catalog is designed in spreads. You can design your portfolio by looking at two facing pages. (Many stylists may not think of this.) I spread my samples out on the floor and rearrange them until I find the most complementary pairs of pages.

A large image might look good next to a small detail from the same shoot, with a border of white space around it. Two similar shots from different projects can make good neighbors. Think about color. You can build themes and create a flow of the subject matter in your portfolio. These concepts will help you when planning out your website also.

You should periodically revise your portfolio to include new work. Add tears and images from tests. At the same time, you can remove samples that

have become dated or don't represent your newer skills. By using removable pages you can change your presentation depending on the client. You may be presenting it to an athletic-wear catalog; in that case, you can pull sports samples from your files to emphasize related experience.

If you are represented by an agency, your portfolio will be an important part of the agency's promotion, and there will be a standard portfolio binder that they use. It's your responsibility to keep the agency supplied with new portfolio work.

MOCK-UPS OF EDITORIALS

A good creative exercise is designing a "mock-up" of an editorial story. Even if you haven't styled for a magazine, you can have a portfolio piece that looks like a magazine page, as long as you are honest that it is a mock-up. You might collaborate with a graphic designer who could use an attractive portfolio addition.

I took a snapshot of my daughter getting into a red Mercedes on prom night that I thought looked like it was right out of a magazine. I scanned it at a high resolution so I could print it larger and asked a copywriter friend to help me with a heading for the "page." She wrote, "Night Moves—Hair and makeup that shimmer and shine in the moonlight." I applied it to the image in Photoshop using an attractive font and "reversed" the type, printing it white against the dark background.

Adobe Photoshop continues to be the gold standard in photography and design. You can change colors, add text, and even fix flaws in this useful software program. When you receive images from photographers, they will most likely arrive in a TIFF or JPEG format, which can be resized and reworked in Photoshop. Saving them in the end as a JPEG condenses the image file size.

If you don't already own Photoshop software, it would be helpful to purchase Adobe Photoshop Elements, a less expensive version that helps with resizing and organizing your photo files and even allows some photo retouching.

With a good printer and photo paper you may be able to print your own portfolio pieces. Check for visible pixels. If the quality is not completely perfect, take your digital files to a photographic printing service.

YOUR ROLE IN THE IMAGES

In assembling my portfolio, I had the challenge of conveying the various roles I had played on different shoots. Sometimes I was not the stylist but had found the locations, built props, or booked the models. I decided to divide the portfolio into five sections marked with side tabs. They are labeled Fashion & People, Clothing Off-Figure, Products, Sports, and Prop Design & Production. I explain to clients that the samples in the last section include various contributions but not necessarily styling.

If you have samples of projects you worked on as an assistant, be very careful how you present them. If you are there when your portfolio is being reviewed, you can state that you were the assistant. Otherwise, you should label the portfolio pages with your role in the shots.

A snapshot was the starting point for this mock-up of an editorial fashion story with headline. Projects like this can add interest to your portfolio and demonstrate creative collaboration. Photographer/designer: Susan Linnet Cox; writer: Nan Gage. © Susan Linnet Cox

YOUR WEBSITE

Your own website is a wonderful tool for promoting yourself as a stylist, whether you are discovered and booked through it, or only use it to display your work. Essentially it serves as a portfolio, a biography, and an open door to contact you, all in one place.

You'll need to start with a domain name for your site. You can go to www.godaddy.com, www.networksolutions.com, or other web services to see if the name you want is available and then purchase it. The full website address (or URL) will include "http://www." then your chosen name, followed by ".com" (or other domain). Your URL may be your own name or your business name.

It's a good idea to purchase your own name as a domain name, if it's available. Even if you don't use it for your styling site, you may beat someone else to it. In addition, it's important to know if someone else has a site with your name—you need to tie your marketing and identity together.

You may purchase hosting services at the same time you buy your domain name, or you may want to work with a web designer on hosting options. The domain name is yours for as long as you decide to pay for and renew it.

There are now easy, do-it-yourself web design options you can select along with hosting. The number of pages displayed on your site is limited, but this may be a perfect way to start. It can help you avoid the problems of finding a cut-rate designer.

The days of setting up your portfolio on a group site are gone. To appear professional, you must have your own domain name and not be nested with another site. However, there are useful resource sites for the photo industry (such as Workbook or Model Mayhem) where you can display your portfolio. Just be sure to have your own exclusive site to refer visitors to.

FIND A WEBSITE DESIGNER

Finding someone to design your site is sometimes the most difficult part of building your site. I strongly recommend paying for a professional, not the free or low-ball services of a friend or acquaintance—and here's why. Let's say your designer friend is starting out and needs more experience. He or she offers to work for free or a low price. Perfect, because you don't want to spend a lot at the start. But if you don't like the style of your new site, it's awkward to say so. You put up with it; at least you now have a site. Things go well for a while until you want to make some changes to the original design. Your friend has become busy with other projects, and since you're not a priority client, your site is on the back burner. You wait and wait, and end up paying someone else to revise the site.

I went through this myself, with three parties working on the site, and I still wasn't satisfied. I paid the original designer her full price to get the look back on track, then studied both HTML web design and Dreamweaver software at a community college so I could maintain the site, add new images, and make other changes.

MAP OUT YOUR SITE

Plan your site by making a diagram, with the home page (called the "Index") at the top, and lines connecting it to the other pages on the site. The pages are linked by buttons or tabs on each page, so you can navigate around the site no matter where you are.

The first tier of pages after the home page may include your portfolio, a biography or other background information, and contact information. These pages can link to another level of pages, perhaps moving from thumbnails (small images) to enlarged views of your work. Every page on the site should have an internal link to get back to the home page or to any other page easily. A copyright line is usually placed at the bottom of each page to discourage illegal use of the images.

It's also important to give a credit to the photographers who shot the images you are using, after you ask for their permission to use them for self-promotion. Links to their sites would probably be appreciated, and if they link to your site, you will have more exposure.

There are other decisions to make about the look of your site, such as the colors, type font, images to display, and where you want the navigation buttons or bars. The most important attribute is the ease with which a viewer can move around the pages and view your work.

Building a creative website is much easier and more affordable now. There are photo gallery designs allowing viewers to scan through your images with sliders or Flash formats. They are easy to customize, upload images to, change information, and update. Web Photo Master (www.webphotomaster. com) is the one I used for Cox Productions, and I found it so easy to use. They also host the site for a nominal amount.

When your images are presented in a Flash format or as a slide show, they cannot be downloaded by others, giving you security from illegitimate use of your images.

Along with a presentation of your strongest images—your online portfolio— there are a few basic pages that help you to present yourself on your site. "Meet (you)," with a brief biography and a photograph, so people will know who you are before you meet; and "Client List," which identifies some of the clients you have worked for. Finally, and very important, is the "Contact Us" page, with phone numbers and email address—I think it is important to identify where you are located too.

You might have a "Recommended Sites" page with links to other sites. This is a service to the visitor but also a good way to build goodwill with other professionals and more exposure for your site. An "In the News" page can be updated with recent publicity about you and your projects. Behind-the-scenes production shots of you working are always popular.

BLENDING WITH OTHER MEDIA

Recently, websites have merged with other social media. Blogs and links to other media can have a prominent position on your site and have a consistent appearance, so the visitor may enter the site from various points of access. We'll look at social media and blogging more closely later in this chapter.

PROMOTE YOUR SITE

The site design should include a good title for each page and "meta tags" that help your site be found on the web. Meta tags are words or phrases someone might typically type into the search bar of a search engine when looking for a stylist. Be sure your designer builds these invisible tags into the structure of the site.

Searchwebservices.com describes the tags this way: "The keywords meta tag lists the words or phrases that best describe the contents of the page. The description meta tag includes a brief one- or two-sentence description of the page. Both the keywords and the description are used by search engines in adding a page to their index. Well-written meta tags can help make the page rank higher in search results."

You might use combinations of words or phrases like "styling, stylist, fashion, fashion styling, fashion stylist, wardrobe, catalog styling, editorial stylist, Minneapolis, Minnesota." This would be a good start to describe a regional stylist. Experiment on your own by searching for other stylists and see what words and phrases get results. And of course, try searching for yourself using your own name, your business name, and any other combination of search terms a potential client might try.

Most search engines have a page where you can submit your site's information to their index of sites. This way, you have a better chance of being at the top of a search results list, rather than on page 16. When submitting your information, you may have to enter a description of the site, so have this information available to copy and paste. Gradually the visibility of your site will spread, but never stop looking for directories and resources to add it to. Alternatively you can pay for search submission services after researching them carefully.

FREE LISTINGS

Shoots.com and Workbook.com are among resources that offer free listings for freelancers, including stylists. Resource Advantage (www.rasource.com) is an example of a targeted subscription directory; formerly free, it now charges a fee. Just reading the categories is interesting. As your site moves around in cyberspace, you may find yourself listed on directories that you don't even know of. It is essential to ask new clients how they found your site, though they won't often remember details of the search process.

An important place to be listed, often for free, and even to advertise, is your local or state film commission's directory, both printed and online. This may be the first place clients look for crew resources, whether they are traveling from out of town or are local.

Remember, your site must provide a way for clients to contact you, preferably an email link and your phone number. Your street address is optional: you may or may not want to post your home address. If your email address changes or you move, remember to change your contact information on your site as well as with other resources where you have posted your information.

SOCIAL MEDIA

As the World Wide Web opened up possibilities for people everywhere to communicate, it was populated with informational and commercial sites, email, and search options. More recently, as we've grown accustomed to using the web, outlets such as Facebook, Twitter, blogs, and even an online store can all be laced together to create a media identity for even everyday users.

Haley Byrd was a student in my college fashion class and is now an up-and-coming stylist working in Los Angeles and her native Hawaii. She is also a blogger and has learned to successfully tie her fashion blog, Twitter posts, and other marketing together in social media. Her blog is *Fashion Rework*, www.fashionrework.com.

Simply having a website was current when I wrote the first edition of this book, but now it is only one spoke in the wheel of our online persona.

FACEBOOK

I started a personal Facebook page in order to create a business page for Photo Styling Workshops; then I realized how simple it was to add frequent updates. A business page is an easy and free way to build a community of friendly customers and fans, who can see information any time you post it.

LinkedIn.com, which I used to call "Facebook for grownups" until I developed my own Facebook habit, is a networking site for professionals in all fields.

I caution you to be careful what you post anywhere on the Internet—nothing political, overly personal, or negative belongs here. Try to keep postings (on both personal and business pages) neutral and upbeat.

TWITTER

Tweeting is one aspect of social marketing that I have decided to ignore. It just sounds like it's a bit too attention-demanding. But I used to think that way about Facebook, and now I love it.

Haley, however, and millions of other people participate. She explains how she uses it: "I post on Twitter each time I have a new blog entry, when I want to direct attention to another article, a designer, or collection that I find interesting. I do try to incorporate some personal tweets within reason, but sparingly. It is not a tool to abuse or you will alienate yourself as a blogger and person of interest. The quality of the content you release should build onto your image."

BLOGGING

I started my own blog, *The Invisible Stylist*, in 2008 to help with promoting myself, my book and workshops, and my styling career. I was surprised how much I enjoyed posting—the way it inspired me to make observations about the world around me and my life as a stylist. The blog has now evolved into a styling community forum, with guest bloggers sharing opinions and techniques.

While many write about up-to-date fashions and beautiful plates of food, fewer blogs are actual stylist career blogs with professional stories and behind-the-scenes photos. In this way, you can make yourself an authority and show your human side at the same time.

It is easy to purchase a domain name for your blog, making it easier to remember than a free name with ".blogspot.com" or another confusing ending provided by the blog host. Mine is www.theinvisiblestylist.com, which could be expanded to more than a blog in the future.

FASHION BLOGGERS

With new technology easily accessible, Haley says, social networking only takes a few minutes a week if you're doing blog posts, but to enhance aspects such as street style, it tacks on an additional half-hour per style post for basic maintenance and community engagement.

"I'd say that my blog now has more thought behind it, and I have every intention to continue doing this for the rest of my life." Creating your blog is relatively easy with intuitive formatting and free blog hosting platforms include Tumblr, WordPress, Blogger, and Blog.com.

FOOD BLOGGERS

Food blogs abound too, and some bloggers have gone on to build a career as a stylist or photographer after the intensive practice of posting their own images.

Other blogs are less gorgeous, simply outlets for amateur recipe development or a record of restaurant meals. Again, a blog about the career of food styling can be a distinctive approach, helping to enhance your status as an expert.

KEEPING TRACK

Haley uses a variety of search tools to find out more about readers, especially the one provided with her blog template from Wordpress. She explains, "It tells me how my readers find me, where they are referred from, and what they are looking up to find me. I have blog followers that are subscribers and then people who visit each day. I also use Google Analytics, which will tell you where in the world they come from and the length of time they spend at your site. These sites can later be referred to again and keep all past information, so you can compare your viewers month to month, week to week, and day by day to make sure you are steadily progressing."

TYING IT ALL TOGETHER

There are communities of fashion bloggers like Lookbook and Chictopia. Your blog posts can be shared to a number of social networking platforms. Bloglovin is a site where bloggers can register to automatically post updates of their blogs to interested followers. You can also see other blogs your followers like.

With so many food blogs, there are directories available for food bloggers like Food Blog Blog and Food Blogs (see more networking resources at the end of this chapter). Be sure your blog is listed in these resources. Saveur.com presents annual awards for the best food blogs.

I like to notify friends and customers of new blog posts on my Facebook pages and have set up a page for the blog itself. Besides, writing a blog is a good creative exercise in sharing your observations about trends. "We don't have to wait for a reporter to interview us. We can create the media and set it free to go viral," says Haley.

BUILDING YOUR RÉSUMÉ

Writing a résumé, one of the traditional tools for self-promotion, is a gradual process of understanding who you are and what you have accomplished.

I have reached a point in my career when I rarely need to use my résumé. As clients started to find me from my website, I gradually had less and less call for a portfolio and a résumé. However, your résumé is still important as your career develops and a necessity when job-hunting.

Spend some time looking back at your experiences, whether learning or work, and make some notes. It will take a while for a good résumé to take form, and thanks to computers, you can add to it at any time (yes, I remember when we had to type them!). Your résumé should be an ongoing project. Update it when you have more expertise or a new address.

THE CLIENT LIST

One important element to add to your résumé (as well as your website) in this business is a "client list." Clients can simply be listed, or you can describe

briefly what kind of work you did for them, whether it was wardrobe styling, assistant stylist, or preproduction. Most of the time, you will have been hired by a photographer to style a campaign for his or her client. But unless it's a well-known photographer, that won't carry much weight or show the type of project you worked on. In such cases, it's fine to list the end client. And just who is the end client? Remember the brochure for the grocery chain from Chapter 10? The grocery chain, Publix, was my end client—technically the advertising agency that represented Publix hired the photographer, who, in turn, hired me. Add to your client list often. You'll be happy to know that eventually you may have so many you won't remember them all.

If you work as a styling assistant on a project, you need to be clear about that. It's not fair to the stylist who hired you to imply that you were the stylist. This is where listing your role on the project comes in.

There are many books available on writing résumés. In a creative field like photography, you have a little leeway in designing yours. The standard style is always acceptable, but you can be more artistic than someone applying for a job as a legal aide, for example.

SELF-PROMOTION: YOUR OTHER HAT

Unless you are represented by an agency, you are in charge of your own marketing. No one but you is going to remind people that you are here. When you're working you are, in fact, promoting yourself, by your professionalism, your personality, and the quality of your work. But that is not enough. You need to find new work.

BUSINESS CARDS

These are the most basic of all marketing materials. Business cards are small and easy to carry and you should never be without them. Several online printing companies have made ordering business cards quick and affordable. Just be sure not to use free business cards that display the name of the printer on the back; these do not look professional enough.

If you want to print your own to tide you over between orders, purchase business-card paper that snaps apart, creating cards that look professionally printed. There are templates you can download to set up the layout. An eye-catching design could include a photo of you or your styling work.

COMP CARDS AND LEAVE-BEHINDS

The cards that models use are known as "comp cards." They are printed on heavy paper known as card stock and half the size of a standard piece of paper. They're printed on both sides, with the model's name and a head shot on the front, and other photos, the model's sizes, and the agency information on the back.

The cards are sent out by agencies when clients request a selection of talent for a project. You can also use comp cards, whether you have an agent or are independent, by leaving them behind with potential clients or at the end of jobs. These "leave-behinds" serve as a reminder of you and your work. Mailed in medium-sized envelopes, comp cards may not need extra postage. They may

end up in a file of possible stylists for the future or, if really attractive, on a bulletin board. By making sure yours contains helpful information and is attractively designed, you can reduce the probability that it will end up in the recycling bin. There are printers that specialize in affordable comp cards.

POSTCARDS AND OTHER MAILINGS

Some of the most effective promotional pieces are postcards, useful for both mailings and leave-behinds. They can showcase one example of your styling work or a group of images. Your name and website should be on the front, and the back should contain more information and a clear area for the address and postage. I suggest some open space also where you can write a note by hand. Postcards under a certain size use lower postage than the regular letter rate, so if you're doing a large mailing you can save money.

Find a printer that specializes in postcards and can provide postal specifications to you. A good one is Modern Postcard (www.modernpostcard.com). Most printers will provide graphic-design services, too.

Cindy Epstein, whom we met earlier, is one stylist who has done a good job of self-promotion using postcards. Here is what she had to say:

> *I did a lot of searching to create a mailing list. The search will obviously depend on the type of stylist. I used the Internet and a number of the local San Diego production companies. I also used the* San Diego Business Journal.
>
> *And then as I got clients, I added them to my list so I could keep in touch. In the beginning, I did a postcard about every six to eight weeks, but that was just too hard to keep up with. So I went to every few months. I don't send as many now, but I do try to send an HTML email that's pretty, funny, edgy—something to make them look at it—about four times a year.*
>
> *More than getting me jobs, what the card did was get my name out, so people knew who I was and that I was in San Diego. I had a lot of referrals from people who got my card and suggested me to someone else. You know how that goes: Someone asks someone else in the biz if they know anyone, and they say I never worked with her, but I got a postcard, etc. But the most work I've gotten was from a Google search and my website. I would say the second most biz came from people who worked with me and passed my name along, and then there is the repeat biz, of course, that we all love so much.*

Mailing lists can be purchased for a reasonable amount. One good source is the Workbook, www.workbook.com, which can break down lists by a number of characteristics and regions. You can gather your own contact list for mailings by visiting sites of local—or national—photographers, photo shoot producers, ad agencies, and catalog companies.

Remember the clients you've worked with during the year by sending holiday greetings at the end of the year. You can buy cards or make your own with holiday images that you've styled. As always, be sure to add your contact information and credit the photographer and the client.

SPECIAL PROMOTIONAL IDEAS

Bedding stylist Susan McDaniel posted a video on her website, www.susanmcdaniel.com. It shows, in time capture, Susan styling a bed. You can

watch the process, from a bare room set to a finished shot, with all the steps and decisions between.

There is magnetic printer paper on the market that is thin enough to fit into your home printer. Some is sized to print business cards, but there are also full size sheets that can be cut into various sizes and shapes. Imagine the possibilities.

An easy promotion was a custom license plate holder I ordered for my car, with "Photo Shoots" and "www.coxproductions.com" above and below the plate. For $15 plus shipping, this was an affordable idea to make my presence known at the shoot.

In my college class, I brighten the marketing segment with a challenge to come up with one unique promotional idea. Some of the ideas are fantastic, like a fashion photography party offering guests one free image and styling, a bookmark, and printed cocktail napkins. One student came up with a fake parking ticket explaining that she had fed the parking meter as a favor and added a coupon for a fashion makeover. I love the contrast between the initial fear and the friendly, reassuring presentation she left behind.

And remember the *My Favorite Glass* package sent out by photographer Dan Whipps in the color insert? Any clever ideas you may have for self-promotion can only help your business by showing off your creativity.

SELF-PROMOTION BETWEEN PROJECTS

Your projects wind down, the returns have been made, you've invoiced the clients, and you're starting to ask, "Will I ever work again?" Now you can really get to work. You have some down time and it's your opportunity to promote yourself. Do it now while the satisfaction of your most recent styling project is still there. Here are some suggestions about how to use that time:

- **Plan a test shoot.** Call a photographer you want to work with to plan a collaborative project. Share some ideas and concepts, and brainstorm together. Since it will take a while to pull the test together and coordinate your schedules, you're free to work on some promotional materials, maybe do a mailing.

- **Design a mailing.** If you have design skills or design software, you may be able to create a postcard or other mail piece. If not, you might suggest an exchange with a graphic designer who could use a styled photograph for self-promotion. Some printing companies provide in-house design.

- **Update your résumé.** Remember to put the most recent clients on your client list. Revise the description of your skills and experience.

- **Add to your portfolio.** Include new tears from recent projects. Scan them and add to your website. Take some time to look at your portfolio as if you haven't seen it before.

Continued on next page

- **Make contact with your peers.** If you are out of jobs, perhaps there's a regional slump in the market. Maybe it's seasonal; after a couple years, you'll learn to expect these trends. If so, others in the field are going through a slow period. It is a good time to email or call photographers who are in the same boat. They may be interested in planning a test shoot and will remember you when the next job comes up.

- **Learn new software.** Add to your computer skills by taking an inexpensive or free software class at a community college or adult-education program. You can learn a web design program so that you can maintain your own site. A desktop-publishing program can help you to create your own business cards, postcards, résumé, and note cards, even if you don't have a graphics background. You might learn a business-management program for creating invoices, doing estimates, and recording your income and expenses. Find out how to use a scanner to copy your styling work for your website or portfolio.

- **Do some cyber research.** Explore the Internet to find out how your site is ranking. See how other stylists are promoting themselves through their sites and the types of work they are presenting. Find organizations, blogs, and sites that provide styling suggestions.

- **Join professional organizations.** ASMP and APA (see Suggested Resources) are photography organizations. Local chapters have regular, informative meetings that you can attend and where you can meet the local photographic talent. Look into business groups in your area that focus on marketing, such as the Direct Marketing Association (www.the-dma.org). Introduce yourself to potential clients who will be interested to learn what a stylist does.

- **Update your kit.** Add any new items you've come up with and restock anything in low supply. Have your kit clean, organized, and ready for the next job.

- **Start a blog.** If you don't already have one, use this down time to design a blog. Write some articles to pull from when you're too busy later. It's best to consistently post new blog entries.

- **Work on your business.** Enter receipts into your accounting software, organize your outstanding invoices so you know what's due and when, file your most recent job envelope, pay bills, get organized, and be ready for the next flurry of work.

> **TIP** Carry a small camera or grab your cell phone for those great behind-the-scenes production shots. They may come in handy later for your blog or a section on your website.

SELLING YOUR TALENTS

If you are feeling overwhelmed by all this discussion of marketing yourself, you're not alone. Selling yourself is one of the hardest things to do: just ask any artist who creates something from the soul and puts it out there for critique. Marketing yourself may take some practice, or you may really enjoy it. Remember that a model or actress goes to about forty castings for every role she gets. A rejection is just a bump in the road on the way to your destination.

Agency representation can take care of much of the marketing for you. However, you must first market yourself to an agency before you are represented. After being told by two Los Angeles agencies that I needed newer samples in my portfolio, but not having a clear understanding of what they wanted, I decided to stay on my own. Rather than pursuing these agencies after having promoted myself for several years, I determined that I can trust myself to sell my skills and talents better than anyone else.

SUGGESTED RESOURCES

- **APA** (American Photographic Artists): www.apanational.com
- **ASMP** (American Society of Media Photographers): www.asmp.org
- **DMA** (Direct Marketing Association): www.the-dma.org
- **Go Daddy**: www.godaddy.com
- **Modern Postcard**: www.modernpostcard.com
- **Network Solutions**: www.networksolutions.com
- **Web Photo Master**: www.webphotomaster.com
- **Workbook**: www.workbook.com

MORE NETWORKING RESOURCES

- **Bloglovin'**, www.bloglovin.com: keep track of blogs and sign up for followers
- **Chictopia**, www.chictopia.com: post and view observations about fashion trends
- **Fashion Industry Network**, www.fashionindustrynetwork.com: make connections, join group and post news.
- **Food Blog Blog**, www.foodblogblog.com: directory of food blogs

- **Food Blogs**, www.foodblogs.com: directory of food blogs

- **Google Analytics**, www.google.com/analytics: free systems for viewing your Web traffic

- **Google Buzz**, www.google.com/buzz shares posts and images for Gmail users

- **Le Book**, www.lebook.com: long known as a print resource in the industry, Le Book is the ultimate professional guide in New York City.

- **Linked In**, www.linkedin.com: networking site for professionals

- **Lookbook**, www.lookbook.nu: fashion networking blog

- **Lots of Style**, www.lotsofstyle.com: a network for fashion stylists, with memberships ranging from free to a monthly fee. You can post portfolio images.

- **Resource Advantage**, www.rasource.com

- **Saveur**, www.saveur.com: annual awards for the best food blogs

- **Shoots.com**, www. shoots.com

- **Workbook**, www.workbook.com

New sites are popping up often, so devote some time regularly to surfing the web. Check on your own status and seek new outlets for self-promotion and networking.

In the next chapter, we'll explore some business practices and organizational techniques that should help you run your styling business smoothly. More information about the agency option is also provided.

14

The Business of Styling

THIS CHAPTER IS PROBABLY not one most readers will read first. In fact, you may put it off—or not read it all. It may seem as exciting as paying taxes, which we will talk about in this part of the book. The information here is important, however, and mastering it can make attending to this part of your styling career much more pleasant. Actually, one of my favorite parts of my work is invoicing; the sooner the invoice is mailed to the client, the sooner I will be paid for my time. I can never understand procrastination about this final aspect of a job.

When I thought about leaving my position as a model agent to devote myself to styling, I made some calculations based on what I was earning at the time. With my average earnings (I was on commission), I figured if I worked five or six days per month as a stylist, I would be ahead. That seemed a feasible goal. I did some test fashion shoots, styled some off-figure shots, and searched through work I had been doing through the years. I designed and ordered a small quantity of an accordion-folded brochure, and sent copies to local photographers. One photographer called me—he had just gotten a new catalog client and was looking for a stylist to do the off-figure styling when my brochure happened to arrive. That client was the only result, but one day of styling work paid for the entire printing.

My professional styling years were beginning, and, though I had already been self-employed much of my life, I learned many lessons about organizing and managing my business along the way.

YOUR STYLING RATE

Determining your styling rate is not easy. It's awkward asking other stylists, who may be your competition, what their day rate is. It's not professional and in fact may be considered illegal restraint of trade! When I started styling, I had the advantage of my photography and art-direction background. I'd been hiring stylists for catalog projects, so I knew the going rate. I started at that rate, then $350 a day, and after a year or two started raising it.

You can get a feel for acceptable day rates in your area by talking with art directors. If you're having a comfortable conversation, it's all right to ask what they usually pay. When you assist a stylist you can ask, in a friendly, nonthreatening way, what rate you might think about working up to.

COMPARING RATES WITH YOUR PEERS

I had an excellent opportunity to compare my rate with other local stylists a few years ago. The Affiliate Chapter of the San Diego APA (American Photographic Artists), a group of makeup artists and stylists, became active and held

several meetings. It was a unique opportunity to meet many of my peers who I wouldn't have met otherwise, since we all work independently.

Most of them were makeup artists, but there were a couple of other stylists. Normally we might be vying for the same work. In one meeting we discussed the local rate, which is comparable for makeup artists and stylists. Actually, it is illegal for such a professional organization to set rates: it's known as "price fixing" and it's a violation of the Taft-Hartley Act. We were careful to avoid stating that this is what local rates *should* be. We did, however, agree that it is good for the local industry if experienced professionals charge a rate we are worth. I realized that the $600 rate I had recently started quoting was what others were charging too. After that I felt confident that my rate was fair and that I should be consistent with it.

Makeup artists might be a good resource for comparison rates in your area. Sometimes rates for makeup artists are a little higher than for stylists—I don't know exactly why, as stylists work as hard, or harder—but you can get a reference point.

QUOTING YOUR RATE

When I am asked for an estimate, I am now comfortable quoting my daily rate. Whether the shoot is on location or in a studio, the rate for one day's work is the same. However, if there is hesitation on the part of the client when I state my rate, I offer to work with their budget—within reason—but such negotiation rarely occurs with experienced clients.

If you are asked to do a longer job of five days or more, you can be flexible with your rate. The extended work period is worth the concession. You might also feel a lower-paying job is worth doing, for experience or for tears.

Often food styling rates are a little higher than other styling rates. This is partly because of higher kit and learning costs, but also because food stylists understand the demand for their professional skills. Remember your skills, experience, and value to clients when determining your own day rate. And remember it is only a starting point in negotiating for work you love.

You won't jump into styling at the top end. At the same time, you don't want to undercut the profession by offering a budget rate. Later when you're more experienced, you'll appreciate the professional standards you've helped maintain. Continue assisting and practicing your skills until you are confident that you can do the work.

REGIONAL RATES

As you would expect, there are variations in rates depending on where you live. Rates in New York, Chicago, and Los Angeles are higher than other cities. But the differences are not huge.

The type of businesses in your area has an affect on styling rates. There may be a large advertiser, publisher, or manufacturer in a medium-sized city, like Target stores in Minneapolis, *Better Homes and Gardens* magazines (owned by Meredith Corporation) in Des Moines, Iowa, or Procter & Gamble in Cin-

cinnati, Ohio. This outlet increases respect for the profession and the rates accordingly. Some areas pay comparable rates for commercial and editorial (magazine) styling; in others there is a greater difference.

Regional rates for assisting vary, too. If you are asked to assist, the stylist will usually tell you what has been budgeted, generally between $150 and $350 a day.

DAY LENGTH

In the photography field, a ten-hour day is the norm, and the day rate is based on it. After ten hours you may charge an hourly rate plus 50 percent (divide your day rate by ten hours and add half of that figure on for your hourly overtime rate) but it's important to inform the client first. You might state that the day is getting close to ten hours, ask how much longer you'll need to work, and mention your overtime rate. This may subtly create an end to the day; but if not, you will be comfortable charging the extra amount.

If the day ends early, say eight hours or less, and you have been booked for a full day, you will still charge your full day rate.

Some shoots are planned for a half-day. Working a half-day prevents you from accepting a full-day shoot, and you're unlikely to be booked the other part of the day. Therefore the half-day rate is more than 50 percent of your normal day rate, up to 75 percent. Often the shoot will go longer than expected anyway and you can, with your client's understanding, charge your full-day rate.

PRODUCTION RATE

I do a good bit of production for clients, involving location scouting, booking models, and arranging permits. I may work a couple of hours calling model agencies or applying for film permits; half a day holding a casting; or six hours scouting locations. I record these hours and when they accumulate to an eight-hour day, I consider that a full day and bill the client accordingly at my usual daily rate.

This honor system seems to be acceptable to my clients. I explain it to them before beginning the job and provide a client agreement, as described in this chapter. I could provide my notes on my job envelope if questioned but that has not happened.

COMPENSATION FOR TRAVEL

If you are asked to travel to a distant location for a shoot, you might charge a half-day rate for the time spent traveling. This is really a matter of negotiation between you and your client. Perhaps you could inquire whether they usually pay for travel time.

It's not such hard work, being flown to a location, but you certainly can't book any other jobs for that day. This is the approach an agency would take in negotiating travel time if you are represented. The value of work lost by a professional stylist while traveling is considered.

If you're driving to another city, the same considerations apply to your time. Most likely you won't charge travel time, but your client will agree to compensation for mileage. This compensation is also important when you're doing a lot of driving for prop shopping. You can use the IRS mileage rate as a reference amount. The mileage rate is an amount that the Internal Revenue Service allows as a deduction. It is calculated to include gasoline as well as wear and tear on your vehicle. The mileage can really add up; don't overlook it. You should keep a record of all mileage driven for your business, both for billing purposes and as an income tax deduction.

"Per diem" is a daily amount calculated for living expenses during business travel, including hotel and meals. If these expenses are coming out of your own pocket, you can deduct them as a business expense. Your client may pay for your hotel room and provide an additional amount for your morning and evening meals. When you receive this compensation, the amount may be considered part of your income, showing up on a 1099-MISC form if you are a freelancer, so be sure to deduct these expenses. (More about the 1099 form follows in the section on taxes.) Visit www.irs.gov or talk to your accountant about deductions for these expenses.

TIP Check on the IRS website for the current mileage rate. Sometimes it may increase during the year to adjust for economic factors. Visit www.irs.gov and search for "mileage rate."

EDITORIAL RATES
The rate paid for magazine projects is generally lower than a commercial rate. For up-and-coming photographers, the opportunity to have photos published in a magazine can boost their careers. The images are more creative than commercial work, they may be displayed better (maybe a cover or a two-page spread), the printing is better, and the photographer's name is usually prominent. These jobs make great portfolio tears.

The same applies to the crew. Many magazines list them in small type near the gutter, some more prominently. You can look for these credits to learn more about editorial work. You'll see the stylist, prop stylist, or food stylist listed, along with agency names if they are represented.

Sometimes local magazines request editorial styling for no fee at all. It may be worth it to acquire tears. Depending on the project, the experience may be valuable enough. I recently was asked to do styling for a regional bridal magazine for free. I accepted because I'd always wanted to see what it's like to style wedding gowns.

FLAT FEE
A number of years ago, a unique wardrobe styling project came my way. It was unique in that I agreed to a flat fee for styling and for wardrobe costs, something I have done only a few times. I was asked to style the participants in a

series of exercise videos for people with health problems, whose capability for movement is limited, as discussed in Chapter 7. It's a good program and the creator was financing the project from sales of her earlier videos. I agreed to accept a flat fee for the project. By dividing the figure she offered, I was able to calculate my day rate for a set number of days, a styling assistant for the most intense days, and have a certain amount left for the wardrobe shopping.

Working this way usually reaches a balance point where the more work you are asked to do, the more it eats into the budget, so that your day rate starts going down. That happened in this case. Then, of course, it's time to bring it to the attention of your client. Maybe there is more available in the budget, or perhaps your investment of time can be scaled back.

Naturally, I was motivated to keep the wardrobe costs low and return as much clothing as possible. The clothing the video participants wore to work out in was not returnable, but I had found some great bargains. And working in a television studio was fascinating for me.

When I've accepted a flat fee, I have done it for a higher purpose, one I consider similar to a pro-bono project. I produced a video for a children's health center and was glad to do it, both for the sake of the program and because I had the opportunity to learn about video production and editing. My entire fee went to the videographer, Carolyn Springer, who herself charged a lowered rate for the project.

ESTIMATING PROJECTS

This is a challenging aspect of working for yourself. If it's any consolation, estimating is hard for most creative, self-employed people. At first you may tend to estimate low so the quote will sound better, or so you'll be more likely to get the job. With experience, and when you have prior projects to refer to, it gets easier.

If you've established your day rate, you're halfway there. The next challenge is determining the number of days needed for preproduction (organization, planning, prop shopping) and postproduction (returns and other aspects of finishing a job). If preproduction is to include casting, location scouting, permits, or travel arrangements, you'll need to estimate how much time that will take. All that will be in addition, of course, to shoot days.

I've found that the number of preproduction days can amount to as many as six days for a complex project. A starting point, in fact, could be to take the number of shoot days and add on the same number for preproduction plus two days for concluding the project. Your client agreement can state that if you work fewer days you will only bill for that number: that way, you're covered if the time does go longer than you anticipate, which it usually does.

When a project is going to require you to do significant prop shopping, it's appropriate to request an advance, which could be a check delivered to you at the beginning of the job. Rather than investing your own money or credit in the client's project, an advance can help with the up-front expenses. You should negotiate this in your early conversations about the project, to allow your client time to request the check. The advance should be noted in your

agreement, and later credited toward the payment due to you in your invoice. (See the sample invoice on page 224).

It is legitimate to charge your client a fee for purchases applied to your own credit card if you don't receive an advance. There is a chance that you might be reimbursed before your bill arrives, but more than likely, you will be charged for interest on your purchases. In either case, you are still assuming responsibility for the payment. Since credit card fees are continually rising, it is not unreasonable to add up to 15 or 20 percent to your expenses. This advisory should be included in your client agreement.

CLIENT AGREEMENTS

After discussing a job and agreeing on your rates, it's a good idea to present a client agreement. This is a contract that clearly spells out the details that have been discussed—or possibly omitted, if you forgot to state your terms for mileage or other expenses. It clearly helps to have a description of the project, what your duties are, and your terms for payment, in a written form.

The sample agreement on the opposite page is available for you to copy or adapt. Create a basic format in your word-processing program, which can be customized for each job. Provide the agreement to your client before beginning the project and ask to have it returned to you with a signature. It can be emailed to you, mailed, or delivered upon starting the project.

In reality, I don't always manage to get my signed copy of the agreement. Presenting it to the client clarifies my terms, though it might not hold up in court. If your client is new and the project is complex, it's especially important to present the agreement and have it signed. When you have any doubts or reservations about the client, or have had payment problems in the past, be sure to get a signed original agreement.

An agreement isn't always needed for a simple studio project with no expenses or other complications. But it would be a better habit to write one for each job, spelling out your terms. The styling community tends to be more lax about agreements than the photographic one; we have less at stake such as photographic rights and liabilities.

HOLD OR BOOKING?

It's important to understand the difference between a "hold" and a confirmed "booking." If a client inquires about your availability and puts you on hold, also known as "an option," the project is either unconfirmed or several stylists are on hold for it, allowing the client to make a choice later. When you're on hold and are offered another project, explain that you are on hold but will see what you can do. It's possible that the first client has changed the dates, delayed the shoot, or chosen another stylist (so you are no longer on hold).

Don't pass up any other work because of a hold, and don't assume that you are working until you hear more. It's not real until you have a confirmed booking.

CLIENT AGREEMENT

To: _____

Project: _____

Date: _____

From: Susan Linnet Cox/Cox Productions

Project Description

Rate & Payment

Rate for location scouting and production is $_____ per day, based on hours accumulating to an eight-hour day. Styling rate is $_____ per day (up to 10 hours). Half-day rate is $_____ (up to 4 hours). In addition, long distance phone calls, cell phone usage, mileage, and other expenses will be billed.

Terms: Invoices are due upon receipt. They become overdue and subject to a finance charge of __% per month, ___days after the invoice date. New clients must provide ___% of the estimated fee before or on the date of services.

Expenses: If expenses are billed on the invoice, there will be a ___% mark-up charge. To avoid this out-of-pocket fee, you may provide a cash advance against the estimated expenses prior to the beginning of the job.

Props: If rented from my collection, the rental fee is ___% of the replacement cost, unless other arrangements are made. If purchased, the props are the property of the client, and may be taken by client after shoot, if desired.

Cancellation fee: A fee of ____% payment is required for any jobs cancelled within ____hours of a shoot, unless another client fills the time. Any expenses incurred on a cancelled job are the responsibility of the client.

These policies are reviewed annually and are subject to change. Please sign below and return agreement prior to beginning project.

Signature _____

Name/Title _____

Date: _____

Thank you, Susan Linnet Cox

Cox Productions

www.coxproductions.com

(Address, phone number here)

Client Agreement, courtesy of Cox Productions

JOB ENVELOPE

Years ago, when I started my own graphic design business, I received some good advice from a mentor. This experienced professional designer suggested job envelopes as a system for keeping track of all the details of a project from start to finish. I ordered a large quantity of 9" × 12" envelopes with a side opening. I had them printed with my company name and spaces for recording job details.

With five hundred printed, I still had some left when I left the design business for my full-time job with Norm Thompson. When I later started Cox Productions, I developed a cover sheet I created in Word software that is taped onto these envelopes to record information for my current projects.

If I am going to work in a studio for only a few days, I don't use a job envelope; they're needed when a project involves multiple roles, such as pre-production planning, prop shopping, model booking, etc.

THE JOB SHEET

As soon as a project becomes a confirmed booking, create the job envelope. I fill in the client and project information, the project dates, and important phone numbers on the job sheet. The side opening allows easier access to the contents; the client and project names at the side make it easy to file alphabetically, so I can access and refer to prior jobs.

As I'm working on production jobs, with sporadic tasks here and there, I write down my hours every day. Sometimes it may be one or two hours, sometimes a full day. When I'm contacted later about a similar project, I can refer to this job and see how much preproduction time it took, how many days on location, and for returns. Whether you charge for time spent in meetings depends on the client.

THE CONTENTS

Once it's been started, I never leave my office without the envelope throughout the course of a production project. It gets pretty beat up. It is handy to have all the information with me, especially contact phone numbers. Inside are print-outs of emails, layouts, shopping lists, and miscellaneous jots. There's even room in the job envelope for a tablet of ongoing notes. At the end I tear off the pages and leave them in the envelope.

Also inside is a smaller envelope for receipts. They are all there in one place when it's time to do returns. On the receipt envelope, I write down the date, amount, and method of payment for any purchases. This step isn't really necessary since the receipts are inside; I just like to have the extra documentation.

This is my technique; you will probably establish a system that works best for you. The important things are organization, having your job information accessible, and keeping track of each project for invoicing and future reference.

USING YOUR LAPTOP

Using your laptop on location is a convenient way to manage a production project. Still, I would suggest using a job envelope even if you do most of your organization on a laptop or web-enabled phone. You will have receipts and various notes to keep together.

Remember that you need to keep an eye on your laptop on location, so I wouldn't suggest it while you are styling and focused on the job at hand.

INVOICING

As I've stressed, it's important to create an invoice as soon as a job is finished. Receiving payment for your work can take anywhere from a week to several months depending on the client's payment cycles. Clients who pay the next week are rare and, naturally, you love to work for them. Typically you'll receive payment in about one month. Some ad agencies and magazines work on a sixty-day cycle. That's a long wait and it helps if you expect it. Try to find out about the typical payment cycles at the beginning of the project.

Your invoice should display your terms of payment at the top. Mine states "Net 30 days" and shows a late-charge percentage on the total. I've tried putting C.O.D. (cash on delivery) in the terms section but it didn't seem to speed up the process.

WHO IS YOUR CLIENT?

When a photographer calls you to work on a project, you need to determine whether you'll be invoicing the photographer or the end client. I have worked both ways. It does get uncomfortable when the photographer waits to be paid before paying your invoice, and a late payment can affect your working relationship. When that happens, arrange to bill the client directly for future projects.

Some photographers may mark up your rate when presenting their own invoices. In that case, it's important to be aware of the rate that was charged if you later work for and bill the client directly.

During the workday, be sure to get the exact billing information for your client, including address and project name. I have received invoices from people who had done freelance work for the huge cable company Cox Communications; they sent them erroneously to Cox Productions.

BILLING FOR EXPENSES

When invoicing your client for your expenses, you will provide a breakdown of the expenses, whether or not you've received an advance for them. You'll also need to provide the original receipts; the client will need the originals for its tax records.

Shown on page 225 is the format I use for expenses. It was created in word-processing software with tabs set for the four columns. I list the date of the purchase, the store, item, and amount. The same categories are listed for returns and items I keep. The result at the bottom is the expense total for the shoot. This amount would be entered on the invoice.

My Address • Phone Number • Cell Number
www.coxproductions.com

Date: 2/4/12 Invoice #: XX020412

Client: My Client's Name and Company
 Client's Address

Project: Styling and production for (Exact Name of) catalog

Terms: Net 30 days; Late charge: .015% per month, 18% annual

Date	Description	Amount
1/24-28/12	Five days product styling @$600/day	$3,000.00
1/19-23/12	Two and a half days pre- and post-production @$600/day	1,500.00
1/21-2/3/12	Expenses (see attached)	442.84
1/21-2/3/12	Mileage (see attached)	276.40
	SUBTOTAL	5219.24
1/20/12	Advance received	(500.00)
	TOTAL	**$4719.24**

30 Days	60 Days	90 Days	120 Days

Invoice sample, courtesy of Cox Productions

Cox Productions
2/3/12

Expenses
(Client Name, Project Name)

Date	Provider	Item	Amount
1/22/12	Vons	Groceries, snacks, water	$78.97
1/22	Vons	Ice	2.36
1/22	Thrift Store	Props	12.82
1/22	Music Rentals	Guitar rental	16.16
1/22	Tiki Land	Props rental	75.00
1/24	Starbucks	Coffee, snacks	23.65
1/24	Vons	Snacks, water	36.38
1/24	Vons	Ice	2.14
1/26	Ralphs	Snacks	13.84
1/26	Ralphs	Ice, water	10.02
1/26	Starbucks	Coffee, snacks	25.35
1/27	Starbucks	Coffee	13.90
1/27	Marina Shop	Prop ropes	35.00
1/28	Coast Surf Shop	Surfboard rentals	80.00
1/28	Vons	Snacks, water	13.25
	Miscellaneous	Tips, valet parking	4.00
Total			**$442.84**

Mileage

1/20/12	18 miles @ .555 cents/mile	$9.99
1/21	22	12.21
1/22	48	26.64
1/23	22	12.21
1/24	40	22.20
1/25	21	11.66
1/26	90	49.95
1/27	66	36.63
1/28	106	58.83
2/3	65	36.08
Total		**$276.40**

Expense list sample, courtesy of Cox Productions. This list will be accompanied by the original receipts. You can see the importance of recording and billing for mileage. Note that the rate is subject to change by the IRS and be sure to confirm it prior to billing.

KEEPING TRACK

Since the client needs to have the original receipts, you should make copies of them for your files. The process of returns, billing, and then making copies of receipts slows down invoicing by a day or two after the conclusion of a shoot. This is another reason to get started on invoicing as soon as possible.

For your own records, staple the receipt copies together with duplicates of the invoice and expense list, and file the packet in a special folder. This "Invoices" folder should be kept where you can regularly check on your unpaid invoices. You can keep track of what is owed to you and on what date, and follow up when it becomes past due. When your check is received, staple the stub to your copy and file that in another "Paid" folder for your accounting records.

FOLLOWING UP ON YOUR INVOICE

Like getting calls from new clients when you're going on vacation, this is another ironic aspect of the styling business. Often when I call a client to follow up on a late invoice, the check is in my mailbox the same day. The check really *was* in the mail. I don't mind laughing my way through this situation.

Sometimes it's not so simple. The due date has passed, the invoice hasn't been paid, and you're getting frustrated. Start with a cordial call to your client—let's say it's the art director—who will offer to check on it. You may get an answer, even a date that the check will be cut.

You can check with the photographer to see if his invoice has been paid; you may both be in the same boat. If they've previously paid on time, the company may be going through a delayed accounting period for some reason or other. You hope it's not serious financial problems.

You don't want to show your frustration to your client yet. This may be a valuable future relationship. A second call or an email is appropriate. Then resubmit your invoice with one month's late charge added. Unless the company has gone bankrupt (something I have not experienced in all these years), you eventually will be paid.

THE W-9 FORM

Another scenario is calling a client about a late payment, being referred to accounting, and finding out that they need you to sign a W-9 tax form. Required of individuals/sole proprietors, corporations, and partnerships, this is a signed statement of your Social Security number (or Federal tax ID number), name, and address. When this happens, I wonder if they were just waiting for me to call to initiate the process, but instead I simply ask them to fax me the form, sign and return it, and receive payment. (You can also download the W-9 form at www.irs.gov/pub/irs-pdf/fw9.pdf.)

This usually happens at the end of the two-month waiting period for magazines and agencies. You could probably avoid this tired situation by calling the art director or accounting department to follow up on your invoice shortly after submitting it. Ask if they need you to send them a completed W-9 form.

BANKING AND CREDIT CARDS

Ideally you should keep your business finances separate from your personal money. As soon as you become a professional stylist, you should establish a business checking account and separate credit card.

BUSINESS CHECKING

If you are working under your own name as opposed to a business name, like Cox Productions, you could deposit checks for your styling work into your personal account. It's better, though, to have a separate account for your business. This account should be used exclusively for business expenses and to pay yourself.

When you receive an advance for prop shopping, it's much easier to keep track of it this way. Use the business account to pay business expenses such as storage-space rent and cell phone bills. You can transfer money to yourself if your accounts are linked online, like giving yourself a paycheck. You could also go through the process of writing yourself a check, making a special ritual out of it. This is known as a "draw" on your business.

If you do use a business name, you may need to apply for a business license and establish a business name to open the account. Check with your local government or your bank to find out about these requirements. You will then be able to deposit checks made out to either your business or your own name.

SAVINGS ACCOUNTS

One of the wisest things I ever did was to open a savings account tied into my business checking account. By setting up an automatic monthly transfer of a specified amount to the savings account, I am able to set aside money for a rainy day, a late invoice, or a month without work. While the interest paid on savings accounts is small these days, it's a convenient way to save. And you can later open a more profitable retirement account when you have accumulated enough.

BUSINESS CREDIT CARDS

It's important to make prop purchases using either a credit card or debit card. If you make your purchases with a check, you'll have to wait for store refunds. Using your own credit to make purchases for a client is a difficult issue (even more complicated if you're married and your credit is tied to another person's).

When you expect a job will require a large investment in prop spending, you should request an advance to alleviate the risk to your own credit, as discussed previously. You can use your credit card knowing you already have the advance to pay the balance.

It can be to your advantage to have a credit card that earns airline-mileage points. Though a considerable amount of your purchases will later be returned, you will accumulate mileage on the purchases you do not return. Many business people who have reimbursable expenses use such a mileage-earning credit card.

I have learned one lesson the hard way: Pay the full balance for each job charged on the credit card as soon as you receive payment, no matter how much you'd like to hold onto the income and make payments gradually. In addition to avoiding interest payments at sky-high rates, you will need the available credit for the next project.

TAXES

When you are a full-time employee, your employer deducts taxes from your pay, and sends them to the appropriate government agencies. Depending on your income and deductions, at the end of the year the tax paid is sometimes more than what you owe, resulting in a refund to you. Social Security tax is also deducted from your pay but the employer matches it, and sends the combined amount to Social Security. That amount stays in your fund for retirement.

SELF-EMPLOYMENT

But you are self-employed and running your own business. Your federal and state income taxes and Social Security are your responsibility. You are responsible for filing your own taxes, IRS Form 1040, along with IRS Schedule C (Profit or Loss From Business), which is a statement of your profit or loss and the expenses for running your business, and Schedule SE (Self-Employment Tax). The process really motivates you to keep all receipts for business-related expenses.

Visit www.irs.gov/businesses/small to view an array of resources provided by the IRS for the self-employed, including business workshops.

The IRS 1099-MISC (miscellaneous income) form currently must be filed by any business paying you $600 or more in a calendar year. Near the end of January of the following year a copy is sent to you and another filed with the IRS. In this way, your earnings are recorded and must match with what you claim you earned when you file your taxes. Likewise, if you pay anyone else, like a styling assistant, $600 or more, you are responsible for filing a 1099-MISC form.

YOUR ACCOUNTANT

I am a photo stylist, not an accountant, and I don't presume to tell you what expenses are deductible from the point of view of the Internal Revenue Service. The best advice I can give is to have an accountant as an advisor for these financial questions, and to assist you with filing your taxes.

When I owned my plant store in the 1970s, I amazed friends and myself by filing my own business taxes. After a lifetime of math-phobia, it was an unlikely adventure. I actually recorded all the business income and expenses in a ledger book with a sharp pencil and totaled them on an adding machine. Now I don't have to bother with this challenging exercise, since computer software makes my record-keeping much less complicated. Financial software such as Quicken is easy to use and you can categorize and total your expenses.

Working with an accountant, you can provide a detailed list of your expenses—or pay the accountant more for the convenience of handing over your receipts. As part of your income tax, you'll be filing a Schedule C, which is a business profit and loss summary. You will have business use of your car and possibly a part of your home. You will need to list and describe equipment purchases. The tax-filing process is complex and accountants know what deductions are valid.

Here are some business expenses that you *may* be able to deduct from your income. You should save all your receipts from these expenses as documentation. Some are obvious, but others you may not have thought about. Again, please confirm them with your accountant.

- Computer equipment and software
- Office furniture
- Office supplies
- Cell phone usage (or the portion used for business)
- Mileage (record all mileage used for business in a small calendar kept in your car), *OR* actual auto expenses (ask your accountant which is better)
- Reference materials (books and magazines)
- Materials for your kit
- Marketing expenses (like web design, printing, postage)
- Props purchased for your own styling use
- Testing costs
- Legal and professional fees
- Portion of utilities, land-line phone, rent, or mortgage (based on the size of your home office)
- Bank fees, check printing
- Professional organization dues
- Travel expenses for work-related travel
- Continuing education relevant to your current position
- Professional conferences and workshops, and related travel
- Meals and entertainment (partially deductible; note who was entertained on receipt)
- Health insurance payments and medical expenses (partially deductible)
- Donations of cash or materials

QUARTERLY PAYMENTS
Generally the federal and state government expects a self-employed person to make quarterly tax payments. These are an estimated amount based on the previous year's income. Your accountant can help you set up this filing process.

BUSINESS LICENSES

Whether a license is required for running your business is a local matter. Check with your city or county government offices for the requirements for establishing a business. You are probably operating a home-based business, and depending on where you live, a license may not be required. Still, you need to know.

If you use a name other than your own name for your styling business, you may need to file a fictitious business-name notice in a local newspaper. Particularly in California, you will need this in order to open a checking account under that name. If you receive checks made out to your business name, you would not be able to deposit them otherwise. Find out about business-name procedures in your area by searching for "business licenses" and your state on the web.

While you can use your own Social Security number, it's helpful to have a Federal ID number for identifying your business. Apply for it by logging onto www.irs.gov and filling out a form. It is more secure than supplying your Social Security number to clients when completing W-9 forms.

PROVIDING YOUR OWN BENEFITS

Benefits are one of the biggest differences between regular employment and self-employment. In addition to regular paychecks, retirement accounts, paid vacation time, and sick days, health insurance has become an important issue for American workers.

HEALTH INSURANCE

Despite great fears about it, individual health insurance coverage in the United States is not so hard to find, if you are young and healthy. By doing some research you can locate information on a variety of policies available. It will take some time to compare deductibles, co-payments, and what services are covered, but it can be done. The rates depend on your age, so when you are in your twenties or thirties you should be more able to afford your own health insurance. Insurance for the self-employed can still be found when you're older but may be more expensive. A policy for catastrophic coverage may be the most manageable option at any age.

While some professional organizations offer membership in group policies, I haven't found the rates are much different from what you can find on your own. You might look at those policies, then look at some major insurers like Blue Cross/Blue Shield and Kaiser Permanente, and other insurance companies when making your decision. Many smaller insurers may provide comparable plans.

UNEMPLOYMENT AND DISABILITY INSURANCE

A small reassurance when you have a job is that if you lose it (if you are laid off or fired, your position is eliminated, or the company closes, but not if you voluntarily quit), you will be entitled to unemployment compensation. This

is not the case with self-employment, only with a part-time or full-time job, which would entitle you to receive a portion of your previous pay through your state's unemployment agency. So when your styling work slows down, you aren't qualified for unemployment.

Another issue is being unable to work because of illness or injury. State disability programs operate much like unemployment and may be administered through the same agency. As an employee, if you are unable to work, you may be entitled to receive a portion of your previous income after a waiting period. Employers contribute to these accounts. Though this would be considerably less than your employment income, it is some cushion. This is part of why people are encouraged to keep a savings equal to a number of months of your salary.

State disability insurance does not apply when you are self-employed (though a long-term disablement may entitle you to some benefits from social security). So a disability insurance policy is an option to explore along with your health insurance. It's hard to imagine these problems could occur when you are healthy, but it's always possible.

BUSINESS INSURANCE

As a stylist, you are working as an independent contractor without an actual place of business. The photo studios or clients you work for have their own business-liability coverage, so you shouldn't need this type of insurance. (These are the same policies that were discussed in Chapter 4, amended to cover locations.)

And you shouldn't need to carry worker's compensation; make sure that your health-insurance policy covers you if you are injured while working. But do check with an insurance expert for information in your state.

When you hire an assistant you might avoid the responsibilities of an employer, and some paperwork, by having the assistant bill the client or photographer directly.

RETIREMENT

When you are old enough to retire, Social Security may have changed a great deal. As it is, your retirement income is based on the amount you have contributed to the system. The more years you've put in as a well-paid employee, or a self-employed person with a profitable business, the more you'll be eligible to receive.

There are many options, however, for you to contribute to individual retirement accounts. If you start contributing to these accounts when you start your freelance career, and keep up your good habits, you should be able to accumulate a decent retirement income.

There's no official age when you can't work as a stylist anymore. I keep wondering how long I'll do this. Though the work requires strength and stamina, I think it's very healthy work, both physically and because of the pleasure of being a stylist. One forty-something stylist styles her hair in an orange Mohawk to maintain a youthful impression, which may extend her career.

GROWING OLDER AS A STYLIST

We can't keep on styling forever. Or can we? Now that I am in my sixties, I have cut back on styling jobs and focus most of my energy on teaching and writing about the profession. The calls have slowed down, since I am not marketing myself as a stylist. Until recently, that is. I suddenly found myself back at work when a photographer friend was in a jam; his staff stylist had a health crisis and he had several huge jobs beginning at the same time. It had been a while since I was putting in long days in the studio doing wall styling and going back the following day. This process continued for several weeks and was surprisingly easy, as if I'd never paused.

At any age, stylists should be fit, healthy, and strong. The days are intense and the work is physical. I believe we stay in condition that way, even when the schedule doesn't allow for much gym time. It's also crucial to keep a sense of humor, be a team player, and stay current with trends.

Food stylist Delores Custer defines the three criteria for styling as being *good* (counted on to come through with the assignment), keeping current with looks and presentation, and having the physical stamina to perform the job. "If you meet these three criteria," she declares, "you can work as long as you like."

Older crew members relate to each other. Los Angeles stylist Anne Ross says, "I find myself glomming on to the older people on the shoots. There's an unspoken experience bond. Just a few conversations and you find yourself on common ground. I have a couple dear producer friends who are older and completely, totally inspiring! I feel like I have so much to learn from them.

"Usually, there is someone on the crew who's older—often it's the photographers, as they've paid their dues to get to the big, fun ad jobs."

WHAT KEEPS US GOING?

Our bedding stylist Susan McDaniel says, "Actually, I think the most important quality is the ability to work with other people. Most of the photographers, assistants, and art directors are decades younger than me, but we have no barriers. They keep me on my toes, and I bring a wealth of experience. That combination is pretty successful for any line of work."

The strength and enthusiasm required to be a stylist in the first place keep us going well into our forties, fifties, and sixties. It's work that keeps one vital and involved in so many aspects of the world around us. Stay healthy and enjoy the perspective your wisdom provides.

LIFE AFTER STYLING

Stylists I've spoken to, being creative in nature, can imagine a vibrant life in other related areas, if not photo styling. Possibilities include art direction, production, fine art, teaching workshops, or "owning a wearable fiber arts store in the south of France."

Delores Custer had built up a book's worth of knowledge about the industry when she dropped back from food styling. But she had to move from New York City to Portland, Oregon, where she could stop working with cli-

ents and slow down enough to complete it. She is also a long-time teacher of the career. She states, "I will teach as long as I can stand and the brain is still working. I love to teach and have taught classes on food styling and recipe writing, cookbook writing, food demonstration and product promotion for the last twenty years. I wrote my book on food styling while I was working, but I have a couple of other books I want to work on as well, and I want to help those starting out (in a food business or in a food career) as a give back in an appreciation for all the gifts I have been given."

I am happy to have found writing and educating younger stylists as my path. I find I need to keep styling at least occasionally to keep my ideas fresh and my perspective up-to-date. Having developed a college course, I have the opportunity to share my knowledge with younger, enthusiastic stylists and see their thrill at discovering this fun career. And Photo Styling Workshops keeps me in contact with stylists worldwide working at all levels of experience, those who want to learn *and* those who are ready to teach their skills to others.

PERSONAL ETHICS

Styling is a commercial profession and there are times that you may have to make a decision about your own ethical standards. Working with clients such as liquor, cigarette, and other controversial companies may be a tough decision for you. Fortunately, cigarette advertising is not the major part of advertising that it was decades ago.

Other factors influencing your decisions may be religious, as when dietary restrictions may affect a food stylist, or political. Only you can decide whether your ethical limitations will override your need for work. When you make that decision, do so diplomatically and try to suggest another stylist for the job.

AGENCY, STAFF, OR FREELANCE

Agency representation can take care of many business details that could be overwhelming. If the business of styling seems too much for you, an agent can take on the burden of finding clients, quoting rates, estimates, negotiations, invoicing, and collecting payment. The percentage of your rate paid to the agency for this benefit may be well worth it, unless you're the most independent sort of person.

HOW AGENCIES WORK

A styling agency is in business for the purpose of finding you work, from which it takes a percentage in order to stay in business. The agents' incomes, marketing, and overhead are all paid through the commissions taken on placements.

Generally, a 20 percent commission is taken from the stylist's rate, and the client pays an additional fee of 20 percent of the rate. Since the client will be paying more when booking through an agency, experienced and professional-quality styling work is expected. Plus the client gets the service of having the details managed by a professional agent and knows a qualified stylist will arrive on the job.

Most often, styling and makeup agencies expect their talent to be exclusively represented by them. It's agreed that all of the stylist's work is to be channeled through the agency. The stylists are not allowed to book jobs independently or through another agency, except an agency in another region or country. The agency takes charge of scheduling work, keeping a calendar for the stylists, with a comprehensive idea of what they can and cannot do timewise. With years of experience with many stylists on their rosters, agents can realistically plan a good schedule, plus negotiate travel compensation.

Many model agencies will also represent stylists, often in a more casual way. The stylists' comp cards may be sent with models' cards to potential clients. Generally you are not asked for an exclusive agreement with model agencies, and this is a good place to start in smaller markets.

CONNECTING WITH AN AGENCY

According to Doni Miller, an agent with Judy Casey, Inc. in New York City, "We like to see a strong portfolio that shows a lot of range and different styles. When you have a strong body of work to show a potential client, the better chance of getting your stylist the job. You never really know what the client wants to see, so the better portfolios usually get the job."

Unless your portfolio is pretty amazing, you may first have to meet with an agency and then develop some new imagery for the agency's specific market—the agents will know what their clients are looking for. An agency may suggest some shots you can add to your portfolio to better represent yourself to the agency's market.

BENEFITS OF AGENCY REPRESENTATION

The agency takes care of every aspect of the stylist's professional life, from the previously mentioned calendar to billings. The rate is negotiated so you don't really have to discuss money with your client. Expenses may be arranged through the agent or directly with the stylist. The agency will invoice the client and make sure payment is received, and then it will pay you. Your agent knows what type of work is marketable and can advise about your portfolio and promotional materials.

Ann Fitzgerald is a Boston-based stylist who joined other stylists in forming the Team Agency in 1986. Ann says being represented by an agency is essential: "Financial issues never need to be discussed between the stylist and client, you don't need to show your book as often, and you can recommend your agency friends for jobs if you are already booked, and vice versa. It is also nice to have that bond with other stylists, especially since we spend so much time searching for the elusive prop, and time prepping alone. It's great to feel comfortable enough to call someone up for a resource if you need to."

TIP Get to know other stylists in your marketplace. Rather than viewing each other as competition, you may gain more from a relationship of sharing styling hints, resources, assistants, and clients you are unavailable for.

DRAWBACKS OF AGENCY REPRESENTATION

In spite of the helpful career management, there is no guarantee that you will have plentiful work through an agency. The jobs depend on the marketplace as well as on your own skill and professionalism. And there is a Catch-22 in that you need to have quite a portfolio in order to be signed on with an agency, and by the time you have that much work, you may have already established your freelance career.

Even with agency representation, you are still responsible for filing your own taxes and acquiring your benefits. You can expect to pay for your own promotional materials too. All these details should be clarified when signing with an agency.

An agency may require exclusive representation or allow you to find work independently or through other agencies. Be sure you understand the expectations before signing an agreement.

Agencies understand the styling demands of clients in different parts of the country and know the market. But you'll be informed about this too, once you network and do research.

AGENCIES REPRESENTING ASSISTANTS

A good time to learn about agency representation is when you're learning the styling profession and working as an assistant. Some agencies do represent assistants; some don't, but will list you as a resource for professional stylists looking for an assistant. The stylists will refer good assistants to each other.

At this point in your career, you can do some research into local agencies and develop your own opinion about a relationship with an agency. While you build your own portfolio, talk to stylists you assist and determine how you feel about marketing yourself, or what agency representation can do for you.

STYLISTS ON STAFF

Full-time positions for photo stylists are few and far between. While most stylists are hired on a freelance basis, some larger retailers and catalog companies maintain their own photo studios and employ stylists. This can be a very good situation for the stylist who desires some stability and prefers not to spend time on marketing and business. (I told the story of one staff stylist in Chapter 3.)

AN INDEPENDENT SPIRIT

An independent spirit and strong motivation to succeed are a plus, if not a requirement, for a freelance stylist. In spite of the workload of testing, promoting yourself, managing your business, *and* styling, you do have freedom. You can work a part-time job, take a vacation, or pursue other interests at the same time.

PART IV:
IT'S A WRAP

CHAPTER 15 The Photographer's Perspective

A COUPLE OF YEARS ago I registered for a class in studio lighting at an art center. Though I'd been in the photo industry as a catalog art director and a stylist for over twenty years, I wanted to learn more about technical aspects of photographic lighting. Most of the concepts presented in the class were what I'd already observed, but it was great to be more involved with the lights, reflectors, and sync cords.

What surprised me in the class was meeting photographers who didn't know about stylists. I'm accustomed to working with commercial, fashion, and architectural photographers who know the value of working with stylists. These class members were shooting products, weddings, and portraits and did everything on their own, from carrying equipment to marketing.

UNDERSTANDING STYLING

More than a few photographers have told me that photo styling was ignored in their photography schools, no matter the quality of the program. Also omitted was crucial instruction in the business of photography—as you know, a necessary element for succeeding. San Diego photographer Greg Lambert found out about styling by doing his own research. "In the '80s, I went to a lot of seminars, and the photographer presenting the seminar would go over what it takes to do a high-end shoot such as hiring a stylist and a makeup artist."

Organizations such as APA and ASMP provide numerous learning opportunities like this, featuring other photographers glad to share their knowledge with others. Sometimes a stylist will present a demo.

While you can save money as a photographer by going it alone, there are many occasions when a stylist is needed. It's important to understand when and how to hire a stylist, to achieve the high-quality photographs you need for a commercial client or for complex productions. If you read the earlier chapters of this book, you will get to know how stylists develop their skills and what they can accomplish on a shoot.

SPECIALISTS IN STYLING FOOD

Many stylists excel in all areas of styling. Others are specialists in one aspect or another. This is especially the case with food stylists who are well trained in culinary arts and food marketing in addition to having the skills required to make food look attractive under the camera.

When an assignment includes food presentations, the need for a professional food stylist is apparent to photographers. With a unique kit and

specialized skills, food stylists have the qualifications to make prepared food appear fresh and delicious under studio lights. Usually a stand-in is created so the photographer can set up the shot while the final dish is perfected. A prop stylist may be hired to work in conjunction with the food stylist to enhance more complex shots.

STYLING FASHION, WARDROBE, AND OFF-FIGURE APPAREL

It's obvious that a photographer would need to work with a stylist for high fashion photography. Editorial fashion is an opportunity to create beautiful magazine pages. Stylists for these features (also known as editors) have the inside knowledge to select and source the fashions—and to make them fit the model. They may be the ones hiring you for the shoot.

Catalogs that market apparel may not always be cutting-edge fashion, but they do provide a great deal of work for photographers and stylists. Intense shoot schedules with a goal of showing the best features of the merchandise require a team including a stylist and hair/makeup artist. In the studio or on location, they work with you to complete complex projects. The stylist is responsible for organizing merchandise, dressing models, and refining the fit of the garments while the photographer assembles and lights the shot.

For lifestyle photography, the stylist dresses the talent in generic items so as not to detract from the featured product or concept. The effect should be just enough that the clothes enhance and do not distract. Shopping for or pulling together a wide selection of garments, the stylist eliminates one more concern for you. The stylist can often maintain hair and makeup and deal with shiny faces during lifestyle shoots.

At the end of the shoot, the stylist makes returns of unused items while you are busy with image files and wrapping the business aspects of a shoot. It helps the budget when a professional knows how to shop economically and return extra items to stores.

The goal of most off-figure clothing presentations is to create a casual look, as if the garment was just plunked down. Techniques range from showing natural-looking folded items to imitating gestures of the human body, all of which is much more difficult than its relaxed look implies.

STYLING PRODUCTS AND PROPS

Stylists are valuable for product photography also. When there is the challenge of making a handbag strap drape gracefully or when props are needed, a stylist has experience and resources that save time and money while greatly enhancing the shots. Often a background surface needs to be selected, as well as props that will give a sense of scale and create interest.

Shoe styling involves standards for showing specific details of footwear. A stylist works on sets and backgrounds while arranging the shoes in gravity-defying positions. Working on a much smaller scale, jewelry photography is improved by a stylist. The stylist presents and positions spotless items in a variety of arrangements, while the photographer carefully controls the tiniest reflections.

ARCHITECTURAL SHOOTS

Architectural photographers, skilled at lighting and shooting a large area without awkward perspective shifts, literally see a bigger picture than many other commercial photographers. You won't need to hire a stylist for an exterior of an office building. But residential details, outside and in, may need more revision. Acquiring and assembling furniture, rugs, curtains, and other props that make a room look like home are the stylist's responsibility.

Many projects for an architectural photographer/stylist team are advertising images, including kitchen cabinets, appliances, windows, window coverings, or grills. The product is the star and, as with wardrobe, the set is styled to enhance it. Editorial projects for home magazines involve a similar attention to detail. When special props are needed, stylists know obscure sources for renting props and how to track them down. Many a stylist appreciates the challenge of building and creating props.

Easily overlooked elements can take away from a great photo, while careful propping suggesting a lived-in space can pull the entire room together. With a large-scale project, it's beneficial to have the extra set of eyes and hands on the set.

ADVANTAGES OF HIRING A STYLIST

- Photographer can focus on photography.

- Another "eye" is watching the shot and sharing responsibility for details.

- Hands-on member of the crew helps transport merchandise and holds the occasional reflector.

- Wardrobe and prop shopping by an experienced stylist saves time and money.

- Organization of products and props helps shoot move more quickly.

- Construction or rental of hard-to-find props expands your resources.

- Return of unused clothing and props after the shoot helps the bottom line.

- Preproduction duties, such as locations, permits, meals, RVs, and travel can be taken care of.

- Casting, booking, and coordination of talent may be handled by stylist.

- More professional impression to client; shows that the photographer is not an amateur but an experienced professional, understanding the scope of photo shoots.

FOOD STYLING

The types of shoots that require a stylist are obvious once you've been working for a while. One of these is clearly food shoots. While many bloggers these days prepare food, prop, style, and shoot their own images, professional photographers have higher expectations for the quality of the shots.

Greg Bertolini works largely on food photography and is the photographer who hired stylist Cindy Epstein (described in Chapter 11) for a major cookbook project. The award-winning cookbook is *Flying Pans*, published by Cabin Fever Press. Greg collaborated with chefs Ron Oliver and Bernard Guillas, and Cindy on prop selections, saying, "Prop styling was a group effort: Cindy, the chefs, and I all made the selection together." He continues:

Sometimes the propping was selected because of a photo angle or look; other times it was selected to complement the food or the plating of the food. We would use stand-in food on different surfaces and look at it through the camera to make our final selections. We were very fortunate that Macy's department store donated all the plateware, since the store's culinary kitchen was being used as a kitchen/studio for the project. We would "shop" their housewares specialty store, looking for the perfect plate, napkin, or accessory.

From a photography perspective, the challenging shots were the ones that involved multiple plateware and food textures. When lighting a shot, the texture of the food dictates where certain lights need to be placed. When dealing with multiple textures in a single shot, I sometimes had to make compromises to the lighting so that the lighting was cohesive and matched the look of the other shots. And of course, any shot that requires the food to look hot or steaming is a challenge: It can take several hours to set up a shot, and during that time the food starts to wilt and lose its fresh look. So trying to keep the food fresh in its prime, mouth-watering state is the most difficult part of food photography.

The fun part of shooting a cookbook is working with the people and being creative. Every shot had its challenges; some shots were frustrating and took hours to problem solve. But when it all comes together—when the photographer, the stylist, and the chefs all look at each other and say, "That's it!"—is when it's fun. When you know you made something special, working through the challenges, that's when you get a smile on your face. Seeing the finished project in a printed book is also quite satisfying.

FASHION, ON AND OFF-FIGURE

The hands-on skills of a fashion stylist are probably not part of your repertoire as a photographer. Along with time spent following fashion trends, developing relationships with designers and boutiques for sourcing garments and accessories, and dressing models on-set, you would have little time left for your photography business.

When addressing a college fashion photography class, I asked the students if they knew what a stylist is. I was not altogether shocked to find that they did not. One might think that since they chose to explore fashion photography for a semester, they would have done some cursory reading of fashion magazines. But by the end of their semester, they had teamed up with

my fashion photo styling students, created lookbooks, and learned to value both the fashion items and the ideas the stylists provided.

If you've read Chapter 8, Styling Off-Figure, you have some idea of how much preparation is involved in the casual look of stacks, laydowns, and wall styling. It would take you twice as long to style, light, and then shoot these presentations, costing your client more money than hiring you and a stylist to work as a team.

BENEFITS OF WORKING WITH A STYLIST

As you progress in your career as a photographer and build clientele in more complex areas, you learn to intuit exactly when you will need to work with a stylist. Most advertising agencies expect you to book a stylist; keep that in mind to present a credible estimate.

I interviewed Charlene Nevill of Vis-à-Vis agency in San Francisco about the styling needs of the photographers she represents. She explains their universal preference for working with a stylist:

> *All of the photographers I represent would choose to work with a stylist whenever possible, and they only work without one when there's not enough money in the budget to hire one or more. For people and lifestyle shoots, stylists are almost always necessary for wardrobe, grooming, and props. If it's a product shoot, it depends on whether additional props are needed, how many, how difficult it is to source them, and how many shots need to be done in one day.*
>
> *Whether the stylist is needed only to shop and drop—or to be on the set as well—depends on the complexity of the job and whether it's for an ad agency, for an annual report, or for editorial. For advertising, it's almost always expected that stylists will be part of the production, while for an annual report or an editorial shoot, it depends on the subject and the client.*

WORKING WITH THE ART DIRECTOR

When a capable stylist is on the shoot, the photographer is free to concentrate on creating the shot the art director is after. Communication with the art director proceeds while the stylist is taking care of the "small details" such as fitting the clothing, building cumbersome stacks of towels, or suspending items in mid-air.

In addition, the sequence of the following shots can be mapped out by the photographer and art director if the shoot is rushed. Be sure to communicate these details so the stylist is kept in the loop.

PRODUCING PHOTO SHOOTS

Typically stylists have a full set of production skills in their repertoires. Stylists accomplish many aspects of photo shoots before, during, and after the shoot days; this allows the photographer to concentrate on creating the photograph. (Chapter 4 provides in-depth descriptions of these production tasks.)

This task of coordinating the shoot may fall to you as the photographer. If you aren't able to sub it out, or if you want to do the preparations yourself,

read Chapter 4 for lots of how-to information. Production is another area that may have largely been ignored in photography school, crucial as it is.

How much to attend to yourself and how much you can delegate to a stylist/production manager depends on the client, the timeline, the complexity of the shoot, and especially your schedule. Hiring a local stylist may provide a resource for an out-of-town crew. Equipment rentals, studio rentals, photo labs, local assistants, and delivery services, as well as your everyday location needs like permits, can be found with the help of the local stylist. The stylist may even arrange travel details such as a photo-crew-friendly hotel.

STUDIO MANAGERS AND SPOUSES

When a photographer has a full-time studio manager, many styling projects are included in that person's daily responsibilities. Preproduction duties and logistics are probably at the top of the manager's list, along with estimates and billing. Simpler prop shopping, lifestyle shots, and basic product styling can be accomplished without hiring freelance stylists. However, complex projects may be better assigned to a professional stylist while the studio manager manages the day-to-day business of the studio.

High-profile photographers like David LaChappelle work with a full-time stylist. Collaborating on extravagant background scenarios requires a more intense work relationship than the typical freelance one.

Often the spouse or partner of a photographer falls into the role of stylist. I have been contacted several times by women who want to learn about styling because they find themselves assisting their photographer husbands in these duties. While most stylists discover the career unexpectedly, this is a natural alliance.

One such team, Tom and Trisha Hassler, was a favorite for product photography when I worked for Norm Thompson in Portland, Oregon. The couple came together to meet with the art directors and review the shot list and layouts. Then they took care of the shots in their studio, bringing back film precisely matching what we wanted. Of course, this can put a strain on some relationships, but I have seen it work successfully—though not yet with a female photographer and a stylist husband.

Experienced photographers want to work with the best and most experienced stylist the budget will allow. For lower budget or editorial jobs, the investment could be balanced by working with a fresh trainee who has gained experience assisting a top-level stylist.

FINDING A STYLING INTERN

This doesn't happen often, but why not find a student or aspiring stylist who wants to learn on the job? You might connect through a college program, social media, or word of mouth.

Benefits for the intern are the chance to see the workings of a photo studio, observe client interactions, and be exposed to various materials and tools while figuring out how to style the products or people you happen to be shooting. Since so much of styling is problem solving, this gives the right person a chance to learn and experiment on the job.

WHEN TO DO YOUR OWN STYLING

Budget constraints are the most common reason for shooting without a stylist. Most photographers would prefer to have a professional handle the products and props so they can concentrate on the many technical and creative aspects of the shoot.

But sometimes that isn't possible. The budget may not allow several hundred dollars a day for styling. It could be quite a shock for a new client who learns how much a photo shoot can cost. Many of them need to be educated about the advantages of a professional shoot and that may happen slowly.

I've been hired by a photographer who wanted to show his client—a skateboard clothing maker who typically shot with a small budget—how a stylist could improve the shots. He actually took my pay out of the studio's budget to demonstrate the improved look and increased volume of shots. The client loved the results and later starting booking stylists.

Some commercial projects don't require a stylist. Portraits and weddings rarely allow for a stylist in the budget and the customer wouldn't perceive the advantage. You don't need professional help with repetitiously setting products in the same position for a client's low resolution website images. But when there are people, clothing, food, props, and production work, it's great to have a stylist's help.

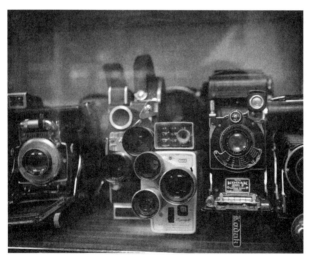

A small part of the collection of cameras available in prop rental warehouse Prop Coop in San Francisco. Photographer: Philippe Lee at Jade Studio Productions. © Philippe Lee

DOING IT ALL

An example of a photographer doing her own styling is a young woman who signed up for one of my styling workshops. She had started out as an assistant in a retail chain's in-house photo studio. When another photographer was needed in the studio, she was handed a camera. I can't say if it's to her credit

or detriment, but she was willing to do her own styling in exchange for the opportunity to *be* a photographer.

The shot-per-day volume was high, and this eager photographer managed to style and prop while keeping up on the shot list. She wanted to know how to style stacks, laydowns, and set up wall styling. I don't advise this kind of blind determination, though it saves the employer or client a lot of money. The photographer can accomplish simple and basic styling, but to maintain a professional appearance, it's better to be a photographer, not a jack-of-all-trades. Reading the earlier chapters on styling specialties will teach you some useful techniques. Chapter 5 provides you with a basic kit for styling. These are the items I have found most useful for general styling projects. Many of them you may already have in the studio.

TIP Experiment with the types of projects you may want to work on with a stylist. Try a test shoot of plated food and props with a stylist and on your own to see how the results compare and how much time the shot takes.

CONVINCING THE CLIENT

It's not surprising that some clients don't understand what the stylist can do for a shoot, especially when the additional day rate is added to the shoot. But organization of products, props, and merchandise can occur while the photographer is setting up the shot, saving valuable time.

Ad agencies already understand the role of the stylist. Your credibility will be increased when you expect to bring in a stylist as a member of the crew. But when budgets are tight, as they often are now, and clients are concerned about making it to the next season, it may take a good bit of convincing, even with seasoned clients. Bringing the discussion back to the budget is probably the best way. If you spend your time styling, the shoot will take twice as long. And your time is likely billed at a higher rate than the stylist's.

Possible ways to negotiate this are looking for a novice stylist (which can be a bit risky if you haven't worked together before), the "shop and drop" idea mentioned above, bringing your spouse or partner on board (not always a real possibility), or finding a styling program which may provide you with a semi-experienced intern.

And remember that for a longer booking (a week or more), it's easier to negotiate a lower day rate with a stylist.

WHEN THE STYLIST NEEDS AN ASSISTANT

Just as you need an extra hand from a photographic assistant, there are styling jobs complex enough to necessitate an assistant stylist. The day rate is comparable to that of a photo assistant. If there is a great deal of prep work, steaming and coordinating garments, many prop options on hand, distance from

the prep area to the location, or just plain complicated shoots, an assistant can free your stylist to watch the shot—it's worth it if you can make it happen.

CHOOSING THE BEST STYLIST

The most important part of hiring a stylist for attending to shoot details is hiring the *right* stylist. You want someone who takes care of duties independently, is quick, and is efficient. The stylist must be confident but able to take changes and revisions in stride without taking them personally. A pleasant personality is important in this working relationship.

Photo rep Charlene Nevill says, "In addition to the obvious—attention to detail, knowledge of the industry, experience doing his or her particular job, a great eye, and knowledge of design—it's important that a stylist is able to work well with the rest of the crew. Our clients not only expect great photography, they want to enjoy themselves on a photo shoot. How well the entire crew works together as a team can make or break a shoot. A sense of humor and willingness to do whatever it takes to get the job done also go a long way."

FLEXIBILITY

Whether the photo shoot is in a studio or on location, it's important for everyone in the crew to improvise and deal with changes. There are always last minute revisions to well-laid plans, and the ability to solve problems is the key.

Stylists learn that the ability to adapt and fulfill multiple roles is important. You won't find many prima donnas and if you do, look further. Production, prop shopping, styling on set, and organization, as well as willingness to clean up at the end of the studio day or run an errand should all be part of your expectations.

STYLISTS WHO PAY ATTENTION

Photographer Greg Lambert says the ability to listen is the most important trait. He expects this from a stylist as well as anyone else on the crew. While you are working as a team, there often is not time to discuss options for the best presentation. The stylist should defer to you, the photographer, and your knowledge of the best ways to capture the image; the ultimate responsibility for the image is yours. A stylist who is a pleasure to work with will understand photography, what you're doing with lighting and sets, when to refine the styling, and at what point to begin evaluating the image. This is someone you'll want to work with again.

At the same time, you need to be able to trust that the stylist knows how to manage products and props within the image, what supplies to use, and when to step in. The stylist should be paying attention and standing by for any changes that need to be made—you should not have to hunt your stylist down. Even when we stylists step away from the set to prep the next shot, we should always be in tune with what's going on in front of and behind the camera.

A good stylist, when watching the shot, should know that the smallest distance away from the camera is going to dramatically change the composition

of the shot. On the other hand, you probably don't want to feel hot breath on your neck.

FINDING A FAVORITE

When you find a stylist you work well with, the relationship continues. You will suggest each other for projects whenever possible so the team can be efficient and familiar.

Finding that special combination is not always easy. Some ways to locate a good stylist include recommendations from other photographers and word-of-mouth reputation in your photographic community. Another option is hiring from an agency that represents stylists fitting the profile for that particular shoot. Industry directories and online searches for local stylists can produce good results.

Winnie P. Ma is a photographer who has attended my workshops. Based in Los Angeles, she is building a successful career in food photography. She wrote an article about her profession that was published in *Canon PhotoYou* magazine. She understands the value of working with a reliable stylist.

> *Though I have some food styling experience, I find that having a great food stylist and assistant to work alongside you is key and will allow you to focus on the photography side of things. Building a great relationship with your team and knowing what they bring to the table can make the difference between a good photo and a great photo. If you're lucky enough to find someone who shares the same business ethics and work aesthetics as you, you'll find that over time you can both look at something on the table and know what to change or modify without even speaking! It's important to understand your roles on the set of a shoot for a successful assignment.*

While one favorite stylist is a comfortable fit, it's best to have two or three stylists on your roster, as your stylist may be not always be available; rotate them occasionally to keep in contact. One may be better at hard goods and another at off-figure or wardrobe, and of course you'll need a food stylist for food shoots.

TIP Keep a file of stylist promos either on a bulletin board or tucked away in a drawer. Even though you may not need one now, you may need to call someone for future jobs–even if it's just for an estimate. And the stylists' images may even inspire you.

COLLABORATION

A test shoot is both a creative exercise and an opportunity to work with new stylists. At the same time you'll most likely produce great images for your portfolios. Working in collaboration with stylists who have original ideas can expand your own way of seeing. You can learn from them and they can learn from you, no matter what the stylist's level of experience.

HOW TO FIND A STYLIST

These are some of the ways photographers can find a stylist to work with, both locally and on location:

- Recommendation from another photographer
- Recommendations from crewmembers
- Referral from a trusted stylist who is not available
- Representative agencies that have already screened stylists
- Portfolio events held by photography organizations
- Web searches by keyword
- Crew resource sites (see examples listed below)
- Film commission directories and listings
- Direct contacts from stylists who would like to show you their work

CREW RESOURCE SITES

- **APA** (American Photographic Artists), www.apanational.com
- **ASMP** (American Society of Media Photographers), www.asmp.org
- **Crews.com**, www.crews.com
- **Propville**, www.propville.com (local San Francisco directory)
- **Resource Advantage**, www.rasource.com
- **Shoots.com**, www.shoots.com
- **Workbook**, www.workbook.com

A test is also a good way to find out how well you work with a particular stylist, rather than on the job. Propose an idea to someone you are interested in working with—you'll find out how well-organized, fast, and creative that person is while you plan and shoot the test.

A good time to begin testing with stylists is when you're starting out as an assistant. You may meet them on the job and develop a rapport. Use these opportunities to push your boundaries, explore creative ideas, and build your portfolio as you gradually purchase equipment.

One word of advice about test shoots. As an art director for a catalog company, I was presented with many photographers' portfolios. When I would pause at an appealing image and ask about it, I frequently heard the reply, "Oh, that was just a test." It is not *just* a test. I believe that a shoot that you and a crew

organize for your own creative purposes is as important as—if not more significant than—a shoot done for a client. It shows that you love photography and shoot whenever you can, have creative ideas that you are anxious to explore and learn from, and work well with a team. It is never *just* a test.

Your professional reputation as a photographer is underlined by every image you shoot. Along with the art director, you are best qualified to determine when having a stylist on your team will help your career. The collaborative trio of photographers, art directors, and stylists on commercial shoots can be the source of creative ideas and techniques for making those ideas come to life.

PORTFOLIO CHALLENGE: MAKE YOUR DREAMS COME ALIVE

Have you had a photographic fantasy that seemed impossible? Maybe one of those spectacles of mundane Americana, a barbecue in the backyard with some poignant, depressing elements next to the average family. Or a fashion shoot with five models on stilts in a rundown warehouse with graffiti on the walls. Or a model in an evening gown reclined on an unmade bed—underwater in a turquoise swimming pool. Whatever you dreamed of, it seemed impossible to pull off. Find a stylist to team up with who loves a challenge and is excited at the prospect of making all this happen. Do an extravagant test shoot together, no matter what it takes. It may be first of many collaborations, both creative and commercial.

Conclusion

THIS BOOK HAS BEEN a joy to write and share with you. I hope it's been beneficial to you in learning more about the photo styling career. Maybe you've decided it isn't the career for you. More likely you're dreaming up photo shoot concepts to begin creating your own portfolio of styling work.

Or maybe you're already a stylist and recognize yourself in many of the stories in this book. It's always fun and reassuring to know that other people have the same experiences and challenges that you do, though we may not often meet. I hope that you've learned some new techniques and approaches and are ready to take your career to the next level.

These are a few more messages I want to give you before I send you on your way.

TAKING CRITICISM
Critiquing photographs is subjective. Everyone sees something different in each photo. Art directors who have the job of analyzing photos often feel the need to find something to criticize. They are not criticizing *you* – they are looking at elements of your styling.

LEARNING AND IMPROVING
Growth never stops in this career. Since each project is unlike any other, you must find new solutions on a daily basis. Enjoy the challenges and the hard work of problem solving. Research provides visual stimulation: Visit museums and galleries, read magazines, look at all the printed materials in the world around you, even those beyond your usual interest area.

PRACTICE, PRACTICE, PRACTICE
Remember to keep testing with other crew members and allow your creative ideas to come to life. And when you are alone and see an inspiring visual, grab your camera to record it. Artfully arrange the food on your plate, work the fabric of your garments as you put them on, and drape your bed in gentle folds in the morning.

HOW TO LEARN MORE ABOUT STYLING
Learning by practicing is the best way to develop your styling skills, but keep your eyes open for any educational opportunities. More schools and programs are offering styling courses, and at any level of your career there is always more to learn from others in this business.

Sharing the knowledge you've gained about styling with others is a tremendous opportunity to realize how much you know. Look at your career, the people you have met, the other businesses you've learned about, and all you have gained from these experiences.

I would love to hear your stories, successes, and even panics. Educators love to hear how their protégés are doing, despite the misconception that they are too busy to be bothered. Please email me at photostylingworkshops@gmail.com.

HAVE FUN IN THE STUDIO OR ON LOCATION

No matter what, enjoy this work. Photographs are all around us in many media. There is nothing like making the world more beautiful by styling these images.

Susan

About the Author

Susan Linnet Cox has been involved in all areas of photo shoots for over two decades. She has specialized in catalog design and art-directing photo shoots, followed by her real love, styling. Susan has cheerfully done everything from ironing to being a model agent to art direction! And having been "the client" as well as the crew, she understands the entire photo shoot as few do.

Susan began teaching weekend workshops after training several interns and discovering the joy of mentoring the next generation of photo stylists. The workshops led to her publishing her first book, *Photo Styling: How to Build Your Career and Succeed* in 2006 and sharing inside knowledge of the field of styling on a larger scale.

From there the idea of teaching the career online grew. Photo Styling Workshops was launched in late 2006 and shortly after its creation, students worldwide were signing up for online classes such as Food Styling 101 and Producing Photo Shoots. There are currently six instructors on staff teaching classes in English and in Spanish, all working professionals in their specialties who are anxious to share their knowledge and experience. In addition, Susan is a professor teaching the course she developed, Fashion Photo Styling, in the fashion department of San Diego Mesa College. She lives in San Diego but has produced, directed, and styled photo shoots throughout the US and internationally.

This completely revised edition of Susan's career manual includes changes that have taken place in the industry and the economy in the past six years. Sections on new digital technology, social media, and aging as a stylist have been added along with tips and portfolios challenges designed to help you build your styling portfolio.

Photography Credits

Haley Byrd, stylist, www.haleybyrd.com. Page 106
Cedric Chang, stylist. Pages 34, 37
Michael Christmas, Michael Christmas Photography, www.christmasphoto.com. Pages 18, 24, 28, 43
Susan Linnet Cox, www.susanlinnetcox.com, www.coxproductions.com, Pages 12, 104, 111, 119, 127, 203
Veronica Guzman, stylist. Page 106
Trisha Hassler, stylist, www.hasslerstudio.com. Page 120 (illustration)
Philippe Lee, Jade Studio Productions, www.jadestudioproductions.com. Page 245
Karen Melvin, Karen Melvin Photography, www.karenmelvin.com. Color insert
Tim Mantoani, Tim Mantoani Photography, www.mantoani.com. Pages 4, 80
Siobhan Ridgway, Siobhan Photography, www.siobhanphotography.com. Front cover, back cover, page 143
George Ross, George Ross Photographs, www.georgerossphotographs.com. Page 188

COLOR INSERT

Dennis Becker, Dennis Becker Photography Inc., www.robinogden.com
Gregory Bertolini, Gregory Bertolini Photography, www.gregorybertolini.com
Haley Byrd (see above)
Michael Christmas (see above)
Colin Cooke, Cooke Studio, www.cookestudio.com
Susan Linnet Cox (see above)
Trisha Hassler (see above)
Daryl Henderson, Daryl Henderson Photographics, www.daryl-henderson.com
Josh Koral, Acme Scenery Company, www.acmescenery.com
Tim Mantoani (see above)
Karen Melvin, Karen Melvin Photography, www.karenmelvin.com
Milwaukee Magazine
Nick Nacca, Nick Nacca Photography, www.naccaphoto.com
Nicole Ollerton, Nicky Alexandria, www. nickyalexandria.com
Beth Reiners, stylist, www.bethreiners.com
Siobhan Ridgway (see above)
Bill Schilling, Bill Schilling Photography, www.billschilling.com
Dave Spataro, Dave Spataro Photography, www.davespataro.com
Dan Whipps, Whipps Photo, www.whippsphoto.com
Kornelia Witek, www.korneliawitek.com

About the Cover Photographer

Capturing soul—in any medium—is a talent available only to those that possess and appreciate it in themselves. In her work, Siobhan Ridgway employs an innate gift for making images resonate with meaning, a gift that transcends the medium and produces art that speaks to its audience. Siobhan earned a BFA in photography, graduating with honors from Pasadena's Art Center College of Design in California. While at ACCD she minored in film. She also earned a BA in sociology from the University of Maryland.

Light, color, and most especially mood are revealed in her insightful photography. "Mind and heart are inexplicably linked. If you capture either (optimally both) on film you have created a legacy for the client and yourself," said Siobhan. Siobhan has a wide range of clients from advertising to editorial. Visit www.siobhanphotography.com to see her work.

Index

A

Abeel, Taylor, 17–18
accountant, 228–229
actors, 56
advertising, 11, 14, 86
agencies for actors, 56
agencies for models' test shoots, 198
agencies for stylists
 assistants and, 235
 benefits of, 234
 commissions to, 233
 drawbacks of, 235
 exclusivity for, 235
 for fashion advertising, 86
 for photographers, 249
 portfolio for, 201, 234
animals, at photo shoot, 27–29
annual reports, photo shoots for, 157
American Photographic Artists (APA), 196,
 212, 215, 239
American Society of Media Photographers
 (ASMP), 196, 212, 239
Armendariz, Matt, 166
art director, 19, 20–21, 23
 for fashion magazine, 84
 off-site, 20
 photographer and, 19, 243
 viewing portfolio, 249–250
assistant photographer, 17–18
 role in Polaroid process, 22–23
 v. digital technician, 18–19
 in studio, 21, 38
assistant stylist, 19, 113–115, 246–247
 agencies representing, 235
interviewing, 114
 rates, 114, 217
 role in images, 113, 202

B

banking, 226–227
Beckwith, Laura, 86
bedding. *See* room sets and bedding
Benoit, Jolie, 18
Bertolini, Gregory, 164, 195, 199, 242
blogging, 166–167, 207–208
blogspot.com, 207
booking v. hold, 220
branding and mood shots, 157
Brown, Jeffrey, 199
Bruns, Jay, 181–183
budget
 constraints for photographer, 245–246
 for test shoots, 198–199
Bumgarner, Lori, 107
business, styling
 accountant for, 228
 agency representation for, 233–234
 banking for, 226–227
 benefits for, 230–231
 billing for expenses for, 223
 booking v. hold in, 220
 credit cards in, 227
 day length and rate in, 217
 draw, 227
 expense list sample for, 225
 expenses, deductible for, 229
 invoices, 223–226
 job envelope for, 222
 job sheet for, 222
 licenses, 223–226
 per diem in, 218
 production rate for, 217
 quarterly payments for, 229
 rates, magazine v. commercial, 218
 staff stylist and, 235

taxes for, 228–229
terms for invoicing, 223
Byrd, Haley, 97, 107, 206–208

C

call sheets, 58
Canon PhotoYou (publication), 248
Capture Pilot, 25
carnet, 93
Carrick, Marty, 18
casting sheet, 54
casting talent, 53-58
 actors v. models in, 56
 agency for actors in, 56
 alternative resources, 57
 booking, 58
 organizing, 57
 street casting, 55, 57
catalog, 10, 120, 139–140
 economic changes, 48, 82
 fashion styling for, 86–88
 fashion styling for, v. magazines, 79–80
 layout,120
 merchandisers for, 88
 product styling for, 139–140
 production cycles, 91
 samples for, 88
 terminology, 87
catering, at shoots, 60
celebrity styling, 10–11, 98
 sports, 105
Chair Dancing (video), 109
children, 26–27
Christmas, Michael, 18
client, 19, 23, 27
 agreement for, 220–221
 identifying, 223
 invoicing for, 223–226
 list for résumé, 208–209
 for room sets and bedding, 177–178
 three rule, in self-employment, 46–47, 48
closed set, 93
clothing. *See also* fitting; wardrobe styling
 construction of, 110, 121–122
 generic for shoots, 103
 fitting, 92
 steamer for, 37–41
 of stylist, for photo shoot, 16, 44

clothing, in off-figure, 119-133
 details of techniques for, 132
 figure sculpting for, 129
 folding for stacks of, 123-125
 hangers, 124
 kit list for, 135-136
 laydowns, 126-128
 mannequins, 128
 shaping techniques for, 123-135
 styling woman's outfit for, 131
 wall styling sculpture of, 128-135
Cochran, Cindy, 80
color
 in off-figure styling, 121
 shopping by, 109
 trends at pantone.com, 96–97
colorways, 87, 121
communication, at shoots, 26, 88, 92
confidentiality. *See* non-disclosure
contributing editor, as stylist, 84, 86, 180
costume making, 110
Cox, Gary, 6, 7
Cox, Elizabeth, 6, 7, 199, 202
Cox Productions, 20, 205, 222–223
coxproductions.com, 211
craft services, 60
craigslist.org, 57
crew
 members, 17–20
 resource sites, 249
criticism, 21
C-stand, 42, 44, 69, 146
Cundall, Teri, 57
Custer, Delores, 172, 173, 232–233
customs regulations, 93–94

D

digital photography
 model and, 25
 at photo shoot, 24–25
digital technician, 18–19, 23
Direct Marketing Association (DMA), 212
donations
 for location, 51
 of props, 64

E

economic changes, 46
editing, for portfolio, 200

networking for, 172–173
project variety of, 163–167
props for, 168–169
rates, 216
recipe development, 166
shopping for, 167, 174
supply resources, 176
techniques for, 173
training for, 170–173
trends, 173–174
Food Styling (book), 173
freelance stylist. *See* self-employment

G

Gage, Nan, 203
general liability insurance, 51–52
Golden Scissors Awards, 95
gotputty.com, 146
Greenawalt, Alexandra Suzanne, 97
Guillas, Bernard, 164, 242
Guzman, Veronica, 4, 98, 105–106

H

hair. *See* makeup/hair artist
happiness effect, on model, 90–91
Hassler, Tom, 244
Hassler, Trisha, 28, 120, 138–139, 148, 244
hero, or feature, 87
high definition video and film, 107
 makeup for, 107
 styling for, 107
hold v. booking, 220
Holland, Leslie, 28
home office, 45–46, 229
home stylist (room sets), 178–180
How to Style a Bed (book), 191

I

income. *See* rates
insurance, 51–52, 230–231
intern/apprentice, 32, 244
 for catalogs, 95
 for fashion, 95
 for food stylists, 171–172
 for runway shows, 95–96
Internal Revenue Service, 45, 218, 226, 228
international photo shoot, regulations for,
 93–94. *See also* travel
invoice sample, 224

invoicing, 223–226
 payment terms, 223
ironing, 73, 91

J

Julie and Julia (movie), 165–166

K

Keter Plastic, 68, color insert
kits
 basic, 69–70
 container for, 68, color insert
 for fashion, 99–101
 fees for, 74, 168
 for food styling, 175
 multiple, 68–69
 for off-figure, 135–136
 for product styling, 150
 for room sets and bedding, 190–191
 supply resources for, 71
 travel with, 74
 for wardrobe styling, 115. *See also* fashion,
 99–101
knock out, KO, silo, silhouette, 143
Kravats, Carl, 195

L

LaChappelle, David, 244
Lambert, Greg, 239, 247
Lazear, Susan, 122
liability insurance, 51–52
lifestyle photography, wardrobe in, 56, 103
location,
 donations for, 51
 for fashion story, 83–84
 insurance for, 51–52
 international, 93–94
 in off-figure, 123
 permits, 51–53
 preview days for, 53
 residential, finding of, 50–51
 RVs for, 53
 safety at, 44
 scouting and permits, 50–52
 streets and highways, 52
 sunscreen for, 44
lookbook, 126

Books from Allworth Press

Allworth Press is an imprint of Skyhorse Publishing, Inc. Selected titles are listed below.

How to Create a Successful Photography Business
by Elizabeth Etienne (6 x 9, 240 pages, paperback, $19.95)

Profitable Wedding Photography
by Elizabeth Etienne (6 x 9, 224 pages, paperback, $24.95)

The Art and Business of Photography
by Susan Carr (6 x 9, 224 pages, paperback, $24.95)

The Business of Studio Photography, Third Edition
by Edward R. Lilley (6 x 9, 432 pages, paperback, $27.50)

The Real Business of Photography
by Richard Weisgrau (6 x 9, 224 pages, paperback, $19.95)

ASMP Professional Business Practices in Photography, Seventh Edition
by American Society of Media Photographers (6 x 9, 480 pages, paperback, $35.00)

Digital Stock Photography: How to Shoot and Sell
by Michal Heron (6 x 9, 288 pages, paperback, $21.95)

The Photographer's Guide to Marketing and Self-Promotion
by Maria Piscopo (6 x 9, 256 pages, paperback, $24.95)

Selling Your Photography: How to Make Money in New and Traditional Markets
by Richard Weisgrau (6 x 9, 224 pages, paperback, $24.95)

How to Succeed in Commercial Photography: Insights from a Leading Consultant
by Selina Matreiya (6 x 9, 240 pages, paperback, $19.95)

Licensing Photography
by Richard Weisgrau and Victor S. Perlman (6 x 9, 208 pages, paperback, $19.95)

Business and Legal Forms for Photographers, Fourth Edition
by Tad Crawford (8 ½ x 11, 208 pages, paperback, $29.95)

Legal Guide for the Visual Artist, Fifth Edition
by Tad Crawford (8 ½ x 11, 280 pages, paperback, $29.95)

The Law (in Plain English) for Photographers, Third Edition
by Leonard D. DuBoff and Christy O. King (6 x 9, 256 pages, paperback, $24.95)

The Professional Photographer's Legal Handbook
by Nancy E. Wolff (6 x 9, 256 pages, paperback, $24.95)

How to Grow as a Photographer
by Tony Luna (6 x 9, 232 pages, paperback, $19.95

Starting Your Career as a Freelance Photographer
by Tad Crawford (6 ¾ x 10, 256 pages, paperback, $19.95)

To see our complete catalog or to order online, please visit *www.allworth.com*.